Photos for Mac and iOS

the missing manual®

The book that should have been in the box®

Lesa Snider

O'REILLY®

Beijing | Boston | Farnham | Sebastopol | Tokyo

Photos for Mac and iOS: The Missing Manual

by Lesa Snider

Copyright © 2015 Lesa Snider. All rights reserved.
Printed in Canada.

Published by O'Reilly Media, Inc.,
1005 Gravenstein Highway North, Sebastopol, CA 95472.

O'Reilly books may be purchased for educational, business, or sales promotional use. Online editions are also available for most titles (*https://www.safaribooksonline.com*). For more information, contact our corporate/institutional sales department: (800) 998-9938 or *corporate@oreilly.com*.

July 2015: First Edition.

Revision History for the First Edition:

 2015-07-06 First release
 2015-08-21 Second release

See *http://www.oreilly.com/catalog/errata.csp?isbn=0636920036340* for release details.

ISBN-13: 978-1-4919-1799-2

[TI]

Contents

Foreword

If you're not a fan of change, a word of advice: Don't get involved with Apple.

Apple loves introducing a technology, singing its praises, wooing us to use it—and then abandoning it when a better technology comes along. The list of inventions that Apple has celebrated and then junked is longer than most companies' entire product histories: The floppy drive. The CD burner. The ADB port. The SCSI port. The FireWire port. The 30-pin iPhone connector. The MagSafe connector. The original Final Cut. The original iMovie.

And now, iPhoto.

Apple has put its aging photo-management/editing program for the Mac onto an ice floe and pushed it gently out to sea.

In iPhoto's place, Apple offers a completely new, free Mac program called Photos. In every possible way, it's meant to look and work like the Photos app on the iPhone and iPad (that is, on iOS). Learn Photos on your phone, and you've pretty much mastered it on your iPad and Mac, too. And vice versa.

If you're now using iPhoto—or the professional photo-management program Aperture, which Apple will also abandon—then this is big news indeed. You've probably got a few questions. You might wonder, for example, what will happen to your existing photo collections, what features you'll gain, which ones you'll lose, what will happen to iPhoto and Aperture, and how to convert your photo library to Photos format.

Above all, you might wonder *why* Apple is asking you to switch to Photos, especially considering that it has *fewer* features. Yes, you read that right: Photos 1.0 doesn't offer star ratings, flags, or events (which existed in iPhoto) or color labels, flags, copyright, contact, and content data (which existed in Aperture). So why is Apple starting from scratch with something that's not fully grown?

Why Photos?

The answer: Speed and stability.

Nowadays, in the phone-camera era, photography has exploded in popularity and quantity. The world has gone picture-mad. We post 1 million photos a day on Flickr, 35 million a day to Twitter, 40 million a day on Instagram, and a boggling 350 million photos a day to Facebook.

Now, iPhoto was a respected, time-honored hero for its day—but after 13 years, its code had become overrun by software weeds. The thing was being propped up by patches for patches.

Photos for the Mac, on the other hand, is all new. It's modern and sleek, designed from the beginning to handle huge photo collections, videos, and the kinds of specialized photography made possible by the iPhone, like slow-mo video, burst-mode photos, time-lapse video, and panoramas.

The combination of Photos (for iOS) and Photos (for the Mac) also work together in some spectacular ways—like iCloud Photo Library. This feature, should you choose to accept it, stores all of your photos and videos online—and lets you view them on any Apple product (Mac, iPhone, iPad, etc.) identically. Change a photo on your Mac, and you see that change instantly reflected on your phone, and so on. (This feature is free as long as your photo/video library is very small. You have to pay to accommodate larger collections; see page 11.)

Making the Move

The transition from iPhoto/Aperture to Photos for the Mac will be gentle, slow, and optional. The original programs still work just fine, so you can keep using them—even side by side with Photos. Which is good, because of those missing features. Over the months and years, Apple plans to restore features, bit by bit, until the new program is even more capable than the old one.

It's a good thing, in other words, that you have this book in your hands. You have not one but two programs to learn (Photos for iOS and Photos for Mac)—and you also have to learn how to hop back and forth between them without duplicating hundreds of gigabytes of photos.

Fortunately, you have the world's best instruction book in your hands. It's in color (as any photography book should be); it's loaded with important tips, tricks, and details; and it's written by Lesa Snider.

When she was a young whippersnapper, Lesa spent three years at my side, producing Missing Manuals with me. Later, she co-authored *iPhoto: The Missing Manual* with me for several editions. Then she took the bestseller lists by storm with her book *Photoshop: The Missing Manual*.

In other words, if anyone embodies that very, very precise intersection of photography, software, Macs, Missing Manuals, and command of plain English, it's Lesa.

So yes, Photos is an all-new program, written from scratch. So conversions, adaptations, and new learnings inevitably lie in your future.

But Apple freely admits that Photos 1.0 is only a starting point—and with *Photos for Mac and iOS: The Missing Manual* as your guide, you're in a perfect position to exploit its panoply of picture-processing powers.

—*David Pogue*

David Pogue is the anchor columnist for Yahoo Tech, having been groomed for the position by 13 years as the tech columnist for the *New York Times*. He's also a monthly columnist for Scientific American, host of science shows on PBS's *NOVA*, and two-time Emmy-winning correspondent for *CBS Sunday Morning*. With over 3 million books in print, David is one of the world's bestselling how-to authors. He wrote or co-wrote seven books in the "for Dummies" series (including Macs, Magic, Opera, and Classical Music); in 1999, he launched the Missing Manual series, which now includes 120 titles.

The Missing Credits

ABOUT THE AUTHOR

 Lesa Snider, founder of *www.PhotoLesa.com*, is on a mission to teach the world to create better imagery. She's the author of *Photoshop CC: The Missing Manual*, coauthor of *iPhoto: The Missing Manual*, and author of *The Skinny* series of ebooks, including *The Skinny on Taking Better Pictures With Any Camera*, *The Skinny on Photoshop Elements*, *The Skinny on Photoshop Lightroom*, *The Skinny on Shooting for Royalty-Free Stock*, and more (*www.theskinnybooks.com*). Lesa has recorded over 40 video courses on image editing and graphic design (*www.photolesa.com/videos*). She writes a weekly column for *Macworld* magazine (*www.Macworld.com*) and the Beginner's Workshop column for *Photoshop User* magazine (*www.photoshopuser.com*), and contributes regularly to *Photo Elements Techniques* magazine (*www.photoshopelementsuser.com*). You can connect with her online on Facebook (*www.facebook.com/PhotoLesa*), YouTube (*www.lesa.in/ytvideochannel*), and Twitter (*@PhotoLesa*).

Lesa lives in Boulder, Colorado with her husband, Jay, and two very spoiled cats, Samantha and Sherlock. She's steadily working her way toward a black belt in Muay Thai kickboxing and loves photography, watching/reading *Star Trek*, cooking, gardening, traveling, concert-going, and Ozzy Osbourne. Email: *lesa@photolesa.com*.

ABOUT THE CREATIVE TEAM

Dawn Schanafelt (editor) is an associate editor at O'Reilly Media. When not working, she runs, makes beaded jewelry, and causes trouble (though not simultaneously). Email: *dawn@oreilly.com*.

Kristen Brown (production editor) lives in Boston with her husband Matthew and a ridiculously large collection of board games and books. Email: *kristen@oreilly.com*.

Jill Wolters (technical reviewer) commutes by bicycle to her tech day job on campus. During off-hours she explores her creative side as a digital artist. She lives with her husband and fellow geek, Jochen, in Northern Colorado. Email: *jill@jillwolters.com*.

Molly Ives Brower (proofreader) is a freelance editor and proofreader who likes cats, vintage paperbacks, and long road trips. Email: *molly@mjibrower.com*.

Ron Strauss (indexer) specializes in the indexing of information technology publications of all kinds. Ron is also an accomplished classical violist and lives in Northern California with his wife and fellow indexer, Annie, and his miniature pinscher, Kanga. Email: *rstrauss@mchsi.com*.

ACKNOWLEDGEMENTS

This book is dedicated to my longtime editor, Dawn Schanafelt, whom I've had the pleasure of working with for the past seven years. Her attention to detail, careful edits, grammatical and project-management superpowers are mind-boggling. Not one of the eight Missing Manuals I've written would have been possible without her expertise and brilliance. I will forever be in Dawn's debt for molding me into the writer I've always aspired to be.

Special thanks to my mentor and friend, David Pogue, for writing the foreword for this book and for teaching me how to write in the Missing Manual voice so many years ago. He also taught me how to create the best book graphics in the west, which I take great pride in and I hope you enjoy.

A big kiss goes to my husband, Jay Nelson, who helped a great deal with this book, and kept me and the two cats fed and watered throughout the project. He makes each day joyful and lovingly supports me in every possible way. Thanks also to my mom and dad, Bob and Fran Snider, for their love and support, and for teaching me that I can do anything I put my mind to. I'd also like to thank Jill Wolters for expertly tech-editing the entire book, as well as Peter Cohen for his advice on the editing chapter.

Much gratitude also goes to my Tran's Muay Thai kickboxing family—Master Vu Tran, Rebecca Logevall, the Grace family, Jennifer Ganter, Pamm McFadden, Britni Burton, and Linda Gutekunst—for inspiring me and for being such incredible subjects to photograph. I'd also like to thank my good friends and neighbors, Guillermo Cassarubias, Bob and Elsbeth Diehl and Michael and Carol Morphew, for their support and input on using Photos in a family situation.

Last but not least, thanks to our beautiful kitties, Samantha and Sherlock, who forced me to get out of my pretty purple Aeron chair and play The Laser Pointer Game with them at exactly 4:15 p.m. each day.

May the creative force be with you all!

THE MISSING MANUAL SERIES

Missing Manuals are witty, superbly written guides to computer products that don't come with printed manuals (which is just about all of them). Each book features a handcrafted index and cross-references to specific pages (not just chapters).

For a full list of all Missing Manuals in print, go to *www.missingmanuals.com/library. html*.

Introduction

Photos, as you probably already know, is a program that you can use to store and edit your digital images and videos. But that just scratches the surface of what it can do. Perhaps most remarkably, Photos can keep your image library backed up and synchronized across *all* your Apple devices. That way your Mac, iPad, iPhone, and iPod Touch all contain the same photos, videos, and albums, all the time, which is pretty darn amazing. And by using Photos' shared albums, your family and friends can share photos from events as they're happening, and you can view them in a self-updating album on any device. Because your photos and videos are always available on all your devices, you can use Photos' incredibly powerful editing tools anywhere—for example, you could start editing on your iPhone, continue on your Mac, and then finish on your iPad.

> **NOTE** Technically speaking, Photos is a database—a special kind of program that tracks all the files you tell it about. Databases perform their tracking magic by creating a support file—a library, in this case—that includes an individual record for each file you import. If that's clear as mud, consider another app that you (likely) interact with all the time: the Contacts app on your Mac or iOS device. The Contacts app is a database that points to a file containing an individual record for each person you've told it about. A physical and somewhat vintage analogy is a Rolodex (database) and all the little cards (records) it contains.

Photos lets you view all kinds of info about each image file, including the camera settings you used when you took the shot (great for improving your photographic skills), as well as the date, time, and location (if your camera has that ability). You can add your own info to each file, too, such as who's in the picture, custom titles, and descriptive phrases that can help you find certain pictures more easily. Even the edits you perform in Photos get tucked into each file's record, so you can undo

the edits whenever you want. And Photos isn't just for managing images and videos taken on digital cameras; it can easily manage pictures you've scanned or had burned onto disc by your local camera store.

But Photos goes far beyond all that. For instance, once you identify a few faces in your photo library (you'll learn how in Chapter 4), the program begins finding and identifying them all on its own, so you can spend more time building creative projects—slideshows, books, calendars, cards—and less time digging through your library to find specific images. Photos helps you organize your digital memory collection in other ways, too. For example, it displays your images in chronological order and automatically creates albums that help you find certain files. such as the last ones you imported, ones you've marked as favorites (page 82), or videos. You can create your own albums, too, and then combine them into projects, convert and export them for use elsewhere, and easily share them with friends and family.

By embracing Photos, you're getting in on the ground floor of something very special: the first complete photo and video organizer for a mobile lifestyle—whether mobile for you means moving from the living room to the bedroom or jetting across the globe. This book is your trusty guide to this amazing new program.

> **NOTE** In the past, the word "program" was used for software that ran on desktop and laptop computers, and the word "app" was to describe software that ran on iOS devices (the iPhone, iPad, and iPod Touch). These days, Apple uses the word "app" to describe all kinds of software, regardless of the device it runs on. This book uses both terms, but leans toward "app." Don't be confused—when you see the term "app" or "program," it just means "software."

■ Photos' Backstory

Apple knows there are precious few people who enjoy the time-consuming task of managing and processing photos, so they've tried to make it as painless as possible. Back in 2002, Apple introduced iPhoto, Photos' predecessor, which enjoyed a long reign as the simplest image-organizing and -editing program available for the Mac. iPhoto introduced millions of people to the joys of image editing, and offered the more adventurous quite a lot of editing power and flexibility. The only problem with iPhoto enjoying such a long life is that it had a lot of outdated code under its hood, resulting in a program that crashed often and, if you had a big photo library, ran as slow as molasses. Therefore, in the summer of 2014, Apple announced that it would stop updating iPhoto and its pro-level sibling, Aperture, in favor of a fresh start with a new program: Photos.

> **NOTE** Just because Apple will no longer update iPhoto and Aperture doesn't mean you have to stop using them. As of this writing, both programs perform perfectly well in Yosemite 10.10.3, right alongside Photos.

Photos is a completely redesigned image organizer and editor that can do (nearly) everything iPhoto could, plus a whole lot more. Built especially for OS X Yosemite, Photos is smokin' fast and has a wonderfully sleek design. Compared to iPhoto, it offers a more logical way of viewing your pictures based on date (instead of events), and easier ways of getting around within the program. Also, Photos' editing tools are more powerful than iPhoto's, and the program inherited many editing features that were found only in Aperture. You get a slew of fun filters for applying nifty color and film-grain effects, plus a simpler process of creating books, cards, slideshows, calendars, and prints. And, as in iPhoto, everything you do in Photos is 100% non-destructive, meaning you can undo your edits anytime you want.

Perhaps the most exciting news is that you can use Photos in conjunction with Apple's iCloud storage service to sync your picture library to all your Apple devices, so you can have all your photos with you all the time. That's right: You can avoid the sinking feeling you get when you want to show a photo to someone, but you can't remember where the heck that picture lives. Alas, this syncing service isn't free, but it's affordable—and the peace of mind you get from knowing your files are backed up is worth the small fee. But you don't have to use it.

Like iPhoto, Photos is built to handle the needs of the *masses*—it's not designed for professional photographers. So if you need the ability to edit certain parts of a photo, fix perspective or lens-distortion problems, and the like, then you need a pro-level image organizer and editor such as Adobe Photoshop Lightroom.

TIP If you want to remove your ex from a vacation picture, combine images, push photos through text, or draw and paint from scratch, you need the advanced editing power found in programs such as Pixelmator, Adobe Photoshop Elements, or the 10-ton gorilla of photo editing, Photoshop. Conveniently, your humble author has written a book about it: *Photoshop CC: The Missing Manual*, available from *www.missingmanuals.com*. (For other books and videos by your author, visit *www.PhotoLesa.com*.)

▇ What Photos Can Do

As mentioned earlier, Photos can do most everything that iPhoto could, save for the exceptions mentioned in the box on page xx. If you're a seasoned iPhoto user or you've used the Photos app on your iOS device (iPhone, iPad, or iPod Touch), then you'll feel right at home in Photos on your Mac. Here's a rundown of what you can expect to accomplish with Photos:

- **Import images.** Photos can import pictures and video from just about anywhere, be it a camera or memory card that you plug into your Mac or an iOS device. If you've got an iCloud account that you sync pictures with, you can import from there, too. Photos understands almost any image format, including the raw format captured by most cameras (page 34).

- **View your snapshots.** Photos logically organizes your pictures and videos by years, collections, and moments. In Years view, you see teeny-tiny thumbnails of your pictures based on the years they were taken, which you can scroll through at high velocity. To see one of your shots at a larger size, just click and hold its thumbnail. To drill deeper into your photo library, click within any year and you open Collections view, which shows pictures taken at the same place within a certain time period—during a recent trip to New York, say. This view is similar to iPhoto's Events. Click inside a Collection and you open Moments view, which displays pictures taken within a shorter time period—your big night out on Broadway, perhaps. If your camera captures location info (as iOS devices do), you can also view your thumbnails plotted on a map. The program's Info panel shows when you took each photo and what camera settings you used. Photos for Mac lets you maximize your screen real estate, too—its Full Screen view makes your pictures feel practically life-sized.

- **Organize your collection.** You can manually arrange pictures into albums that you create, though Photos includes several built-in albums such as All Photos, Faces, Last Import, Favorites, and Videos. If you're lucky enough to have a newer iOS device that has a camera with the nifty Panorama, Slo-mo, Time-lapse, and Burst features, you automatically get albums for that stuff, too. Photos also has a powerful (and trainable) facial-recognition feature, as well as smart albums, which self-populate based on criteria that you set. You can mark your best pictures with a Favorites tag, making them easier to find later on, and also create and assign keywords, which let you find groups of photos based on similar content (such as flowers, food, or Fido).

- **Find pics quickly.** Photos includes a powerful search field that lets you easily locate photos based on any text associated with them, such as a filename, keyword(s), a face you've named, a description you've added, or where you took them. This field also lets you locate photos taken during a certain time period or on a specific date.

- **Sync and share images.** Apple's iCloud Photo Library lets you sync all your pictures across all your Apple devices, and ensures that full-size versions of everything in your library are safely backed up onto Apple's servers. This service is insanely convenient, though as page 11 explains, you do have to pay for it. You can also use iCloud to create shared albums (which are great for sharing photos with far-flung friends or relatives) and you can easily upload pictures to social media sites such as Facebook, Flickr, and Twitter. Emailing pictures from Photos is a breeze, as is sending them to others via text message. You can also transfer pictures onto other Apple devices using AirDrop.

- **Edit your pictures.** Photos offers editing tools for every skill level. You can use its one-click options to easily enhance, rotate, crop, straighten, and flip your images horizontally or vertically, and to apply a plethora of filters to give your shots creative color treatments. In Adjust mode, you'll find powerful and innovative preview-based controls for adjusting lighting (exposure, highlights, shadows, brightness, contrast, and so on), and color (saturation, contrast, and

cast), among other things. You can reveal additional controls for things like sharpening, adding definition, reducing noise, and adding an edge vignette. Photos also lets you zap blemishes, scratches, and stray hairs with the Retouch tool, and even conquer pesky red-eye. Once you've corrected one picture, you can easily copy and paste those edits onto another image. And it's super simple to duplicate a photo if you want versions with different effects (say, a full-color version and a black and white).

- **Make slideshows and movies.** You can create instant and saved slideshows using Photos' beautiful built-in themes, which come complete with background music. When you craft a saved slideshow, you can add text to any slide you want (a feature that even iPhoto didn't have). You can also customize elements such as transitions, slide duration, and whether the slideshow loops. Photos also lets you view and edit any movies you've imported—you can trim clips, adjust the timing of slow-motion videos, select a preview frame, and export frames as pictures. And when you're done creating your slideshow or movie masterpiece, you can easily export it to share with others and send it over to iTunes for syncing with your iOS devices.

- **Print your images.** Photos lets you print pictures in a variety of sizes on your own printer or order pro-level prints from Apple. Either way, Photos handles all of the resizing so you don't have to worry about it. And if you print on your own printer, you can easily gang multiple pictures onto a single page.

- **Create books, calendars, and cards.** Photos includes several themes you can use to create some of the world's most beautiful photo books, calendars, and greeting cards (of both the folded and postcard variety). The program's easy-to-use design controls let you make every page of every project look just the way you want. After that, you can upload the whole kit-and-caboodle to Apple so they can professionally print it, and then ship it to you or your lucky recipient.

Using Photos for iOS

To keep things simple, Apple designed Photos for the Mac to be virtually identical to Photos for iOS (that is, the version for iPhone, iPad, and iPod Touch). In Photos for iOS, you can view, tag, edit, and share your pictures just like you can in Photos for Mac. That said, you need your Mac—and a much bigger screen than any iOS device has—to build projects such as slideshows, books, calendars, and cards, and to order prints.

There are slight differences between the two programs, and they'll be duly noted in this book when they occur. The most obvious difference is that, rather than *clicking* things like you do on a Mac, you *tap* them on your touchscreen. So if you're reading this book while working with an iOS device, whenever you see the word "click," think "tap" instead. Also, you get fewer editing tools in Photos for iOS than in Photos for Mac. But for the most part, mastering one version of the program means you've also mastered the other, which is convenient.

■ About→These→Arrows

Throughout this book, and throughout the Missing Manual series, you'll find sentences like this one: "Open your User folder→Pictures→Photos Library." That's shorthand for a much longer set of instructions that direct you to open three nested items in sequence. Those instructions might read: "On your hard drive, you'll find a folder called Casey (or whatever your user folder is named). Open it. Now locate the Pictures folder and open it, too. Inside it you'll spot a file called "Photos Library.""

UP TO SPEED

Photos vs. iPhoto

As with most things Apple-related, the company giveth and it taketh away. While Photos can do most of the things that iPhoto can, it's missing a few features. Here's the lowdown on what you can do with iPhoto that you *can't* do in Photos (as of this writing, anyway):

- **No Events.** Apple replaced events with Collections and Moments views (page 43), which you can use to get a birds-eye, chronological view of images you took around the same time.

- **No star rating system.** Photos doesn't let you add star ratings, but it does convert any star ratings you added in iPhoto or Aperture into keywords, so all is not lost. In fact, you could use keywords to continue your own star rating–type system, as explained in the box on page 96.

- **No manual geotagging.** Unfortunately, the only way to connect location info to a picture in Photos is for your camera to include it when you snap the shot (though the box on page 90 has a few workarounds). Your iPhone captures location info automatically, and your iPad can do so if it's on a wireless network or you sprang for a cellular data plan. Most newer, pricier cameras can do this, too. And while there's no Places map in Photos per se, you can use Collections and Moments views to see a huge map with tiny thumbnails marking the locations where they were taken.

- **No album sorting by keyword, title, or rating.** Bummer!

- **No shared libraries.** If someone else on your wireless network uses Photos, you can't access their library on your Mac. Heck, you couldn't do this in the last version of iPhoto, either. The only way to share photos is to set up shared albums using iCloud (page 211), which is mercifully painless. (Page 14 details a tidy and stress-free solution for sharing pictures among family members.)

- **No external editors.** Alas, you can't send a picture from Photos to another program (such as Photoshop Elements) for additional editing.

- **Limited smart album criteria.** Photos lets you create smart albums that self-populate based on criteria you set, but your criteria options are limited. For example, you can't create a smart album that tracks down all the photos that you haven't applied any keywords to.

- **No slideshow captions.** You can still add titles and descriptions to your photos using the program's Info panel, but you can't pull that info into slideshows for use as captions. That said, you can add custom text to any slide.

- **Limited fun with AppleScript.** For the more technical folks in the audience, you may be saddened to hear that you can't use AppleScript to automate as many things in Photos as you could in iPhoto. Also, Photos doesn't work with scripts you cobble together yourself in Automator.

Will any of these features be introduced in future versions of Photos? Possibly, though there's no telling if or when. Maybe Apple is just giving the program plenty of room to grow.

Similarly, this kind of arrow shorthand helps to simplify the business of choosing commands in menus. The instruction "Choose File→Export→Export Slideshow" means, "In Photos, open the File menu at the top of your screen, and then choose the Export command. In the hierarchical menu that appears, choose Export Slideshow."

About the Online Resources

As the owner of a Missing Manual, you've got more than just a book to read. At the Missing Manuals website, you'll find tips, articles, and other useful info. You can also communicate with the Missing Manual team and tell us what you love (or hate) about this book. Head over to *www.missingmanuals.com*, or go directly to one of the following sections.

■■ MISSING CD

This book doesn't have a physical CD pasted inside the back cover, but you're not missing out on anything. Go to *www.missingmanuals.com/cds* to find a list of all the shareware and websites mentioned in this book, as well as Appendix C.

■■ REGISTRATION

If you register this book at oreilly.com, you'll be eligible for special offers—like discounts on future editions. Registering takes only a few clicks. Type *http://www. oreilly.com/register* into your browser to hop directly to the registration page.

■■ FEEDBACK

Got questions? Need more info? Fancy yourself a book reviewer? On our Feedback page, you can get expert answers to questions that come to you while reading, share your thoughts on this Missing Manual, and find groups for folks who share your interest in iPhoto. To have your say, go to *www.missingmanuals.com/feedback*.

■■ ERRATA

In an effort to keep this book as up to date and accurate as possible, each time we print more copies, we'll make any confirmed corrections you've suggested. We also note such changes on the book's website, so you can mark important corrections in your own copy of the book, if you like. Go to *http://bit.ly/Photos-Mac-iOS_TMM* to report an error and view existing corrections.

■■ The Very Basics

You'll find very little jargon or nerd terminology in this book. You will, however, encounter a few terms and concepts that you'll see frequently in your Mac life. Here are the essentials:

- **Clicking.** To *click* means to point the arrow cursor at something onscreen and then—without moving the cursor at all—press and release the clicker button on the mouse or trackpad. To *double-click*, of course, means to click twice in rapid succession, again without moving the cursor. And to *drag* means to move the cursor while keeping the button continuously pressed.

When you're told to ⌘-click something, you click while pressing the ⌘ key (it's next to the space bar). *Shift-clicking*, *Option-clicking*, and *Control-clicking* work the same way—just click while pressing the corresponding key on your keyboard. (On non-U.S. Mac keyboards, the Option key may be labeled "Alt" instead, and the ⌘ key may have a Windows logo on it.)

> **NOTE** New Macs come with Apple's Magic Mouse, a mouse that looks like it has only one button, but can actually detect which side of its rounded front you're pressing. If you've turned on the feature in System Preferences, then you can right-click things on the screen by clicking the right side of the mouse or by clicking with *two* fingers instead of one. Doing so typically produces a shortcut menu of useful commands.
>
> All through this book, you'll see phrases such as, "Control-click the photo." That's telling you that Control-clicking will do the job—but if you've got a two-button mouse or you've turned on the two-button feature of the Magic Mouse, right-clicking might be more efficient.

- **Keyboard shortcuts.** Every time you take your hand off the keyboard to move the mouse, you lose time and potentially disrupt your creative flow. That's why many experienced Mac fans use keystroke combinations instead of menu commands wherever possible. ⌘-P opens the Print dialog box, for example, and ⌘-M minimizes the current window to the Dock.

 When you see a shortcut like ⌘-Q (which quits the current program), it's telling you to hold down the ⌘ key, and, while it's down, type the letter Q, and then release both keys. And if you forget a keyboard shortcut, don't panic. Just look at the menu item and you'll see its keyboard shortcut listed to its right. (To see a list of *all* the keyboard shortcuts in Photos for Mac, choose Help→Keyboard Shortcuts.)

- **Gesturing.** On an iOS device, you do everything on the touchscreen instead of with a mouse and keyboard. The same is true if you use a trackpad connected to your Mac (either the built-in version you get with a laptop or the wireless, Magic Trackpad). You'll do a lot of *tapping* of onscreen buttons on an iOS device, though you'll also navigate by *swiping* your finger across the screen (say, to move from one image to another, and so on). Dragging is also a factor, which you do by sliding your finger across the glass or trackpad in any direction—like a flick (described next), but slower and more controlled. A *flick* is a faster, less-controlled slide. For example, you flick vertically to scroll through lists of thumbnails, which is a lot of fun—the faster you flick, the faster you scroll up or down. Scrolling lists have a real-world sort of momentum, so they slow down after a second or two, so you can see where you wound up. Last but not least, you can zoom in on a photo by *spreading*—that's when you place two fingers (usually thumb and forefinger) on the glass and spread them. The picture magically expands as though it's made of rubber. Once you've zoomed in like this, you can zoom out again by putting two fingers on the glass or trackpad and *pinching* them together. To see a quick, animated demo of common gestures, choose →System Preferences→Mouse or Trackpad. You can also learn more about gestures by visiting *https://support.apple.com/en-us/HT4721*.

If you've mastered this much information, you have all the technical background you need to enjoy *Photos for Mac and iOS: The Missing Manual*.

> **NOTE** When you Control-click (or right-click) something on your Mac, a little menu pops up. What's listed in the menu depends on what you clicked—which is why they used to be called *contextual* menus. But these days, Apple calls them *shortcut* menus, so that's the term this book uses.

■ Safari® Books Online

Safari Books Online is an on-demand digital library that lets you easily search over 7,500 technology and creative reference books and videos to find the answers you need quickly.

With a subscription, you can read any page and watch any video from our library online. Read books on your cell phone and mobile devices. Access new titles before they are available for print, and get exclusive access to manuscripts in development and post feedback for the authors. Copy and paste code samples, organize your favorites, download chapters, bookmark key sections, create notes, print out pages, and benefit from tons of other time-saving features.

O'Reilly Media has uploaded this book to the Safari Books Online service. To have full digital access to this book and others on similar topics from O'Reilly and other publishers, sign up for free at *http://safaribooksonline.com*.

Getting Started with Photos

I f you're new to OS X or you've never before used iPhoto, then you can breeze through this chapter in no time flat. You'll learn how to get Photos (if you don't yet have it) and read an incredibly helpful overview of iCloud Photo Library (page 11), the Apple service you can use to back up and then sync your Photos library onto all of your Macs and iOS devices. This chapter also includes a wonderful strategy for managing Photos in a *family* situation (page 14) so that your Photos world doesn't get out of hand. Feel free to skip everything else in this chapter and move to more exciting topics like importing your pictures and videos, which is covered in Chapter 2.

If, on the other hand, you've been in the Mac universe for a while and you've been using iPhoto or Aperture to manage your digital memories, there are some important things to consider *before* launching Photos. As you'll learn starting on page 4, there's a fair amount of preparation you need to do in order to smoothly migrate from those older programs to Photos. This chapter arms you with everything you need to know.

■ Getting the Photos App

You may be wondering how much Photos costs. Good news: It's free! On both Macs and iOS devices, Photos is part of the *operating system* (the software that lets everything run). On Macs, the operating system is called OS X, and on iOS devices it's called, well, iOS.

The Photos app is installed on every Mac sold since April 2015. You'll find its circular, rainbow-colored icon in the Dock and in your Applications folder. (To open this folder, go to the Finder and press Shift-⌘-A or choose Go→Applications.)

If you bought your Mac *before* April 2015, you have to update your operating system to OS X 10.10.3 (a.k.a. Yosemite) or higher to get Photos. (As of this writing, the latest version of OS X Yosemite is 10.10.4. The box on page 3 helps you determine whether your Mac can run this version of OS X.)

> **NOTE** Before updating your operating system, it's a good idea to make a backup of everything on your Mac. See the box on page 285 for a great backup strategy.

To update your operating system, click the menu at the upper left of your screen, choose App Store, and then click Updates at the top of the App Store window. You see a list of updated software patiently waiting to be installed on your machine. Locate the update named OS X Update Version 10.10.3 (or later) and click Update. Your Mac downloads the update, restarts, and installs the new version.

OS X 10.10.3 weighs in at two gigabytes, so the download process can take a while. Of course, the speed of your Internet connection plays a big role in how long this takes. You can continue working until the download is finished and your Mac restarts. When the update is complete, you see the rainbow-colored Photos icon in your Mac's Dock and Applications folder.

> **TIP** If you don't have a high-speed Internet connection, updating your operating system can take a painfully long time and it may never fully download (say, if the connection times out). In that case, you can haul your Mac to the nearest Apple retail store, where they're more than happy to upgrade it to the latest and greatest version for you.

Your Mac isn't the only device that can have Photos fun—there's a version of Photos for iOS, too. If you're one of the billions who own an iPhone, iPad, or iPod Touch and the device is running iOS 8 or later, you'll spot the same Photos icon on your home screen (unless you moved it, that is). To see which version of iOS your device is running, fire it up, tap Settings, and then tap General. On the screen that appears, if you tap Software Update, you see your device's current iOS version. If your device can run iOS 8, Software Update helpfully offers to install it. You're in good shape if you have an iPhone 4S or newer, an iPad 2 or newer, or an iPod Touch fifth generation or newer.

Your First Foray into Photos

If you're on a brand-new Mac (lucky you!) or you haven't previously used Apple's older photo-related programs iPhoto and Aperture, then the first time you launch Photos, the program creates a new, empty file named Photos Library and plops it into your Pictures folder. (If you're an iPhoto or Aperture veteran, jump to the next section.) A welcome screen appears that offers you a tour of your shiny new Photos app. When you click Get Started, the rather uninspiring screen shown in Figure 1-1 appears.

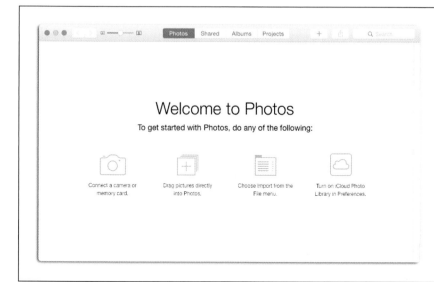

FIGURE 1-1

When you launch Photos for the first time, you get a sparkling clean and 100% empty library. Happily, you don't have to remember where your library lives; Photos opens it automatically when you launch the program.

Mac Requirements for Photos

Because Photos is included with OS X 10.10.3 (a.k.a. Yosemite), your Mac has to be able to *run* OS X 10.10.3 in order for you to get Photos. If your Mac is included in the following list, you're good to go:

- iMac: Mid 2007 or newer
- MacBook: Late 2008 aluminum or early 2009 or newer
- MacBook Pro: 13-inch, Mid-2009 or newer; 15-inch, Mid/Late 2007 or newer; 17-inch, Late 2007 or newer
- MacBook Air: Late 2008 or newer
- Mac mini: Early 2009 or newer
- Mac Pro: Early 2008 or newer

Here's how to find out which version of OS X your Mac is currently running: Click the at the top left of your screen and choose About This Mac. The window that appears prominently lists which version you have, such as "OS X Mavericks Version 10.9.5."

If your Mac is running OS X 10.6.8 or higher, then the update to OS X 10.10.3 is free. If you have OS X 10.6 through 10.6.7,

you must first update to OS X 10.6.8 before you can install OS X 10.10.3. If, on the other hand, you're rolling retro with OS X 10.5 or 10.4, you have to pay Apple $19.99 for a DVD that you can use to update your Mac to OS X 10.6 (Snow Leopard); only *then* you can update to OS X 10.10.3. You can order the OS X 10.6 installer DVD online at *http://store.apple.com* or buy it at any Apple retail store.

To use OS X 10.10.3, your Mac needs to have at least two gigabytes of memory (RAM) and eight gigabytes of available storage space on a hard drive or SSD (solid state drive). However, those are just the minimum requirements. Photos *devours* memory and storage space at an alarming rate—blame file sizes, not the program—so the more memory and storage you have, the more smoothly and speedily Photos will run (it's common for a Photos library to reach over 100 gigabytes in size). Your Mac's processor speed also affects Photos' performance, but if you have to choose, increasing your amount of memory makes a bigger impact than increasing your processor speed. That's good news considering memory is more affordable than a new Mac!

At this point, you can skip ahead to Chapter 2 to learn about importing new content. However, it might be helpful to read the useful overview of iCloud Photo Library that starts on page 11, and you'll find a wonderful strategy for using Photos with family members on page 14—handy if you harbor multiple Mac- and iOS-using, picture-taking people under your roof. If you're curious about using and maintaining *multiple* Photos libraries, then skip to page 272.

Migrating from iPhoto or Aperture to Photos

If you're a longtime Mac user, you've probably been running iPhoto and/or Aperture for years. Alas, Apple has decided to stop updating those programs, so while it's not urgent, your eventual best course of action is to switch over to using Photos. (Unless you relied on Aperture to edit parts of your photos, that is, in which case you'll want to switch to Adobe Photoshop Lightroom instead.) Here's what you should do to prepare for the transition to Photos:

NOTE If you never update your Mac's operating system, the newest versions of iPhoto and Aperture will run forever. Even if you do update your Mac's operating system regularly, you can count on using iPhoto or Aperture for several more years.

- **Update iPhoto or Aperture to the latest version, and then open your library.** To check for updates in iPhoto, open the iPhoto menu and choose "Check for Updates"; in Aperture, head to the Aperture menu instead. (The latest version of iPhoto is 9.6.1, and the latest version of Aperture is 3.6.) Once you've updated the program, open your library in it. By doing this, you ensure that all is well with your libraries and that they're organized in a way Photos can understand. In other words, shiny new programs usually communicate better with the latest versions of other programs.

- **Empty your iPhoto and Aperture Trash.** Both iPhoto and Aperture are extremely careful with your pictures. When you instruct either app to delete an image, they move the file into the app's own Trash, and that's where it stays until you empty the app's Trash. Even then, those images are merely moved to your *Mac's* Trash. It's only when you empty the Finder's Trash that the image is permanently deleted from your iPhoto or Aperture library.

 This protective system is brilliant, save for the fact that most people forget to empty their app-specific Trash can; they simply assume the files are long gone. And even if they remember to take that step, they often neglect to empty their Mac's Trash. The result of upgrading a library in this state is like watching an episode of *The Walking Dead*—all those not-yet-deleted images come marching back to life in Photos.

Some of these zombie images are funneled into Photos' Recently Deleted folder (File→Show Recently Deleted) while others appear in the program with empty, ghost-like gray thumbnails. Appendix A teaches you how to deal with this problem (page 290), but it's easy enough to avoid in the first place. Here's how:

- **In iPhoto,** choose iPhoto→Empty iPhoto Trash, and then click OK.

- **In Aperture,** choose Aperture→Empty Aperture Trash, and then click Delete.

- **In the Finder,** choose Finder→Empty Trash, and then click Empty Trash.

- **If you have multiple Aperture or iPhoto libraries, merge them or delete the ones you don't need.** Page 9 and page 10, respectively, have the details.

When you're finished with these housekeeping tasks, do a happy dance and know that you've done everything possible to ensure an easy transition to Photos.

When you first launch Photos, it searches for iPhoto and Aperture libraries on your internal hard drive and any external hard drives attached to your Mac. If Photos finds an existing library (or several), you see the Choose Library screen shown in Figure 1-2. (If it doesn't find one, you see the rather Spartan welcome screen shown in Figure 1-1.)

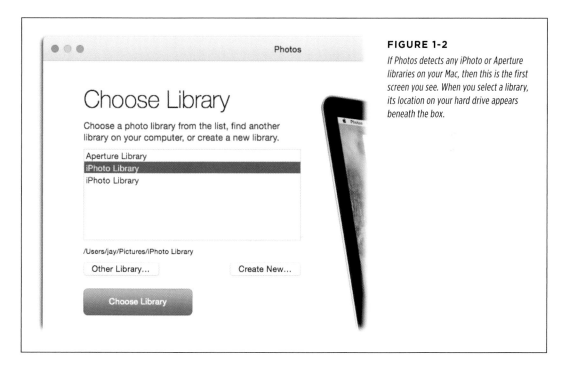

FIGURE 1-2

If Photos detects any iPhoto or Aperture libraries on your Mac, then this is the first screen you see. When you select a library, its location on your hard drive appears beneath the box.

If you pick a library from the list and click Choose Library, Photos sets about upgrading it for use in Photos. Your old library remains in its original location; Photos merely builds a new one and stores it in the same spot.

At this point, you may be getting a little panicky: "I don't have enough hard drive space to duplicate my entire image library!" The short answer is don't worry—Photos doesn't duplicate your old libraries. Instead, Photos uses some seriously slick behind-the-scenes voodoo to link the contents of your old library to the new one that it creates. The box below has more info.

Now that you know your new Photos library won't devour all your hard drive space, go ahead and pick your most important library, and then click Choose Library. When you do, Photos creates a new library for itself that contains everything from your iPhoto or Aperture library that it knows how to use. (See page 7 for details on what does and doesn't get converted.)

In the next few sections, you'll find important info about upgrading iPhoto and Aperture libraries for use in Photos. Understanding this transitional stuff up front will put you at ease and better equip you for life in Photos.

FREQUENTLY ASKED QUESTION

Duplicate Library Magic

I already have Aperture and iPhoto libraries on my hard drive. Am I going to run out of space if I add a Photos library, too?

Fortunately, the answer is no. Instead of duplicating your existing iPhoto or Aperture libraries, Photos makes use of a feature called *hard links*, which are similar to the aliases that the Finder uses. When you open an iPhoto or Aperture library in Photos, each photo or video remains in its original library, and Photos simply remembers where they are and points to them.

Of course, all this happens under the hood, so it's hard to tell what's going on. If you view your various libraries in the Finder, it lists the file size of your new Photos library as only slightly smaller than your original libraries, which may lead you to think that the Photos library is using as much hard drive space as the old ones, but that's not the case. The Finder is just trying to warn you that if you copy your Photos library to another drive, the duplicate will consume an enormous amount of space, because doing so forces your Mac to extract copies

of all the files from your old libraries and include them in the duplicate Photos library.

This concept actually makes sense if you can wrap your brain around it. On your Mac, Photos knows where the original content is stored in your iPhoto or Aperture libraries, which are also on your Mac. If you copy the Photos library to a location that's not on your Mac, all the hard links are lost, so the new drive is forced to store *all* the original content your Photos library contains.

This explains why, if you look at the amount of disk space your drive had available before you converted your iPhoto or Aperture library to Photos, the difference is nowhere near the size the Finder lists for your new Photos library. The only time your Photos library actually consumes the amount of disk space the Finder reports is when you delete your old iPhoto or Aperture library. Doing so takes a long time because your Mac has to shuffle content from those libraries into your Photos library.

iPhoto and Aperture Edits Become Permanent

If you've worked with iPhoto or Aperture for any length of time, you know that whenever you edit a picture or video, the program merely keeps a running list of your edit requests; your originals remain fully intact. This is what powers the "Revert to Original" command in both programs. However, when you export content from either program, the exported version is a duplicate of your original with your changes permanently applied to it.

Photos makes use of this same system when it migrates your iPhoto or Aperture libraries: It applies all the edits you made in either program and creates a new original for each file you've edited. Because of that, you can't use Photos' "Revert to Original" command to revert all the way back to the *real* original in iPhoto or Aperture—you can only revert to the original in Photos (which is the edited version delivered by iPhoto or Aperture).

For this reason, you may want to keep iPhoto or Aperture hanging around for a while, along with their respective libraries. That way, if you need to revert an image to its *true* original state, you can. To do that in iPhoto, find the image and choose File→Export. In the dialog box that opens, pick Original from the Kind menu, and then click Export. To do that in Aperture, choose File→Export→Original, set the export options, and then click Export Originals. Unfortunately, doing this strips the image of any custom metadata you've added to it in iPhoto or Aperture, such as keywords, face and location tagging, and star ratings (fortunately, the metadata assigned by your camera remains intact).

How Photos Handles Albums, Events, Projects, and Metadata

When you upgrade your iPhoto or Aperture library, Photos maintains all the organizational details that it knows how to use. For example:

- **iPhoto albums and events.** Photos preserves your albums, but since Photos doesn't use Events, they migrate to a folder named iPhoto Events in Albums view. Each of your iPhoto Events becomes an album in that folder, named after the Event itself.

- **iPhoto books, cards, and calendars.** Most iPhoto projects are preserved and viewable in Photos' Projects view. However, if a book, card, or calendar uses a theme that Photos doesn't have, it gets converted into an album instead.

- **Aperture albums and projects.** Photos preserves any albums you made in Aperture, but all subfolders, as well as book and web projects, migrate to a folder named Aperture Projects in Albums view. (In early versions of Photos, these Aperture projects may inexplicably be placed in the iPhoto Events album, so have a look there as well.)

- **Slideshows.** Happily, slideshows from both iPhoto and Aperture remain fully intact as slideshow projects, viewable in Projects view. That said, if a slideshow made in those programs uses a theme that Photos doesn't have, the Classic theme is substituted instead.

- **Smart albums.** If your iPhoto or Aperture library has any smart albums that rely on features not included in Photos—say, star ratings or Places tags—Photos appends "(modified)" to the end of their album names. It's then up to you to examine those albums to see how Photos has modified their criteria. Fortunately, Photos converts star ratings and Places tags to keywords (described next) and converts smart album criteria to look for that stuff instead. However, if your original smart album uses only conditions that Photos doesn't understand, such as "photos edited in an external editor," then that smart album doesn't show up in Photos at all.

- **Metadata.** Photos preserves most metadata such as keywords and titles, but Photos converts most everything else to keywords. For example, star ratings become keywords (1 Star, 2 Star, and so on), as do iPhoto Places tags (say, "Place is Maui") and Aperture color labels (Green, Purple, and so on). Photos assigns the keyword "Flagged" to flagged images from either program and corrals them into a smart album named Flagged in Albums view. Unfortunately, custom Aperture metadata doesn't migrate to Photos at all.

In summary, take heart that most of your iPhoto and Aperture world gets ported into Photos albums, so you'll need to root around in Albums view to find much of your stuff. That said, slideshows stay intact in Projects view, which is really nice. Overall, the migration from iPhoto or Aperture to Photos isn't too painful, though the inability to back out of your previous edits in those programs is a galactic drag. While a few organization tools get converted to albums and keywords, that's better than not having those organizational goodies at all.

The truth is that switching to *any* program from iPhoto or Aperture, even the extremely capable Adobe Photoshop Lightroom, puts you in the exact same transitional boat...if not worse.

Continuing to Use iPhoto or Aperture

As mentioned earlier in this chapter, upgrading an iPhoto or Aperture library for use with Photos doesn't move or replace it. Instead, Photos creates a duplicate library that's a fraction of the original library's size, as the box on page 6 explains.

The takeaway here is that if iPhoto or Aperture has a beloved feature that you can't live without, you can keep using those programs. At least, you can for as long as you keep those libraries hanging around *and* your Mac's operating system can open those programs. Unfortunately, there's no way to know exactly how long that will be, but based on Apple's history, you should be safe for several years.

NOTE As of this writing, if you update to the latest version of OS X 10.10.3 before you update iPhoto to the latest version of 9.6.1, iPhoto flatly refuses to launch—even if you have version 9.6. Worse yet, the iPhoto 9.6.1 update disappeared from the App Store so there's no way to get it. This is a tragedy of epic proportions and not something that Apple is likely to fix. Fortunately, Appendix A has a few solutions.

But think carefully about the consequences before embarking on this path. If you continue to use iPhoto or Aperture, Photos won't know about any changes you make in those programs. As far as Photos is concerned, those libraries were frozen in time the moment you converted them. Similarly, don't expect iPhoto or Aperture to know about any changes you make in Photos—their libraries are completely separate. The best you can hope to accomplish by continuing to use iPhoto or Aperture is to export newly edited items, and then import them into Photos. If you find yourself in that situation, it's helpful to create a smart album in iPhoto or Aperture that gathers up all the stuff you've changed since you told Photos to convert your iPhoto or Aperture library.

NOTE Unfortunately, if you create projects in iPhoto and Aperture *after* converting those libraries for Photos, you can't export those projects individually from iPhoto or Aperture, so you'll have to work with them in those older apps. And even if those apps could export a project, Photos can only import individual image and video files. Oh well!

Merging iPhoto or Aperture Libraries

While you can create multiple Photos libraries, as Chapter 10 explains, maintaining and merging them is a nightmare. So if you have multiple iPhoto or Aperture libraries—or if you created extras by accident because you have multiple user accounts on your Mac (see page 14)—it's best to merge them *before* you upgrade to Photos.

Fortunately, merging Aperture libraries is easy. To merge other libraries into the currently active one, launch Aperture and then choose File→Import→Library. Navigate to where the other library lives, select it, and then click Import. In the resulting dialog box, choose whether you'd like to merge the two libraries to avoid duplicate images or whether you'd rather *add* all images from the imported library. Repeat this process for any additional Aperture libraries you wish to merge. When you're finished, use Photos to upgrade the newly merged Aperture library to a new Photos library. That's it!

Unfortunately, iPhoto doesn't have the ability to merge libraries, so you have two different ways to proceed:

- If you have Aperture 3.3 or higher, you can use *it* to combine multiple iPhoto libraries into a single Aperture library that you can then upgrade to Photos. Before you begin, be sure to open each iPhoto library in the latest version of iPhoto (9.3 or higher) to ensure the iPhoto library is arranged in a way that Aperture understands.

Once you've done that, launch Aperture and choose File→Switch to Library→Other/New. Use the library selector to highlight one of the iPhoto libraries you'd like to merge and click Choose. Next, choose File→Import→Library, and then pick one of the other iPhoto libraries you want to merge with the first one you picked. Repeat this process for each additional iPhoto library that needs merging.

The result is an Aperture library that includes everything from the first iPhoto library you picked and from all the additional iPhoto libraries you imported. This new library exists in Apple's *unified* library format, which means it can be shared between iPhoto and Aperture. You can now use Photos to upgrade the resulting merged library to a new Photos library.

• You can buy a program to merge your iPhoto libraries, which is by far the most civilized approach. One such program is the $29.95 iPhoto Library Manager from Fat Cat Software (*www.fatcatsoftware.com*). Using it is a straightforward affair: Simply drag your iPhoto libraries onto its window, select some options for handling duplicate images, and let it rip. You can then upgrade the resulting merged iPhoto library to a new Photos library. As a bonus, iPhoto Library Manager includes PowerPhotos, which adds some slick features to Photos that it doesn't (yet) have.

Deleting iPhoto or Aperture Libraries

Once you've told Photos to create a new library from your iPhoto or Aperture libraries, it won't ever look over its digital shoulder at those libraries again. After you've confidently used Photos for a while, you can delete them—with the following exceptions:

• If you used iPhoto or Aperture to edit some pictures or videos, you should export those files before deleting their libraries. Afterward, you can import the exported goodies into Photos in myriad ways, as Chapter 2 explains.

• If you created a project in iPhoto or Aperture that you can't easily duplicate in Photos, you may want to keep iPhoto or Aperture and their libraries available for future use. (You can't export and import projects such as cards, calendars, books, or slideshows into Photos.) Just be aware that in a few years OS X may be so far advanced that iPhoto or Aperture stop working.

Honestly, since your new Photos library won't take up much hard drive space—at least, not until you delete the old ones, as the box on page 6 explains—you may want to keep the old libraries hanging around, just to be on the safe side.

That said, when you want to send your old libraries packin', locate them on your Mac—they're likely in the Pictures folder—single-click a library file you want to delete, and then choose File→Move To Trash (you can also drag the file onto the trash icon in your Mac's dock). Either way, the file disappears from its original location (in the Pictures folder or wherever it was) and cools its heels in the Trash. To delete the file from your Mac, choose Finder→Empty Trash. Your Mac will take some time to fetch all the pictures and videos that Photos needs from that library and move them to Photos' library.

■ Meet the iCloud Photo Library

One of the main reasons Apple created Photos is to provide a better way to manage and access all your pictures and videos across your devices: your Macs, iOS devices, cameras, and so on. Part of Apple's goal is to reduce the time you spend managing your digital memory collection so you'll have more time to be creative. Apple named their solution iCloud Photo Library.

NOTE While the dynamic duo of Photos and iCloud Photo Library is *more* than adequate for most people, professional photographers need a more robust solution. In that case, consider using Adobe Photoshop Lightroom CC in conjunction with Lightroom Mobile instead.

The concept is brilliant: Once you turn on iCloud Photo Library, the pictures, videos and albums in your Photos library are uploaded to Apple's iCloud servers. That content is then downloaded into the Photos app on your other devices (Macs and iOS gadgets included). Changes you make on one device are automatically synced to all your other devices. You can even view and manage your Photos library from any Internet-connected web browser. And there's more:

- **It's a space saver.** You can't store all your photos and videos on all your devices; there just isn't enough storage space. iOS devices have limited space, and Apple's newest MacBooks have less space than they used to because they sport SSD drives, which are smokin' fast but lack the storage capacity of their traditional hard drive forebears.

FREQUENTLY ASKED QUESTION

Syncing Part of Your library

My Photos library is huge, but I don't want to pay Apple to store all of it. Can't I just sync part of it to iCloud?

It depends on which iCloud-sharing service you go with. Apple offers three ways to share your picture and videos across multiple devices, and they each suit different purposes:

- **iCloud Photo Library** (free–$19.99/month) gives you access to *all* your photos and videos on all your devices.

- **iCloud Photo Sharing** (free) lets you share one or more albums of pictures and videos with other people and your other devices, be that another Mac or an iOS device.

- **My Photo Stream** (free) automatically syncs all your *recent* pictures and videos with all your devices (Mac and iOS gadgets).

So, to avoid paying Apple for the full volume of storage space your library requires, you'll probably want to use the free iCloud Photo Sharing instead of iCloud Photo Library. You'll learn far more about these sharing options in Chapter 8 (starting on page 211), though it's important to know what your options are sooner rather than later.

iCloud Photo Library solves this storage conundrum by putting full-quality versions of all your pictures and videos on Apple's iCloud servers. It then delivers smaller versions onto your iOS devices. When you need the full-quality version of an image—say, when you edit it—iCloud Photo Library delivers it to the device. As your device runs out of space, full-quality versions of the pictures and video you access the least are removed to make room for the new ones. As explained in the box on page 22, you can choose to use smaller versions of files on your Mac, too.

- **It manages your albums.** iCloud Photo Library manages all of the albums you make in Photos. For example, if you create or edit an album on one device, that change propagates to all your other devices. (Unfortunately, smart albums—page 69—aren't included in the syncing party.)

- **Edit anything, anywhere.** If you add, edit, or delete a picture or video on one device, the change happens on all your other devices, too—as long as they're connected to the Internet. That means you can start editing a photo or video on one device and finish the job on another. And because editing in Photos doesn't mess with your originals, you can also revert to the image's original state on any device.

- **See your pictures and videos on any computer.** You can log into your iCloud account from the web browser on any Internet-connected computer. Just go to *iCloud.com* and log in, and you can view and organize your entire photo and video library. How cool is that?

- **It's a backup system.** By its very nature, iCloud Photo Library serves as an off-site backup for all your digital memories (at least, all the ones in your System Photo Library; there's more on that in the next section). If your Mac, iPhone, or iPad gets lost or destroyed, your pictures and video are safe on Apple's iCloud servers. This includes *everything* you add to your Photos library—pictures from other digital cameras (including raw files), scans of old photos and documents, videos, screen captures from your iOS devices—everything.

- **What it costs.** Everyone who registers their Mac or iOS device with Apple gets an Apple ID and five gigabytes of free storage space (Apple prompts you to register the minute you power up your new Apple device). While this is sufficient for backing up your iPhone, storing email, and saving a few Keynote files, snap-happy photographers will use up this space at warp speed. As of this writing, Apple's monthly storage rates are 20 gigabytes for $0.99; 200 gigabytes for $3.99; 500 gigabytes for $9.99; and 1 terabyte for $19.99. These prices are *per person,* meaning that no one else can share the extra storage with you. In other words, each person with a Photos library is responsible for his or her own iCloud storage.

NOTE While other cloud-based storage services such as Dropbox, Google Drive, Microsoft OneDrive, and Amazon Cloud Drive cost less per gigabyte of storage than iCloud, they don't offer the instant, automatic cross-device syncing of pictures and videos in your Photos library. So you pay a premium to use Apple's system, but it greatly simplifies your Photos life.

If you pony up for more iCloud storage space but then stop paying, your devices keep the items that are already stored on them, but syncing between devices comes to a screeching halt and you no longer have a complete backup of all your stuff on the iCloud servers. (Apple doesn't say exactly *when* your content is deleted, but it does happen.) The result is that your Mac becomes the only device that has full-quality pictures and videos, and your iOS devices contain a mix of full-quality and smaller versions.

Alas, iCloud Photo Library isn't all peaches and cream. Aside from the monthly fee, uploading your library for the first time and syncing it to your iOS devices can take days. If you're ready for that, then read on.

NOTE By the time you're reading this, it's possible that Apple may have come up with a way to speed up the initial upload process. One can hope!

What Gets Uploaded

Before you turn on iCloud Photo Library as explained in Chapter 2, it's helpful to understand exactly what Apple will upload. Apple doesn't want to shock (or extort) you the second you start using Photos, so turning on iCloud Photo Library is optional—you're respectfully invited to do so when you create your first Photos library. Here are three key things to remember:

- **Only the content of your System Photo Library is uploaded to iCloud.** If you maintain multiple Photos libraries (see page 272), you can anoint only *one* of them your System Photo Library (page 274 explains how)—iCloud ignores all your other libraries. You can think of the System Photo Library as the master library that gets used by all iCloud services: iCloud Photo Library, iCloud Photo Sharing, and My Photo Stream (there's more on those services in Chapter 8). It's also the library that iTunes pulls from to deliver photos and videos to your iOS devices and your Apple TV (see the box on page 175).

 If you change Photos' normal behavior of copying your content into its library—by deselecting "Copy items to the Photos library" in Photos' preferences (see page 28)—then any items you add thereafter *won't* be uploaded to your iCloud Photo Library. This is one of the many reasons why maintaining a single Photos library per Mac user account makes managing Photos a whole lot easier.

- **How it works.** Since your iOS devices have limited storage space, iCloud Photo Library uses what Apple calls *optimized storage*, which provides each device with files that are optimized for its particular screen size. All your images are stored as thumbnails, while your most recent, favorite, and frequently accessed photos are also stored in high enough quality to be viewed clearly on that device's screen. When you edit an image, iCloud downloads a higher quality version. The result is that the pictures that are most important to you are always available at a size optimized for the screen you're displaying them on.

- **Security and privacy.** iCloud Photo Library encrypts your digital memories to keep them secure when transferring files to and from your Mac and iOS devices, and also while being stored on the servers. This means that snoopers can't see your stuff. Of course, no system is 100% hacker-proof, so to be safe, don't store any incriminating photos in your iCloud Photo Library.

In short, iCloud Photo Library is amazing. It costs a few bucks per month, but there's nothing like the confidence and peace of mind you get from knowing that all your files are constantly backed up and that all your images are available on all your Apple devices.

Photos for Families

So you did your family a huge favor and bought a Mac. And of course you set up *four* user accounts on the shiny new Mac, because your two kids are old enough to be responsible Mac users and you want them to learn how to use it. While doing so is completely logical, it causes a seriously unpleasant Photos-related consequence: Each user account you create on your Mac gets its very own Photos library.

WORKAROUND WORKSHOP

Got PICTs?

Here's a bit of history for you: Before OS X, the file format of graphics created and used by the Mac operating system was PICT (OS X, in contrast, creates PNG files). Back in the 1990s, Mac folks often saved their scans of printed photos in PICT format, so it's not unusual to have some PICT files loitering in your iPhoto or Aperture libraries.

Unfortunately, Photos doesn't understand PICT files. They tag along in the library-conversion process, but in Photos they appear as a thumbnail with a gray triangle and an exclamation point. The fix is to convert your PICT files to another format, and then reimport them into Photos.

First, you need to liberate the PICT files from Photos. In Photos, select any odd-looking PICT thumbnails you find (they're easy to spot), and then choose File→Export→Export Unmodified Original. In the resulting pane, tell Photos how you want to name the file.

Click Export, and then use the next pane to choose a location for your exported files. (If you're exporting a slew of PICTs, it's best to export them into a folder.)

Second, use Preview to convert the exported PICTs to PDFs. Unless you want to end up with a single PDF file of all your exported PICTs, you have to convert them one by one. To do that, launch Preview (it lives in your Dock and in the Applications folder), and then choose File→Open, navigate to where the first PICT file lives, and click Open. (If you wisely exported your PICTs into a folder, just select the folder to open all of them.) Your PICTs appear as thumbnails on Preview's left. Select a thumbnail, choose File→"Export as PDF," and then pick a location for the exported file. Rinse and repeat until you've converted all the PICT files.

After all that, you can import the exported PDF files into Photos. Chapter 2 explains how.

Let's say your partner comes home and uploads some pictures into the currently active Photos library, which may or may not be the one associated with his user account (maybe someone else forgot to sign out when they were done computing). You, being the responsible manager of your family's expensive DSLR camera, log into your user account on the Mac and import pictures into your Photos library. And of course your kids randomly upload photos into whatever Photos library is active at the moment.

Before long, nobody has the faintest idea where their pictures live, and you're left with the unpleasant task of managing four completely separate Photos libraries. In a moment of desperation, you may even create a new Photos library and demand that everyone start using it instead.

NOTE Don't panic if you're already living a shared-Mac, multiple-Photos-libraries nightmare. You can skip ahead to the page 275 and learn how to merge Photos libraries and regain some sanity

Fortunately, there's a four-part solution that keeps everyone happy:

- If you haven't already, **give each person their own user account on the shared Mac.** As mentioned earlier, doing so gives them each their own Photos library, email, document storage, and so on. (If you need help creating user accounts, see *https://support.apple.com/kb/PH18891.*)

- **Give each person their own Apple ID and iCloud account.** Here's where the magic starts—by doing this, everyone gets their own email address and the ability to share their pictures and videos with the rest of your family. (Though as you learned on page 12, you can't share iCloud *storage space* with other family members.) The section on Family Sharing in Chapter 8 (page 224) walks you through this step, as well as the next two processes in this list.

- **Set up iCloud Family Sharing.** This maneuver tells Apple that each person—up to six—is a member of your family and thus can share iTunes and App Store purchases among them. That way, everyone gets to use the same credit card— you get to approve kids' purchases from your device, and you can set spending limits—and you can share a family calendar using Calendar. (You'll learn how to set up iCloud Family Sharing on page 224).

- **Set up a shared family photo album.** When you set up Family Sharing, a shared album automatically appears in Shared view in the Photos app on all your family members' devices. Now you can all add pictures, videos, and comments to that album, and everyone will be notified when something new is added. Members of your family can also choose to import specific items into their own libraries—say, to create a book or calendar project (Chapter 9).

This system gives everyone a little privacy, plus it's a great long-term solution. For example, as family members get additional iOS devices or their own Macs, or they move away (yippee!), their unique Apple ID ensures that all their pictures, videos, emails, and so on migrate to the new devices. Plus they can continue to share digital proof of their adventures...even from far away.

Importing Pictures and Videos

With Photos up and running, you're ready to import your pictures and videos to populate your library. After all, why doom your digital mementos to a life lived only on an iOS device or memory card? Once they're in Photos, you can do amazing things with them if you invest a little time.

The easiest stuff to import comes from your iPhone and iPad—the process is practically automatic—but you can also import pictures from digital cameras, scanners, your iCloud photo streams, and even websites you visit. And if you've got any pictures and videos tucked into folders on internal or external hard drives, or archived on CDs, DVDs, or other storage devices, importing them is just a drag-and-drop away.

If you previously used iPhoto or Aperture and you imported those libraries into Photos, then you already have a bunch of pictures and videos in Photos to play with. (If you haven't yet done that, flip back to Chapter 1 for info on how to get it done). This chapter teaches you how to import additional content from sources *other* than your old libraries.

But first, a quick tour of the Photos workspace is in order.

The Two Faces of Photos

Photos for Mac gives you two different ways to view and work with pictures and videos. The first option looks a lot like Photos for iOS—you get one giant, uncluttered window with tabs that let you change your view (see Figure 2-1). The Photos tab displays all your pictures and videos in chronological order; the Shared tab lets you see any pictures you've shared via iCloud;the Albums tab lets you see thumbnails of

all the albums you've made; and the Projects tab shows you all the slideshows, books, cards, and calendars you've made. You'll learn more about these views in Chapter 3.

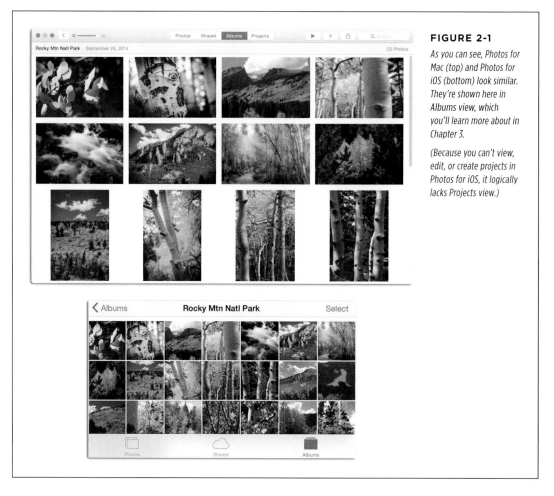

FIGURE 2-1

As you can see, Photos for Mac (top) and Photos for iOS (bottom) look similar. They're shown here in Albums view, which you'll learn more about in Chapter 3.

(Because you can't view, edit, or create projects in Photos for iOS, it logically lacks Projects view.)

The second option for viewing and working with your digital goodies adds a sidebar to the left of the Photos for Mac window, which displays your organizational structure in a vertical list (Figure 2-2). You can turn it on by choosing View→Show Sidebar or by pressing Option-⌘-S; to turn it off, choose press the keyboard shortcut again or choose View→Hide Sidebar. While you can accomplish all your organizational tasks without the sidebar—scooting pictures between albums, adding images to projects, and so on—displaying it may make you more efficient.

You'll learn all about navigating around Photos and organizing your digital mementos in Chapter 3. The rest of this chapter focuses on getting your goodies into the program.

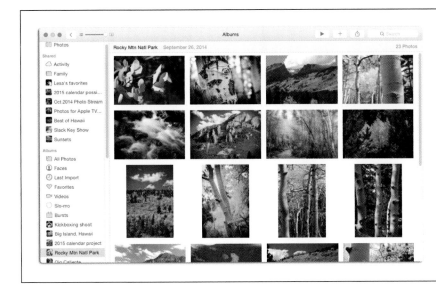

FIGURE 2-2

If you miss iPhoto's Source list, don't fret; just turn on the Photos sidebar. When you do, your organizational structure appears in it. If you're used to working in iPhoto, you'll want to keep the sidebar turned on.

(Photos for iOS doesn't include a sidebar.)

Importing from iCloud

As you learned in Chapter 1, iCloud is Apple's syncing and sharing service. If you're one of the over 350 *million* iCloud users, then you've got some pictures to import from it. There are three different iCloud sources from which you can import pictures into Photos: iCloud Photo Library, iCloud Photo Sharing, and My Photo Stream. This section explains you how to get your photos out of those sources and into Photos.

iCloud Photo Library

If you turn on iCloud Photo Library on your Mac and your iOS device(s), and you sign into the same iCloud account on all your Apple gadgets (meaning you use the same Apple ID everywhere), then all the pictures and videos you take (or edit) with your iOS devices magically appear in Photos for Mac. The opposite is also true: When you add, delete, or edit items in Photos for Mac, your changes are automatically reflected in Photos for iOS. Here's how to make this magic syncing happen:

- **On your Mac.** In Photos for Mac, choose Photos→Preferences, and then in the iCloud pane that appears, turn on iCloud Photo Library (see Figure 2-3). When you do, fireworks explode (kidding!) and your Mac starts uploading your System Photo Library (page 13) to iCloud. This process hogs all the upload bandwidth your Internet connection can handle, which is good because it takes a really... long...time.

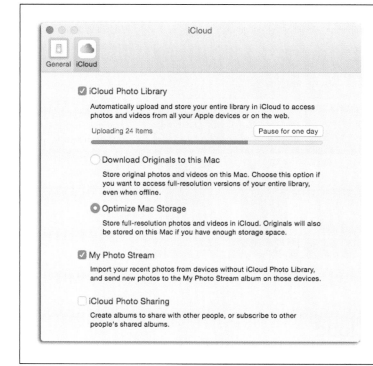

FIGURE 2-3

Uploading the contents of your System Photo Library to iCloud can take hours or days, and can slow your Internet experience to a crawl. For that reason, you'll want to start this process just before you go to bed. That way (hopefully!) the upload will be finished by the time you wake up.

TIP Your Photos library continues uploading even if you quit Photos. If you suspect the upload is interfering with your other Internet-related work—or if your Internet usage is metered and you need to break up the process over several days—you can tell Photos to pause for a day. Choose Photos→Preferences and in the iCloud pane, click "Pause for one day." Photos stops uploading your library and resumes 24 hours later. To resume the upload manually—say, when you go to work or out for dinner—click the same button again, which is now labeled "Resume." Photos then diligently ferries your pictures to iCloud until it finishes or you tell it to pause again.

- **On your iOS device.** To use iCloud Photo Library, your iOS device needs to be running iOS 8.1 or later, so you may need to update your software; to do that, tap Settings→General→Software Update. Once you're running the necessary software, you're ready to turn on iCloud Photo Library. Fire up your iOS device, tap Settings (it's probably on your home screen), and then scroll down until you see Photos & Camera. Give it a tap and on the next screen, tap the switch next to iCloud Photo Library (it turns green as shown in Figure 2-4). That's it!

NOTE If you've been using iTunes to sync your pictures and albums onto your iOS devices, you can continue doing so—right up until the second you turn on iCloud Photo Library. Once you do that, all picture-syncing operations are taken out of iTunes' hands and given solely to Photos (which, if you think about it, makes a lot more sense than using a music app to manage your pictures ever did). If you copied photos to your iPhone or iPad via iTunes, you'll see a message that all images will be removed if you activate iCloud Photo Library. Tap Remove Photos to proceed.

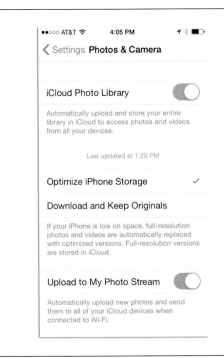

FIGURE 2-4

If you have more than one iOS device (lucky you!), be sure to turn on iCloud Photo Library on all *of them (or none of them). Why? Because if one of your devices has it turned on but another one merely has My Photo Stream enabled (page 23), you won't see pictures from one device on the other one.*

As you turn on iCloud Photo Library on each Mac and iOS device you own that uses the same Apple ID, that device's contents get uploaded to the iCloud's servers and merged with what's already there. The combined content is then downloaded to all of your devices. In fact, this is one way you can merge multiple Photos libraries, as page 275 explains.

iCloud Photo Library isn't cheap (page 12 has current pricing), but the convenience and confidence you get as a result are worth the cost. Once iCloud Photo Library is enabled on all your devices, you can enjoy working with your pictures and videos on any of those devices, and your changes are instantly visible on all the others.

TIP Photos makes it easy to see if photo is stored locally or not—files that aren't stored on your device have a cloud icon on them.

iCloud Photo Sharing

Another way to import pictures into Photos is through iCloud Photo Sharing, whose special purpose is sharing a handpicked batch of pictures and videos with specific people you invite to a shared album. If a recipient accepts your invitation, she can import the shared content into her own Photos library and (if you allow it) add her own content to the album, which you can then import into *your* Photos library. The same holds true if you're on the receiving end of a shared-album invitation.

Chapter 8 teaches you everything you need to know about turning on and using iCloud Photo Sharing (page 211), but the iPhoto veterans among you are likely knee-deep in it already. Here's how to import previously shared content into your Photos library:

- **Photos for Mac.** It's easier to import content from a shared album if you have Photos' sidebar turned on, so do that first (choose View→Show Sidebar or press Option-⌘-S). Next, in the Shared section of the sidebar, click an album that someone shared with you, and then select the thumbnail(s) of the items you want to import. You'll learn several ways to do this on page 57, but you can pick and choose certain thumbnails by ⌘-clicking or select everything in the album by pressing ⌘-A. Next, either Control-click one of the thumbnails and choose Import from the shortcut menu that appears, or simply drag the thumbnails onto the word "Photos" at the top of the sidebar or into any album or project you've made (as you drag, a green circle with a + sign appears next to your cursor).

Optimizing iCloud Storage Space on Your Devices

On its servers, iCloud always stores your pictures and videos at full size. However, to save space, it places smaller, *optimized* versions of your oldest and least-used files on your iOS devices. Only when you tap to enlarge or edit a photo does your iOS device download the full-size version. If you like, you can choose to store optimized versions of your files on your Mac, too, which is handy if you have a MacBook, MacBook Air or MacBook Pro with limited storage space. Conversely, you can choose to store originals of photos on your iOS devices in case you want to edit them when your device doesn't have access to iCloud. Here's how:

- **To store optimized files on your Mac**, choose Photos→ Preferences and in the iCloud pane that appears, turn on

Optimize Mac Storage (this setting is turned on in Figure 2-3). You don't see anything happen, but once space gets tight, behind the scenes Photos replaces any full-size copies with smaller ones.

- **To store full-size files on your iOS device**, tap Settings→ Photos & Camera→"Download and Keep Originals" (shown in Figure 2-4). Here again you don't see anything happen as iCloud begins migrating originals of everything in your Photos library file onto that device. If there isn't enough space on the device for original versions of everything, you get optimized versions for the ones you access least often.

You can change these settings anytime you want.

- **Photos for iOS.** To import shared content in Photos for iOS, tap Shared (if that takes you to the Activity page, tap Sharing in the top left), and then tap an album that someone shared with you. Tap Select at the screen's upper right, and then tap the thumbnails of the items you want to import. Finally, tap the share icon circled in Figure 2-5, left, and then, in the pane that appears, tap Save 2 Images (or however many you selected).

FIGURE 2-5

Left: Importing content others have shared with you is easy in Photos for iOS. The first step is to select the content you want to import, and then tap the Share icon (circled).

Right: In the pane that appears, tap the icon circled here and the selected content is instantly inhaled by the Photos app on that device.

My Photo Stream

If you'd like some of the convenience of iCloud Photo Library without uploading all your pictures and videos, you can use My Photo Stream instead. It collects all the pictures you've taken in the last 30 days on all your devices (up to 1,000 photos) and sends them to the My Photo Stream album on all your devices that have My Photo Stream turned on (you'll learn how to turn it on in a sec). Unlike iCloud Photo Library or iCloud Photo Sharing, My Photo Stream is limited to pictures—videos aren't included—and syncing to your iOS devices only occurs when they're on a WiFi network (it doesn't work over a cellular network). Also, the pictures that are downloaded to your iOS devices are optimized and smaller than the full-resolution versions stored on your Mac. (The box on page 22 has more about optimized vs. full-size files.)

NOTE My Photo Stream only understands a few file formats: JPEG, TIFF, PNG and raw. If you import images to Photos that are in any *other* format (such as GIF, BMP, or PDF), they won't be included in your Photo Stream.

Here's how to turn on My Photo Stream:

- **On a Mac,** choose Photos→Preferences and then, in the iCloud pane that appears (Figure 2-3), turn on My Photo Stream.

- **On an iOS device,** open Settings and scroll down until you see Photos & Camera. Give it a tap and on the next screen, tap the switch next to My Photo Stream (it turns green). While you're in the Photos & Camera settings on your iPhone 5S (or later) or iPad Air 2 (or later), have a look at the Upload Burst Photos option (burst mode is explained in the box on page 50). Since Burst mode captures 10 shots per second, it can generate a *ton* of pictures in a matter of seconds. From the factory, Apple wisely disables uploading all those shots to your iCloud Photo Stream. Instead, only the pictures you select from that burst get uploaded (the box on page 50 tells you how to do this). However, if you turn on Upload Burst Photos, your iOS device uploads *all* the pictures in the burst set to your Photo Stream.

> **NOTE** My Photo Stream pictures are only stored on Apple's servers for 30 days, so if you don't import them into the Photos app on your iOS devices, only those pictures that were captured on that specific device continue to live on that device. You can think of My Photo Stream as a way of temporarily ensuring that your recent pictures exist on more than one device for 30 days.

When you turn on My Photo Stream on a Mac or iOS device, an album named after the current month and year—such as October 2015 Photo Stream—appears in Shared view (page 46). If you're using iCloud Photo Library, the items in My Photo Stream simply appear in Photos view in chronological order according to the date they were captured.

My Photo Stream has some additional limitations. Aside from the drawbacks already mentioned, Apple limits the number of pictures you can upload to 1,000 per hour, 10,000 per day, or 25,000 per month (as noted earlier, only the most recent 1,000 appear). If you exceed those limits, nothing new is added to your Photo Stream until the next hour, day, or month has passed (depending on which limit you blew past). But we're talking about a free service here, so what do you expect?

> **TIP** If you prefer to avoid using the airwaves to transfer your photos and videos to your Mac (or if you're somewhere without a cellular or WiFi network), you can attach your iOS device to your Mac with a cable and transfer those valuable files the old fashioned way. Just grab the USB cable that came with your iOS device, and plug one end of it into the device and the other into a USB port on your Mac. Your iOS device then behaves just like any other camera or memory card reader that you plug into your Mac (see the next section for details).

■ Importing from a Camera or Card Reader

Every digital camera comes with a cable that you can use to connect it to your Mac's USB port, but that's not the necessarily the best way to import your digital goodies.

A better approach is to remove the memory card from your camera and stick it into a card reader, and then plug *that* into your Mac. Heck, some iMacs and MacBook Pro models even have built-in SD card readers.

The advantage of connecting your camera directly to your Mac is that you don't have to fish out the memory card, but there are three advantages to using a card reader. First, you won't use up your camera's battery while you're importing stuff, which saves it for taking pictures. Second, card readers copy files more quickly than your camera's cheapo USB cable, so there's less time for something to go wrong during the transfer. And third, most card readers can read multiple kinds of memory cards, which is handy if you shoot with different camera brands that use different kinds of memory cards (like, say, Canon and Sony).

The process for importing pictures into Photos is the same whether you plug a camera, memory card, card reader, or iOS device into your Mac. Here's what you do:

1. **Connect your camera (or card reader) to your Mac.**

 Your digital camera has a tiny USB port (it's usually under a rubber flap) and your Mac has a larger, rectangular USB port. Grab the cable that came with your camera; plug the small end into your camera and the bigger end into a USB port on your Mac. Then turn on your camera so Photos can detect it.

 If you're using a card reader, or if your Mac has a built-in card reader (you lucky person, you), turn off your camera, eject its memory card, and then simply insert the memory card into the card-reader slot.

2. **If necessary, launch Photos.**

 A few moments after you connect your camera (and turn it on) or insert your memory card, Photos should open automatically and place you in Import view where you see thumbnails of the memory card's contents (see Figure 2-6). If Photos *doesn't* launch, fire it up yourself.

 TIP If your Mac doesn't see your camera after you connect it, try turning the camera off and back on again.

 You see the name of the camera or memory card at the screen's upper left and in the sidebar (if you have it turned on). If you want Photos to automatically spring open whenever you attach the same camera or memory card, be sure the "Open Photos for this device" checkbox is turned on.

3. **Select the pictures and videos you want to import.**

 If you want to import *everything* on the memory card, you can skip to the next step.

 If you prefer, you can pick and choose only the items that are worthy of importing. Tell Photos which items to import by clicking any thumbnail to select it; Photos dims the thumbnail and adds a blue circle with a checkmark to its lower right. (To enlarge the image thumbnails so you can see them better, drag the

zoom slider rightward.) To deselect a thumbnail, click it again to remove the checkmark. You can also click in the white space outside the thumbnails, and then drag across multiple thumbnails to select or deselect them—each thumbnail your cursor touches changes to the opposite condition (selected or deselected).

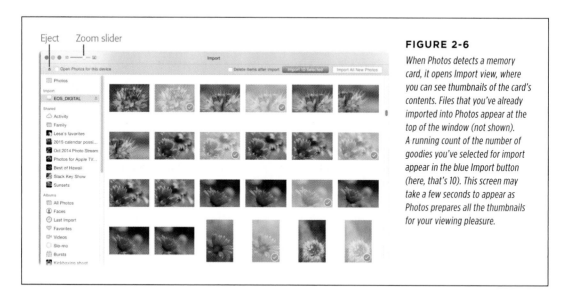

FIGURE 2-6

When Photos detects a memory card, it opens Import view, where you can see thumbnails of the card's contents. Files that you've already imported into Photos appear at the top of the window (not shown). A running count of the number of goodies you've selected for import appear in the blue Import button (here, that's 10). This screen may take a few seconds to appear as Photos prepares all the thumbnails for your viewing pleasure.

TIP Resist the urge to turn on the "Delete items after import" checkbox. If you turn on this setting, Photos will remove the imported pictures from your memory card. That sounds convenient, but if anything were to go wrong during the import process, you could lose all your pictures. It's much safer to clear your memory card using your camera's software instead. In fact, try reformatting the card instead of merely erasing the pictures it contains (check your camera's owners' manual to find out how). Doing so wipes your memory card spick and span so it's ready for your next batch of pictures—just double-check that Photos successfully imported your pictures before you erase that card.

4. **Import your images.**

To import *all* the new items the memory card contains, click Import All New Photos. If you selected a few thumbnails in the previous step, click Import # Selected. Either way, Photos starts copying the files onto your Mac. As it finishes importing each one, it moves that each image's thumbnail to the Already Imported section at the top of the window.

As those photos are being imported, Photos switches to Album view and displays the Last Import album, which shows the files as they're being imported. When importing lots of files, a little pie-chart icon appears at the right of the zoom slider to show the progress of the import process. When it's full, the import is complete.

5. **Unplug your camera, or eject and then unplug your memory card or card reader.**

 When you're finished importing, turn off your camera and unplug its USB cable (there's no need to eject it first). If you plugged a memory card into your Mac or a card reader, you see a tiny eject icon at the upper left of Photos' toolbar (it's labeled in Figure 2-6) and to the right of the memory card's name in the sidebar. Just click this icon to let your Mac know you're finished with it, and then unplug it.

Importing Other Image Files

Chances are good that you've got pictures and videos to import that don't live on a memory card or smartphone. For example, maybe you scanned some old pictures (or paid a service to do it) onto your hard drive, you archived some pictures onto a CD or DVD, someone sent you a disc full of pictures, or you snagged some images off of a photo-sharing website and saved them on your hard drive.

All this stuff is easy to import into Photos. Simply drag the files (or a whole folder full of them) onto the Photos icon in your Dock or into the Photos window. Alternatively, you can select one or more files in the Finder, and then click the Share icon at the top of any Finder window (the square with the up arrow on it) and choose "Add to Photos" from the menu that appears. To add files from inside the Photos app, choose File→Import, and then navigate to the files or folder and click "Review for Import." A window opens where you can select items, and then click Import Selected or Import All New Photos.

Importing Images from Non-Apple Phones

If you own a smartphone that isn't from Apple (gasp!), you can still import the pictures or videos it contains into Photos. In fact, there are two ways to do it:

- **Attach the smartphone to your Mac with a USB cable,** and then follow the steps on page 25 to import the images. This method is easy, but it won't up your geek status.

- **Use Bluetooth to transfer the files.** If the smartphone has Bluetooth built in, you can connect it to your Mac wirelessly, and then use the Bluetooth File Exchange app on your Mac to import the pictures. First, make sure the smartphone is turned on and that its Bluetooth feature is set to Discoverable. Then, on your Mac, launch the Bluetooth File Exchange app (you'll find it in the Applications→Utilities folder). If the "Select File to Send" dialog box appears, click Cancel, and then choose File→Browse Device. Either way, a list of Bluetooth devices appears. Select the smartphone, and then click Browse. The phone may need to approve your connection through a process called *pairing*, so you may need to enter a passkey on it and then click Respond, or you may merely need to click Accept. Eventually, a list of the files the smartphone contains appears on your Mac. Just drag and drop the ones you want to copy into the Photos window or onto the Photos icon in your Dock. You can also drag the files into a folder for importing into Photos later as described on this page. Many Mac users simply forget about Bluetooth as a way to transfer files, so be sure to spread the word about your Bluetooth know-how.

For more about using Bluetooth to share files—even from other Macs—launch Bluetooth File Exchange, and then choose Help→Bluetooth Help or check out the grandaddy of all Mac reference books, David Pogue's *OS X: The Missing Manual*.

Whichever method you use, the newly added files appear in the Photos view in chronological order according to when the files were last modified, burned onto disc, or originally imported onto your hard drive. The new files also hang out in the Last Import album—that is, until you import something else. Since images you add in this way can be difficult to find in Photos later on—due to the variety in dates—you may want to select the newly imported files and stick them into an album (page 60). Or you can apply a keyword to the files so you can easily find them later (say, "Macworld 2000," "Space Camp," or whatever). Page 91 tells you how.

> **NOTE** When you import files from a folder on your hard drive (or from a CD or DVD), Photos ignores whatever directory structure that folder used. For example, if you've painstakingly stored your pictures on your hard drive using subfolders named by date or event—say, a folder named 2016 that contains a folder named San Diego Comic-Con that contains a folder named Thor—those folders disappear in Photos and the images are all lumped together in the Last Import album. To recreate your original organization, you need to divvy the pictures into albums (see page 60).

Copied vs. Referenced photos

Photos can keep track of the pictures and videos you import in two different ways: either by *copying* them into its library or by *referencing* their location outside its library. From the factory, Photos *copies* your digital mementos into its library file for safekeeping. But you can change this behavior so that Photos doesn't copy the original files, it merely remembers where they are—on your internal or external hard drive, a CD or DVD, a flash drive, a networked hard drive, and so on. Photos refers to these files as *referenced*, and they remain firmly rooted where they are on your hard drive.

You control this behavior with Photos' preferences: Choose Photos→Preferences→ General (see Figure 2-7). If you turn off "Copy items to the Photos library," any future content you import won't be copied into Photos' library. Instead, Photos remembers the original locations of your pictures and videos, and that's where it expects to find them...*forever*.

Let us count the reasons why using referenced photos is fraught with peril:

- If you move a referenced file, Photos loses track of it. If you try to open the referenced picture in Photos, you get a message politely requesting you to go find it. If you can locate it in the Finder, Photos happily relinks it, at which point you can continue working with the image in Photos. If not, you may as well delete it from Photos, because you'll never be able to do anything with it there.

- If you rename a referenced file, Photos loses track of it permanently. If you try to open the referenced picture in Photos, you get a message requesting you to find it. Even if you can locate the renamed file in the Finder, Photos won't relink to it, because the file's name has changed.

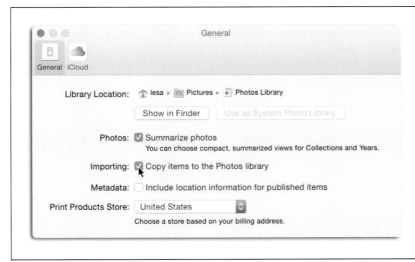

FIGURE 2-7

Here's where you can instruct Photos not to copy imported files into its library. Think long and hard about turning off this setting. If you're not careful with your files, you'll soon have a Photos headache of galactic proportions.

- Only copied pictures and videos work with iCloud Photo Library (page 11). In other words, using referenced files defeats the whole purpose of iCloud Photo Library, which is to have a backup of your files, sync all of your content across your devices, and optimize storage space on those devices.

- Referenced files don't live in the Photos library, so you have more files to remember to back up.

- If you delete a referenced file in the Photos app, the program forgets about it but the file still lives in its original location, so you don't reclaim any hard drive space.

- If you forget that you switched to using referenced files and you import some files and then innocently delete them in the Finder, those files are gone for good.

So why offer the referenced file option at all? Well, if you have a laptop and you're not using iCloud Photo Library (page 11), you've got limited storage space on your internal drive, so you may be forced into keeping pictures elsewhere and referencing them. Though in all honesty, if your image collection is spread out across multiple hard drives, you probably shouldn't be using Photos. Try a program that's made to track pictures that live in other locations, such as Adobe Photoshop Lightroom.

Nevertheless, if you have referenced files, you may want to see where those files live or decide to copy them into your library and be done with the whole referenced business. Here's how to do both:

- **View a referenced file.** In Photos, select a referenced file's thumbnail, and then choose File→"Show Referenced File in Finder." Photos opens a Finder window and shows you the file's last known location.

• **Consolidate referenced files.** In Photos, select the thumbnail(s) of the referenced file(s), choose File→Consolidate, and then click Copy. Photos dutifully copies the referenced files into its library. Of course, your success with this command depends on your ability to locate referenced files to begin with. Figure 2-8 explains a quick way to round them all up.

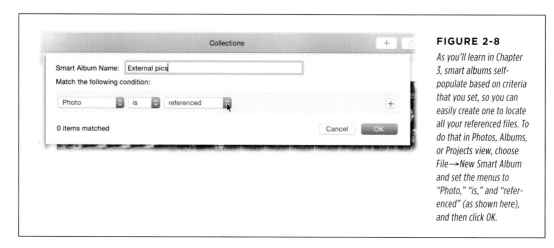

FIGURE 2-8

As you'll learn in Chapter 3, smart albums self-populate based on criteria that you set, so you can easily create one to locate all your referenced files. To do that in Photos, Albums, or Projects view, choose File→New Smart Album and set the menus to "Photo," "is," and "referenced" (as shown here), and then click OK.

Importing Files from Other Apps

OS X is very wise. It knows full well that you'll encounter files you want to import into Photos in several places on your Mac, including in other programs. Here are a few likely scenarios:

• **Finder.** If you encounter a photo or video in a folder or on your desktop—perhaps a scan you made, a photo you were given, or something you downloaded from the Internet—Control-click that item, and then choose Share→"Add to Photos" from the resulting shortcut menu or, if the item is in a Finder window, click the share icon circled in Figure 2-9, and then choose "Add to Photos."

TIP In some cases, you can import an image into Photos by dragging it from an app's window onto the Photos window. However, this doesn't always work. If you don't see a green circle with a + sign appear next to your cursor when you drag the item to the Photos window, you're out of luck. There seems to be no rhyme or reason as to why this works with some images and not others, but hey, it doesn't hurt to try. After all, nothing ventured, nothing gained!

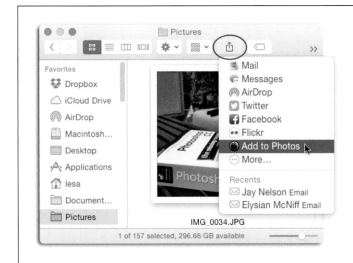

FIGURE 2-9

If you select an image or video in a Finder window, you can use this menu to import it into Photos; simply click the share icon circled here to open it. You can also import the file by dragging it onto the Photos icon in your Dock or onto the Photos window.

- **Mail.** If you get an email with a picture or video attached, simply Control-click the item and, from the shortcut menu that appears, choose "Export to Photos" or Share→"Add to Photos." You can also drag the item onto the Photos icon in your Dock.

- **Messages.** If you receive an image in the Messages app, Control-click it and choose "Add to Photos Library" from the shortcut menu. Alternatively, you can drag the image from the Messages app onto the Photos icon in your dock or atop the Photos window.

- **Safari.** If you use Safari to browse the Web or check your email, you can snatch an image on the page or in an email message by Control-clicking it and choosing "Add Image to Photos." You can also drag the file onto the Photos icon in your Dock.

- **Photo Booth.** If you capture an image using Photo Booth (an app that comes preinstalled on your Mac), select the image, and then click the Share icon and choose "Add to Photos." Or simply drag it onto the Photos icon in your Dock or onto the Photos window.

- **Preview.** If you open an image in Preview, click the Share icon in Preview's toolbar and choose "Add to Photos."

Fortunately, Photos doesn't have to be running for these import tricks to work. When you use any of these commands, OS X quietly and efficiently adds the files to your System Photo Library (page 13) whether it's open or not (technically they're tucked into a "waiting area" folder inside the library file). This is a good reason to maintain a single Photos library: If you have multiple libraries (page 272) and the open one

isn't the System Photo Library, then you won't see the newly imported content until you open the System Photo Library.

You can also import goodies into Photos for iOS using other iOS apps. Many iOS apps sport a share icon, which you can use to save the image to your device's Photos library. If you're the lucky recipient of a picture or video in the Mail or Messages app, simply tap the file preview, and then tap the Save Image icon that appears. If you're surfing the Web in Safari and you come across an image you want to save—say, an image of the couch, car, or man cave of your dreams—tap the image and hold your finger down until a menu appears. In that menu, tap Save Image.

Importing Images from Apps that Don't Share

Some apps are selfish and don't offer a way to easily pass pictures to Photos. Shockingly, the list of such apps includes Apple's own Pages and Keynote, as well as Adobe's Acrobat and Reader; unsurprisingly, *none* of the Microsoft Office apps share. Fortunately, your Mac's Preview app can moderate the situation and import images from those programs into Photos. Here's how:

1. **Copy the image to your Mac's clipboard.**

 In any program that lets you select an image, click the image, and then copy it to your Mac's clipboard (memory) either by choosing Edit→Copy or by Control-clicking the image and choosing Copy from the shortcut menu.

2. **Launch Preview, and then choose File→New from Clipboard.**

 The Preview app lives in your Applications folder as well as in your Dock (unless you removed it). Once you launch the program, create a new document by choosing File→New from Clipboard. When you do, your Mac automatically pastes the contents of your clipboard—namely, the image you just copied—into the new document.

3. **In Preview's toolbar, click the share icon and choose "Add to Photos."**

 The share icon looks like the one circled in Figure 2-9. When you choose this command, your Mac imports the image into your System Photo Library (page 13), where—after a second or two—it appears at the end of the All Photos album. The newly imported image is also visible in Photos view, inside the moment it belongs to (based on the date and time you created the Preview document). You'll learn all about moments in Chapter 3.

Interestingly, this Preview trick also works for importing headshots that are stored in the Contacts app on your Mac. In Contacts, click an image associated with one of your acquaintances and choose Edit→Copy (or press ⌘-C). Switch to the Preview app, follow steps 2 and 3 in this section, and—ta-da!—your Mac swiftly imports the image into Photos.

Importing Videos

Today's smartphones and digital cameras can capture remarkably high-quality video clips. Conveniently, Photos can import, organize, play, and even trim (page 177) your videos right alongside still images. It recognizes any video format the QuickTime Player app can play (a lengthy list indeed), though its favorite formats are MOV and AVI.

You don't have to do anything special to import or work with video files in Photos. The program includes an album that automatically gathers your videos so you can find them easily, as page 49 explains.

UP TO SPEED

Scanning into Photos

With portable, high-quality scanners available for about $70, swarms of family historians are invading the homes of their relatives to politely ask permission to scan meaningful documents and photos. For example, Epson's Perfection V19 is about the size of a 15-inch MacBook—and only about an inch thicker—and is powered by the same USB cable that connects it to your Mac. With a resolution of 4800 x 4800 dpi and powerful image-enhancement features built in, this scanner is a family historian's dream.

What most people fail to realize is that you can scan *directly* into your Photos library. The trick is to use Apple's Image Capture utility (it's in your Applications folder.) Whenever your scanner is plugged into your Mac, or available wirelessly on your network, Image Capture recognizes it and summons that scanner's own scanning software and adds Photos to its Scan To menu, as shown here.

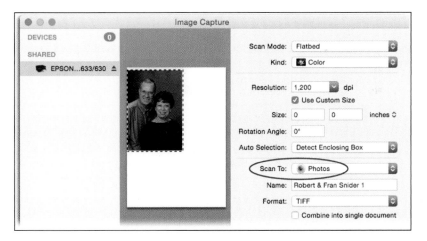

■ Fun with File Formats

You can import and work with all kinds of image files in Photos, though the most common format is JPEG—the acronym stands for the Joint Photographic Experts Group that developed it. This is the format that most folks capture on their cameras, which makes perfect sense; JPEGs contain a wonderfully wide range of colors, so they're perfect for color photographs. JPEGs are also compressed, which means they consume less disk space than other files while maintaining a very high level of quality.

> **NOTE** Confusingly, the terms JPG, JPEG, JFIF, and JPEG 2000 all refer to the same kinds of files.

In addition to JPEGs, Photos can work with a slew of other file formats, as this section explains.

Raw Files

Most newer (and pricier) cameras can capture photos in *raw* format—the fully uncompressed, unprocessed raw information the camera recorded when you took the picture. You may not realize it, but when you shoot in JPEG format, your camera processes the image by applying a little noise reduction, sharpening, and color boosting. If you compared the exact same picture in both JPEG and raw format, the JPEG always looks better, due to the in-camera processing. However, using raw data in Photos gives you more editing flexibility and control because you can process the image however you want. So if you're serious about having total control over how your images look, you may want to try shooting in raw format. Your camera's manual should explain how to do that.

The only caveat to shooting and importing raw files into Photos is that the file sizes are *humongous*, and consume giant swaths of storage space on your camera's memory card and your hard drive.

> **NOTE** Many cameras let you shoot in JPEG + raw format, wherein two files are produced for each shot you take. While doing so gives you the best of both JPEG and raw worlds, it's also one of the fastest ways to use up space on your memory card or hard drive. If you shoot in JPEG + raw, Photos lets you specify which file to use as the original in Edit mode. Page 152 has the lowdown.

Other File Formats

Here are a few other file formats that Photos is happy to import and let you play with:

- **TIFF,** whose name is short for *tagged image file format*, has long been considered the gold standard for high-quality image files, so nearly any program can work with this format. Saving a file in this format doesn't compress it, so the quality is always as pristine as the original. Some cameras can capture images in this format.

- **GIF** is often used for website graphics that have a limited number of colors (think cartoon art), a transparent background (so it's see-through), or are animated. You may encounter this kind of file in emails or on the web.

- **PNG** is the up-and-comer because it supports transparency and a wide range of colors. It produces higher-quality images than JPEG format, but the file sizes are bigger, soo.

- **PSD** is a format used by Adobe Photoshop (and Photoshop Elements), the world's most popular image-editing and photo-retouching program. Photos can import *layered* Photoshop files—ones where different image adjustments or graphic elements live on separate layers stored inside a single document. (To master Photoshop, pick up a copy your humble author's book *Photoshop CC: The Missing Manual*. It's 1,000 pages of pure Photoshop fun!)

- **PDF** is short for *portable document format*, and is hugely popular for sharing single- and multipage documents. Saving a file in this format is like taking a picture of the file: All the fonts, images, and videos it contains are included, so it looks just like the original, but you don't have to own the software that created it. This format can be opened and printed by most every computer on the planet, so it's often used when saving a file from a desktop scanner or all-in-one printer/scanner. (You may receive scans of business documents in PDF format, too.) While Photos lets you import multipage PDFs, you can only see, and thus edit, the first page of them.

TIP You can generate a PDF file from anything your Mac can print. With the file open, choose File→Print, and in the resulting OS X Print dialog box, click PDF at the dialog box's lower left and choose "Save as PDF." Pick a location to save the new file, and then drag it onto the Photos icon in your Dock or onto the Photos window (or use the File→Import command in Photos). Remember: Photos only displays the first page of long PDFs, so reserve this trick for single-page documents only. You can also save book, calendar, and card projects in PDF format for easy sharing with others; see page 257 for details.

- **BMP** is a popular graphics file format used on Windows-based PCs. So if you use a PC at work, or if you've got friends who do, you may encounter this format.

- **SGI** and **Targa** are specialized graphics formats used on high-end Silicon Graphics workstations and Truevision video-editing systems. Unless you moonlight for the likes of Pixar or DreamWorks, you'll likely never encounter these formats, but if you do, Photos can work with them!

After the Import

After you import a batch of pictures into Photos, you'll want to have a good, long look at them to see if they're worth the library space they take up. Unless you shoot on an iPad, this is likely your first opportunity to see your images at full-screen size.

As you learned on page 26, when Photos finishes importing, it displays the Last Import album, which contains the files you just imported. (If you don't see the Last Import album, you can get there by clicking Albums in Photos' toolbar, and then double-clicking the Last Import album's thumbnail. If you turned on the sidebar [page 18 and the box on page 51], just single-click Last Import in the sidebar's Album section.) To kick off your post-import inspection, double-click a thumbnail to enlarge the picture in Photos' preview area; alternatively, you can single-click the thumbnail, and then tap the space bar. Once you're viewing a picture at this large size, you can move through the album using the arrow keys on your keyboard—a satisfying way to assess your captures. To see all your thumbnails again, press the spacebar or double-click the enlarged image.

If you're feeling frisky, you can make your pictures even *bigger* by using Full Screen view, as shown in Figure 2-10. Just click the green button at the upper left of the Photos window or choose View→Enter Full Screen, and your image consumes every last pixel on your screen.

TIP To keep Photos' toolbar visible while you're in Full Screen view, choose View→"Always Show Toolbar in Full Screen."

Viewing your pictures in this manner is perfect for deleting bad shots, fixing a picture's rotation, marking images as favorites (page 82), and more. Here's the full list of things you can do as you walk through your pictures at large size, either in Full Screen view or not:

- **Browse photos** by pressing the left and right arrow keys on your keyboard. You can also use the sidebar (page 18 and the box on page 51) to see other albums and such.

- **Delete a photo** by pressing the Delete key on your keyboard. A confirmation dialog box appears asking if you're sure you want to delete the item(s). Click Delete to confirm, or Cancel if you change your mind. To bypass this confirmation message, hold down the ⌘ key when pressing the Delete key; with this method, the picture immediately disappears. (But don't worry—you can bring it back by pressing Edit→Undo Delete Photo before you do anything else in Photos.)

- **Mark a photo as a favorite** by pressing the period (.) key on your keyboard. You'll learn more about favorites on page 82, but they're a great way to flag pictures that you want to do something with later—say, create an album or print. Photos corrals pictures you mark in this way into an album named (not surprisingly) Favorites.

- **View a photo's details** by Control-clicking it and choosing Get Info. When you do, Photos opens the Info panel, which shows the picture's filename, the date and time you took it, what camera you used, and more. You'll learn all about the Info panel on page 74.

FIGURE 2-10

*You can use Full Screen
view (shown here with
the sidebar turned on)
anywhere in Photos: while
browsing, editing (Chapter
5), or building a project
(Chapter 9). Once you
enlarge an image, you can
cruise through others in
the same album, moment,
or collection by using your
keyboard's arrow keys or
by pointing your cursor
at the left or right side
of the image to reveal
navigational arrows like
the one circled here.*

TIP To summon the Photos menus and toolbar while in Full Screen view, point your cursor at the top of the screen. To exit Full Screen view, tap the Esc key on your keyboard.

- **Rotate a photo** by Control-clicking it and choosing Rotate Clockwise from the shortcut menu. This rotates the picture clockwise 90 degrees each time you choose the command. Press and hold the Option key while choosing this command to rotate the photo counterclockwise instead. This is handy if you shoot a lot of pictures while holding your camera vertically. That said, most newer cameras are capable of flipping your photos in the right direction automatically, before they get to Photos.

- **Duplicate a photo** by Control-clicking it and choosing Duplicate 1 Photo from the shortcut menu. This creates a copy of the file, which is handy when you want to edit it in different ways (say, you want a full-color version and a black-and-white). You'll get the full story on editing pictures in Chapter 5.

- **Share a photo** by Control-clicking it and choosing Share. The resulting menu displays the myriad sharing options Photos offers, such as email, text message (Messages), AirDrop, iCloud Photo Sharing, or posting to Facebook, Twitter, or Flickr. You can even use this menu to assign the photo as your desktop picture (page 228). Sharing is covered in detail in Chapter 8.

- **Hide a photo** by Control-clicking it and choosing Hide 1 Photo. Hiding isn't the same as deleting. When you hide an image, it remains in your Photos library but you can't see it. This lets you get it out of the way without deleting it. You'll learn more about hiding pictures on page 59.

By taking the time to assess your pictures right after you import them, you keep your Photos library lean and mean. And using the commands listed above while viewing your pictures in a big, beautiful format makes this process feel less like a chore.

> **TIP** Deleting photos on an iOS device becomes tedious very quickly—especially if you have lots to delete. Rather than using those few square inches of glass to select and delete items, you can use the Image Capture app in your Mac's Applications folder instead. First, attach your iOS device to your Mac with the cable that came with it. Then launch Image Capture and select your iOS device from the list of devices. Now you can select multiple items quickly (see page 57 for tips on selecting), and then click the red circle-with-a-slash icon at the bottom of the Image Capture window. A confirmation dialog box asks you to Confirm or Cancel deleting these items. When you click Confirm, those items are removed from your device.

▨ Dealing With Duplicates

Photos is mercifully smart when it comes to preventing duplicate pictures and videos from infiltrating your library. By using filenames, dates, file sizes, and other technical data, the program can spot duplicates from a mile away. When it encounters a file on your memory card or camera that matches one that's already in your library, Photos politely asks whether you want to import it.

> **NOTE** If you converted one or more iPhoto libraries to use in Photos (page 4), the program automatically removes any duplicates images it finds in those old libraries. Sweet!

That said, duplicates may occasionally sneak into your Photos library. Unfortunately, there's no automated way to locate them. But if you browse pictures in Moments view (page 43), you can easily spot duplicates, because their thumbnails are sitting side by side.

▨ Visiting Your Photos Library

One of the beautiful things about using Photos to organize your digital image world is that you don't ever need to know where Photos stashes your files or how it performs its special brand of file-management and manipulation magic. Much like a refrigerator, telephone, or light switch, you don't have to know *how* Photos works to enjoy and appreciate its benefits. But in case you're curious, here's some info about where Photos stores your stuff. (For more details, see Chapter 10.)

As you learned in the note on page xv, Photos is a database, and thus your Photos experience consists of two separate parts: the Photos app (which lives in your Applications folder) and a database called the Photos Library file. Technically, the latter can live anywhere on your internal or external hard drive, but it's usually tucked inside your Pictures folder (for example, Macintosh HD→Users→[Your name]→Pictures→Photos Library).

The Photos Library is no ordinary file—it's a *package* of folders and files that behaves like a single file. If you're the inquisitive type, you can peek inside the Photos Library file, though doing so requires a bit of OS X voodoo, as Figure 2-11 explains.

> **NOTE** Look but don't touch! Your Photos app expects everything in these folders to be exactly where it put them. If you move or rename anything in the Photos Library package, Photos gets confused and will alert you the next time it needs to access the file you changed. The exception is that it's okay to *copy* a file in your Photos Library package to another location. However, it's safer to use Photos to do that rather than mucking about in the library's innards.

There are really only two interesting folders in the Photos Library package file (remember, this is look-but-don't-touch-territory!):

- **Masters.** This folder houses your original pictures and videos, exactly as you imported them. It's the key to one of Photos' most remarkable features: the "Revert to Original" command (page 111).

- **Previews.** Once you use one of Photos' editing tools (Chapter 5), Photos *duplicates* the file and stores the edited copy in this folder.

In case you're dying to know what the other folders in the Photos Library file are for, here you go (depending on your situation, you may see some or all of these folders):

- **Apple TV Photo Cache.** If you have an Apple TV, this is where Photos keeps the database of photos you've told it to use as a screensaver. (See the box on page 175 for more on Apple TV's ultra-cool screensaver feature.)

- **Background Import.** When you import a file using the "Add to Photos" feature in the Finder or in other apps (page 27), this is where the file goes. If Photos is running when you do the importing, Photos immediately imports the file. If it isn't, the file cools its heels here until you next launch Photos; think of this folder as a waiting area.

- **Database.** All the parts and pieces of your Photos library are tracked here—albums, face and location tagging, and so on.

- **iPhoto or Aperture Items.** You'll only see these folders if you upgraded an iPhoto or Aperture library to Photos. They store info about that old library.

- **Modified and Originals.** These folders include aliases (pointer files) to the Previews and Masters folders, respectively. In other words, opening the Modified folder opens the Previews folder, and opening the Originals folder opens the Masters folder.

- **Thumbnails.** This folder contains index-card–sized previews of your pictures, organized by date.

If this sneak peek has piqued your interest, you can read tons more about your Photos library in Chapter 10.

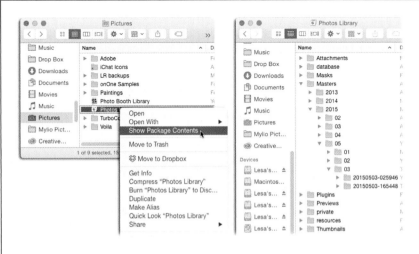

FIGURE 2-11

Left: To expose the individual components of the Photos Library file, Control-click the file and choose Show Package Contents.

Right: Here you can see the hidden organizational structure of the Photos Library file. For the most part, this stuff won't mean anything to you. However, the Masters and Previews folders are pretty important, as this section explains.

Moving the Photos Library

Do I have to keep my Photos library in my Pictures folder?

While the Pictures folder is the obvious place to keep your Photos Library file, if you like, you can move it to another spot on your hard drive or onto an external drive that you plug into your Mac.

To move your library, quit Photos by pressing ⌘-Q. Next, either drag the Photos Library file from your Pictures folder to another location on the same hard drive, or ⌘-drag it onto a different

hard drive (if you don't add the ⌘ key modifier, you *copy* the file instead of moving it).

When you're finished moving the file, launch Photos again and, amazingly, it locates your library and opens it. On the off chance that it can't find it, Photos opens the Choose Library dialog box so you can tell it where you stashed the file. You can also press and hold the Option key when launching Photos to summon a dialog that lets you pick which library to open (page 274).

Viewing and Organizing Your Images

I f there's one thing for certain, it's that you won't have *fewer* pictures next year—you'll have more. In all likelihood, hundreds—if not thousands—of photos will make their way into your life within the next few months alone. That's because digital cameras (and their prices) are better than ever, and every cell phone known to man now sports a surprisingly high-quality camera. Combine that with the selfie epidemic and the "I must photograph everything I eat" phenomenon, and you've got yourself a *ton* of photos to manage.

For most people, photo management is where the fun of digital photography abruptly ends. While it's a blast to chronicle every moment of your life in pictures, few people enjoy organizing a honkin' big photo collection. At best, you trudge through organizing and culling only a few pictures, but at worst you avoid it like the Tarellian plague (*Star Trek*, anyone?).

Happily, Photos provides many practical ways to view your image collection in neatly organized bundles, though you can organize them further into albums and folders you make yourself so that you can actually *find* them whenever you want. Heck, as you'll learn in this chapter, Photos fills a slew of built-in albums *automatically* to save you the trouble.

In this chapter, you'll learn everything you need to know about Photos' different views, as well as how to select images, create albums, and use folders. You'll also find out how to change filenames, delete images, and employ the Info panel to view even more data about your collection. Finally, you'll learn how to access your files on the Web.

■ Photos' Views

Photos for Mac is designed to look, feel, and work exactly like Photos on your iOS device. Sure, there are some minor differences—Photos for iOS doesn't include the iPhoto-esque sidebar (see the box on page 51) and you can't use it to create slideshow or print projects—but for the most part, the two versions look and feel similar.

The first time you launch Photos for Mac, you see four tabs centered in its toolbar: Photos, Shared, Albums, and Projects (see Figure 3-1). (In Photos for iOS, you get three icons at the bottom of your screen: Photos, Shared, and Albums.) When you click one of these tabs (or icons), you're transported into the following views:

- **Photos view** is where you do your hunting and browsing by date. This view displays your thumbnails as Moments, Collections, and Years. As you'll learn in the next section, this view takes a little getting used to, but it's hands down the fastest way to find pictures if you know (roughly) when they were taken. The keyboard shortcut for entering this view on a Mac is ⌘-1.

- **Shared view** is where you view pictures and videos that you've shared with others or that other Photos-using folk have shared with you. People can comment on the items you share, you can comment on theirs, and—if you allow it—they can even upload their own pictures and videos to albums you share. It's a wonderful way to access and enjoy pictures taken by other people. You'll learn all about sharing in Chapter 8. Keyboard shortcut: ⌘-2.

- **Albums view,** as you may suspect, shows thumbnails of all the albums that you (or Photos) create. Pictures and videos can appear in as many albums as you like without duplicating the file or consuming additional disk space. As this chapter explains, Photos automatically creates many albums to help you find your stuff more quickly. For example, there are albums for the last batch of files you imported, videos, and pictures where you've tagged people (page 97). These automatic albums are surprisingly handy when you want to find, say, your most recent kitten videos. Keyboard shortcut: ⌘-3.

- **Projects view** houses thumbnails of all the slideshow, book, calendar, and card projects you make in Photos for Mac. (You can't create projects in Photos for iOS, so that version of the app doesn't include an icon for this view.) These fun and satisfying projects are covered in great detail in Chapters 6 (slideshows) and 9 (everything else). Keyboard shortcut: ⌘-4.

When you first start using the program, you'll spend most of your time in Photos view. Once you start making albums (page 60), you'll begin spending more time in Albums view. The same is true of Shared view and Projects view—you won't spend much time in those views until there's something inside them to see.

Photos View

Photos for Mac and Photos for iOS both automatically group your content based on when and where the pictures and videos were taken, which is what this view is all about. It shows you thumbnails all of your pictures in chronological order, and you can scroll through your entire library at breakneck speed. Using Photos view, you can easily find that picture of you and William Shatner at the sci-fi convention in 1998.

Photos view actually includes several sub-views, which can be a bit confusing. Navigating through them takes a little getting used to, but it's well worth the brief learning curve. To get around in Photos for Mac, you rely upon the back and forward arrows labeled in Figure 3-1 to zoom in and out of a bird's-eye view of your library. In Photos for iOS, you see only a left-pointing arrow that takes you to a larger sub-view (for example, from Moments to Collections or from Collections to Years). To go to a smaller sub-view, tap the group of photos you want to zoom into.

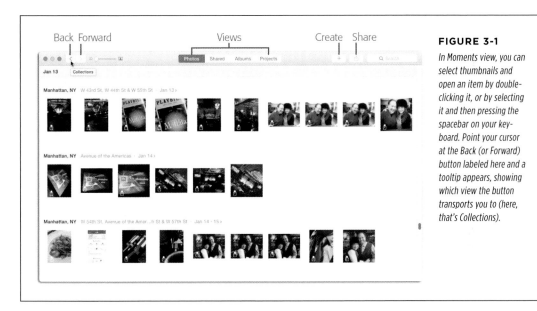

FIGURE 3-1

In Moments view, you can select thumbnails and open an item by double-clicking it, or by selecting it and then pressing the spacebar on your keyboard. Point your cursor at the Back (or Forward) button labeled here and a tooltip appears, showing which view the button transports you to (here, that's Collections).

By using those buttons, you can access sub-views that offer three levels of detail and organization, listed here from smallest to largest thumbnail grouping:

- **Moments.** In Photos, a *moment* is a group of pictures you took in one place at about the same time—for example, all the shots you took at your kid's soccer game. If your camera or phone recorded the location where you took the shots, Photos uses that info to name each moment: "Pearl Street Mall, Boulder, CO" or "Shelter Island Shoreline Park, San Diego, CA," for example. If you click a moment's name, you open a map showing where those pictures were taken (see Figure 3-2).

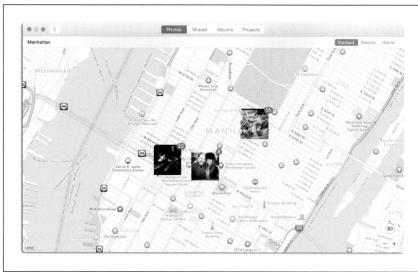

FIGURE 3-2

But wait, there's more! If you click a Moment's name, a map springs opens with thumbnails that show exactly where the pictures were taken (if your camera captured location info, that is). This works in Moments, Collections, and Years views. This map is the closest thing Photos has to iPhoto's Places view.

- **Collections.** When you take pictures near each other in terms of time or location, Photos gathers them into a collection. For example, if a soccer game is but one activity in a weeklong tournament you photographed, Photos groups the whole tournament into a single collection and displays a *summary* of your images as a grid of tiny thumbnails (see Figure 3-3). You don't see individual shots in this view. Instead, Photos combines similar, sequential photos into just a few thumbnails using its summarize feature, but you can click a thumbnail grouping to open it in Moments view and see thumbnails of all the shots in that grouping, and then select individual thumbnails from there.

- **Years.** This view, which displays all the pictures and videos you captured during a given year as teeny-tiny thumbnails, resembles a colorful mosaic of your photographic life (Figure 3-4 shows an example). With your content organized and grouped this way, you can quickly scroll to the approximate time a picture was taken, click a grouping of thumbnails to zoom into a specific time period via Collections view, and then click *another* grouping of thumbnails to reveal its individual thumbnails in Moments view. If you click the location info next to a year label in Year view, Photos opens a map and tacks your thumbnails onto the locations where they were captured.

> **TIP** When you're viewing a grid of thumbnails in a year or collection, you can hold your mouse button (or finger, in Photos for iOS) down within the batch to see a larger thumbnail, and—get this—you can slide your mouse or finger around *within* the mosaic of thumbnails to find a particular shot. When you let go, that image fills Photos' window.

FIGURE 3-3

*Collections view shows
a summary of your
thumbnails, which helps
you find certain pictures
more quickly, though you
can't select individual
thumbnails. To switch from
viewing collections to mo-
ments, click the Forward
button. (Here again, if you
point your cursor at the
Back or Forward button, a
tooltip appears and indi-
cates which view that but-
ton takes you to: Moments,
Collections, or Years.)*

FIGURE 3-4

*Here's Photos' incredible
Years view, where all the
pictures and video you
take in a year appear as
tiny thumbnails. As you
can see, the Back button is
dimmed, meaning this is
as far out as you can zoom
chronologically.*

Thankfully, switching between Photos view's different sub-views is easy, but it does
take a little practice. You have to get used to clicking (or tapping) the back and
forward arrows to zoom in or out chronologically. (In Photos for iOS, you can also
use the pinch and spread gestures to zoom in or out.)

It's important to remember that you can only select individual thumbnails in Moments view; in all the other sub-views, you're viewing a summary of thumbnails. (Page 56 tells you how to change Photos' preferences to show you *all* of the thumbnails in those views.) While all this takes some getting used to, you'll quickly appreciate the brilliance of this chronological organization scheme. Sometimes, Apple really does know what's best, however odd this style of navigation may feel at first.

Shared View

Shared view is where you find all the albums you've shared with other people, as well as any albums that others have shared with *you* (see Chapter 8 for details). This view also harbors a chronological log of all the recent sharing activity that's gone on in your Photos world. Here's what you see in Shared view:

- **Activity.** If you're familiar with Facebook, think of the Activity album as your timeline (it's not *technically* an album, but it's okay to think of it that way). This is where Photos automatically gathers your most recent sharing activities and arranges the images as large thumbnails in a grid. At a glance, you can catch up on your friends' trip to Miami and comment on or like all their pictures of sandy white beaches, mojitos, and Cuban cuisine. This album displays items you've shared and any comments your subscribers have made. You can also see notifications when a person accepts an invitation to a shared album, items other people have added to your shared albums (if you let them), and so on. As you and your friends participate in these fun and satisfying activities, they're added to the top of this giant, scrolling log (which means you'll want to visit this album fairly often to keep up).

- **Family.** When you set up a Family Group (page 224), Photos creates this shared album. Pop in to have a look at the pictures and videos your family members have added, write or read comments, import shared items to your own Photos library for inclusion in projects, or add your own goodies for other family members to see. This is a fantastic solution for anyone who's ever fantasized about an image organizer that works for several people.

- **Shared albums.** Once you share an album or subscribe to one shared by someone else, it appears as a thumbnail in this view. Just like the Family album (which is really just a specially named, automatically created shared album), you can add and delete items in albums you've shared, add and delete items to albums you've subscribed to (if the owner allows it), and import other people's images into your own library.

Here again, the back and forward navigation arrows in the toolbar in Photos for Mac (and the arrow at the top left of Photos for iOS) come into play to determine what you see in this view. When you first enter Shared view, you see a thumbnail for each of the albums mentioned above. Once you double-click (or tap) an album to open it, or you click to select it and then press Return, you use the back arrow to return to viewing all the albums this view contains.

If all this sharing business sounds like a lot of fun, feel free to skip ahead to Chapter 8, where you can learn how to get the sharing party started.

Albums View

The best way to organize your library is to use albums. They're a fantastic way to corral pictures that have something in common. For example, you could make an album of the best shots from your kid's black-belt test, all the sunset photos you've taken over the years, pictures you want to include in your yearly book project, or whatever.

As you'll learn later in this chapter, you can stuff items into albums manually, or you can set criteria that tells Photos to add images to albums *automatically* (page 69). And Photos comes with several built-in albums, which help you find certain kinds of content more quickly (say, all your videos). Here's what awaits you in Albums view (Figure 3-5).

Zoom slider: Drag to change thumbnail size

FIGURE 3-5

The built-in albums appear at the top of this view, and the ones you create appear below the My Albums heading. Use the zoom slider labeled here to change the size of album thumbnails.

- **All Photos (Mac only).** This album displays all your photos and videos in one super-long list that's sorted by the date you imported them into your Photos library—not the date they were taken—with the oldest items at the top and the most recent at the bottom. If you turned on iCloud Photo Library or My Photo Stream, this album also stores all the goodies transferred from your other iOS devices and other Macs that have one (or both) of those services turned on. Contrary to what you may think, there's no way to access Moments, Collections, or Years view in this album. (To do that, you have to use Photos view instead or, if you turned on the sidebar [page 18 and the box on page 51], choose Photos at the top of the sidebar and use the arrow buttons on the left side of Photos' toolbar.)

- **Camera Roll (iOS only).** When you take pictures and videos with your iPhone or iPad, they show up here. And unless you're using My Photo Stream (page 23), this is where they stay until you connect your iOS device and import them into Photos for Mac (page 25), and then let Photos delete them from your iOS device.

> **TIP** To keep your pictures and videos from hogging all the storage space on your iOS device (*especially* videos), remember to occasionally attach it to your Mac and import your Camera Roll into Photos for Mac. Otherwise, you'll wind up with two copies of each item on your iOS device: one that Photos helpfully saved in your Photo Stream (page 23) or iCloud Photo Library (page 19), and the one you originally captured on the device itself.

- **Faces.** The Faces album is especially fun—almost magic. You'll learn all about Photos' facial-recognition feature (which powers this album) in Chapter 4. On Photos for Mac, the five people whose faces you've tagged the most appear inside circles on the thumbnail of this album. When you open the Faces album, those five faces also appear in bigger circles at the top of the preview area. This is a surefire way to be reminded of who's most important in your Photos realm. As you'll learn in Chapter 4, Photos makes it fun to identify the faces in your life. The more you train Photos in this way, the better it becomes at identifying the people in your pictures.

- **My Photo Stream.** If you haven't turned on iCloud Photo Library (page 19) but you have My Photo Stream turned on for your iOS device, you see all the newest photos from your iOS device(s) in this album. Page 23 has more on using My Photo Stream.

- **Last Import (Mac only).** The last batch of goodies you import into Photos lands in this automatically created album. When you import new stuff, the previously imported thumbnails disappear from this album but remain safely in your your library—this album is just a way for you to see what you most recently imported. Chapter 2 serves as a manifesto on all the ways you can import items into Photos.

> **TIP** If the items you most recently imported are related in a meaningful way, make a habit of popping into the Last Import album after each import, creating an aptly named album, and then placing those items in it. This is especially useful when you import files stored in folders on your Mac; since those items don't tend to be recent captures, they don't conveniently appear at the bottom of Photos view or the All Photos album. In other words, if you don't immediately stash them in an album, you may need to go back to the Finder and note the dates the pictures were taken in order to find them in Photos.

- **Panoramas.** Newer iPhones and iPads have incredible picture-taking abilities. You can even use them to take *panoramic* photos, where your iOS device stitches together a series of pictures to form one really wide shot. Photos helpfully stores all your *panos* (as the cool kids call 'em) in this album so they're easy to find. So when you're desperately trying to find the panorama you shot at the Grand Canyon, start your search here.

- **Videos.** Photos helpfully gathers all your videos into this album, which is good news because the thumbnail of a video looks identical to that of a still image, save for the microscopic video icon at lower left (if you keep File Type visible; see page 55). Since videos are gigantic in file size, this album is a great place to look for items to delete if you're looking to slim down your Photos library. To put it in perspective, each *minute* of video takes up the space equivalent of 25 photos—about 80 megabytes.

- **Slo-mo.** If you're the proud owner of an iPhone 5S or iPad Air 2 (or newer versions of either), you can capture video in slow motion. These devices can capture videos in 1080 or 720 pixels in width at 240 or 120 frames per second, depending on the settings you pick (see the tip on page 179). Photos collects all your slo-mo videos in this album so you can get to them quickly. Page 178 teaches you how to edit slo-mo clips.

- **Time-lapse.** This album stores all your time-lapse videos, which is a feature that Apple introduced in iOS 8 (which runs on the iPhone 4s, iPad 2, iPad mini, or iPod Touch 5G or newer). Time-lapse videos are incredibly cool: You can use them to create a video of a flower opening, a candle burning, or any other slowly changing subject. They're also impressive when capturing a quickly moving foreground against a non-moving background—think busy streets or an intersection in Manhattan. When you switch to time-lapse mode in the Camera app on your iOS device, your first tap of the Record button triggers the camera to capture one or two shots per second. Tap the button again to stop the recording. In a moment or two, the Camera app combines those pictures into a 20 to 40-second video. Apple says you can record for as long as 30 hours, battery life and space permitting; however, the longer you record, the fewer pictures the Camera app retains per second (say, it goes from two to one).

TIP If you're stuck with an older iOS device that doesn't have a Slo-Mo or Time Lapse option in its Camera app, all is not lost. You can download a low-cost slow-motion app, such as SlowCam ($2), Video Slo-Mo ($5), Time-Lapse Video ($5), or Hyperlapse ($1) from the App Store. Just be aware that the cameras in older iOS devices aren't nearly as good as the newer ones, so your slo-mo videos may appear choppy (though time-lapse videos should look about the same).

- **Bursts.** Newer iPhones and iPads can take bursts of 10 photos per second, which is handy when you want to capture that perfect shot during a fast-moving event such as the Great Blowing Out of the Birthday Candles. Any pictures you take in this mode are piled into a single stack in Photos for Mac and in Photos for iOS and grouped into this album. See the box on page 50 for more on shooting in Burst mode.

- **Recently Deleted (iOS only).** This album shows up only in Photos for iOS and displays the pictures you most recently marked for deletion. You'll learn more about this handy album on page 77.

- **My Albums (Mac only).** This section of Albums view stores all the albums you create. As this chapter explains, these could be albums that you fill manually or self-populating albums based on criteria you set. (The latter is called *smart albums*, and you'll learn all about them on page 69.)

You'll find out how to create and manage albums later in this chapter.

Projects View

This view contains thumbnails of all the various slideshow, book, card, and calendar projects you can create in Photos for Mac. (You can't create projects in Photos for iOS, so you don't see this view there.) You'll learn all about slideshows in Chapter 6 and print projects are covered in Chapter 9. When you first enter this view, you see thumbnails of all your projects. Once you open a project, you can use the Back button in Photos' toolbar to return to viewing all your projects.

UP TO SPEED

Bursting at the Seams

Some subjects are notoriously difficult to capture, such as squirming children, frolicking ferrets, and anything that's subject to the whims of the wind. Your only hope of ensuring at least one halfway sharp shot is to fire off multiple shots in rapid succession.

If you have an iPhone 5S or an iPad Air 2 (or newer), you can invoke its Burst mode to capture a whopping 10 pictures per second. To give it a whirl, grab your iOS device, open the Camera app, and then pick either Photo or Square mode. Next, either tap and hold the Shutter button on your device's screen, or press and hold the Volume-up button on its side. Either way, a moment later, you'll have 10 shots for every second you held the button. Your device doesn't make any kind of sound to indicate that you're shooting in Burst mode, but if you glance at your screen, you see a counter that lets you know you're indeed shooting at warp speed.

Fortunately, Photos avoids overwhelming you with burst-captured thumbnails by grouping each set of bursts into a stack (so you see one thumbnail instead of 10). Photos also picks the ones it thinks are best and puts a gray or white dot beneath their thumbnails. (For some reason, this doesn't work on the iPhone 5S—apparently it's not smart enough to tell a good shot from a bad one.)

After shooting in Burst mode, you can use Photos to determine which shots to keep. The process is the same in Photos for Mac and Photos for iOS: Just locate the burst stack, double-click (Mac) or tap (iOS) the stack to open it, click or tap Make Selec-

tion to open all the shots, click or tap to select the pictures you want to keep, and then click or tap Done. If you change your mind and want to keep *all* the shots, tap Keep Everything. Otherwise, tap Keep Only [number] Favorites (iOS), or click Keep Only Selection (Mac). Photos then deletes the rest to help you regain a little disk space. (While the button you click in Photos for iOS includes the word "Favorites," those pictures aren't tagged as a favorite, so they don't end up in the Favorites album. Imagine that the button reads "Selection" instead.)

If you want to play with Burst mode but you're unsure what to shoot, try some burst selfies. Just reverse your iOS device's camera so you can see yourself, and then capture a burst while you make various facial expressions. Such silliness is great fodder for sharing via social media or for, say, creating your own *Hard Day's Night*–style album cover.

The downside to shooting in Burst mode is that you end up with a ton of nearly identical pictures. While all the images in a burst are uploaded to iCloud Photo Library (page 19), only the ones you mark as favorites are included in your Photo Stream (page 23). Likewise, when you connect your iOS device to your Mac, only the shots you favorited on the iOS device are available for import into Photos for Mac (the others aren't visible). However, you can easily change this behavior: To make *all* your burst images visible (and thus available for importing into Photos for Mac and uploading to your Photo Stream), open the Settings app on your iOS device, tap iCloud, tap Photos, and then turn on Upload Burst Photos.

◼ Viewing, Opening, and Scrolling

Once you get used to using the back and forward arrows to navigate Photos' different views, you're ready to learn how to customize each view to your liking. You can customize what you see in a variety of ways, including changing the size of thumbnails and summoning a split view where you see thumbnails on the left and large photos in the preview area. There's also a variety of methods for scrolling through your collection, and you can reveal all kinds of info about your content that shows up while you're viewing it in thumbnail form. This section teaches you everything you need to know.

Resizing Thumbnails

When you need to compare similar images, bigger is definitely better. You can change the size of the thumbnails in Photos for Mac using the zoom slider in the toolbar (it's labeled back in Figure 3-5). Drag the slider left to make the thumbnails smaller or right to make them bigger. This works anywhere you see thumbnails—that means anywhere other than Collections and Years views.

> **TIP** You don't actually have to *drag* the zoom slider; just click anywhere along the slider to make it jump to a new setting. You can also scale all the thumbnails by clicking the tiny icons at either end of the slider: One click takes them to the halfway size point, and a second click takes them to the smallest or largest size (depending on which icon you click).

In Photos for iOS, you can't resize the thumbnails, but you *can* zoom into an image by double-tapping it once it's open.

UP TO SPEED

Displaying the Sidebar

Apple really wanted Photos for Mac to be identical to Photos for iOS, but let's face it: A Mac with a keyboard and mouse (or trackpad) is a lot more efficient than tapping a glass rectangle (even one with elegantly rounded corners). Thus, Photos' sidebar was born. If you ever used iPhoto or iTunes on a Mac, then you're familiar with—maybe even addicted to—the vertical Source List on the left side of the program that shows how all your content is organized. To open the equivalent in Photos, choose View→Sidebar or simply press Option-⌘-S. (It's shown back in Chapter 2 on page 19.)

The sidebar is helpful in myriad ways: You can see your *entire* organizational structure in list form—shared albums, regular and smart albums you've made, the albums Photos automati-

cally creates (Faces, Last Import, and so on), and any projects you've created. The sidebar lets you quickly access the contents of any item by single-clicking it; drag thumbnails from the preview area into albums and projects; Control-click an item in the list to reveal a shortcut menu that lets you duplicate, rename, and delete albums and projects; and more.

The only trick about the sidebar is that in order to enjoy Moments, Collections, and Years views, you have to click the Photos item at the top of the sidebar, and then use the back and forward arrows in Photos' toolbar to zoom in or out chronologically. (This makes sense because, as page 42 explained, Years, Collections, and Moments are sub-views of Photos view.) Other than that, using the sidebar is a piece of cake.

Opening Files

The easiest way to open a file in Photos for Mac—whether it's a picture, video, or album—is to double-click its thumbnail. Alternatively, you can also select it and then tap the space bar. In Photos for iOS, simply tap a thumbnail to pop open the file.

Whichever route you take, the picture or video opens in the preview area, scaled to fit the viewable screen real estate. For more on controlling and editing videos, see page 174. If you open an album in this way, you see all the thumbnails it contains.

To close the picture or video and go back to viewing thumbnails on a Mac, double-click the photo or tap the spacebar again. Or you can click the Back button on the left side of the Photos' toolbar—which is also how you close a file in Photos for iOS. (To close an album, use the Back button to return to viewing all the album thumbnails. You'll learn more about albums later in this chapter.)

Using Split View (Mac only)

Once you open a picture, you can't see the other thumbnails in the current view or album you're perusing. That is, unless you turn on split view, as shown in Figure 3-6. When you do, the other thumbnails are visible on the left of the Photos window. (Alas, Photos for iOS doesn't offer this view). To turn this *Split view* on or off, choose View→Show Split View or press Option-S (choosing the same menu command or pressing the same keyboard shortcut also turns Split view off). Normally, the thumbnails shown in Split view are square to optimize the narrow space allotted to them, but you can change them to the shape of the original photos by choosing View→"Display Square Thumbnails in Split View," which turns that setting off.

Scrolling Through Thumbnails

Once you populate your Photos library, scrolling through thumbnails to find what you want becomes a major part of your photographic life. Fortunately, scrolling through a bazillion thumbnails in Photos for Mac is a zippy affair. The process is a little different in Photos for iOS. This section teaches you tips for both versions.

■ PHOTOS FOR MAC

There are several ways to scroll through your Mac's photo library, depending on whether you have a mouse or trackpad, and your preferred scrolling method. For example, you can:

- **Drag the vertical scroll bar** on the right side of the Photos window to glide through your thumbnails.

- **Swipe up or down with two fingers** on a laptop trackpad, Apple Magic Mouse, or Magic Trackpad. If your mouse has a scroll wheel (or a scroll pea, like Apple's old Mighty Mouse), you can use that to scroll, too.

FIGURE 3-6

Split view lets you see all the thumbnails the current view or album contains. Click a file's thumbnail to open it, or point your cursor at the right side of the image to reveal the arrow circled here, and then click to view the next image. Point your cursor at the left side of an image and you get a left-facing arrow that takes you to the previous image instead.

- **Option-click the spot on the scroll bar** that corresponds to the location in your library you want to see. If you want to jump to the bottom of the library, for example, Option-click near the bottom of the scroll bar.

NOTE You can change the standard behavior for all OS X scroll bars by going to →System Preferences →General and turning on "Jump to the spot that's clicked." With that setting turned on, you won't need the Option key—simply clicking the scroll bar will do the trick. If you turn on that setting and then *do* use the Option key, you'll jump to the next page (or window-full) instead.

- **Press the Home or End key on your keyboard** to jump to the very top or bottom of your photo collection (respectively). If the keyboard has Page Up and Page Down keys, you can use them to scroll one window-full of thumbnails up or down. (On some keyboards, you may have to hold down the fn key to make any of these keys work.)

- **Use the arrow keys on your keyboard** to jump to the thumbnail above, below, or to the left or right of the currently selected thumbnail. Alternatively, you can use the arrows that appear to the left and right of an image after you open it to go to the previous or next photo. To see these arrows, point your cursor at the left or right side of the photo. To view an enlarged version of the previous or next image, respectively, click one of the arrows. When you hit the beginning or end of a moment, your next click takes you to the previous or next moment in your library.

■ PHOTOS FOR IOS

Scrolling through your photos on your iPhone or iPad is more like *strolling* through them. When you're looking at a large number of thumbnails, swipe up or down and watch them slide by. A barely noticeable scroll bar appears on the right side of your screen to indicate approximately where you are in the current set of thumbnails. When you've opened an image or video, swipe left or right to go to the previous or next item in that view. The date and time of the current photo is helpfully displayed at the top of the screen. Tap the picture once to see it displayed atop an uncluttered, solid black background, or tap it twice to zoom in on it.

Viewing Metadata

Ever helpful, Photos for Mac adds little icons to certain thumbnails to help you identify them. For example, videos sport a tiny video-camera icon, slo-mo videos have a circle made of tick marks, images you've marked as favorites bear a tiny white heart icon, and so on. Photos knows which icons to put on which files thanks to their *metadata*.

Metadata is a term borrowed from librarians to describe all the data about a picture or video. For example, an image file includes info about the time, date, and location where you took that shot, its size and file format, and the camera settings you used, as well as copyright info, Faces tags (page 97), keywords (page 91), and so on. While some of that info is visible only in Photos' Info panel (described in the next section), you can tell Photos to display much of it on or below the thumbnails. To do that in Photos for Mac, choose View→Metadata and pick one or more options from the following list:

- **Titles.** In addition to the name your camera gave the file, you can give it a name of your own in Photos. By turning on this option, the new name appears as tiny text beneath the image thumbnail, as shown in Figure 3-7.

- **Keywords.** As you'll learn in Chapter 4, *keywords* are descriptive words or phrases that you can assign to images to make them easier to find. If you turn on this option, a tiny tag icon appears at the lower left of any picture or video thumbnail that has one or more keywords assigned to it.

- **Edited.** Turn on this option and a cute little toolbox icon appears at the lower right of any thumbnail that's spent time in Photos' Edit mode (Chapter 5); one is visible on the upper-right thumbnail in Figure 3-7.

FIGURE 3-7

When you turn on metadata, you can see all kinds of helpful info on or below the thumbnails of your pictures and videos. Favorite, Edited, and Movie icons are visible here in the corners of these thumbnails, as are Titles (think "image names") that were added in Photos.

In Photos for iOS, you automatically see file-type icons on thumbnails, but you don't see the other metadata described in this section. See the box on page 56 for tips on viewing metadata on your iOS device

- **File Type.** This option, which is turned on straight from the factory, shows special icons at the lower left of each thumbnail that give you a clue as to what kind of file it is. As mentioned earlier, videos get a tiny video-camera icon, slo-mo clips have a circle made of tiny tick-marks, and time-lapse captures also have a circle made of tick-marks but with twice as many marks. Unfortunately, the only file-type icons Photos shows for still images is HDR (high dynamic range), which is a bit of a bummer.

- **Favorite.** As you'll learn in Chapter 4, marking files as favorites makes them easy to find. If this option is turned on, a tiny white heart appears at the upper left of any thumbnail you bless in this manner.

- **Referenced File.** As you learned on page 28, your pictures don't have to live in your Photos library; you can leave them where they are and have Photos *reference* their current locations instead. When you turn on this option, a tiny arrow-on-a-box icon appears at the lower left of any referenced files' thumbnails.

- **Location.** If your image was captured with a device that has geotagging capabilities, turning on this option summons a tiny pushpin-in-a-square icon at the lower left of any thumbnail that includes a location tag. Your iPhone does this automatically, and your iPad *can* if it's on a wireless network when you take the shot or if you sprang for a cellular data plan for it.

Using Summarize View

When exploring your photos in Years or Collections view (page 42), Photos for Mac and Photos for iOS tries to help you focus by combining similar photos taken at the same time into fewer representative thumbnails (say, 3 instead of 10). This keeps you from being overwhelmed by a bazillion thumbnails and helps you find the items you want more quickly, because you have fewer thumbnails to wade through.

If, for whatever reason, you want to turn this feature off in Photos for Mac, choose Photos→Preferences→General, and then turn off "Summarize photos" (see Figure 3-8). From then on, you see thumbnails of every single picture in your library in Years and Collections view. (You can't turn it off in Photos for iOS.)

■ Selecting and Hiding Files

If you're cruising through your thumbnails in any view *other* than Collections or Years, you can easily select a single picture or video in order to open or edit it, include it in an album or project, drag it into an album or project, or duplicate or delete it. To do that in Photos for Mac, simply click the thumbnail, and a blue border appears around it to let you know that it's selected.

Viewing Metadata in Photos for iOS

For some inexplicable reason, Apple doesn't let you view meta-data in Photos for iOS. Of course, third-party (a.k.a. non-Apple) app developers leapt at the opportunity to create apps that do. Most third-party apps of this nature are free if you don't mind a few ads, but if you pay a small fee, the ads disappear and additional features are unlocked—in some cases, features that even Photos for Mac doesn't have.

One such free and popular app is Danny Anderson's Photo Investigator, which, once you install it, you can access on an iOS device by tapping the Share icon while viewing a picture in Photos. When you do that, you see the image's shooting location as a pin on a map, with all its other metadata in a list. If you like, you can click the pin to open the Maps app and get directions to that location—great for nostalgic, "Let's go recreate that shot each year!" shots.

That said, if you fork over 99¢ for the *paid* version of Photo Investigator, the ads disappear and you gain the ability to edit or remove metadata—great for adding location data if your camera didn't capture it (or for hiding it, if you're in the witness protection program). When you do either, Photo Investigator makes a copy of your image in Photos and leaves the original intact. You can use Photo Investigator within the Photos for iOS app to remove metadata from the copy it makes of your image, but to change its location you need to switch to the Investigator app itself. Either way, you'll see the new location info (or lack thereof) in Photos when you click the copy that Investigator made.

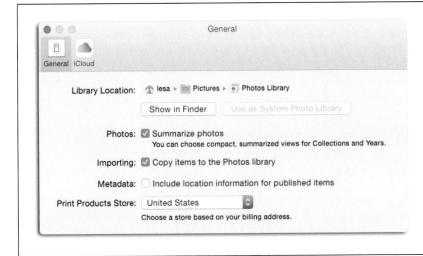

FIGURE 3-8

If you value your sanity (and your ability to find images quickly), you should keep the "Summarize photos" setting turned on.

You also need to know how to select *more* than one thumbnail at a time—a necessary skill for doing anything with a slew of thumbnails en masse. When you're in any view other than the summarized version of Collections or Years views (see the previous section), use these methods to select multiple thumbnails in Photos for Mac:

- **Select all the thumbnails in the window you're viewing.** Press ⌘-A or choose Edit→Select All.

- **Select several thumbnails by dragging.** Click outside a thumbnail, and then drag diagonally to select a group of nearby thumbnails. You don't have to enclose the thumbnails completely, either; as long as your cursor touches any part of a thumbnail, it gets selected. If you keep dragging past the bottom of the Photos window, the program scrolls so you can see more files.

TIP If you include a particular thumbnail in your dragged group by mistake, ⌘-click it to remove it from the selected cluster.

- **Select consecutive thumbnails.** Click the first thumbnail you want to select, and then Shift-click the last one. Photos selects those two thumbnails and all the ones in between, as Figure 3-9 (top) shows.

- **Pick and choose thumbnails.** If you want to select, say, the second, fourth, and sixth thumbnails in a window, click the first thumbnail, and then ⌘-click the others, as Figure 3-9 (bottom) shows.

- **Deselect a thumbnail.** If you're selecting a bunch of thumbnails and you grab one by mistake, don't panic; just ⌘-click it to deselect it. (If you want to start your selection over from the beginning, you can quickly deselect all the thumbnails by clicking an empty part of the window.)

This ⌘-click trick is useful for selecting *nearly* all the thumbnails you're viewing. For example, you can press ⌘-A to select everything that's visible, and then ⌘-click any unwanted thumbnails to deselect them. You can also combine ⌘-clicking with Shift-clicking. For example, you can click the first thumbnail and then Shift-click the 10th thumbnail, and Photos selects all 10. Next, you can ⌘-click photos 2, 4, and 6 to remove them from the selection. Both maneuvers save you a lot of time.

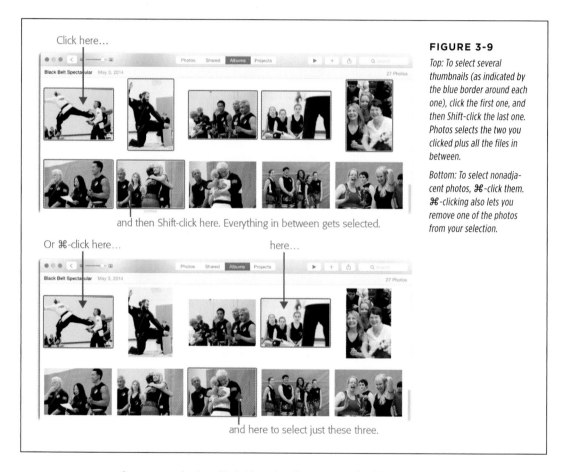

FIGURE 3-9

Top: To select several thumbnails (as indicated by the blue border around each one), click the first one, and then Shift-click the last one. Photos selects the two you clicked plus all the files in between.

Bottom: To select nonadjacent photos, ⌘-click them. ⌘-clicking also lets you remove one of the photos from your selection.

Click here...

and then Shift-click here. Everything in between gets selected.

Or ⌘-click here... here...

and here to select just these three.

Once you select multiple thumbnails, you can do things to (or with) them all at once. For example, you can drag them onto your desktop—or better yet, drag them into a folder on your desktop—to export them, apply keywords to them (page 91), mark them as favorites (page 82), drag them into an album in the sidebar (page 18), and so on.

In addition, when you have multiple photos selected, the commands in the File, Edit, and Image menus—including Export, Share, Print, Rotate, Duplicate, and so on—apply to *all* of the selected images. Ditto for the icons in Photos' toolbar: You can play a slideshow of just those selected items, add them to an album or project, or share them via iCloud, email, text message, Twitter, Facebook, or Flickr.

> **TIP** When you have multiple items selected, the Info panel (page 74) shows their combined dates, file size, keywords, faces, locations, and so on.

Selecting a slew of thumbnails is also super easy in Photos for iOS: Simply tap Select at the upper right corner of your screen, and then tap each thumbnail you want to select. That's it! The selected items' thumbnails dim, and a blue circle with a white checkmark appears at their lower right. To deselect a selected thumbnail, just tap it again. The thumbnail returns to full color and the blue checkmark disappears. A handy running count of selected thumbnails appears above your selection.

> **TIP** Using Burst mode on your iOS device is a great way to fire off several shots to get one that's reasonably sharp. The only problem is that you end up with a bunch of shots that are exactly the same. The solution is to tell Photos which image in the burst set you like best by marking it as a favorite. The box on page 50 tells you how to do that in Photos for Mac and Photos for iOS.

Hiding Thumbnails

Let's face it: Not all of your shots are worth showing off or including in projects. If a picture is super blurry or the lighting is such that you can't make out who (or what) is in the image—and you can't save it using the Adjustment panel (page 134)—then by all means, use the techniques described on page 75 to send it on its way and make room for new and better captures. However, if you don't want to delete the picture (say, because you can't recreate the shot or you think you may need or want it someday), you can *hide* it instead. That way, the image stays in your Photos library but doesn't stare back at you each time you scroll past it in, say, Moments view or the All Photos album.

To hide some thumbnails in Photos for Mac, use the techniques described in the previous section to select them, and then choose Image→Hide [number] Photos, or press ⌘-L and then click Hide Photo (or hit Cancel if you change your mind). Photos shuffles the unsavory thumbnails into the Hidden album and they disappear from Moments, Collections, and Years views.

> **NOTE** If you included an image in an album *before* hiding it, that image remains visible in that album. The fix is to delete the newly hidden image from the album. (As you'll learn on page 65, deleting images from an album doesn't delete them from your Photos library.)

To reveal all your hidden images, choose View→Show Hidden Photo Album. A new album named Hidden appears in Albums view, where it remains until you hide it

again by choosing View→Hide Hidden Photo Album. To unhide specific images, select their thumbnails, and then choose Image→Unhide [number] Photos or press ⌘-L. Those thumbnails now reappear in Moments, Collections and Years views.

To hide thumbnails in Photos for iOS, open an image, and then tap and hold your finger on top of it to reveal a Hide button. Give that button a tap, and then tap Hide Photo in the sheet that appears. The image will be hidden from Moments and Collections views, but you'll still see it in the All Photos album in Albums view. Nevertheless, once you hide an image, Photos for iOS creates an album named Hidden.

■ The Wide World of Albums

Remember when creating a photo album meant carefully placing envelopes full of snapshots onto sticky pages and then covering them with sheets of cellophane? While nostalgic folks can still do that, making digital albums in Photos is far easier, plus you can easily create a beautiful book from the album when you're finished (see page 238).

While Photos' albums are a 21st-century, unbelievably flexible version of this concept, an album still refers to a collection of pictures that you group together. Taking the time to make albums gives you an organizational leg up. For example, it helps you find certain pictures more quickly, because you don't have to scroll through thousands of thumbnails to find them. Creating albums is also the only way to customize the sort order of thumbnails, which is especially handy when crafting slideshows (Chapter 6), as well as book, calendar, and card projects (Chapter 9).

You can add as many pictures and videos as you want to albums, and you can have as many albums as you wish. Photos even lets you add the *same* content to multiple albums—all without duplicating the files. The program simply points to the originals and uses them when you view the album. This gives you a lot of flexibility, because you don't have to pick just one album for a picture—you can put it in as many albums as you see fit. This also means that if you edit the photo while viewing it *anywhere* in Photos, the edited version shows up in all the albums it belongs to.

You can create albums that you populate manually, or you can create *smart albums* that self-populate by matching certain criteria that you set—for example, all videos with the keyword *kittens* could automatically go into a smart album, or all pictures with the word *beach* in the title or description, taken before 2010, that have your favorite niece in them. This section teaches you how to create both kinds of albums.

Creating an Album

To create a new album with nothing in it, click or tap the + button in Photos' toolbar and choose Album. (In Photos for iOS, you need to be in Albums view.) In Photos for Mac, you can also choose File→New Empty Album. In the sheet that appears, enter a meaningful name for the album—Comic-Con 2016, Mayhem in Madagascar, or whatever—and then click OK or tap Save. Your new album appears at the beginning of the My Albums section in Albums view and in the Album section in the sidebar, at the top of the list of albums you created (if you have it turned on; see page 18).

Another way to create an album in Photos for Mac is to base it on a moment or collection you're browsing in Photos view. That way, Photos puts all the items in that moment or collection in the album. As you scroll through your thumbnails in Photos view, point your cursor at the upper right of the moment or collection and a + button appears. Just give it a click and choose Album from the resulting menu. Figure 3-10 has more.

FIGURE 3-10

When you create an album in Moments view, Photos automatically selects all the thumbnails contained in the moment you're currently viewing. Unfortunately, when you create an album in this way in Collections view, Photos doesn't select any thumbnails. Instead, it plops you into another view that lets you click to add the thumbnails you want.

You can also create albums from a selection of thumbnails you make. When you do that, Photos tucks the selected items into a new album for you. Here's how to do it:

1. **Select some thumbnails using the methods described on page 57.**

 If you're cruising through thumbnails in Moments view, the images don't have to be from the same moment; you can scroll to select thumbnails from multiple moments.

2. **Create a new album.**

 In Photos for Mac, click the + button in Photos' toolbar and choose Album, and then choose New Album from the Album menu. Or choose File→New Album, or press ⌘-N.

 In Photos for iOS, be sure you're in Albums view, then tap the + button in the toolbar.

3. **Enter a name for your new album, and then click OK or tap Save.**

 Photos adds the selected goodies to the new album, which appears at the beginning of your albums list in Album view, as well as at the top of your list of albums in the sidebar in Photos for Mac.

Finally, you can create albums from projects (Chapter 6 covers slideshow projects and Chapter 9 covers books, calendars, and cards). If you create a project that you

then want to turn into an album—say, in order to share the pictures in the project with someone else (page 211)—it's easy enough to do. In Photos for Mac, select the project's thumbnail in Projects view, and then click the + button in Photos' toolbar. In the menu that appears, you see the number of thumbnails in the project. Choose Album; in the resulting sheet, choose New Album from the menu, and then enter a name in the text field. Click OK and call it done. (You can't see projects in Photos for iOS, so you can't create albums from them, either.)

Adding files to an Album

Photos for Mac gives you several ways to populate your albums with pictures and videos. Select some thumbnails using the techniques on page 57, and then:

- **Drag them onto the album's icon in the sidebar** (page 18), as shown in Figure 3-11.

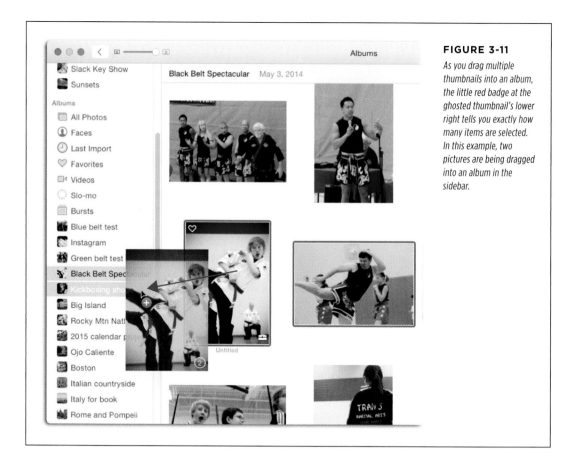

FIGURE 3-11

As you drag multiple thumbnails into an album, the little red badge at the ghosted thumbnail's lower right tells you exactly how many items are selected. In this example, two pictures are being dragged into an album in the sidebar.

- **Drag files from the Finder** into an open album in Photos, or onto the album's icon in Albums view or in the sidebar (page 18 and the box on page 51). You can add a folder full of images to an album in this way, too—just drag the whole folder instead of the individual files inside it.

- **Click the + icon in Photos' toolbar** and choose Album. In the sheet that appears, pick an existing album from the menu, and then click OK.

In Photos for iOS, tap an album or a moment to see the items it contains. Tap Select in the toolbar, and then tap all the items you want to add to your album. A checkmark circled in blue appears on each item you select—tap a thumbnail again to deselect that item. Then tap Add To at the bottom of the screen, and choose the album you want to add them to. (Albums you can't choose are dimmed—these are albums created by other devices, or ones that are automatically created by Photos.) Photos dutifully adds the selected thumbnails to the album.

Viewing an Album

While this may seem obvious, it's worth stating: To view the contents of an album in Photos for Mac, double-click its icon in Albums view, or select it and then press Return. If you turned on the sidebar (page 18), you can also open an album by single clicking its icon there. In Photos for iOS, switch to Albums view, and then tap the album's icon to open it.

Either way, only the thumbnails lucky enough to be included in that particular album appear in the preview area. To go back to viewing thumbnails of all your albums, click or tap the Back button in Photos' toolbar (or in Photos for Mac click the Albums view tab.)

Changing an Album's Key Photo (Mac only)

When you create an album, Photos uses the oldest picture in it—called the *key photo*—as the album's cover. That photo may not be the most visually pleasing choice, so you can use Photos for Mac to change the key photo to another picture in the album. To do that, open the album and Control-click the thumbnail of the photo you want to use as the key photo (shockingly, you can use a video as a key photo), and then choose Make Key Photo from the shortcut menu shown in Figure 3-12. Alternatively, select the thumbnail, and then choose Image→Make Key Photo. Either way, the next time you're in Albums view, that photo is featured on the album's thumbnail.

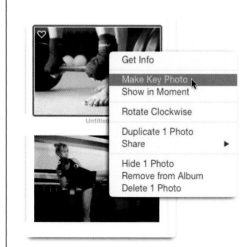

FIGURE 3-12

Changing key photos may seem frivolous, but it can actually make your Photos experience more enjoyable. After all, Mac users love to customize stuff!

You can change the key photos of any regular albums that you create, but you can't change the key photos of smart albums (page 69) or any built-in albums, such as Last Import. However, you can change the key photo of individual faces albums (not the main Faces album). See page 101 for more

Renaming an Album

You can edit album names whenever you want, and it's super easy to do. To rename an album in Photos for Mac, click its name in Albums view. Photos highlights the current name in blue; just enter a new name to replace the old one, and then press Return. You can also rename albums in the sidebar (page 18 and the box on page 51)—either click the album to select it and single-click its name, or Control-click the album and choose Rename Album from the shortcut menu that appears. Either way, enter a new name for the album, and then press Return.

Figure 3-13 explains how to rename albums in Photos for iOS.

Moving Files Between Albums

Once you get the hang of using albums, you'll be moving thumbnails between them fairly often. (After all, what's the fun of organizing your stuff if you can't reorganize it on a whim?) There are two ways to shuttle thumbnails between albums:

- To *move* a thumbnail from one album to another in Photos for Mac, select the thumbnail, and then choose Edit→Cut (or press ⌘-X) to remove it from the first album. Next, open the destination album, and then choose Edit→Paste (or press ⌘-V). The thumbnail is now in the *second* album. (This feature isn't available in Photos for iOS, so you need to copy the thumbnail as explained in the next paragraph, and then go back and delete it from the first album.)

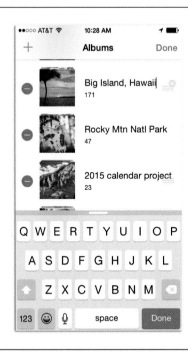

FIGURE 3-13

In Photos for iOS, go into Albums view and tap Edit at the upper right. In the list that appears, tap the album's name, and then enter something else. When you're finished, tap Done at the upper or lower right.

- To *copy* a thumbnail into another album so that it lives in both, select it, and then (in Photos for Mac) click the + button in Photos' toolbar or (in Photos for iOS) tap Add To. Next, choose the album you want to copy the photo into and, in Photos for Mac, click OK; in Photos for iOS, you just see the thumbnail(s) leap into the album you picked. In Photos for Mac, you can also drag thumbnails onto the destination album's icon in the sidebar (page 18 and the box on page 51). Now the photo belongs to *both* albums.

No matter which method you opt for, you'll likely find that using the sidebar in Photos for Mac is the easiest way to scoot thumbnails between albums.

Removing Files from an Album

Fortunately, deleting a thumbnail from an album isn't a scary affair. The picture or video remains safely nestled inside your Photos library; Photos simply removes its reference from that particular album. If the same image lives in other albums or projects, it stays there.

To remove items from an album, gather your confidence and select the thumbnails. Then in Photos for Mac, use from the following methods:

- Press the Delete key on your keyboard. (This would be a scary maneuver if you hadn't read the first paragraph of this section!)

- Choose Image→"Remove [number] Photos from Album."

- Control-click one of the selected thumbnails and, from the resulting shortcut menu, choose Remove From Album.

- Choose Edit→Cut or press ⌘-X. With this method, the items remain in your Mac's temporary memory (called the *clipboard*), which gives you the option to paste them into another album by choosing Edit→Paste or pressing ⌘-V. Neat, huh?

> **TIP** If you accidentally zap a photo from an album, don't freak out: Just choose Edit→Undo and Photos promptly puts it back.

In Photos for iOS, there's just one method for removing stuff from an album. Once you select the thumbnail(s), tap the trash can icon at your screen's lower right. In the confirmation sheet that appears, tap "Remove from Album." If you change your mind, tap Cancel or tap elsewhere on the screen to dismiss the sheet. 'Nuff said.

Duplicating Files

It's often useful to have more than one copy of a picture. For example, you may want to edit them in different ways, or want a color version and a black and white, or want to crop them to different sizes. There's just one problem with this scenario: You can't add a file to the same album twice. Confusingly, it certainly *seems* like it works: If you add the image by dragging its thumbnail into an album, you get the comforting green + icon next to your cursor, and if you use the + button in Photos' toolbar, you get to pick the album from the menu, and then click OK. However, take a peek inside the album and you'll find just one copy of your picture.

So obviously there's a trick to making it work. The answer is to duplicate the image so there's another copy of it in your Photos library. Yes, it consumes more disk space, but this is the only way to get a picture into an album twice (or to edit the picture in different ways, as mentioned earlier).

To do this, select some thumbnails and choose Image→Duplicate [number] Photos, or Control-click one of the selected items and choose "Duplicate [number] Photos" from the shortcut menu. A copy of each selected item appears. If you turned on View→Metadata→Titles (page 54) you see the suffix "- Version 2" added to its name (or 3 or 4, if you duplicated it before). Now you have a fresh copy of the image to edit, improve, or adjust in any way you like without affecting any other copies.

> **NOTE** If you duplicate a photo in an album, you'll see the duplicate in the album *and* in your library. If, on the other hand, you duplicate a photo in Photos view, that's the only place you see the copy—it isn't duplicated in any albums that contain the original.

Sorting Thumbnails in Albums

As you add items to the albums you make in Photos, they appear in the order in which you added them: The first thumbnails you add are followed by the ones you add later. Fortunately, you're not stuck with that order. In fact, creating a custom sort order is probably one of the reasons you created an album in the first place.

> **NOTE** You can't change the sort order of any of Photos' built-in albums (All Photos, Faces, Last Import, Favorites, Videos, Slo-mo, and Bursts), nor can you change it in shared (page 211) or smart albums (page 69). You also can't change the sort order of *any* album content—even in albums you create—in Photos for iOS.

To rearrange a thumbnail in an album, click and drag it to a new position between two others, or drag it to the beginning or end of the batch. (Dragging multiple thumbnails works, too.) As you drag, the other thumbnails scoot over to make room. When you get the thumbnail in just the right spot, release your mouse button, and Photos moves it to its new position. If you're dragging thumbnails to a new location and you change your mind, release your mouse button and undo the move by pressing ⌘-Z.

If you later decide that you instead want to see your items in chronological order—by their *creation* date, not the date they were added to the library or album—choose View→Keep Sorted By Date. What's odd about this command is that, despite its name, it doesn't *keep* the album's contents sorted by date. Oh sure, it initially sorts your thumbnails by date, but you can immediately rearrange them again. In fact, if you use this command and then change your mind, just choose it again and your thumbnails pop back into your custom arrangement. A more accurate name for this command is Sort By Date, so feel free to think of it that way.

Sorting Album Thumbnails

Aside from changing the sort order of the thumbnails inside an album, Photos for Mac lets you change the sort order of the album's thumbnails themselves. To do that, pop into Albums view, and then drag an album's thumbnail to whatever position you want. To view albums in alphabetical order by name, choose View→Keep Sorted By Title.

Unfortunately, there's no way to sort the individual album thumbnails you see in Photos for iOS; they appear in chronological order no matter what. However, if you turned on iCloud Photo Library (page 19), your album sort order in Photos for iOS matches that of Photos for Mac. Who knew?

> **TIP** While viewing album thumbnails, you can use the zoom slider in Photos' toolbar to make them bigger or smaller, as illustrated back in Figure 3-5.

Duplicating an Album

Let's say you carefully crafted an album full of cherished photos. Later, you want *almost* the same arrangement of photos, but with a few removed and a few new ones added—possibly to share with someone else or to post them online (Chapter

8). Rather than messing up the original album, you can simply duplicate the album and then do your rearranging there.

To duplicate an album in Photos for Mac, first select its thumbnail in Albums view or in the sidebar (page 19). Choose Image→Duplicate Album, press ⌘-D, or Control-click the album, and then choose Duplicate Album from the shortcut menu. Whichever method you use, the duplicate album appears at the beginning of the albums you created, and any changes you make to the duplicate don't affect the original.

TIP While there's no command in Photos for iOS for duplicating an album, there's a workaround: Tap to open the album you want to duplicate, select all the thumbnails it includes, and then tap Add To. A list of your existing albums appears; scroll to the bottom and tap New Album. Give it a meaningful name, and then tap Save. When you do, Photos creates your new album, adds all the selected thumbnails to it, and places it at the end of your albums list. Sweet!

Merging Albums

Photos doesn't have a merge command for albums per se, but it's simple enough to combine the content of multiple albums into one. For example, if you've got an album for every Comic-Con you've attended, you may want to combine them into a *single* album called "Comic-Con" instead.

The quickest merge method is to pop into Albums view and select the thumbnails of the albums you want to merge. (Oddly, you can't select multiple albums in the sidebar.) Next, click the + button in Photos' toolbar and choose Album. In the resulting sheet, choose New Album from the menu, and then give it a name in the text field underneath. The end result is one *giant* album containing the contents of the original albums. You can delete the original albums if you like, or you can keep them hanging around. Because albums contain *references* to your content—not the pictures and videos themselves—they only take up a teeny-tiny sliver of disk space, so keeping them won't eat up your hard drive space. The only downside to keeping them is that you have a longer list of albums to deal with.

Deleting an Album

In Photos for Mac, there are several ways to delete an album. In Album view, click once to select an album, and then do any of these things:

- Press the Delete key on your keyboard.

- Choose Image→Delete Album.

- Control-click the album and, in the shortcut menu that appears, click Delete Album.

Whichever approach you take, Photos displays a dialog asking you to confirm that you want to delete this album. Click Delete to confirm that you want to be rid of this beast, or Cancel to keep it safely stored in your Photos library.

To delete an album in Photos for iOS, enter Albums view, and then tap Edit at the upper right. Scroll past the list of built-in albums to the ones you created. On an iPhone, you see a red circle with a dash to the left of each one; tap the red circle and a big red Delete button shown in Figure 3-14 appears. Next, tap Delete. On an iPad, you see an X in a black circle at the top left of the album's icon instead; Tap it to delete the album. Either way, tap Delete Album from the confirmation message that appears (on an iPad the message simply says Delete). When you're finished, tap Done at the upper right.

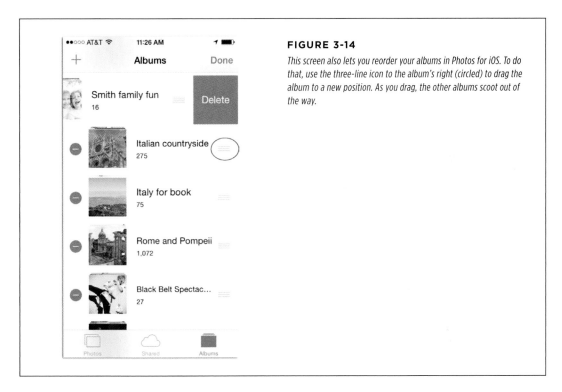

FIGURE 3-14

This screen also lets you reorder your albums in Photos for iOS. To do that, use the three-line icon to the album's right (circled) to drag the album to a new position. As you drag, the other albums scoot out of the way.

Smart Albums

While it can be lots of fun to select and add your digital goodies to albums, Photos for Mac has a feature that lets you automatically corral content into albums: *smart albums*. These albums are smart because they populate themselves based on the criteria you set for them. When Photos detects an image that matches those details, it adds it to the smart album. (If you've ever made a smart playlist in iTunes, Photos' smart albums work the same way.)

NOTE As of this writing, iCloud Photo Library doesn't work with smart albums, so those you create in Photos for Mac never show up in iCloud Photo Library or on any devices other than the one on which they were created. With luck, Apple will fix this with an update to OS X. If you don't use iCloud Photo Library, you can use iTunes to copy smart albums to your iOS device, just like any other album. See iTunes' Help menu to learn how.

Smart albums are insanely handy, and they're the pinnacle of automated organiza-
tion in Photos. For example, you could create a smart album that collects all the
pictures you take that have a certain keyword (page 91) that fall within a certain date
range and that are marked as favorites (page 82). Or maybe you want an album that
contains pictures of all three of your kids that include the keyword *vacation*. You can
also use smart albums to round up all the pictures you've taken with a particular
camera model or using a special lens.

NOTE The more you use Photos' organizational features such as favorites (page 82) and keywords (page
91), the more creative leeway you get with smart albums.

To create a smart album in Photos for Mac, choose File→New Smart Album or press
⌘-Option-N, and you see the sheet shown in Figure 3-15. (Sorry, you can't create
smart albums in Photos for iOS, though you can *view* them there if you don't have
iCloud Photo Library turned on, as mentioned in the Note on page 69.) There, you
can use the various menus to choose the criteria for items you want in your new
smart album. After you choose your first criterion, you can include additional criteria
by clicking the + button on the right side of the sheet. To remove a criterion, click
the – button.

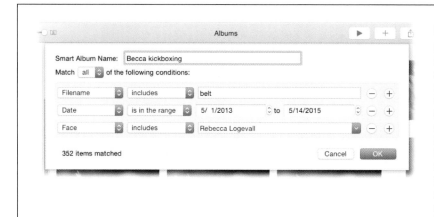

FIGURE 3-15

*Smart albums can turn
Photos into a powerful
search engine. With the
settings shown here,
Photos will gather all
the pictures that include
the text "belt" in their
filenames, taken between
May 1, 2013 and May 14,
2015 that include Rebecca
Logevall. Photos helpfully
reports that the resulting
smart album will contain
352 items (the tally is at
lower left).*

NOTE As soon as you add a second search criterion, you need to choose whether you want to include photos
that match *any* of your criteria or *all* of them. To do that, use the "Match ____ of the following conditions" menu
near the top of the sheet. You'll collect a lot more photos in the smart album if you choose *any*, because a photo
only has to match one of your criteria to be included. You may want to think of *any* as *or*, as in, "If a Face in the
photo is Deanna *or* Jean-Luc *or* Geordie, include it in this smart album." The other choice is *all*, which means that
only items that match all your criteria will be included in this smart album.

Here are the criteria you can choose from:

- **Album** lets you limit the smart album's search to a certain album. Or, by choosing "is not" from the second menu, you can *eliminate* an album from consideration. Either way, your albums are listed in the third menu for you to choose from. An awesome use for this criterion is to locate all the pictures and videos that don't yet live in an album, so you can easily find ones that need homes. To do that, create a smart album named "Not in an album," and then set the menus to "Album," "is not," and "Any." That way, as you add images to albums, they disappear from this smart album.

- **Date** is surprisingly flexible, as Figure 3-15 shows. For example, by choosing "is in the range" from the second menu, you can use the Date criterion to create an album that includes the holiday pictures you took between December 23 and January 2. Combine dates with Faces criterion to find, say, photos of your daughter before she went off to college. (You'll learn all about Faces in Chapter 4.)

- **Description** not only lets you find items that contain a specific word or phrase, but also items that don't have a description at all.

- **Face** makes use of Photos' magical ability to identify people in your photos. Once you've tagged the people in your pictures (see page 98), you can include specific ones in your smart albums. For example, you can create a smart album that gathers all the pictures of your parents so you can use it as a slideshow at their golden-anniversary party. Conversely, if you recently experienced a painful breakup, you can easily exclude your ex from a smart album of, say, vacation shots.

- **Filename** lets you search for characters in the name of the file, which is mostly useful for finding files of a specific format, such as TIFF or PDF images that you scanned or GIF files you saved from a website (raw files are easy to find using the Photo criterion described in a sec). Just keep in mind that the filename is not the same as the name you give a file in Photos—that's its *title*. Filenames are assigned by the camera and often looks something like IMG_5309.jpg.

TIP As you add criteria to a smart album, Photos keeps a running total of how many items would be included in that smart album if you clicked OK right then. Just look in the bottom left of the sheet as you enter your criteria to see the number of items that match.

- **Keyword** finds a specific keyword (or phrase) you assign to pictures and videos. The third menu lists all the keywords you've used, which makes it easy to choose one to include or exclude. If you upgraded to Photos from iPhoto (page 4), this is a great way to find all the items you assigned star ratings to in iPhoto (star ratings are converted to keywords in Photos; see page 8). Just search for 1 Star, 2 Star, 3 Star, 4 Star, or 5 Star to gather them up into a smart album. You'll learn all about keywords in Chapter 4.

TIP Photos' keyword feature doesn't provide a way to see how many items you've assigned a specific keyword to, but you can use a smart album to find out: Just choose that keyword when defining a smart album. The running total of items matched at the bottom left of the sheet lets you know how many items use that keyword.

- **Photo** is a bit of a catchall list of qualities. If you want to find all the pictures or videos you've marked as favorites (page 82), hidden, or edited, this criteria lets you do that by noting the running total at the bottom left of the sheet. Similarly, you can collect all your movies, raw files, or referenced items in your Photos library (those you imported but left in their original location without copying into your library; see page 28). And finally, this criteria lets you find all the items that contain GPS (location) info.

NOTE Since Photos has built-in albums that collect your favorites, videos, panoramas, and so forth, don't bother making a smart album for them. Instead, you can use one of those as criteria in conjunction with something else (say, a date range or Faces tags) to collect a subset of those items into a new smart album.

- **Text** searches your library for words or letters that appear in the title, description, or keywords that you add to your pictures and video.

- **Title** searches the titles you entered into Photos for individual pictures and videos. Besides using this criterion to find specific titles, you can also use it to collect photos you haven't entered a title for—as you add titles to them, they disappear from your smart album.

- **Aperture, Camera Model, Flash, Focal Length, ISO, Lens**, and **Shutter Speed** are all behind-the-scenes data (called metadata—see page 54) that your camera automatically attaches to each shot. Thanks to these options, you can do things like round up all the pictures you took with the flash turned on, with an ISO (light sensitivity) setting of 800 or higher, at a certain shutter speed, and so on. What's nice about these choices—besides being able to find any conceivable combination of camera settings you used—is that Photos only lists the cameras and settings you've used for at least one of your photos. In other words, Photos won't let you add criteria that don't exist in your library.

TIP Say you went to a birthday party with friends, and then everyone sent everyone else all the pictures they took there. You've imported those pictures into your library, but now you're having trouble finding a specific shot your friend took. If you know the type of camera your friend used, you can collect only the photos taken by that person during that event. Just create a smart album that includes only the shots taken by her camera on the date(s) of the event. (To find out which camera was used to take a specific photo, select the picture and then look at the Info panel [page 74].)

Once you have all the criteria for your smart album just right, click OK and it appears at the beginning of your list in Albums view and in the Albums section of the sidebar. Smart album icons sport a special badge that looks like a tiny gear, so they're easy to spot. When you open a smart album, you see thumbnails of all the items in your

library that match the criteria you set. The best part is that Photos keeps this album updated whenever your library changes—as you add new favorites, import photos, tag more people, and so on.

TIP To edit or peek at a smart album's criteria, click it in Albums view or in the sidebar, and then choose File→Edit Smart Album. When you do, the criteria sheet shown in Figure 3-15 appears. Alternatively, you can Control-click the album's icon and choose Edit Smart Album from the shortcut menu.

■ Using Folders

Because regular and smart albums are so darned useful, people tend to create a *lot* of them. At some point, a little album organization is called for, which you can easily do using *folders*. Just like folders in the Finder or in iTunes, a folder in Photos can contain any number of albums, smart albums, and even other folders. A folder can't, however, contain shared albums or projects—apparently those items need to remain in their own realm.

NOTE You can only create and manage folders in Photos for Mac. And unless you turn on iCloud Photo Library, they don't appear at all in Photos for iOS.

To create a folder in Photos for Mac, choose File→New Folder. A new folder appears at the beginning of your albums, highlighted so you can type in a name. Do so, and then press the Return key.

You can use Albums view or the sidebar (page 18) to manage folders just like you manage albums. For example, you can rename them or drag them up and down the sidebar's album list. You can also Control- or right-click a folder and use the resulting menu to delete it or trigger an instant slideshow from its contents.

WARNING Deleting a folder deletes all the albums (and other folders) it contains. All your pictures and videos remain safe in your library, but your album organization goes out the window. Fortunately, Photos warns you of this impending album doom when you try to delete a folder.

Adding and Removing Items from Folders

Moving albums and folders into and out of folders is a straightforward affair. To move an album or another folder into a folder, just drag its thumbnail onto the folder itself. You can do this in the sidebar by dragging an album onto a folder's icon or, if the folder's content is visible in the main Photos window (say, because you clicked it in the sidebar), you can drag the album into that window. You can also add albums to a folder in Albums view—just drag them onto the folder's icon.

To quickly remove an album or folder from a folder when the sidebar isn't showing, Control-click the album or folder and choose "Move Album Out Of [folder name]."

When you use this technique, the album or folder scoots to the end of Albums view and to the end of the Albums section in the sidebar.

TIP Immediately after adding an album (or folder) into a folder, you can choose Edit→Undo Move To Folder or press ⌘-Z to undo the move and send the item back from whence it came.

If you turned on the sidebar (page 18 and the box on page 51), you can also drag an item out of a folder, which has the advantage of giving you control over where the thing lands. As you drag the album or folder back into the sidebar, a blue line appears to indicate where it'll go when you let go of your mouse button. You can drop the item into the main list of albums or into another folder.

The Mighty Info Panel

Although it's hidden away at first, the Info panel will quickly become your best friend in Photos for Mac (you don't get an Info panel in Photos for iOS). This floating panel displays all kinds of information (called *metadata*) about whatever is currently selected—and you can even edit some of the info that appears.

To open the Info panel, choose Window→Info or press ⌘-I. You can also open it by Control-clicking any thumbnail and choosing Get Info from the shortcut menu that appears.

When you select a thumbnail, the Info panel tells you everything you can reasonably expect to know about it (see Figure 3-16). You see a field where you can add or edit a title, see the filename, date, time, camera model and its settings, add or edit a description, add or edit keywords you've assigned, and see and add Faces tags (page 101 tells you how to do the latter). If the camera captured location data long with the picture, a map appears at the bottom of the panel showing where it was taken.

If you select multiple thumbnails of images, albums, or whatever, the Info panel tells you how many pictures and videos are selected, their date range, combined file size, keywords, Faces, and locations on a map (again, if location data was captured by the camera). The right side of Figure 3-16 shows an example.

NOTE The description for an item appears only in the Info window. It's not available by choosing View→Metadata or looking anywhere else, so if you want to view or edit an item's description, you need to use the Info window.

The Info window is also helpful when you select a project thumbnail in Projects view. When you do this, the Info panel displays the date range of the pictures and videos it includes, how many pictures and videos were actually used in the project—a project doesn't have to use *all* the items you added to it—their combined file size, and any Faces tags in those items. You'll learn all about slideshow projects in Chapter 6, while book, calendar, and card projects are covered in Chapter 9.

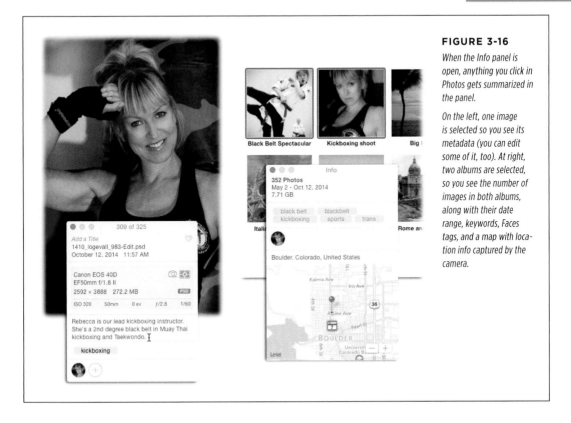

FIGURE 3-16

When the Info panel is open, anything you click in Photos gets summarized in the panel.

On the left, one image is selected so you see its metadata (you can edit some of it, too). At right, two albums are selected, so you see the number of images in both albums, along with their date range, keywords, Faces tags, and a map with location info captured by the camera.

Deleting Pictures and Videos

The storage space on your Mac and iOS devices being what it is, you may want to delete images and videos to gain back some space and clean up your library. Deleting files is a straightforward affair in both Photos for Mac and Photos for iOS.

To delete content from your library in Photos for Mac, use one of these techniques:

- In any view, select some thumbnails, and then Control-click one of them and choose "Delete [number] Photos" from the shortcut menu that appears. This method deletes the photo from your library and *everywhere* you used it—albums, books, cards, calendars, slideshows, and print projects alike.

- In Photos view, select some thumbnails, and then press your keyboard's Delete key or choose Image→Delete [number] Photos. If you're in Albums view, this menu item reads "Remove [number] Photo from Album" instead, meaning the item will be removed from the current album, but live on in your library and in any other album (or project) that includes it.

NOTE Oddly, you can't delete items from your library while viewing them in a shared album. While you can certainly choose Image→"Delete [number] Photos from Shared Album" (this command also appears in the shortcut menu that appears when you Control-click a thumbnail), Photos merely removes the items from the shared album but keeps them in your library. In this case, Photos is confusing the word *delete* with *remove*, which is surprising given Apple's dedication to uniformity and clarity in naming things.

To delete content in Photos for iOS, use the techniques described on page 57 to select some thumbnails, and then tap the trash can icon at the lower right of your screen. In the confirmation sheet that appears, you see how many items are on the chopping block, and Photos warns you that they may also be removed from your Photo Stream (page 23) and iCloud Photo Library (page 11). Tap "Delete [number] Photos" to get rid of them, or tap Cancel if you change your mind.

Changing Dates and Times

Sometimes a picture or video has the wrong date and time in its metadata. It may be the result of an incorrect camera setting, or perhaps you scanned an image and then added it to your Photos library (in which case the file's date is the *scan* date, not the date you took the photo). Or maybe you added an item to your library from a hard disk, flash drive, CD, or DVD, and its date in Photos is whatever date the original file had attached to it. No matter how the date mistake occurred, changing it in Photos is straightforward and rather fun.

First, select one or more thumbnails of pictures and videos in Photos for Mac. (If you select multiple items, Photos knows to apply your changes to all of them *intelligently*—that is, Photos shows you the date and time of the earliest item you selected, then adjusts the date and time of the others by the same amount that you change the first one. For example, if you change the first one by three hours, they all change by three hours.)

Second, choose Image→Adjust Date and Time. A sheet opens that displays the date and time from the first file and a map with a blue pin showing the location and time zone it thinks you were in when you took the first picture. You can adjust the date and time in two ways:

• Drag the pin to a new location on the map or choose a new location from the menu near the bottom of the sheet.

When you do, Photos adjusts the time by the appropriate number of hours in the new time zone. If you just want to adjust the time zone but keep the time the same, drag the pin, but then change the time back to what it was originally (be sure to note AM or PM.)

• Enter a new date or time into the text field, or use the up and down arrows next to the date and time to adjust it.

Either way, the sheet shows you that Photos is about to adjust the selected content by the equivalent amount, effectively time-shifting everything based on your first image. This is an incredibly efficient way to adjust all the times or dates of all the photos from a trip or event.

When you're finished, click Adjust, and Photos changes the date and time of all the selected items. If those items are in an album or view that's sorted by date, they move to a new position based on their new dates and times. If they're included in a smart album that's based on date range, they may appear or disappear from that album based on their new dates and times.

You can also use this kind of time and date shifting to reorder pictures taken by other people. For example, it's not that Uncle Rick doesn't know how to use his camera—his time code setting may just be slightly different from yours.

If you've turned on iCloud Photo Library (see page 19), any items you delete may remain in iCloud for up to 30 days, at which point they're removed from all the devices that have iCloud Photo Library turned on.

Viewing or Recovering Recently Deleted Items

No matter how you go about deleting pictures and videos, Photos protects you from your hypercaffeinated, overzealous housecleaning tendencies by *temporarily* storing deleted pictures and videos in the Recently Deleted album. To see thumbnails of what you've tossed lately, choose File→Show Recently Deleted and you see the screen shown in Figure 3-17. In Photos for iOS, all your recently deleted items are in an album named Recently Deleted.

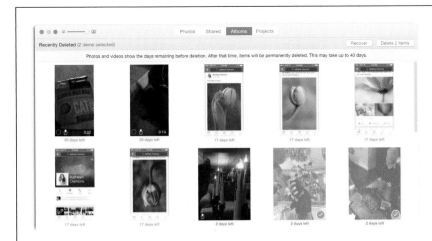

FIGURE 3-17

The Recently Deleted album displays each item you recently zapped, along with the number of days left before Photos permanently deletes the item. The timer starts at 30 days and counts down to a permanent bye-bye.

To delete that totally awful shot immediately and regain some storage space, select it, and then click or tap Delete. You can also select multiple thumbnails and immediately (and *permanently*) delete them in one fell swoop by clicking or tapping Delete.

To recover an item from its Recently Deleted limbo, select it, and then click or tap Recover. Your photo or video returns to its previous spot in Photos view, as well as in any albums or projects that included it.

> **NOTE** Recovered items also return to the Photos drawer of any projects you used them in (think slideshows, books, cards, and calendars), but they *don't* reappear where they were placed in the project itself. In other words, you need to drag them out of the Photos drawer and back into the (now) empty picture placeholders where they were before.

You can also delete items via a web browser on any Internet-connected device in the world. The next section explains how.

Accessing Your Photos Library on the Web

Your Mac and iOS devices aren't the only way to see your Photos library. If you find yourself in a remote location with just a computer and an Internet connection (it sounds so uncivilized, doesn't it?) and you have iCloud Photo Library turned on (page 19), you can view and download anything in your Photos library. Surprisingly, you can even upload new images. That said, you can't create albums, projects, slideshows, or do any of the other organizational stuff you can do in Photos for Mac or iOS.

To log into your iCloud Photo Library on the Web, point any Internet-connected web browser on any computer—Mac, PC, iPad, Galaxy tablet, or whatever—to *www.iCloud. com*. Enter your Apple ID and password, and then click the right-facing arrow. On the screen that appears, if you click the (now familiar) Photos icon, iCloud prepares your library for viewing online. It takes a few minutes, but the process continues even if you leave the iCloud site. Eventually, you see your whole Photos world in the browser window, as Figure 3-18 shows.

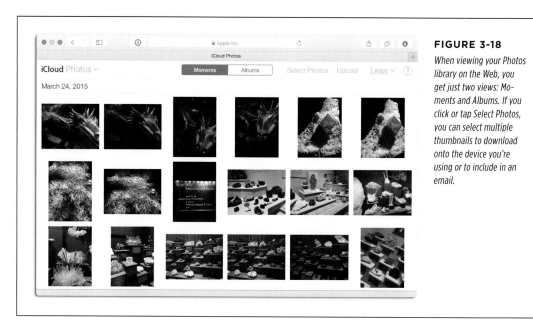

FIGURE 3-18

When viewing your Photos library on the Web, you get just two views: Moments and Albums. If you click or tap Select Photos, you can select multiple thumbnails to download onto the device you're using or to include in an email.

Navigating your content on the Web in this way feels almost identical to using Photos for iOS. (The biggest challenge is remembering to use *iCloud's* navigation buttons instead of the ones in your browser's toolbar.) For example, to select multiple thumbnails, click Select Photos at the upper right, and then tap the thumbnails of the ones you want to select.

To open a picture or video, click or tap it. While viewing it this way, you can use the zoom slider in the toolbar to zoom into or out of the photo, and use the arrows on the photo's left and right to see the previous or next photo in that moment or album. To declare the photo a favorite, click or tap the heart on the toolbar—it turns

a beautiful shade of red. To unfavorite it, click the heart again. (You'll learn more about marking images as favorites in Chapter 4.) Figure 3-19 has more.

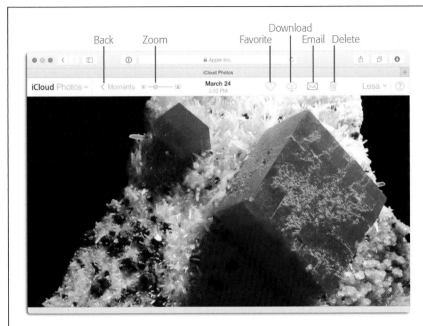

FIGURE 3-19

Open an image on the Web and the icons shown here appear. You can use them to favorite an image, download it to the device you're using, email it, or delete it (you get a confirmation sheet if you attempt the latter).

In case you're curious, this is a picture of the world's largest piece of rhodochrosite, which was found in Colorado.

NOTE If you get lost deep inside an album, click or tap the left-pointing arrow at the upper left of the browser window twice. The first click or tap takes you back to the album, and the second takes you back to viewing album thumbnails.

The whole deleting versus removing discussion (see the note on page 76) applies while viewing your library on the Web, too. For example, if you're viewing items in Moments view, you can select some thumbnails, and then click or tap Delete to delete them from your library. However, if you're in Albums view, the Delete button changes to Remove. When you click it, the items are taken out of the current album, but they stay in your Photos library and in any other albums or projects they're in.

You can also upload photos or videos from the device you're using into your Photos library (isn't that amazing?). To do that, click or tap Upload, and then navigate to the item(s) you want to upload. This is a surprisingly handy way to gather photos from friends and relatives that you're visiting. If you trigger the upload process while you're viewing the contents of an album, the new stuff is added to that album.

Finding Pictures

The more pictures you have in your Photos library, the harder it gets to find the ones you want. Even with all the automatic albums Photos makes—Last Import, Favorites, Videos, and so on—and the albums you can create yourself (Chapter 3), it can still be difficult to locate certain stuff. You may get frustrated to the point that you're tempted to swear off digital photography altogether—but don't lose hope!

Photos has several features that can help. For example, you can add a *favorite* tag to certain images and Photos automatically rounds them up into a special album. And the program's powerful search field lets you locate pictures and videos based on text or a date they include in their metadata (page 54). Another great way to find stuff is to add *keywords* to them that describe certain characteristics. And then there are Faces tags, which let you identify the people in your photographs (if you used iPhoto's Faces feature, you'll appreciate Photos' simplified version). Many of these methods really shine when you combine them with smart albums (page 69).

In this chapter, you'll learn how to use all of these features, and get strategic suggestions for assessing the images you import.

> **NOTE** Unlike iPhoto, which had a five-star rating system, Photos has what you might call a three-level rating system: hidden (page 59), normal, and favorites (page 85). Perhaps Apple found that people didn't use all five stars, and that three levels provides all the photo-rating power most people need.

◼ Using Favorites

To find certain photos quickly, you can designate them as favorites. When you do, Photos adds a tiny white heart icon to their thumbnails' upper-left corners and includes the pictures or videos in the Favorites album. You can find this album in Albums view and in the Albums section of the sidebar (page 18), if you turned it on.

The favorites feature is handy for marking the best pictures or videos you take—say, the best shot from your kid's black-belt test, a family reunion, or your camel-riding adventure in Egypt. If you tag all your best photos during the year as favorites, for example, you can then easily trigger a year-in-review slideshow (page 159) that you can play on your Mac, iPad, or Apple TV (see the box on page 175). Doing so also gives you a huge head start on assembling a yearly photo book, a calendar for the coming year, or a newsletter-style card (Chapter 9) that you mail each December.

Or you can use favorites to mark the best pictures from a recently imported batch of images so you can include them in an album (there's more on this on page 84). Favorites is a flexible feature that you can use however you like.

TIP If you have an Apple TV, you can point it to the Favorites album and use that as a screensaver or slideshow. That way, as you add and remove favorites, your slideshow stays current with your favorite content. See the box on page 175 for details on how to access Photos from an Apple TV.

Designating Favorites

Photos makes it really easy to tag a picture or video as a favorite. You can do so just about anywhere in the program, in any view *except* Shared, either while viewing thumbnails or an open image. The only problem with the favorites feature is that—after a year's worth of happy-go-lucky favoriting—the Favorites album can become bloated. To keep this album at a manageable size, it's a good idea to periodically *unfavorite* pictures. (The alternative is to create smart albums whose criteria include "Photo," "is," "favorite," and specifics such as album names, Faces tags, location, keywords or a date range. To learn more about smart albums, see page 69.)

Here's how to favorite and unfavorite items in Photos for Mac:

- **Click the Favorite icon on a thumbnail, in Photos' toolbar, or in the Info panel.**
 If you're viewing thumbnails in, say, Moments view (page 43), point your cursor at a thumbnail and click the heart outline that appears at upper left. Photos fills the outline with white (see Figure 4-1, top). If a picture or video is open in the preview area, click the heart button in Photos' toolbar, and Photos fills the heart outline with gray to let you know your click was successful (see Figure 4-1, bottom). And if the Info panel (page 74) is open, you can select a thumbnail or open an image, and then click the favorites icon at the panel's upper right.

 To unfavorite an item you've favorited using one of these methods, simply repeat the process: click the heart icon on the thumbnail again, click the heart button in the toolbar, or click the heart icon in the Info panel.

NOTE Photos doesn't let you favorite items in shared albums, regardless of whether you shared it or merely subscribe to it. Instead, you can use the *Like* button (see page 222).

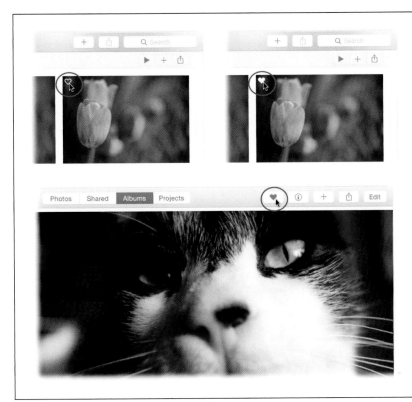

FIGURE 4-1

Top Left: When you point your cursor at a thumbnail, you see a heart outline in the upper-left corner (circled).

Top Right: When you click it, the heart turns white (circled) to let you know you've favorited that image.

Bottom: When viewing an open image, just click the Favorite button in the toolbar (circled) and Photos fills it with gray, as shown here.

NOTE If you don't see the heart icon when you point your cursor at a thumbnail, then you must have turned off the setting that lets you see favorites. To turn it back on, choose View→Metadata and see if Favorite *doesn't* have a checkmark next to it. If it doesn't, then select Favorite again in this menu to turn it back on.

- **Choose Image→Add to Favorites.** If you prefer using menus to tag favorites, select a thumbnail or open an image, and choose this menu command. To unfavorite the item, select or open it, and then choose Image→Remove from Favorites.

- **Press the period key on your keyboard.** If you're more of a keyboard person, just tap the period key to mark a thumbnail or open picture or video as a favorite.

TIP When a picture is open, you can use the left and right arrow keys on your keyboard to quickly navigate to the previous or next photo, and then favorite (or unfavorite) those shots by tapping the period key or clicking the heart button in Photos' toolbar.

To favorite an item in Photos for iOS, tap a picture or video to open it, and then tap the blue heart outline at the bottom (iPhone) or upper right (iPad) of the screen. The heart turns solid blue to let you know this item is favorited, as shown in Figure 4-2. Tap the same icon to unfavorite the item, and the heart changes back to the sad, hollow version.

FIGURE 4-2

In Photos for iOS, you can mark an image as a favorite by tapping to open it, and then tapping the heart-shaped favorites icon at the bottom of your screen. When you do, the heart turns blue, as shown here.

If you upgraded to Photos from iPhoto, you may want to favorite the items that you previously flagged or starred in iPhoto. As page 8 explains, Photos adds special keywords (page 91) to those items, so you can easily round them up by creating a smart album for anything that has the keyword 1 star, 2 star, 3 star, 4 star, 5 star, *or* flagged. *Then you can open those smart albums and tag the best shots as favorites. Page 69 has the full scoop on using smart albums.*

Using favorites to tag your cream-of-the-crop shots is but one strategy for this feature. As you can imagine, the Favorites album can quickly become too large to be useful—unless you use favorites tags in conjunction with smart albums, as explained at the beginning of this section.

A different strategy is to favorite pictures you want to include in an album. For example, after importing some pictures, you can open the Last Import album and mark the best thumbnails as favorites. Next, pop into the Favorites album, press ⌘-A to select them all, and then click the + icon in Photos' toolbar and choose Album. Once the coveted captures are tucked into an album, you can unfavorite the (already) selected thumbnails by choosing Image→"Remove from Favorites." The end result is an album of the best pictures from the last bunch you imported and an empty Favorites album. (The box on page 95 has more on using Favorites in an image-assessment strategy.)

Which strategy is best? That's up to you. There's no right or wrong way to use favorites, and the only way to find out which strategy works best for you is to start *using* the feature.

Viewing Favorites

Once you've blessed at least one picture or video as a favorite, Photos creates a Favorites album that you can see in Albums view or in the Albums section of the sidebar (page 18). This album (shown in Figure 4-3) is essentially a smart album that gathers all the items you've tagged as favorites. In Photos for Mac, you can open it by double-clicking its icon in Albums view, or by selecting the album and then pressing Return. If you turned on the sidebar, you'll spot the Favorites album in the Albums section; just give it a single-click to open it. In Photos for iOS, go into Albums view, and then tap the Favorites album to open it.

FIGURE 4-3

If you use favorite tags to mark your best shots, then the Favorites album contains quite a variety of thumbnails.

As with most albums that Photos automatically creates (Faces, Videos, and so on), you can't drag to rearrange the thumbnails it contains. The Favorites album is sorted by the date the picture was taken or, if your picture doesn't contain data metadata, by the date in which you imported it into Photos.

> **TIP** Once your Favorites album gets huge—and it will—you can create smart albums that find all the pictures and videos you favorited in a given year or specific date range. To do that, choose File→New Smart Album and set the first row of menus to "Photo," "is," "favorite." Next, click the + icon to add another row of criteria and set the first menu to Date; use the other two menus in that row to drill down to the date you want. Finally, choose "all" from the Match menu so Photos only finds items that include both these criteria.

■ Searching by Text and Date

A powerful way to find certain items is to search for text or date info that a picture or video includes. For example, if you add titles and descriptions to your digital goodies in Photos, you can search for a piece of text that's in either field. If you add Faces tags to your pictures (page 97), you can search for a person's name. Or maybe you haven't done any of that stuff yet, but you (miraculously) remember the filename or the approximate time when you took the picture. If you snapped the shot on your iOS device or another camera with GPS capabilities, you may remember *where* you took it. In all of these situations, you can use Photos' search field to locate your stuff.

To do this in Photos for Mac, click the search field at the right end of Photos' toolbar. (If the search field isn't visible, click the Back button on the left side of Photos' toolbar to back up one view level.) Enter any combination of words and characters. Photos tracks down only the items that contain *all* the words—or parts of words—you enter, and displays a list of where that term occurs in each image's metadata (page 54). For example, the word "beach" may be in a picture's title, description, keyword list, Faces tags, filename, album name, city, street, or even neighborhood (whew!). Figure 4-4 has more.

> **NOTE** It doesn't matters which view you're in when you use the search field. Whenever you use it, Photos searches your *entire* library, even if you're viewing a specific album at the time.

You can enter multiple search terms; just be sure to separate them by *spaces,* not commas. (Entering commas makes Photos hunt for items that include commas in their metadata, which will get you zero results unless you added a comma in the Info panel's description field). The more words you enter into the search field, the fewer results you get, because Photos searches for *all* the words. For example, if you enter *kickboxing Boulder Vu Tran*, Photos dutifully tracks down all the pictures and videos that include the word kickboxing *and* the location tag for Boulder *and* the faces tag for Vu Tran.

You can also use the search field to find items based on date, which saves you the trouble of scrolling through moments, collections, and years in Photos view (page 43). Give it a whirl by clicking in the search field and entering a month and year—say, *December 2002*. Photos begins displaying matches as you type. When you finish typing, you see a list of all the items in your library that have both December *and* 2002 in their metadata. Just click a category in the search results to see the thumbnails it contains.

In Photos for iOS, the search field tries to be even more helpful. When you tap the magnifying-glass–shaped search icon, some prefab choices appear, including photos taken a year ago, your favorites, photos taken near your current location, and your recent searches. You also see an option for a seemingly random month from your library. You can tap one of these choices or type your search term(s).

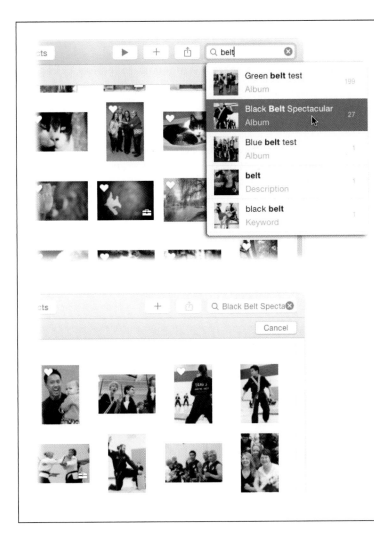

FIGURE 4-4

Top: As you type, Photos displays a list of matching items, grouped into categories based on where in the image's metadata your search term occurs. To see all the thumbnails in a category, click the category's name in the list.

Bottom: The thumbnails appear clustered by date as shown here. To cancel your search and return to what you were previously viewing, click Cancel or the X on the right side of the search field.

The search field is for simple text-based searches. For more complex hunting and gathering, use smart albums (page 69) instead. For example, you can use a smart album to search for nearly any combination of details, including some that the search field can't find. For example, smart albums let you search by metadata—the photographic details like camera model, f-stop, flash status, exposure settings, and so on—and they let you set multiple search criteria. The more you use smart albums, the more you'll see how handy they are.

■ Viewing Pictures by Location

The only way to find content by location is to use the search field, as explained in the previous section. And even then, it only works if you used a camera that can capture GPS information, such as one of Canon's newer PowerShots or your iPhone (your iPad can capture location info too, but only when it's on a wireless network or using cellular data). Unfortunately, Photos doesn't let you *add* location info except in a map in a book project (page 238), though the box on page 90 has a workaround.

As of this writing, Photos lacks the super-slick Places map of its predecessor iPhoto, which showed all the photos in your library plopped atop a big, glorious map. In Photos, you can view thumbnails on a map, though the most you can see is one year's worth of photos. You can also select a few thumbnails and view them on a map. Here's how to do that in Photos for Mac:

- **To see a map of all the photos that are in a moment, collection, or year,** go into Photos view and click the location link that's to the right of the moment, collection, or year—say, Manhattan, NY or Rome, Italy (see Figure 4-5, top). When you click this link, a map appears in Photos' main viewing area, with thumbnails on the spots where they were taken, as shown in Figure 4-5, bottom. If there's just one photo in a location, click it and it expands to fill the viewing area. If there are multiple photos in a location, a circled number appears on a stack of thumbnails to indicate how many there are. Click a thumbnail in the stack or the circled number to view all the thumbnails shot in that location.

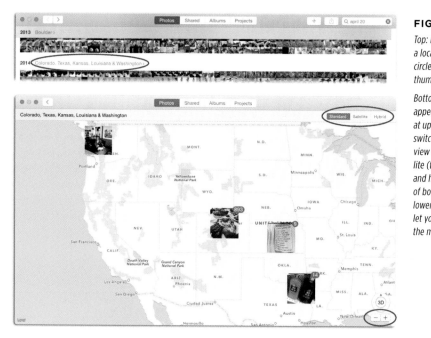

FIGURE 4-5

Top: In Photos view, click a location link like the one circled here to view those thumbnails on a map.

Bottom: In the map that appears, use the buttons at upper right (circled) to switch between standard view (shown here), satellite (topographic) view, and hybrid view (a mix of both). The buttons at lower right (also circled) let you zoom in and out of the map.

- **To see the locations of all the photos in your library that have GPS data,** switch to Photos view and open the Info panel (⌘-I). The panel's tiny map displays a red pin on each location, as Figure 4-6 shows. You can't resize the Info panel, so you need to scroll around the map by clicking and dragging.

- **To see the locations of the selected photo(s) or all the photos in an album or project,** simply select the photo(s), album, or project, and then follow the instructions in the previous paragraph. (This maneuver is shown back in Figure 3-2 on page 44.)

FIGURE 4-6

When you're in Years view, the Info panel shows pins where all your location-tagged images were taken. You can double-click the map to zoom in or click the + button at lower right. To zoom out, Option-double-click the map or click the – button.

The only other place in Photos where you encounter maps is in a map layout in a book project, but those are dumb maps—they don't access the location tags in your photos. Instead, you have to manually add pins to indicate a location. Page 248 has the scoop.

Alas, there's no way to view your digital mementos on a map in Photos for iOS. You can't see location labels in Photos view, nor is there an Info panel to open. Maps notwithstanding, Photos for iOS is still pretty darned cool.

Finding Photos by Location with Smart Albums

Another handy use for smart albums (page 69) is to find photos that include location tags. For example, you can use smart albums to find all the photos you took with a camera that can record GPS data, or all the ones you took in a specific spot. Figure 4-7 shows you how.

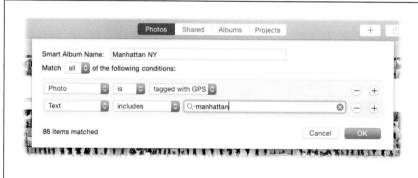

FIGURE 4-7

This smart album finds all the photos that contain GPS info and the text "Manhattan." With the Match menu set to "all," only pictures that were taken in Manhattan, New York show up, which excludes all the pictures you've taken that include the word "Manhattan" elsewhere in their meta-data—say, in a description of the famous cocktail you imbibed.

WORKAROUND WORKSHOP

Adding Location Tags

Unlike iPhoto and Aperture, Photos doesn't let you add a location to a picture or video that doesn't already have it. But if a location tag exists when you import the item into Photos, then the program recognizes that data and is happy to use it.

Your iPhone automatically adds location data to pictures and videos you take with it. Your iPad can, too, though it has to be on a wireless network or include a cellular data plan to do that. Even if you're shooting with a GPS-enabled camera, you may need to root around in your owner's manual to learn how to turn this feature on (GPS eats batteries at warp speed, so it's usually turned off from the factory).

If your preferred camera lacks location-tagging abilities, all is not lost. Here are a few solutions:

- The Eye-Fi Mobi card is a remarkable SD memory card, the smallish kind you put into most camera models, that has a built-in pseudo-GPS feature, so it can add location info to your pictures. As of this writing, it costs $50 for

an 8-gigabyte card, $80 for 16 gigabytes, and $100 for 32 gigabytes. See *www.eye.fi* for details.

- Use an app such as the $4 Geotag Photos Pro from *www.geotagphotos.net*. It's available for iPhones and Android phones, and includes a desktop app for syncing the location data it captures with your images when you import them onto your Mac. You simply install the app on your phone, and launch it when you start your photo safari so it tracks your location. Then, before firing off your first shot, you make sure your camera's clock is set to the exact same time as your phone. When you're done shooting, use your Mac's Image Capture utility—it's in your Applications folder—to copy the pictures from your camera into a folder on your Mac. Next, launch the Geotag Photos Pro companion app on your Mac to match the location data to the timestamp of each shot. When it's finished doing that, import those pictures in Photos. (This app also lets you manually assign locations to photos.)

◾ Using Keywords

One of Photos' most powerful features for tagging pictures is *keywords*, which let you apply descriptive words such as "food," "vacation," or "kickboxing" to images (you can create keywords for your pets, too). By searching for text included in the keywords you apply—using the search field (page 86) or a smart album (page 69)—you can locate specific pictures and videos quickly, regardless of which album, moment, collection, or year they're in.

> **NOTE** As of this writing, keywords are only available in Photos for Mac.

How are keywords different from albums? Generally speaking, keywords are great for describing characteristics of images that are also likely to appear in *other* images, whereas albums are better for grouping pictures for projects such as slideshows (Chapter 6), books, calendars, and cards (Chapter 9). Also, pictures that share a keyword can live in different albums.

Keywords are super easy to create and even simpler to apply to your digital goodies. You can apply multiple keywords (as many as you want), and then perform impressive stunts such as finding all the *food* pictures you've ever taken while on *vacation* in *Italy*.

> **NOTE** It's pointless to use keywords to identify people in your pictures. That job is far better suited for Photos' Faces tags (page 97). And if you're shooting with a GPS-enabled camera, don't bother adding location keywords. However, if your camera can't capture location info and you're not using one of the workarounds described in the box on page 90, then applying location keywords makes perfect sense.

Adding, Removing, and Editing Keywords

There are a couple of ways to start using keywords. You can go forth with careless abandon, entering any keyword you see fit into the Info panel, or you can handcraft a list using the Keyword Manager. The latter method also lets you edit and remove Photos' built-in keywords. Here's how both methods work:

> **TIP** Photos' keyword feature doesn't provide a way to see how many items you've assigned a specific keyword to, but you can use a smart album to find out: Just choose that keyword when defining a smart album (page 69). The running total of items matched at the bottom left of the sheet lets you know how many items use that keyword.

- **Using the Info panel.** Select a thumbnail (or use the techniques described on page 57 to select more than one), and then open the Info panel (Figure 4-8) by choosing Window→Info or pressing ⌘-I. If you already opened a photo or video, you can also open the Info panel by clicking the circled-i icon in the toolbar. In the lower part of the Info panel, click "Add a Keyword," and then enter the keyword you want to assign. As you type, Photos makes suggestions based

on keywords you've used before or those assigned by other programs (think Aperture, Photoshop Elements, and so on). If you see the keyword you want in the list, click it, and then press Return. Otherwise, type what you want, and then press Return. To add multiple keywords to the selected image(s), type one keyword, type a comma or press Return, type the next keyword, and repeat until you're satisfied. Click anywhere else when you're finished adding keywords.

To remove a keyword, click it in the Info panel, and then press Delete on your keyboard.

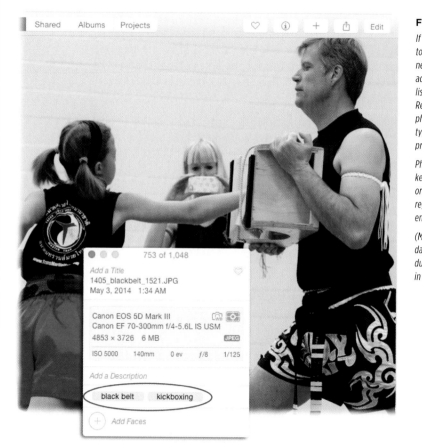

FIGURE 4-8

If you use the Info panel to add a keyword you've never used before, Photos adds it to your keyword list the second you press Return. To enter a keyword phrase such as black belt, *type both words, and then press Return.*

Photos displays your keywords in alphabetical order in the Info panel regardless of the order you entered them.

(Mr. Grace and his daughter are pictured here during her black-belt test in Muay Thai kickboxing.)

NOTE If you import images into Photos from your hard drive (page 27), they may have keywords you didn't assign. These keywords can come either from the program you used to import the images from your camera, or from someone else (a stock photographer, say). For example, many apps, such as Adobe Photoshop Elements, automatically assign keywords—Raw, Blurry, Closeup, Longshots, and so on—when they import and analyze images. Since that info is stored in the photos as part of their metadata (page 54), those keywords come along for the ride into Photos.

- **Using Keyword Manager.** Select a thumbnail (or 10), and then open Keyword Manager by choosing Window→Keyword Manager or pressing ⌘-K. The window shown in the background of Figure 4-9 opens. It includes the built-in keywords "birthday," "family," "kids," and "vacation," along with any keywords added by other programs (see the note on page 92). To apply an existing keyword, click it in the list or press the keyboard shortcut for the one you want to apply (F for "flower," for example). These single-letter shortcuts appear in a light blue circle to the right of the keywords in the Quick Group area of the Keyword Manager, as well as in the list that appears when you click Edit Keywords.

> **NOTE** When you apply a keyword via Keyword Manager, you get visual feedback—the keyword appears briefly in the center of the preview area when viewing thumbnails or atop the image itself when one is open.

To add your own keywords, click Edit Keywords, and Photos opens the Manage My Keywords window shown in the foreground in Figure 4-9. There, click the +, enter a keyword, and then click OK. (If the word you typed is already in your keyword list, Photos displays a message; you can then click OK to dismiss the message, and then enter something else.) The new keyword appears in Quick Group area at the top of the Manage My Keywords window, so it's easy to find. Photos also assigns a one-letter keyboard shortcut to it, based on its first letter (or second or third letter, if the first or second letter is already taken by another keyword). The shortcut letter is displayed in a light blue circle to the right of the keyword. You can apply that keyword to a selected thumbnail by simply pressing that key on your keyboard anytime the Keyword Manager is open.

To edit an existing keyword, click Edit Keywords in the Keyword Manager to open the Manage My Keywords window. Select the keyword in question, and then click Rename. Type the name you want, and then press Return. Just keep in mind that any images you tagged with that keyword now display the edited version.

To add or change the keyboard shortcut for a keyword, click Edit Keywords in the Keyword Manager to open the Manage My Keywords window, select the keyword, click Shortcut, type your preferred shortcut, and then hit Return. If that shortcut is already in use by another keyword, Photos displays a message that lets you click OK to assign that shortcut to this keyword and remove it from the previous one, or click Cancel to dismiss the message and then enter something else. Once a shortcut is added to a keyword, it moves into the Quick Group area until you remove its shortcut. Since there are 26 lowercase letters, 26 uppercase letters, and 10 numbers from 0–9, you can assign up to 62 shortcuts—but good luck remembering them all!

To delete a keyword altogether, click Edit Keywords in the Keyword Manager to open the Manage My Keywords window, select it and then click the – button at lower left. You can delete multiple keywords by Shift-clicking or (for nonconsecutive ones) ⌘-clicking them in the list before clicking the – button. When you're done editing, adding, and deleting keywords, click the OK button to close the Manage My Keywords window.

NOTE When you delete a keyword, Photos also removes it from all the pictures and videos you applied it to.

Back in the Keywords window (Figure 4-9, background), to remove a keyword from an image, click the previously applied keyword's button. When you do, the keyword *briefly* flashes in red in the middle of the preview area or on top of your photo, then "explodes" with the same animation you see when you remove an icon from your Mac's Dock. When you're done playing with keywords, click the red dot at the top left of the Keywords window to close it.

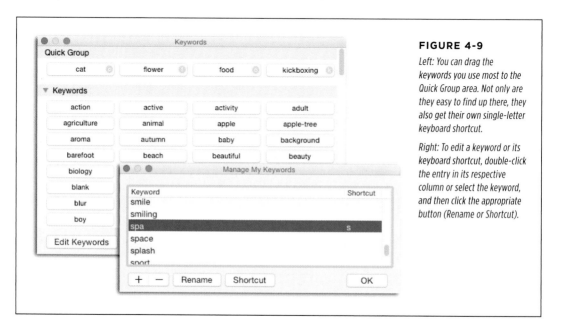

FIGURE 4-9

Left: You can drag the keywords you use most to the Quick Group area. Not only are they easy to find up there, they also get their own single-letter keyboard shortcut.

Right: To edit a keyword or its keyboard shortcut, double-click the entry in its respective column or select the keyword, and then click the appropriate button (Rename or Shortcut).

NOTE Unlike its predecessor iPhoto, Photos doesn't let you use a smart album to gather all the pictures that don't have keywords applied. Why? Because Photos' smart album criteria don't include a None option. Bummer!

It takes time to develop a great set of keywords, and some effort to assign them, but it's worth it. Once you apply some, you can put them to good use in both smart albums (page 69) and the search field (page 86).

NOTE If you imported an iPhoto library that you used for ages, you may see a checkmark keyword. This checkmark can mean anything you want—it only exists because old versions of iPhoto used it. Similarly, if you flagged items in iPhoto, you see a Flagged keyword in Photos, and all your previously flagged items will have this keyword assigned to them. While it's a drag that Photos doesn't have a flagging feature, using a keyword to flag images is nearly as easy.

Viewing Keyword Assignments

Once you've tagged a few pictures with keywords, you can see the keywords assigned to those pictures in three ways:

- **In Keywords Manager,** when you select a photo, its assigned keywords turn blue in the keywords list.

- **In the Info panel,** when you select a photo, its assigned keywords appear in light blue in the Keywords section near the bottom of the panel.

- **On the photo.** If you have Keywords turned on in View→Metadata, a little white tag appears in the bottom left of every thumbnail that has at least one keyword assigned to it. Click the tag to see the assigned keywords, as shown in Figure 4-10.

A Photo-Assessment Strategy

If you don't weed out the bad shots in your Photos library, it's guaranteed to become less fun to use as unwanted pictures pile up. Plus, if you use iCloud Photo Library, those unwanted pictures and videos can cost you a small fortune for storage space. That's why it's important to adopt a simple strategy that keeps *wanted* photos handy while safely removing *unwanted* pics. Here's one solution:

1. As soon as you import photos, open the Last Import album either via Albums view or the sidebar (page 18). Thumbnails of all the items you just imported appear in the preview area.

2. Enter Full Screen view (page 36) by clicking the green dot on the left side of Photos' toolbar or pressing Control-⌘-F. This helps you avoid being distracted by other stuff on your screen while you're assessing your latest batch of snapshots.

3. Adjust the zoom slider in Photos' toolbar so you can see at least five thumbnails to a row. This is big enough to determine whether each photo is a keeper, but not so big that you'll be compelled to jump into Edit mode and spend 20 minutes tweaking each shot.

4. As you scan your thumbnails, click the ones that are obvious keepers and press the period (.) key on your keyboard to tag them as favorites (page 82).

5. When you see an ugly or unwanted shot, click it and press ⌘-Delete. This moves it to Photos' Recently Deleted area (to display the Recently Deleted area, choose File→Show Recently Deleted). If you change your mind about it in the next 30 days or so, you can recover it there.

6. When you see a photo that you want to keep but not necessarily see all the time, click it and press ⌘-L or choose Image→Hide to hide it. (There's more about hiding photos on page 59.)

If you shoot pictures on an iPad, iPhone, or iPod Touch, you can get a head start on assessing before you get back to your Mac by hiding, deleting and favoriting shots right on your iOS device. Just tap a photo or video to open it, and then tap the heart icon at the bottom (iPhone) or top right (iPad) of your screen to tag it as a favorite, tap the trash can icon to move it to the Recently Deleted album, or tap and hold a picture to reveal a Hide button.

Using a strategy such as this makes it far easier to keep your Photos library manageable—and prevents your hard drive from filling up. Try it as a starting point, and then adapt it to create an assessment strategy that works for you. Alternatively, instead of using favorites to tag keepers, you can use keywords to assign star ratings from one to five, as described in the box on page 96.

FIGURE 4-10

Once you choose View→Metadata→Keywords, you see the tiny tag icon shown here at the lower left of any thumbnail or open image that has keywords assigned. Give it a click to see the specific keywords assigned to that image.

Using Keywords as Star Ratings

For whatever reason, Apple didn't see fit to include a star-rating system in Photos. (If you applied star ratings in Aperture or iPhoto, they morph into keywords instead.) At first this seems like a huge loss, but you can use keywords to produce the exact same results, and it involves the exact same steps required in iPhoto.

First, open Keyword Manager (press ⌘-K) and see if the keywords 1 Star, 2 Star, 3 Star, and so on already exist. If so, it's because you used star ratings in Aperture or iPhoto and imported them into your Photos library. If those keywords don't yet exist, you can create them using the techniques described on page 91.

Second, either drag those keywords into the Quick Group section at the top of Keyword Manager (which assigns each one a keyboard shortcut of 1, 2, 3, 4, and 5, respectively), or click Edit Keywords and add those keyboard shortcuts to the appropriate keywords (see page 93).

After that brief bit of setup, you can instantly assign any of those keywords to a picture. If you're viewing thumbnails, select one (or more), and then press the appropriate key on your keyboard (1 to 5). If you opened an image, the process is the same—press the keyboard shortcut that represents the rating you want to assign. Either way, the keyword momentarily appears on the photo to confirm your choice.

You can then find all your items starred items by entering *1 Star*, *2 Star*, *3 Star*, and so on into the search field. For even greater convenience, create five smart albums—one for each star rating. For example, to create a smart album for your five-star goodies, choose File→New Smart Album and name it *5 Star*. Set the menus in the first criterion row to "Keyword," "is," and "5 Star," and then click OK. Photos reviews your entire library to find photos that have the 5 Star keyword applied, and dutifully tucks them into your new smart album. And as you add that keyword to future items, Photos automatically adds them to that smart album.

Getting the Most Out of Keywords

If you diligently tag your photos with keywords, the big payoff arrives the second you need to find certain pictures. Here are some important points to remember when performing searches based on keywords:

- If you're using the search field, your search terms have to exactly match your keywords (although capitalization doesn't matter). You can unburden yourself of keyboard stress by copying them directly from the Keyword Manager itself. Just click Edit Keywords in the Keyword Manager, and then double-click the keyword you want to search for to highlight it. Press ⌘-C to copy it, click Photos' search field, press ⌘-V to paste it, and then Return to start the search.

- To find photos that match *multiple* keywords, repeat the copy-paste routine described above for each keyword. Be sure not to add commas between keywords in the search field. Instead, use a space between them—otherwise Photos will only find items that have commas in their metadata.

- If you frequently search for the same keywords, create a smart album (page 69) that gathers those images instead. That way, you find all the images that have those keywords as well as any *future* content you apply them to.

The takeaway here is that the more you use keywords, the more you can get out of them. In other words, applying keywords is a habit well worth forming.

■ Faces

You may not realize it, but Photos is looking at your pictures. It's not just glancing at them either—when it imports pictures, it takes a good long gander at them to see if they include people. If it finds any, Photos then tries to figure out who they are using its sophisticated facial-recognition powers.

Photos identifies people by noting attributes such as the distance between someone's eyes, their hair and skin color, the shape of their nose, and so on. After a brief, fun training period where you name people and confirm the faces Photos finds, Photos' facial-recognition feature is on autopilot. The program creates an album named for each person you tell it about, and stores these albums inside the Faces album. As you import pictures in the future, Photos analyzes them and, when it finds a face it recognizes, tucks them into that person's album. In other words, with minimal effort on your part, Photos maintains self-populating albums for each person in your photographic life—your kids, parents, partner, buddies, and so on. It's almost magical.

To see all the faces Photos has located in your pictures—even though they're unnamed for now—go into Albums view (page 47) and double-click the Faces album (or select the album, and then press Return). If it's the first time you've opened this album, you see a few faces inside circles and a big, blue Get Started button. Click it and you see a screen similar to the one in Figure 4-11.

NOTE If you shoot only scenery and not people, you won't see a Faces album at all. It may sound obvious, but the fix is to start taking pictures that have people in them!

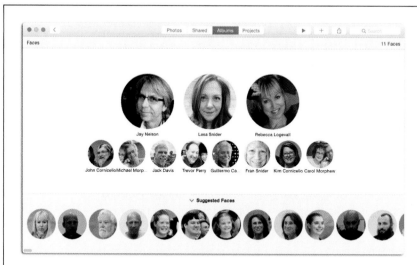

FIGURE 4-11

Ever wonder who's the most popular subject in your photographic life? The people who appear most in your pictures are displayed in large circles, while those who appear less frequently are displayed in smaller ones. Unidentified faces appear at the bottom of the window; scroll horizontally to see them all.

With the Faces album open, you can double-click a face to see a chronological list of all the pictures in your library that include that person. If Photos shows you the whole of every picture that person is in, you can switch to viewing a close-up of just the person's face in those pictures by clicking Faces in Photos' toolbar (to see entire pictures again, click Photos in the toolbar). To see pictures of someone else, enter their name into the search field at the upper right. As you type, the names of people you identified in Faces appears below it—just click the person's name in the list that appears, and then hit Return. When you do that, all the pictures you identified as that person in appear in the preview area. (The next section teaches you how to identify the people in your pictures.)

To get the most out of your Faces album, you need to spend some time identifying the faces Photos found so it can gather them into albums automatically. That's what the next section is all about.

NOTE As of this writing, you can't tag faces or view face albums in Photos for iOS. Le sigh.

Tagging Faces

The most efficient way to identify the faces in your pictures is to train Photos to do it automatically, though you can also tag thumbnails yourself nearly anywhere in the program. Think of the training process as a game: It doesn't take all that long and it's fun, plus there's a feeling of satisfaction that comes from knowing that you're training the app to organize your library into albums *for* you.

The first step in introducing Photos to all the people in your pictures is to get comfy. Grab a beverage, turn on some music, and then follow these steps:

1. **In Albums view, open the Faces album.**

 Click Albums in the toolbar, and then double-click the Faces album to open it. If the sidebar (page 18) is showing, then you can also double-click the Faces album there.

2. **Open the Suggested Faces drawer.**

 Unless you've closed it, the Suggested Faces drawer is already open at the bottom of the window. If it isn't, just click the down-pointing arrow to its left.

3. **Open a face album.**

 You can scroll horizontally in the drawer to see all the faces it contains. When you find the one you want to identify, double-click it.

4. **Enter the person's name in the sheet that appears, and then click Continue.**

 As you type, Photos tries to match the name with entries in your Contacts app to guess who you're identifying, as shown in Figure 4-12.

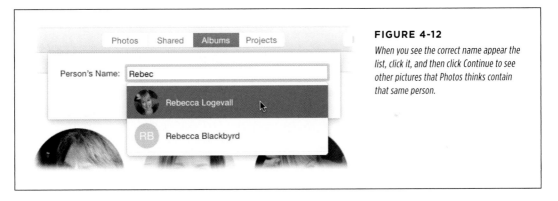

FIGURE 4-12

When you see the correct name appear the list, click it, and then click Continue to see other pictures that Photos thinks contain that same person.

5. **In the list of thumbnails that appears, reject the ones the person isn't in, and then click "Add and Continue."**

 Photos places a blue circle with a white checkmark at the lower right of any thumbnail it thinks contains the same face, as shown in Figure 4-13. If it's wrong, click the thumbnail to let Photos know it. When you do, the icon disappears, the thumbnail turns gray, and you see the text "Not [person's name]" across the bottom of the thumbnail. Photos keeps a running count of how many images it has added to the person's face album and displays it at the upper left of their thumbnail.

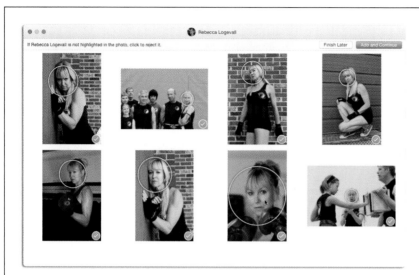

FIGURE 4-13

Here are the pictures that Photos thinks Rebecca is in. Point your cursor at one of the circles to enlarge that area to get a better look at the person in the picture, as shown here in the third thumbnail in the second row.

6. **Repeat step 5 until Photos doesn't show you any more thumbnails, and then click Done.**

 Photos keeps showing your pictures until it runs out of possible candidates for the face album you opened in step 3. If you lose steam and you want to pause the process, click Finish Later. When Photos runs out of candidates, you see a screen that tallies how many pictures you identified of that person.

 TIP If a face in the Suggested Faces drawer at the bottom of the main Faces window matches one you've already identified, simply drag the suggested face icon onto an identified icon (in other words, onto one of the circles in the main preview area).

That's all there is to training Photos to recognize faces. If you're feeling frisky, you can double-click another album in the Suggested Faces drawer and keep on trucking, though feel free to take a break and pat yourself on the back. The more images you tag, the better Photos gets at identifying people. By making a habit of periodically opening the Faces album and dealing with the suggested face albums, you keep your library gloriously organized and up to date.

■ TAGGING FACES MANUALLY

You can also tag pictures manually wherever you encounter thumbnails:

- **Turn on View→Show Face Names,** and then point your cursor beneath any thumbnail to reveal the name field shown in Figure 4-14, top. Enter a name, and then press Return.

- **Double-click a thumbnail to open it** and, if Photos detects a face, click the Unnamed tag that appears, and then enter the correct name. If Photos doesn't detect a face, choose Window→Info (or press ⌘-I). In the Info panel that appears, click the + circled in Figure 4-14, bottom and Photos drops a gray circle onto your image. Keep clicking the + until you've identified all the people in the picture.

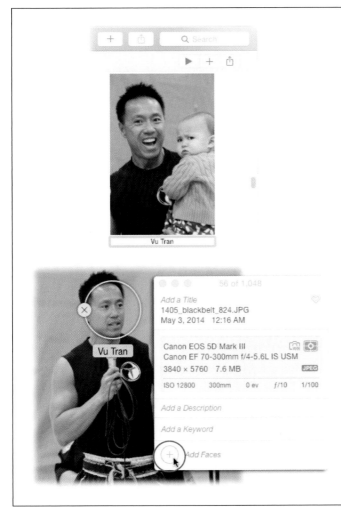

FIGURE 4-14

Top: If the person exists in your Contacts app, then as you type, you see a list of names you can choose from.

Bottom: When it encounters a face or you click the + circled here, Photos adds a naming circle to your image. You can drag the circle to reposition it so it's positioned over the face in your picture. If a naming circle appears in an area that isn't a face, click the X to delete it.

As of this writing, you can't add other details to a face such as an email address, which means that the pictures you post onto Facebook using Photos aren't automatically tagged with the people in them.

Managing Faces Albums

Once you've introduced Photos to the people in your life, you can do the following things to organize your Faces album the way you want:

- **Change the key photo.** As you learned on page 63, key photos represent all of the pictures an album includes. To have Photos use a different picture, open that person's faces album. When you find a picture you like, Ctrl-click it and then choose Make Key Photo from the shortcut menu.

- **Rearrange individual face albums.** To reorder your faces, drag them where you want them. This works for the albums in the main preview area, but not for the ones in the Suggested Faces drawer. Unfortunately, you can't change the sorting order of the main Faces album—say, to make face albums appear in alphabetical order. Photos lists face albums according to how many times a person appears (and is tagged) in your pictures. It makes sense but is still frustrating.

- **Edit and correct Faces tags.** If a misspelling or erroneous identification snuck into a face album, you can easily fix it. If you spot the error in Albums view while you're perusing the contents of the Faces album, just click the name beneath the circle and enter the correct information. If you're cruising through thumbnails in some other view (say, Photos), turn on face names by choosing View→Show Face Names, then open a picture to see the names appear on the picture itself—just click a name to edit it.

- **Combine face albums.** Photos lets you combine face albums, which is handy when you prefer to have just one album for, say, the couples in your life. To do this, select a face album, and then ⌘-click to select another. Then Control-click one of them and choose "Combine 2 Faces" from the shortcut menu. Photos merges both face albums (or however many you selected) into a single album.

TIP Think long and hard before you combine face albums. If there's a chance you'll want to access pictures of just *one* of those people down the road (for a slideshow, say), then leave their individual face albums intact, and instead create a smart album based on multiple face tags. To do that, choose File→New Smart Album and in the pane that appears, set the menus to Face, "is," and then pick a face tag from the last menu. Click the + icon to add another line of criteria, and then choose the same menu options but pick another name. Repeat this process until you've includes all the people you want in that smart album. (Faces in the Suggested Faces drawer aren't available in the smart album menus; you have to confirm some of them before they show up in the list.)

- **Delete a face tag.** Photos is a little overzealous with its facial recognition, and frequently tries to tag faces it finds in statues, wall art, *Star Trek* action figures, and so on. In these cases, you can improve Photos' recognition skills by deleting the tag (that way, Photos remembers not to try and tag pictures like that in the future). To do so, double-click the picture to open it, point your cursor at the desired face, then click the X on the white circle that appears.

- **Delete a face album.** Alas, there are times when a person in your photographic life needs to take a hike. Whether the split is due to a break-up or a disagreement on which band will go down as the greatest in rock-and-roll history, you can easily delete people's face albums. This doesn't delete any *pictures* the album contains, but at least you don't have to stare at the person's face each time you pop into the Faces album. To delete a face album, select it, and then press the Delete key. In the confirmation pane that appears, click Delete. You can also Control-click an album's icon, and then choose "Remove 1 Person from Faces" in the shortcut menu that appears. To delete a photo from the Suggested Faces drawer, Control-click it and choose "Ignore this face."

Making the Most of Faces

To get the most out of Photos' facial-recognition prowess, here are a few things to remember as you go face-tagging:

- **Tag pictures that have a clear, full-frontal view of the person's face**. Photos tries to match other pictures in the library with the first one you tag, and the whole thing works best when it has a clear, fairly large face to recognize.

- **Tag faces in profile**. While it's important to tag full-face photos, tagging profile shots also helps Photos tweak its identification algorithms.

- **Tag faces of different ages**. If you've got several years' worth of pictures in your library, chances are good that you've got pictures of various people at different ages. Identifying shots of your kids when they were 2, 8, 10, and 14 helps Photos improve its identification superpowers.

- **Don't tag blurry or poorly lit photos, or those with teeny-tiny faces**. Each time you tag a photo with a face, Photos broadens its search for other pictures that the person might be in. Tagging terrible shots can actually make it harder for Photos to recognize people. So if you encounter these kinds of shots when you're training the program (page 98), just click the thumbnail to reject them.

- **Tag some faces manually**. As impressive as Photos' facial-recognition abilities are, it can't identify *every* face. If someone is wearing sunglasses or their face is half-hidden by a floppy hat, then Photos may fail miserably. In that case, spending a little time manually tagging those pictures helps Photos get the hang of things.

The payoff for all this tagging work is huge. You can, for example, trigger an instant slideshow (page 159) based on one or more face albums; easily gather all the pictures of one or more people in order to use them in a saved slideshow (page 163), book, calendar, or card project (Chapter 9); and create smart albums based on face albums (page 71). The latter is helpful when you want to periodically use the contents of two or more face albums in a slideshow or other project, but you don't necessarily want to *combine* their face albums.

Improving Your Pictures

One of the coolest things about digital photography is the fuss-free manner in which you can edit your pictures. Editing film photography required a high tolerance for the color red, locking yourself in a closet laced with smelly chemicals, and sheer bravery—after all, there's no undo command in a darkroom. Happily, bringing out the best in your pictures in Photos is easy *and* non-toxic—and if you change your mind, you can always undo what you've done.

This is great news because digital photos that don't need correcting are as rare as kids who impulsively clean their rooms. When you stop and think about all the variables that come into play when you're snapping pictures, it's a miracle *any* of them turn out halfway decent (though the high quality of today's cameras—even the ones in smartphones—certainly tip the odds in your favor). Most of your pictures will benefit from some quality time spent in Photos' Edit mode, and there are lots of ways to get creative.

You'll find that Photos' powerful editing tools are suitable for any skill level, so don't be afraid to jump in and start playing around. Most of the controls are slider-based, so they're incredibly easy to use. Let's dive in!

> **NOTE** Photos is no Adobe Photoshop, so you can't use it to do advanced stuff like combine photos into a spiffy collage, swap people's heads, add text, or remove anything much bigger than a blemish. And because you can't tell Photos what *part* of a photo you want to change, the majority of your edits affect the whole enchilada. That said, Photos' editing tools are more than enough to suit the needs of the picture-taking masses. In this chapter, you'll learn how to wield each of its editing tools so you can turn the pictures you *have* into the pictures you *want*.

▩ Editing Basics

Photos' easy-to-use editing tools are perfect for common photo-fixing chores such as rotating, cropping, straightening, lightening, and darkening; adjusting contrast, saturation, color tint, and white balance; removing red-eye and blemishes; reducing noise; sharpening; and creating a host of special effects, including turning a color photo into a black-and-white image, adding a sepia (brown) tint, applying a variety of popular film looks, and blurring or fading the picture's edges (whew!). Heck, there's even a one-click Enhance tool that prompts Photos to perfect your picture's color and lighting all by itself.

Before diving into *using* Photos' edit tools, you need to learn the lay of the land. This section teaches you how to get into (and out of) Edit mode, and how to use Photos' fabulous Full Screen view and the handy thumbnail browser. You'll also pick up some slick tricks for zooming and scrolling, learn the secret to viewing before and after versions of your pictures, and find out how to undo your edits anytime you want.

NOTE When you edit a picture in Photos, your changes are visible *wherever* that photo appears—in every album, project, and (if you turned on iCloud Photo Library [page 19]) on your iOS devices. However, if you copy and paste a photo into a different album, you can edit the two versions independently of each other. And as a bonus, copying and pasting an image in this way doesn't use up any more disk space. You can also change how one version of a photo *prints* (when ordering prints from Apple) without having those changes affect the other version. Details on that trick begin on page 197.

Entering Edit Mode

Editing in Photos is a wonderfully intuitive and uncluttered experience. The program's Edit mode uses a dark color theme (see Figure 5-1) that's easy on your eyes *and* lets you see the image's colors more accurately. On a Mac, the edit tools you'll use the most are parked on the right side of the screen. If you choose View→Show Split View (page 52), the other photos in the album or view you're currently in appear as thumbnails on the left.

To enter Edit mode on your Mac, do one of the following:

- Select a photo, and then press Return (pressing Return again spits you out of Edit mode).

- Select a photo, and then choose Image→Show Edit Tools.

- Double-click a picture, and then either click Edit in the toolbar or press the E key on your keyboard.

- Select a photo, press the space bar to enlarge it, and then either click Edit in the toolbar or press the E key on your keyboard.

To enter Edit mode on an iOS device, tap a picture, and then tap Edit at the upper right of your screen. You don't see the capture time and date or the raw badge shown in Figure 5-1, and the editing tools appear above and below the image when holding an

iPhone or iPod Touch vertically, or on the left and right when holding it horizontally. On an iPad, the tools are parked below or to the right of the image (respectively).

Show/hide split view Zoom in/out of photo Editing tools

Thumbnail browser

FIGURE 5-1

Here's what Edit mode looks like in Photos for Mac. The program displays the time and date you captured the picture at the top of the window. If the image was shot in raw format (page 34), you also see the raw badge shown here. To exit Edit mode and return from whence you came (viewing an album or whatever), click Done, or just press Return.

NOTE When editing images in Photos for iOS with iCloud Photo Library turned on (page 19), you may encounter a message saying that your device is downloading the photo. That means the full-size image lives on iCloud's servers and your device is downloading it so you can edit it.

Another message you may encounter if you're *not* using iCloud Photo Library is "This photo is not editable." That means the image lives in your My Photo Stream (page 23) or it's in a shared album (page 211). In other words, the image doesn't yet live on your iOS device. If that happens, simply tap the "Duplicate and Edit" button to save the image to your iOS device, and then edit away.

Going Big: Full Screen View

Odds are good that your Mac's screen isn't big enough to show an entire digital photo at full size. That's perfectly fine when you're organizing, sharing, and assembling projects, but not when it comes to editing. In order for you to see all the details your image contains, you need to view it at 100% zoom level. That's why the wise engineers at Apple created Full Screen view, which hides Photos' menu bar, toolbar, and thumbnail browser (page 108)—if it's on—and magnifies the picture to fill your whole screen. As Figure 5-2 illustrates, this view is *magnificent*.

You can use Full Screen view anytime; you don't have to be in Edit mode. To enter Full Screen view, choose View→Enter Full Screen or press ⌘-Control-F; either way, the current picture takes over your entire screen. The same keyboard shortcut also takes you *out* of Full Screen view, though it's easier to just tap your keyboard's Esc key.

FIGURE 5-2

To experience an editing environment that's 100% distraction free, use Full Screen view. You get this view automatically in Edit mode in Photos for iOS.

To temporarily summon the menu bar and toolbar, move your cursor to the very top of the screen. To edit the previous photo in the album or view you're currently in, press the left arrow key on your keyboard. To edit the next photo, press the right arrow.

NOTE If you enter Full Screen view while you're in Edit mode, Photos doesn't let you access other albums or views. To regain those options in Full Screen view, exit Edit mode by pressing Return or pointing your cursor at the top right of your screen and clicking Done, and then point your mouse at the top of your screen again to see those controls.

Browsing Thumbnails

Another useful feature of Edit mode is *Split view* (page 52), which reveals a thumbnail browser parked at the left side of the window. This browser is handy for selecting another photo to edit within the same album or view (you can't select more than one thumbnail at a time). To toggle the thumbnail browser on or off, (say, to give your picture more elbow room), click the Split view button near the top left of your screen (it's labeled in Figure 5-1) or choose View→Show Split View.

NOTE Unlike iPhoto, you can only view *one* picture at a time in Photos' Edit mode. As of this writing, there's no way to compare multiple shots side by side in order to pick the best of the bunch.

In Split view, thumbnails are shown as uniform squares, regardless of how you held your camera. To view them in landscape or portrait orientation instead, choose View→"Display Square Thumbnails in Split View" to turn that option off (the checkmark to the left of the command's name disappears).

Adjusting Your View: Zooming and Scrolling

You'll do a *lot* of zooming and scrolling within your pictures once you start editing them (especially if you go blemish-zapping with the Retouch tool). To zoom in or out of a photo you're editing in Photos for Mac, use the zoom slider at the program's upper left (it's labeled in Figure 5-1) or press ⌘+ to zoom in or ⌘- to zoom out.

TIP To fit a photo onscreen so you can see the whole thing, drag the zoom slider all the way left. To view the image at full size (200%), drag the slider all the way right. You can also click the tiny icons at the left and right ends of the slider to toggle between Fit, 100% zoom, and Fill. Pressing the Z key on your keyboard toggles between Fit and 100% zoom only.

A Farewell to External Editors...for Now

Seasoned iPhoto jockeys will remember that iPhoto let you to assign an external editor to that program's Edit mode. That way, you could organize your photos with ease in iPhoto and edit your images in more powerful programs such as Aperture, Photoshop Elements, and so on.

Alas, Photos doesn't let you use external editors...yet. Will future versions be able to pass a picture to a different editing program and still keep track of it? Maybe, though only time will tell. In the meantime, you can always export a picture (page 231), edit it in any program you want, and then *reimport* the edited version into Photos. It's more work, but it gets the job done.

Happily, if you use Aperture—Apple's pro-level, no-longer-updated-yet-still-functional editor—you have an *easier* export option. In Photos for Mac, select the picture(s) you want to send to Aperture, and then click the share icon in the toolbar. From the menu that appears, choose "Add to Aperture" (this command only appears if Aperture is installed on your Mac). When you do, Photos exports

the image as a JPEG and copies it into Aperture's database (as you learned on page 10, Photos doesn't share its library with Aperture). You can then edit the image(s) in Aperture to your heart's content. Of course, you won't see the changes you make in Aperture until—you guessed it—you *reimport* the edited picture(s) back into Photos.

Photos for iOS makes it easy to send a photo to *another* editing app on the same device (assuming you have any). To do that, open a picture in Photos, and then tap Edit. Next, tap the icon circled here and, in the resulting menu, tap the icon for the editing app you want to use. If you don't see the app's icon, try tapping More to reveal a list of photo editors that work with Photos. Tap the green switch of the app you want to use, and from now on it'll appear in the first menu (shown here). If your favorite editing app isn't listed, you're stuck with using that app's Open command to access pictures on your device.

Once you've zoomed into a picture, you can reposition your view *within* it by dragging with your mouse (your cursor turns into a tiny hand). If you're used to iPhoto, you may be disappointed to learn that Photos doesn't include a Navigator panel, nor can you use the numeric keys on your keyboard to zoom.

In Photos for iOS, you use gestures to zoom: Use the spread gesture (move two fingers apart) to zoom in and the pinch gesture (move two fingers together) to zoom out (see page xxii if you need a refresher on these gestures). And to move around within your image, simply drag with one finger.

You might be surprised to learn that you can use gestures in Photos for Mac too. If you've got a Magic Mouse, you can adjust your settings to let you zoom into a picture by double-tapping your mouse with one finger. To turn this handy feature on, choose →System Preferences→Mouse, click the "Point & Click" tab, and then turn on "Smart zoom." With this setting turned on, once you're zoomed in on a photo, you can scroll the zoomed area in any direction by dragging (swiping) one finger across your mouse.

> **NOTE** You can also point your cursor at the thumbnail browser and use the swiping gestures described here to scroll up and down through it.

If you've got a Magic Trackpad or a MacBook, you can zoom in by double-tapping the trackpad with two fingers, and then scroll the zoomed-in picture by dragging (swiping) two fingers in any direction. You can also spread to zoom in on a photo, and pinch to zoom out. If you want to adjust your trackpad's settings, choose →System Preferences→Trackpad, and then click the Scroll & Zoom tab.

Comparing Before and After Versions

It's incredibly helpful to assess the edits you're making by peeking at before and after versions of your image. That way you can see how much the picture has (hopefully) improved. But if you go rooting around through Photos' menus, you won't find any such command. The *only* way to do it is to use the M key on your keyboard (iPhoto used the Shift key instead).

To see the before version of an edited photo, press and hold down the M key; release the M key to see the after version. Be sure to memorize this keystroke, because you'll use it a lot.

> **TIP** Photos is *riddled* with useful keyboard shortcuts. To see a full list, choose Help→Keyboard Shortcuts, and then in the Photos Help window that appears, click "Keyboard shortcuts" in the list on the left. You may want to print the list and keep it on your desk. When you're finished, just click the red circle at the window's upper right to close Photos Help.

Undoing Your Changes

Editing pictures can be nerve-wracking...that is, until you realize that you can *undo* your edits anytime you want. How cool is that?

While you're in Edit mode, you can undo the changes you've made to a photo, no matter how many edits you've made. For example, if you've cropped a photo, you can uncrop it in Photos for Mac it by choosing Edit→Undo Change Crop or by pressing ⌘-Z (the Note below explains how to undo edits in Photos for iOS). The only downside is that you have to undo your changes *one by one*. If you crop a photo, change its exposure, and then apply a filter, you have to use the Undo command three times—first to undo the filter, then to undo the exposure change, and finally to undo the crop. In other words, you can't pick and choose *which* edits to undo (and there isn't an editing program on the *planet* that lets you do that).

But here's the catch: If you switch to editing another picture (say, using the thumbnail browser) or leave Edit mode, you forfeit the ability to undo *individual* edits. At that point, the only way to undo your edits is to click "Revert to Original" at the program's upper right or choose Image→"Revert to Original." Either way, Photos strips away *every* edit you've made since you imported that picture.

NOTE To undo edits you've made in Photos for iOS, *before* exiting Edit mode, tap Cancel, and then tap Discard Changes on the menu that appears. If you've *already* bailed out of Edit mode, just tap Edit, and then tap Revert at your screen's lower right; in the resulting menu, tap "Revert to Original."

If you've turned on iCloud Photo Library (page 19), undoing the edits you've made to a picture on your iOS device removes the edits from that same picture on your Mac, too (and vice versa).

How does the "Revert to Original" command work, you ask? Good question. When you edit an image in Photos, it creates a *list* of your changes and records them in its database; Photos doesn't really apply those changes to the image until you export it for use *outside* of Photos. Because of this, you can remain secure in the knowledge that in a pinch, Photos can *always* restore an image to the state it was in when you first imported it, whether that's next week or next year.

On a Mac, to restore a picture to its original state (undoing all cropping, rotating, brightness adjustments, and so on), select a thumbnail, and then either choose Image→"Revert to Original," or Control-click a photo and choose "Revert to Original" from the shortcut menu. If you're in Edit mode, a "Revert to Original" button appears at upper right the moment you make a change to the picture. Either way, Photos swaps in the original version of the photo, and you're back where you started.

◼ Photos' Editing Tools

Photos for Mac and iOS both approach editing by giving you set of task-based tools, and the ones you'll likely use the most are visible when you enter Edit mode (see Figure 5-1). But don't let the simplicity of these tools fool you—there's editing power aplenty tucked inside them. Instead of bombarding you with every single tool, panel, slider, and whatnot, you can reveal additional editing tools whenever you want. This keeps the program looking streamlined, and prevents casual Photos users from getting overwhelmed.

Photos has everything you need to fix the color and lighting in your images; heck, you can even remove small items from your pictures. And as you learned in the previous section, you can always undo what you've done. Photos' tool arsenal also features eight filters that you can use to add a tasteful burst of creativity to your pictures by mimicking the look of traditional film photography; these filters are also helpful for saving images that you can't color-correct to your liking. (You may have encountered these filters before in Photos for iOS.)

In the sections that follow, you'll learn to use *all* of Photos' editing tools so you can bring out the best in your pictures. You'll also find out how to easily apply your changes to *other* photos, which can save you time. So read on, dear Grasshopper! This is where Photos gets *really* fun.

> **TIP** Switching between editing tools in Photos for Mac and iOS is incredibly easy. There's no need to deactivate the current tool; just click the next tool that you want to use. You can deactivate a tool by tapping its icon again, which, in Photos for iOS, lets you see any editing tools that were temporarily hidden by the active tool's controls. (Since you can always see all your editing tools in Photos for Mac, there's no real reason to deactivate a tool in this way.) When you're finished editing and you're ready to exit Edit mode, simply click Done.
>
> In Photos for Mac, you can press an edit tool's keyboard shortcut to pop into Edit mode *and* activate that tool from whatever view you're in. For example, pressing C in Photos view takes you into Edit mode and activates the Crop tool. You'll find each tool's keyboard shortcut listed throughout this chapter.

The Enhance Tool

To quickly improve a picture that looks a little dark, dull, or washed out, make sure you're in Edit mode, and then give the Enhance tool a click. (As you saw back in Figure 5-1, this tool's icon is a magic wand. In Photos for iOS, all you see is this icon without a label.) When you do, Photos analyzes the picture's pixels and does its best to improve the image's overall brightness, contrast, and color. This tool also tries to identify areas that are in focus in an attempt to bring out the subject a little more, as well as make skin tones warmer and details sharper. Depending on the picture, you can end up with richer and more vivid colors than you started with, as shown in Figure 5-3.

FIGURE 5-3

The Enhance tool works particularly well on photos that are a little dark and lack contrast, like the tulip image shown here on the left. In some cases, a single click of the Enhance button may be all your picture needs to look better and brighter, like the right-hand image here.

TIP To glean a little insight into what the Enhance tool does, open the Adjustments panel (page 134) and take a peek at the sliders in the Light and Color sections that appear (you'll need to expand those sections to see all the sliders they contain, as explained on page 122). In your image's *original,* pre-Enhanced state, all the sliders are positioned in the middle of each section. By taking note of which sliders the Enhance tool changed, you can manually adjust them to amplify the correction.

While the Enhance tool can work wonders on *some* images, it can't fix 'em all. When you use this tool, Photos makes its best guess as to what kind of correction your image needs, but it can't make heads or tails out of the picture's *content*. In other words, the Enhance tool can't tell if you've captured an overexposed image of a brightly colored flower or a well-exposed image of a pale flower on a cloudy day. If the image needs more fixing than the Enhance tool applies, reach for the more targeted and powerful controls offered by the Adjustments panel (page 134).

TIP The Enhance tool is a one-click wonder; it doesn't have any additional controls. That means you can use it while any other tool is active, save for the Adjustments panel, which is helpful if you've forgotten to use it when you're cropping or applying a filter, for example.

The Rotate Tool

Photos does a great job of importing pictures so they're oriented correctly. In other words, photos captured while you held your camera vertically arrive right side up, as do images you captured horizontally. But if you need to rotate an image in Edit mode in Photos for Mac, simply select it, and then click the aptly named Rotate tool.

> **TIP** The Rotate button spins photos 90 degrees counterclockwise. If you want to spin them in the *opposite* direction, press and hold the Option key before clicking this button (the tool's icon flips around, too). Unlike iPhoto, you can't use Photos' preferences to customize the direction it rotates your pictures.

Technically, you don't even have to be in Edit mode to rotate photos. You can use the following methods to spin them around no matter *where* you are in Photos:

- Choose Image→Rotate Clockwise (or Rotate Counterclockwise).

- Press ⌘-R to rotate selected photo(s) counterclockwise, or Option-⌘-R to rotate them clockwise.

- Control-click a photo or thumbnail and choose Rotate Clockwise from the shortcut menu.

> **TIP** If you need to rotate a photo *more* than 90 degrees—say, if you took the picture upside down—just keep tapping the Rotate button.

You can speed up this rudimentary editing chore by rotating the pictures that need it as soon as you import them. Just select all the thumbnails that need rotating—say, by ⌘-clicking each one or by dragging a box around them to select them, as described on page 57—and then use one of the methods listed above to fix the selected photos in one fell swoop.

In Photos for iOS, the Rotate tool is tucked *inside* the Crop tool. Grab your device, open an image, and then tap Edit. Next, tap the Crop tool (it looks like two overlapping corner brackets), and then tap the Rotate tool. It looks like a square with a small curved arrow, and you'll spot it at lower left if you're holding your device vertically, or at upper right if you're holding it horizontally. Just keep tapping this tool until the image spins around the way you want it.

The Crop Tool

Cropping and straightening are among the most basic edits you'll ever make, but that doesn't mean they aren't important. A bad crop (or no crop) can ruin an image, while a good crop can improve it tenfold by trimming away useless or distracting stuff around the edges. Slightly crooked pictures—not those captured at a *purposefully* creative angle—are just plain distracting. The ability to flip a photo horizontally or vertically comes in handy, too, especially when you're creating projects like a photo book (page 238) and you want your subject facing left but he's facing right. Photos' Crop tool lets you do *all* that.

Here are some of the things that cropping lets you do:

- **Remove wasted space.** If you captured something that adds no visual interest to your picture—say, a messy bedroom or random tourists—you can crop that area out. Doing so puts the focus back on your *subject* and not your subject's *surroundings*.

- **Delete objects.** If your ex is on the edge of an otherwise lovely family portrait, you can easily (and satisfyingly) remove him by cropping the picture.

- **Resize the photo.** If you want to print and place your prized photo in a specific-size frame, you may need to change its proportions so it'll fit. The Crop tool includes a menu that helps you crop to several common sizes (page 116 has details).

- **Change the composition.** There's a reason professional photos look so darn good; often it has to do with how the shot is composed. Good composition accentuates the picture's subject, drawing the viewer's eye right to it. Typically this means cropping tightly around your subject, using the Rule of Thirds (page 116), or cropping in unconventional ways, as shown in Figure 5-4.

FIGURE 5-4

For fun, challenge yourself to think outside the box and crop in unexpected ways, as in these examples. Oftentimes, revealing just part of your subject can create a more visually interesting picture than showing the whole thing.

> **NOTE** When you crop a photo, you change it in all the albums and projects in which it appears. If you want a photo to appear cropped in one album but not in another, you have to *duplicate* it (select it, and then choose Image→Duplicate 1 Photo), and then edit each version separately. (You can also duplicate a photo by pressing ⌘-D or by Control-clicking it and choosing Duplicate 1 Photo from the resulting menu.)

■ HOW TO CROP, STRAIGHTEN, AND FLIP A PHOTO

You can either crop and straighten pictures manually (you'll learn how in a sec), or you can have Photos do it *for* you. If the latter method is the way you want to roll, then in Edit mode, click the Crop tool to activate it, and then click Auto. When you do, Photos analyzes the image, rotates it just enough to straighten any lines it finds, and smartly crops the image according to the Rule of Thirds (which is explained in the following list). If you don't like the results, you can manually fine-tune the crop box to your liking using the techniques described below.

> **NOTE** Cropping in Photos for iOS works the same way as it does in Photos for Mac. The only difference is that, in Photos for iOS, there's no option to flip your image.

To take cropping and straightening into your *own* hands, follow these steps:

1. **Open an image in Edit mode, and then either click the Crop tool or press the C key on your keyboard. (In Photos for Mac, you can also simply press the C key to enter Edit mode *and* activate the Crop tool.)**

 Photos places a light gray, resizable crop box around your image, as Figure 5-5 shows, and a circular dial appears to its right (this dial is visible in Figure 5-6), which you can use to straighten the image. You can resize the crop box by dragging its edges; if you do, the dial temporarily disappears. If you don't care what *aspect ratio* (width-to-height ratio) the cropped photo ends up having, go ahead and drag. But if you want to preserve the picture's original proportions or change them to something specific, skip to the next step.

 As you drag, a grid appears to help you crop according to the *Rule of Thirds*—a compositional guideline cherished by photography and video pros. The idea is to divide the picture into nine equal parts using an imaginary tic-tac-toe grid. If you position the image's horizon on either the top or the bottom line—never the center—and the focal point (the most important part of the image) on one of the spots where the lines intersect, you (theoretically) create a more interesting shot.

 When you're finished dragging with the crop box, release your mouse button and the circular dial reappears. To straighten your picture, click anywhere on the dial, and then drag up or down.

2. **To change the picture's aspect ratio, click Aspect, and then pick a size from the menu.**

 When you choose an option from this menu, Photos constrains the crop box to the proportions you pick. Most digital cameras produce photos whose proportions are 4:3 (width to height), which is suitable for lots of things but not for, say, creating a slideshow (see Chapter 6) that you plan to display on a high-definition TV, which uses different dimensions, or for ordering prints (Chapter 7), which only come in standard photo sizes (like 4 × 6, 5 × 7, and 8 × 10). Choosing the appropriate ratio from the Aspect menu means that your cropped photos will fit nicely onto your TV or photo paper. (If you *don't* constrain your crop this

way, your images will automatically be cropped when you print them—though as pages 191 and 198 explain, it's easy enough to adjust any autocropping that occurs before you hit print. The box on page 187 has more on cropping for print.)

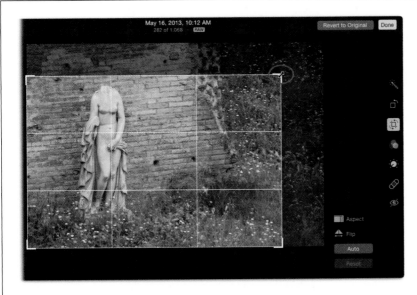

FIGURE 5-5

Point your cursor at a corner of the crop box and the cursor changes to the double-sided arrow (circled); drag inward to shrink the box. If you point anywhere else on the crop box's edge, your cursor turns into a line with an arrow on either side of it; just drag to resize the box however you want. To reposition the box over your image, click inside it and drag.

When you release your mouse button, Photos hides the area outside the crop box to preview what the image will look like once you click Done.

The Aspect menu also contains an Original option (which maintains the proportions of the original photo even as you make it smaller) and a Square option (great for posting on Instagram, a popular online photo-sharing site). You can also order square prints from Apple, which makes for interesting wall art. Choose Custom from this menu and two fields appear so you can enter any proportions you want.

NOTE Despite its ability to control the *proportions* of the crop box, Photos doesn't tell you pixel dimensions of the resulting image. To crop a picture to *precise* dimensions (say, for posting online), you have to use another program such as Pixelmator, Photoshop Elements, or Photoshop CC.

When you make a selection from the Aspect menu, Photos adjusts the crop box to the proportions you pick. While the box always starts out matching the picture's original orientation, once you pick a different option from the Aspect menu, you can use the two icons that magically appear at the top of the Aspect menu to switch from landscape (horizontal) to portrait (vertical), as shown in Figure 5-6.

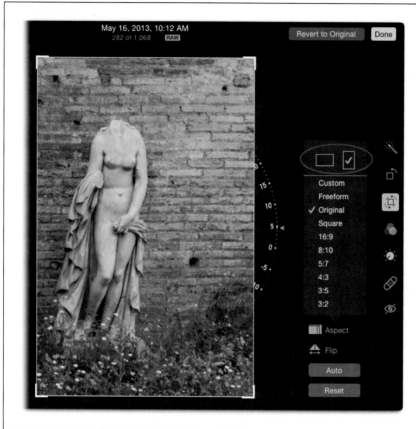

FIGURE 5-6

To straighten your image, click and drag the circular dial shown here. To flip your crop box 90 degrees, use the Aspect menu's orientation buttons (circled). This photo was flipped from landscape to portrait orientation and was straightened by about five degrees.

In order to access the Aspect menu's orientation buttons—so you can flip a photo from landscape to portrait (or vice versa)— you have to choose an aspect ratio other than Freeform or Square.

3. **If you want to flip your picture horizontally—so your left-facing subject becomes right-facing, for example—click Flip.**

4. **If necessary, adjust the crop box's size and position.**

 As described in step 1, you can drag the crop box to change its size. To reposition your image within the box, click and drag inside the box to move the image. When you do, Photos displays the whole picture beneath the box to keep you oriented within the image. Remember, the straightening dial temporarily disappears while you're resizing the box.

 TIP If you decide *not* to restrict the crop to a certain aspect ratio, or if you just want to start fresh, click Reset.

5. **When the crop box is just the way you want it, click the Crop tool, press the C key, click another photo that needs cropping, click another editing tool, or click Done to exit Edit mode.**

You don't need to click a button to accept your crop; Photos just applies the crop and deletes the pixels outside the box. If you have another image that needs cropping, click it in the thumbnail browser, and then crop away. If you have more editing to do on the cropped image, click the next tool that you want to use. If you're finished editing, click Done or press Return to exit Edit mode.

Don't be alarmed that Photos tosses all those edge pixels—you can always get them back. If you crop an image and then immediately realize you've messed up and you're still in Edit mode, click "Revert to Original," choose Edit→Undo, or press ⌘-Z to go back one editing step. In Photos for iOS, tap Cancel, and then click Discard Changes. If you regret the crop next *week*, simply select the photo in Photos for Mac and choose Image→"Revert to Original." On your iOS device, open the image in Edit mode and tap the red Revert button. After asking if you're sure, Photos reinstates the original photo, discarding *every* change you've ever made to it.

UP TO SPEED

Cropping Tips for Print

It's important to remember that cropping shrinks your photos. If you delete too many pixels, your picture will be too small to print: That is, its *resolution* may become too low to print at high quality. Resolution is the measurement that controls pixel size by determining how many pixels are in a square inch of your photo (you've likely heard it expressed as *ppi* for "pixels per inch" or as *dpi* for "dots per inch"). The higher the resolution, the smaller the pixels become, and the smoother your print looks.

For example, let's say you start with a 1600 × 1200-pixel image. Ordinarily, that's large enough to print as a high-quality, 8 × 10-inch portrait. But then you crop the image in order to improve its composition or remove a distracting background, and now you're left with only 800 × 640 pixels. That picture no longer has enough pixels in it to print at a resolution high enough for a nice, smooth 8 × 10 version. If you print it at that size, the printer enlarges the picture to fill the paper, producing an image with pixels that are big enough to see *individually*, as if it were constructed from Lego bricks. So if you're determined to print the photo, be sure to print it at a smaller size.

This is the type of a situation where having a high-resolution digital camera (at least 10 megapixels) offers a significant advantage over, say, an iOS device. Because each shot starts out with such large pixel dimensions, you can trim away a few hundred thousand pixels and still have enough left over for good-sized, high-resolution prints.

The moral of the story is to know your photo's intended use. If it's headed for a printer, don't crop off more pixels than you can spare.

Applying Filters

Photos offers eight one-click filters that you can use to apply color and lighting effects to your pictures. They're as handy for adding an artistic feel to an image as they are for camouflaging bad color or lighting. You can use them to turn a color photo into a black and white, oversaturate the colors in an image, create an overprocessed or bleached look, or make the picture look like it was taken with an instant camera.

To access Photos' Filters, simply press the F key on your keyboard or, if you're in Edit mode, click the Filters tool. (In Photos for iOS, select a photo, tap Edit, and then tap the icon that looks like three overlapping circles.) When you do, you see the filter buttons shown in Figure 5-7 appear.

FIGURE 5-7

Photos' Filters panel includes eight trendy color effects. Click each one to see how it changes your image (the Process filter is shown here). Aside from giving an image a creative feel, these filters are great for disguising terrible lighting conditions.

To remove a filter you've applied, click None at the top of the filter list.

Applying these filters is a piece of cake: Just click (or, on an iOS device, tap) the filter's button to apply it to your picture. To customize a filter's effect, you can use the Adjustments panel, which is described in the next section. Heck, while rooting around in the Adjustments panel after applying a filter, you may come up with your own custom filter looks, though there's no way to save your settings as a canned, one-click affair (say, so you can use the same settings again later on a different image). That said, you can always *copy* the changes you make to one photo, and then paste them onto another, as page 146 describes.

Making Adjustments

Apple knows that not everyone wants to spend a ton of time correcting images. Heck, lots of people are content with clicking the Enhance tool (page 112) and calling it done. But the Enhance tool can't fix *every* picture you take, and you can't use it to apply *incremental* corrections. For example, if your shot looks too dark, you may need to lighten only the shadows. Or if the snow in a skiing shot looks too blue, you can warm it up by adding some red to it. And if the colors in your sunset shot are *blown out* (so bright that they turn white), you need to darken just the highlights. To do that kind of stuff, you need the advanced editing power found in Photos' Adjustments panel.

However, advanced adjustments aren't for everyone. They're confusing to most mortals and, honestly, even some photographers. Fortunately, Apple's design team did a *heroic* job of simplifying Photos' advanced editing controls to make using them easy and intuitive.

■ USING THE ADJUSTMENTS PANEL ON A MAC

To summon Photos advanced editing controls, open the Adjustments panel by pressing the A key on your keyboard or, in Edit mode, clicking the Adjust icon. When you do, you see three basic adjustment categories: Light, Color, and Black & White (see Figure 5-8). The first two categories contain a vertical slider (it looks like a white line) atop a row of thumbnails of the photo you're editing. These are called *smart sliders*, and the thumbnails give you a preview of what that particular adjustment will look like applied to your picture. (The Black & White slider doesn't show up until you click the row of thumbnails, at which point your image goes from color to black and white.) For example, to darken a photo, simply drag the Light slider toward the darker thumbnails on the left. To lighten it, drag the slider toward the lighter thumbnails on the right. What could be simpler?

NOTE Both the Enhance and Filter tools perform their magic by tweaking various settings in the Adjustments panel. So if you've used either of those tools, some of the sliders you encounter in the Adjustments panel will already be changed. If you *haven't* used those tools, then the sliders will be centered in their factory-fresh position.

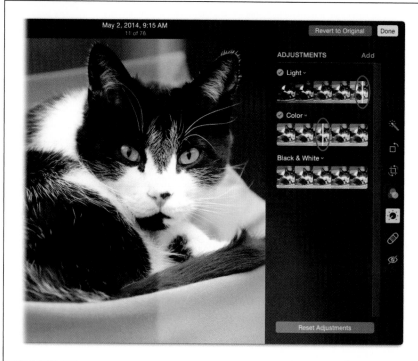

FIGURE 5-8

Photos' Adjustments panel gives you maximum control over color and lighting.

This figure shows a simulated split-screen view of a picture corrected using the Light and Color smart sliders (circled). The right half of the cat photo has brighter, more vibrant colors than the left half. Don't let the simplicity of these sliders fool you; they're more powerful than the ones in iPhoto and easier to use than the ones in Aperture and Adobe Photoshop Lightroom.

Smart sliders are smart because dragging one adjusts a slew of settings simultaneously. For example, dragging the Light slider adjusts a whopping *six* settings, including exposure, highlights, shadows, brightness, contrast, and the photo's black point (which controls how light or dark the color black appears in your image). To expand a smart slider to see—and use—its *sub-sliders*, point your cursor at the smart slider's name, and then click the icon circled in Figure 5-9, right. This brilliant two-tier setup lets those who are aren't comfortable with advanced adjustments fix their images using smart sliders while letting more experienced folks take fine adjustments into their own hands with the sub-sliders. But even if you're nervous about playing with advanced settings, there's no reason *not* to experiment with the sub-sliders, because you can always undo what you've done.

NOTE Once you make an adjustment, a blue circle with a black checkmark appears next to the adjustment's name (like the one next to the word "Light" in Figure 5-9, right). Clicking the checkmark temporarily turns the adjustment off, which is handy for seeing a before and after version of a particular adjustment. Click it again to turn the adjustment back on.

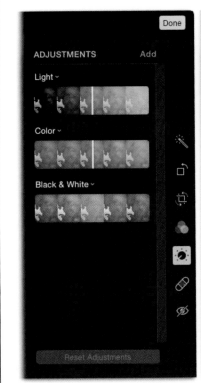
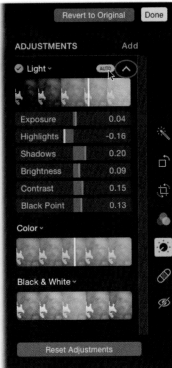

FIGURE 5-9

Here's an unexpanded (left) and expanded (right) view of the Light smart slider. Once it's expanded, you can drag its sub-sliders to fine-tune corrections or double-click a sub-slider's number and enter a new value.

To put the picture-fixing respon-sibility in Photos' hands, click the Auto button that appears when you point your cursor at a smart slider's name, like the one the cursor is pointing at in the upper right here. Consider the Auto button a great starting point: Click it, and then fine-tune the smart slider.

And that's not all—there's still *more* power lurking in the Adjustments panel. To keep the panel uncluttered, Photos initially shows you only three basic correction catego-ries: Light, Color, and Black & White. However, there are several other adjustments worth trying. To see them, click the Add button at the panel's upper right. When you do, the menu shown in Figure 5-10 appears. This menu contains adjustments that affect your image's details—sharpen (page 135), definition (page 137), noise reduction (page 137), and vignette (page 138)—as well as advanced adjustments of white balance (page 139) and Levels (page 141).

TIP In Photos for Mac, you can set any sub-slider back to its original setting by double-clicking its name. How handy is that?

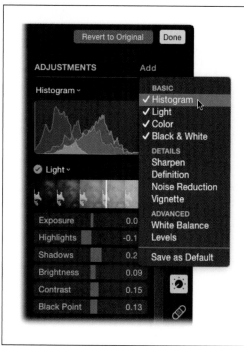

FIGURE 5-10

*Click the Add button to reveal this menu. Adjustments that are cur-
rently displayed in the Adjustments panel have checkmarks next to
their names. To open another adjustment, click its name in this menu
(Histogram [page 127] was added here).*

*To save your current configuration of adjustments so they're always
open in the Adjustments panel, choose Save As Default at the bottom
of the menu.*

Undoing changes you've made in the Adjustments panel is easy. To undo *everything*
you've done in the Adjustments panel, click Reset Adjustments at the bottom of the
panel. To undo an adjustment in a specific *category*, click the tiny down-pointing
chevron icon next to the category's name and choose Reset. To remove an adjustment
from the panel (so you don't see it), click the same icon, and then choose Remove
Adjustment. (You can always summon that adjustment again using the Add menu,
as describe in Figure 5-10.)

To open the Adjustments panel in Photos for iOS, select a photo, tap Edit, and
then tap the icon that looks like a little dial. The panel works pretty much the same
as it does on your Mac except that it lacks an Add menu, so you can't display the
advanced adjustments that you get in Photos for Mac. Nevertheless, you get smart
sliders for the same basic categories—Light, Color, and Black & White—plus you can
easily access their sub-sliders. Figure 5-11 has more.

TIP The smart sliders and sub-sliders in Photos for iOS, which are red instead of white, are really small, even
on an iPad. Rather than straining your eyes to aim your finger at a slider, simply tap the adjustment you want to
apply (Light, for example), and then drag your finger left or right across the *picture* instead of the slider.

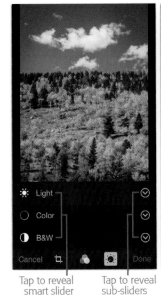

FIGURE 5-11

Left: Here's the Adjustments panel in Photos for iOS, shown in vertical orientation. To access the smart sliders, tap an adjustment category's name. To go straight to its sub-sliders, tap the down-pointing chevron icon to its right.

Right: Once you've summoned and tweaked a smart slider (like the B&W slider shown here), a tiny gray dot (circled) appears above the smart slider, indicating its original position. To reveal and adjust its sub-sliders, tap the icon labeled here.

Tap to reveal
smart slider

Tap to reveal
sub-sliders

Tap to reveal
sub-sliders

Using the Adjustments panel in Photos for iOS requires a lot of tapping to reveal the hidden controls because the device's screens are so small, as Figure 5-12 shows. (Things look slightly different on an iPad because the screen is slightly bigger, so the controls aren't quite so hidden.) When you tap and hold a smart slider or sub-slider, you're not so much dragging the slider as you are dragging the controls underneath it—the thumbnails of a smart slider or the tick marks of a sub-slider. For that reason, you drag in the *opposite* direction that you want the slider to go. For example, to move a slider to the right, you tap and drag left; to move a slider to the left, you tap and drag right. It takes a little getting used to but it works really well, and the ability to edit your images in such powerful ways on an iOS device, using a free program, is awesome.

Undoing the changes you make in the Adjustments panel in Photos for iOS depends on what you've done. You can undo changes you've made with the Light and Color smart slider and sub-slider by tapping Cancel, and then tapping Discard Changes in the confirmation sheet that appears. This strips away all the edits you made to that image during this round of editing, and spits you out of Edit mode. Alternatively, you can undo specific changes by moving each slider that you changed back to its original position, which is indicated by the gray dot circled in Figure 5-11.

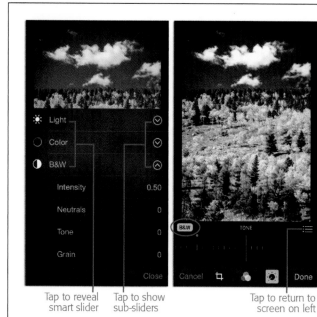

FIGURE 5-12

Left: When you tap to reveal any adjustment's sub-sliders, you see this screen. Tap the chevron icon to the right of an adjustment's name to show or hide that adjustment's sub-sliders. To use a sub-slider, tap its name.

Right: Here the Tone sub-slider in the B&W category is open, and what a difference it makes on this black-and-white photo! To turn off the black and white effect, tap the B&W button (circled). When you're finished using the sub-slider, tap the button labeled here to return to the screen shown at left.

Tap to reveal
smart slider

Tap to show
sub-sliders

Tap to return to
screen on left

Photos for iOS's Black & White category, on the other hand, works like an off/on switch, so you can turn off just the black-and-white bit without undoing any changes you made using the Light and Color categories in this editing session. For example, once you tap the B&W icon in Photos for iOS to reveal its smart slider and then you move the red smart slider, your image changes from color to black and white, and the little B&W label itself goes from black to gray (it's turned on and circled in Figure 5-12). So, to restore your image's color, you can turn *off* the black-and-white effect by tapping the label itself (it goes from gray to black).

When you're finished using the Adjustments panel in Photos for iOS, you can do one of the following:

- **Deactivate the Adjustments panel** by tapping its icon again. When you do, its icon goes from gray to black and you can see all the other editing tools (Enhance, Crop, and Filters).

- **Save the edited image and exit Edit mode** by tapping Done. Photos saves the new version of the image and you return to the view from whence you came. Don't worry: You can always restore the image to its original state by opening it in Edit mode again and tapping the red Revert button. In the confirmation message that appears, tap "Revert to Original," and your image returns to the state it was in when you imported it.

- **Undo your changes** by tapping Cancel. In the resulting confirmation message, tap Discard Changes and Photos removes all the changes you made in this editing session (changes you made in *prior* editing sessions are preserved).

Over the next few pages, you'll learn what *all* the settings in the Adjustments panel mean, and how to use them to improve your pictures. The remainder of this section focuses on Photos for Mac because the controls in Photos for iOS's Adjustments panel work the same way.

■ THE MIGHTY HISTOGRAM

You can indeed improve your pictures by dragging the Adjustments panel's smart and sub-sliders around, but if you want to understand the changes you're making and learn to use the sliders more effectively, you need to get cozy with your picture's *histogram*: the colorful graph shown in Figure 5-10. Go ahead and add it to your Adjustments panel by clicking Add, and then choosing Histogram from the menu that appears.

A histogram is a self-updating collection of graphs that represent the dark and light tones in your picture. Chances are you've encountered a histogram before, say, on the screen of your digital camera. A histogram may look complicated at first, but it's a *terrific* tool once you get the hang of using it. The data a histogram displays can tell you if the photo was properly exposed and what the lighting conditions were (harsh or dull, for instance). The histogram gets even more powerful when combined with a Levels adjustment, which you'll learn about later in this chapter (page 141).

The first step in learning to read a histogram is to understand that digital images are made up of individual pixels (short for *picture element*) made from a combination of the primary colors: red, green and blue (let's call these *color channels*). Within each pixel, each of these three colors has a brightness value that's represented by the width of the histogram: no brightness is on the far left (0%) and full brightness is on the far right (100%). For Photos to display a histogram of your picture, it counts how many pixels there are at each level of brightness in each color channel. The result is three tiny bar graphs superimposed atop each other in the histogram: one for the red channel, one for green, and another for blue. (You can see an example back in Figure 5-10.) The taller the graph at any given point, the more pixels you have at that particular level of brightness in that particular color channel. If the graph reaches all the way to the *top* of the histogram, it means that particular color has been *clipped*—pushed to the highest possible brightness value, meaning you can't see any details in the area that's that color.

TIP Another way to think of a histogram is to imagine that your photo is a *mosaic* and its individual tiles have been separated into same-color stacks. The taller the stack, the more tiles you have of that particular color.

Within each graph, the scheme is the same: Your picture's darker tones (*shadows*) appear toward the left side of the histogram, the lighter tones (*highlights*) appear on the right, and the tones in between (*midtones*) appear in the middle. So if you're working on a very dark picture—a black cat at night, say—you'll see lots of data at

the left side of the histogram, trailing off to nothing toward the right. A shot of a white cat in the snow, on the other hand, will have lots of data on the right side of the histogram and very little on the left. The histogram in Figure 5-13, left, has a bunch of data bunched up on the left, so you can tell that the photo is too dark.

The width of these graphs reveal the picture's *tonal range*—the total number of tones possible in the image, from dark to light—which you can compare to the total possible tonal range, which is represented by the width of the histogram. For example, a histogram with data that spans the histogram's full width indicates the photo has a good balance of dark and light tones. In the histogram for a *bad* photo—a severely under- or overexposed one—the graphs are all bunched at one side or the other and may have some clipping. Rescuing those kinds of pictures involves spreading the data out across the histogram, as Figure 5-13 shows, and reducing the brightness of any clipped tones so you can see the details in those areas of your photos.

You perform these rescue missions using the Light and Color adjustments (described in the following sections) or a Levels adjustment (page 141). Which method is best? It depends on the picture, how much control you want, and how much time you have. Perfectionists who love to tinker will adore the precise control that only a Levels adjustment can provide (the one in Photos is as powerful as the one in Aperture), and everyone else will be happy using Light and Color adjustments (they'll spend less time parked in front of their Macs, too). However, if a picture is in *really* bad shape, only a Levels adjustment can save it.

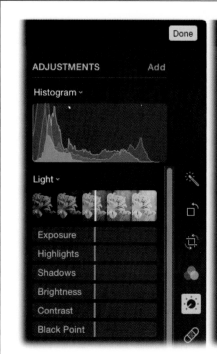
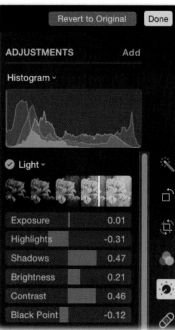

FIGURE 5-13

By watching how the histogram data changes as you scoot the Light and Color smart sliders around, you can balance the dark and light tones in your image. The histogram for the original, unbalanced shot is shown here on the left (you can tell that the image is too dark because most of the data is bunched up on the left side of the histogram), and the adjusted version is on the right. Without watching the histogram, your corrections are just guesswork.

■ LIGHT

The Light adjustment, as you might suspect, affects the *lighting* in your image. Dragging the Light smart slider to the left darkens your picture and dragging it to the right lightens it. That *sounds* simple enough, but in order to darken or lighten your picture, the Light smart slider actually adjusts *six* incredibly powerful sub-sliders that are usually found only in pro-level image-editing programs (which makes it impressive that Apple put these controls in a free app). Here's what all those sub-sliders do (if you need a refresher on how to summon them, see page 122 [Mac] or 124 [iOS]):

- **Exposure.** Exposure is determined by how much light your camera's sensor captured, and is measured in *f-stops* (which indicate how much light your camera's lens lets in). The exposure slider makes your picture lighter when you move it to the right and darker when you move it to the left.

 The effect this slider has differs slightly depending on your picture's *file format*. If you're editing a JPEG (the format used by most pictures from most cameras and *all* the pictures taken with your iOS device), it primarily affects the image's midtones (the tonal values between the darkest shadows and lightest highlights).

 If you're editing raw files (page 34), this slider changes the way Photos interprets the dark and light information your camera captured. The effect is similar to changing your camera's ISO setting (its sensitivity to light) *before* taking the picture—except that you can make this change long *after* you snap the shutter. This is one of the advantages of shooting in raw format: raw files give Photos a lot more information to work with than JPEGs. As a result, you can make exposure adjustments without sacrificing the picture's overall quality.

TIP Be sure to watch the histogram as you move the Exposure slider to avoid shoving data *beyond* the histogram's edges. If that happens, you're tossing details in the image's darkest shadows or lightest highlights. You may also notice that the red, blue, and green graphs move in *unison* when you adjust the exposure; despite changing shape, they essentially stick together. By contrast, when you make changes using Photos' Color adjustments (page 132), you'll see the individual color channels move in *different* directions.

- **Highlights and Shadows.** These two sliders let you recover details (think texture) in areas that look too light or too dark. Drag the Highlights slider left to darken *only* the highlights, as Figure 5-14 illustrates, or drag it right to lighten them; the shadows and darker midtones remain unchanged. The Shadows slider works the same way: Drag it left to darken *only* the shadows or drag it right to lighten them; the highlights and lighter midtones don't change.

TIP The effects of the Highlights and Shadows sliders are fairly subtle (especially on JPEGs), so if your picture is severely over- or underexposed, those sliders aren't going to save it. To keep your images looking natural, resist dragging either slider too far in either direction, or your picture will take on a weird, radioactive-looking sheen.

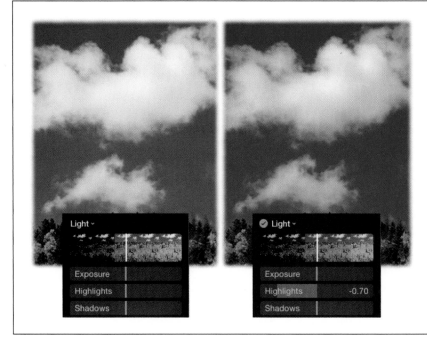

FIGURE 5-14

The Highlights and Shadows sliders let you recover details and texture in areas that are too light or too dark.

Here you can see how dragging the Highlights slider left recovered details in these clouds.

- **Brightness.** This slider is similar to Exposure in that it lightens or darkens your picture. However, it doesn't change areas that are *already* bright (in other words, it avoids messing with the lightest highlights). With that in mind, you can drag it rightward to subtly brighten shadows and midtones, or drag it leftward to *darken* midtones and shadows, while leaving highlights alone, which can produce a dramatic, moody look.

- **Contrast.** This slider adjusts the difference in brightness between the darkest and lightest tones in your picture. When you drag this slider to the right (increasing contrast), you "stretch out" the histogram's data, creating darker blacks and brighter whites, as shown in Figure 5-15. If you drag this slider to the left (decrease contrast), you scrunch the histogram's data inward, shortening the distance between the darkest (pure black) and lightest (pure white) endpoints, making the picture's tones look flat or muddy.

> **TIP** You can also stretch out a histogram using a Levels adjustment (page 141): Just scoot the outer black and white sliders inward to the edges of the histogram data. Which method is better? If the histogram's data is centered, then Contrast is the easier adjustment because it pushes the data outward evenly. But if the histogram's data is skewed to one side or the other—or if you're correcting a raw image (page 34)—then Levels is the better choice because you can adjust the brightness of highlights, midtones, and shadows *independently*. The details begin on page 144.

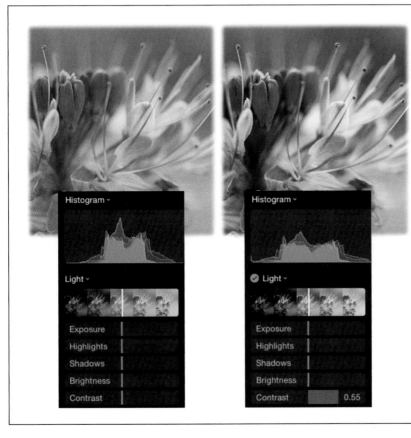

FIGURE 5-15

While the overall lighting in this close-up shot is nice, the picture lacks contrast. Dragging the Contrast slider to the right helps improve things.

Notice how the histogram info is bunched in the middle in the original (left) and expanded over a wider tonal range after boosting the contrast (right).

- **Black Point.** This slider controls what black looks like in your picture. "Wait a minute," you say, "how can black be anything other than black?" If you think about it, black can be jet black or it can be a really dark gray that just *looks* black. When you drag this slider to the left, Photos makes the blacks in your picture darker (more black, if you will). If you drag it to the right, Photos lightens the blacks.

 Changing the black point shifts the light values of *all* the tones in your image to be darker or lighter, depending on which way you drag the slider. If you like the blacks in your pictures to be *really* black, then drag this slider slightly leftward. Just be careful of dragging it *too* far left or your shadows will get so black that you can't see the details they contain (pros call this *plugged shadows*). Likewise, don't drag the slider too far right or your shadows will become a dull gray mess.

On a Mac, if you don't like the effect you've created by dragging the Light sub-sliders around, simply click Reset Adjustments at the bottom of the Adjustments panel. On an iOS device, drag the slider back to its original centered position or click Cancel (as you learned on page 127, the latter method nixes *all* the changes you've made during that editing session and takes you out of Edit mode).

■ COLOR

This smart slider lets you make the colors in your pictures more or less dramatic. If you drag the Color slider leftward, Photos tones down your picture's colors; if you drag it *all* the way left, the colors disappear and you end up with a black-and-white photo. To *boost* the colors in your picture so they stand out more, drag the Color slider rightward (Photos adds a bit of color contrast, too). Here's what the Color adjustment's sub-sliders do (see pages 122–124 if you've forgotten how to display them):

- **Saturation.** This setting lets you control color *intensity*. Drag it to the right to make colors more vivid, so they pop off the page (see Figure 5-16). The more intense the colors, the brighter (and sometimes more fluorescent) they become, so be careful of using this slider on pictures of people, as skin tones can go hot pink in a hurry. Conversely, you can drag this slider left to *tone down* colors in your picture so they're less intense, which is helpful if they look garish or they distract from the image's composition. For example, you might want to lower the saturation of photos of a festive Latin American market or Hawaiian flowers, whose colors are often so brilliant they make your eyes water. Lessening saturation is also helpful if you've got a picture that you can't color-correct to your liking. By toning down the color, the picture can take on an artistic feel.

- **Contrast.** Similar to the Contrast sub-slider in the Light adjustment (page 130), this sub-slider lets you control the differences in intensity *between* the colors in your picture. Drag this slider leftward to decrease differences in color intensity or drag it rightward to increase them, creating a more vibrant image. However, increasing this setting can easily strip areas of *color detail*. For example, if you've got a lot of variation in color—say, in a picture of fall foliage—boosting color contrast can push all the colors toward the one that's dominant, so that instead of an intricate forest of yellows, oranges, and reds, you end up with a big blob of mostly yellow (or whatever color was dominant).

- **Cast.** This slider lets you shift a picture's colors toward green and blue by dragging it left, or toward red by dragging right. That lets you cool down a photo that looks too yellow or warm up a photo that looks too blue. These kinds of *color casts* are often due to lighting conditions (fluorescent lighting is the worst offender), the time of year you snapped the shot (winter versus summer), or your camera's white balance setting (explained on page 139). If this adjustment doesn't whip your picture's color into shape, try the more powerful White Balance adjustment described on page 139.

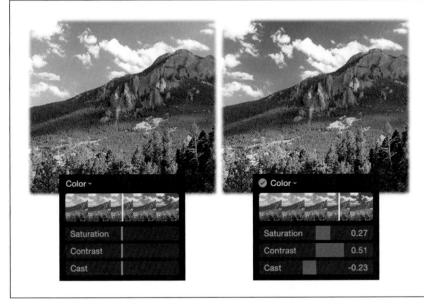

FIGURE 5-16

Using Photos' powerful Color sub-sliders (Saturation, Contrast, and Cast), you can make the colors in your images pop off the page (notice the difference in the blues and greens in this shot). Dragging the Cast slider to the left also cooled down this image a little.

■ BLACK & WHITE

When you want to make a *big* difference in a picture with one simple change, you can't beat converting it from color to black and white. This Ansel Adams approach doesn't just evoke nostalgia, it also puts the focus on the subject in a powerful way, as Figure 5-17 shows. Going grayscale also lets you salvage an image that you can't color-correct, or beautify a subject whose teeth need whitening (which you can't do in Photos) or whose skin needs retouching (page 147). Those problems and others all but disappear when you enter the realm of black and white.

If you click anywhere on the Black & White smart slider, Photos dutifully drains the color from your picture. Drag the slider left or right to adjust contrast and produce the look you want. (On an iOS device, you have to tap B&W, and *then* tap the slider that appears.) Dragging this slider leftward pushes the histogram data rightward, which lightens the picture and gives it an ethereal look (great for camouflaging uneven skin tones in portraits). Dragging this slider rightward pushes the histogram data leftward, which produces a darker and more dramatic feel (you may want to avoid this on portraits, as it emphasizes undereye shadows). Here's what the Black & White sub-sliders do (flip back to page 122 [Mac] or page 124 [iOS] if you need help displaying them):

TIP To produce the black-and-white image of your dreams, you may also need to tweak the settings in the Light and Color adjustment categories, though the Tone sub-slider described in this section creates a gloriously high contrast black and white, as evidenced back in Figure 5-12 (right).

- **Intensity**. Think of this slider as *strength*. Once you find a look you like using the Black & White smart slider, drag the Intensity slider rightward to make the effect more pronounced, or leftward to tone it down.

- **Neutrals.** This slider to adjusts the brightness of the *neutral* tones in your picture. Neutral tones are those that have nearly the same values in all three color channels (red, green, and blue).

- **Tone.** This slider affects the brightness values of the non-neutral tones in your image, which also affects contrast. To increase contrast, drag this slider to the right, which spreads the histogram data out evenly in both directions, adding drama to your picture. Drag it leftward to bunch the histogram data in the middle of the graph, which decreases contrast.

- **Grain.** If you want to add speckles to your photo that mimic the look of film photography, drag this slider rightward. Unless you're going for a gritty and grungy look, avoid adding grain to portraits.

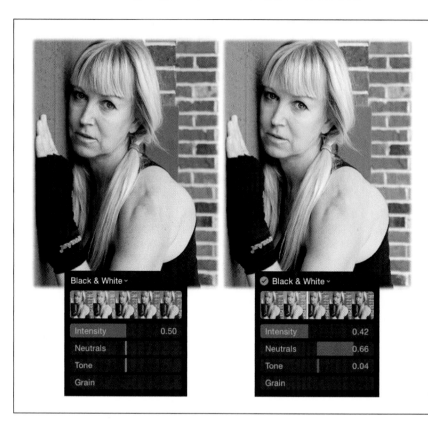

FIGURE 5-17

The high contrast of the bricks in this portrait makes it a great candidate for converting to black-and-white.

If your subject has noticeable light reflections in their eyes, drag the Neutrals slider rightward to lighten them so their eyes sparkle even more!

Advanced Adjustments

As you learned earlier in this chapter, Photos includes even *more* controls that you can add to the Adjustments panel. Just click the Add button at upper right to reveal

a menu that lets you turn on these advanced photo fixer-uppers. (Sadly, Photos for iOS doesn't include an Add button. If you want to use the adjustments described in the following pages, you have to use Photos for Mac.)

TIP Some of the adjustments described in this section—Sharpen, Definition, Noise Reduction, and Vignette—are applied to your image the second you add them to the Adjustments panel. However, if you decide to always keep those adjustments open in the Adjustments panel—by clicking the Add button and choosing Save As Default—then they're not automatically applied to subsequent pictures you open; you have to drag their sliders to apply them.

If you're already overwhelmed by the adjustments explained in the previous pages, do yourself a favor and stop reading. Spend some time getting comfortable with what you've learned thus far, and then return to this section whenever you're ready. Why? Most of the adjustments explained in this section were lifted from Aperture, Apple's short-lived, pro-level image-editing program. While the adjustments are easy to use—they're all slider-based—understanding what their sub-sliders do is a different story. That said, mastering Photos' advanced adjustments is incredibly rewarding, and gives you maximum control over the color and light in your pictures.

■ SHARPEN

Much like sharpening a knife in your kitchen accentuates its edge, sharpening an image in Photos accentuates the high-contrast edges it contains (that is, places where light and dark pixels meet). This adjustment works by lightening light pixels and darkening dark pixels wherever they appear next to each other.

NOTE Sharpening should generally be the *last* adjustment you make. If you apply other adjustments *after* sharpening, you may discover that you have to adjust the sharpening slider again (but all in all, that's really no big deal). Also, sharpening isn't magic: It can't fix a blurry, poorly focused image. The only real way to produce sharp images is to stabilize your camera on a hard surface or use Burst mode, as the box on page 136 explains.

Photos sharpens your picture the second you add this adjustment to the Adjustments panel—you don't have to click its Auto button. Before you grab the Intensity slider and increase the sharpening, set your image to 100% zoom level using the zoom slider (page 109), and then reposition your picture so you're seeing the most important part (say, the eyes). Next, slowly drag the Intensity slider rightward. Keep in mind that photos with a lot of hard lines—landscapes, architecture, and such—benefit from a stronger dose of sharpening than portraits, where a lot of sharpening makes the subject's pores leap out of the photo. And if you're going to print the picture, it's okay if it looks a little too sharp onscreen because the printing process will soften it a little. It's a good idea to sharpen *all* the photos you'll print or use in book, calendar, and card projects (Chapter 9). Otherwise, they can look unnaturally soft.

In addition to the Intensity slider, the Sharpen adjustment sports two other powerful sub-sliders, which are visible in Figure 5-18 (see pages 122-124 if you need a refresher on how to display them). Here's what they do:

- **Edges.** This setting lets you restrict the sharpening to certain areas by specifying how much contrast there has to be between pixels for them to quality as an edge. The lower this setting, the fewer areas Photos will sharpen; the higher this setting, the more areas Photos will sharpen. (Drag this slider *all* the way left and Photos won't sharpen anything, no matter what the Intensity slider is set to.) For portraits, keep this setting fairly low to avoid sharpening skin. And if you start noticing noise (page 137) in areas that don't have much contrast, then drag the Edges slider back toward the left.

- **Falloff.** While it may *look* like Photos sharpens your whole image at once, it doesn't. When you first mess with the Intensity slider or click the Sharpen adjustment's Auto button (put your cursor over the word "Sharpen" to display it), Photos applies one round of sharpening in its initial pass, and then applies *two more* rounds (it's impossible to see this; it all happens in the blink of an eye). Those last two rounds are called *falloff*, and this slider lets you control the amount of sharpening Photos applied during them. (Why so many rounds? By adding smaller amounts of sharpening in multiple passes, you avoid creating sharpening *halos*, white gaps between contrasting pixels.)

This Falloff slider is measured in percent and is applied *proportionally* to the last two sharpening passes. For example, a falloff setting of 0.69 means that Photos applies 69% of the original sharpening amount (controlled by the Intensity slider) during the *second* pass, and then applies 69% of the amount of sharpening from the *second* pass during the *third* pass. Generally speaking, everyone except professional photographers who are used to using Apple's Aperture will leave Falloff at its factory settings. However, if your picture has a lot of defined edges in it (say, a forest, leaves, or lots of small objects) you may want to reduce it a little. Just be sure you're viewing your image at 100% zoom level or you'll never see the subtle differences this slider makes.

The Benefits of Burst Mode

Can Photos' Sharpen adjustment fix blurry, out-of-focus photos? Based on its name, you'd think that's exactly what this adjustment is for. Sadly, the answer is no. Sharpness can only emphasize the edges in your photo, which makes them stand out more. That's why it's important to stabilize your camera so your pictures are sharp to begin with.

Pros know that the only way to produce sharp images is to shoot with a tripod. However, the next best thing to hauling around a tripod is to employ your camera's burst mode (consult your camera's manual to learn how to use this feature). When you do, your camera fires off several shots each time you press the

shutter button. (The Camera app on your iOS device can do this, too—just keep your finger on its circular shutter button.) This is handy for making sure at least *one* photo in the bunch is nice and sharp (usually the middle one), because fiddling with the shutter button can jiggle the camera.

Unfortunately, shooting in Burst mode also means having several *versions* of the same picture in your library, but it's worth it to get at least one sharp image. Thankfully, when you're in Year view (page 44) Photos hides multiple versions of the same shot. For more on using Burst mode, see the box on page 50.

TIP One method for using Photos' extremely advanced sharpening controls is to set the Intensity slider to its maximum value (1.00), and then adjust the Edges slider until you can clearly see which parts of the picture Photos is sharpening (just be careful not to drag it so far right that you introduce noise into your image). Next, adjust the Falloff slider so only the edges you *want* to be sharpened are actually sharpened. Finally, decrease the Intensity setting until the sharpening looks good to you. Again, you must view your image at 100% zoom level to notice any changes.

■ DEFINITION

This adjustment is great for accentuating the details in your image *without* over-doing contrast. It adds clarity by adjusting contrast in the midtones, which is where many fine details reside.

Photos applies some definition to your picture the minute you add this adjustment to the Adjustments panel (page 134 tells you how to do that). Dragging this slider to the right can make a flat or hazy picture look sharper, though its impact isn't the same as using the Sharpen slider (which affects *all* the tones in your image). You'd be hard-pressed to find a photo that won't benefit from at a little extra definition (see Figure 5-18)—except for portraits (nobody looks good with extra definition in their skin!). This adjustment is a one-trick pony; it doesn't have any sub-sliders.

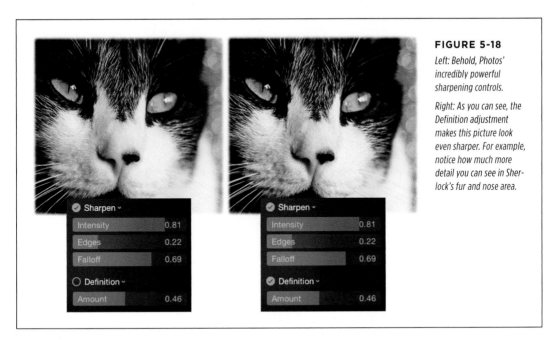

FIGURE 5-18

Left: Behold, Photos' incredibly powerful sharpening controls.

Right: As you can see, the Definition adjustment makes this picture look even sharper. For example, notice how much more detail you can see in Sherlock's fur and nose area.

■ NOISE REDUCTION

In photography circles, the term *noise* refers to graininess in your images—the colored or grayscale speckles produced by shooting in low-light conditions or at a high *ISO*, your camera's light-sensitivity setting. (Typically, any ISO above 800 puts

you in the noise danger zone.) This slider reduces noise by *blurring* your picture, so use the minimum amount necessary. Also, be sure to view your image at least 100% zoom level when using this slider and keep your eyes glued to any dark areas, which is where noise lives. This adjustment doesn't have any sub-sliders.

TIP The Noise Reduction slider is also handy to use if you've lightened shadows as described on page 129, which can *introduce* noise into photos.

■ VIGNETTE

If you've ever seen a picture with a softly darkened edge, you're familiar with vignettes. (Technically speaking, vignettes are pictures whose brightness fades from their centers to their edges). Adding a vignette is a great way to downplay a distracting background or accentuate your subject, as Figure 5-19 shows. You'll likely use this slider on every portrait you take.

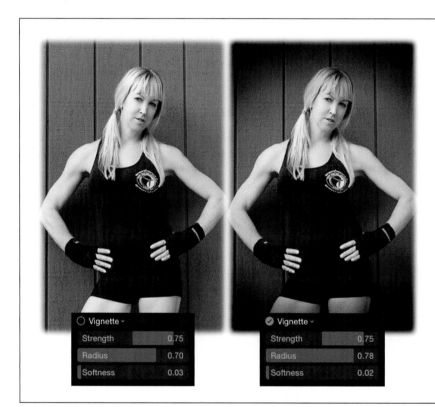

FIGURE 5-19

Rare is the portrait that won't benefit from a dark-edge vignette! Adding one gives your portrait a classy and elegant final touch, and helps tone down a distracting background.

When you add this adjustment to the Adjustments panel (page 134), Photos applies a vignette at 0.75 intensity, though you can adjust that with Strength slider. Dragging rightward increases the amount of dark shading, and dragging leftward decreases the shading. Avoid dragging this slider left into negative numbers; if you

do, the edges of your picture turn oddly light. Here's what the Vignette adjustment's sub-sliders do (to display them, put your cursor over the word "Vignette" and click the down-pointing icon that appears to its right):

- **Radius.** This slider change the size of the vignette. Drag it right to make the vignette bigger or left to make it smaller.

- **Softness.** This slider controls the width of the *transition* between what's darkened and what isn't. Drag it right to make the transition wider and softer. But beware: If you drag it *all* the way right, Photos darkens the whole image.

▨ WHITE BALANCE

This adjustment lets you change the color of *light* in your shot. Different kinds of light—fluorescent lighting, overcast skies, and so on—lend different color casts to pictures. White balance, both in Photos and in your camera, is the setting that eliminates or adjusts the color cast according to the lighting. But isn't that what the Color adjustment's Cast sub-slider does, you might ask? Yes, but Photos' White Balance adjustment is *far* more powerful.

NOTE For the best results, adjust your picture's exposure, as described on page 129, *before* adjusting its white balance.

When you first add White Balance to the Adjustments panel, you see an eyedropper and a menu. The menu controls the *method* this adjustment uses and the eyedropper lets you tell Photos which part of your image to analyze.

There are two ways to use Photos' White Balance adjustment (see page 134 if you need help adding it to your Adjustments panel):

- **Automatic white balance.** To fix your image's white balance automatically, point your cursor at the words "White Balance" and click the Auto button that appears. When you do, Photos analyzes your picture and, if it finds a face, it picks *Skin Tones* from the method menu and then adjusts the white balance in a way that preserves fleshy colors. If Photos *doesn't* find a face, it picks *Neutral Gray* from the method menu and adjusts the white balance based on the neutral grays it finds in your picture. (Technically speaking, neutral gray is a medium gray that has the same numeric values in all three color channels: red, green, and blue.)

 If you're pleased with the results of using the Auto button, pat yourself on the back and continue on your editing journey. If not, click the White Balance eyedropper to activate it and, for the Skin Tone method, click your subject's face, as in Figure 5-20. For the Neutral Gray method, click an area that *should* be medium gray. If at first you don't succeed, grab the tool again and click another spot in your image; rinse and repeat until you're satisfied with the results. (It would be nice if the eyedropper stayed active until you told Photos that you were finished with it, but that's not how it works.)

The Skin Tones and Neutral Gray methods have the same Warmth sub-slider; just expand the White Balance adjustment to see it (put your cursor over the words "White Balance," and click the down-pointing icon that appears). This sub-slider is great for refining the white balance adjustment by cooling or warming the tones in your picture: Drag the slider left to cool your image with bluish/green tones or right to warm it with reddish/yellow tones.

NOTE If the Skin Tones method doesn't get your subject(s) looking quite right, see the box on page 142 for tips on taking good people photos.

FIGURE 5-20

Click the White Balance adjustment's Auto button (not shown) and, if your image contains a human face, the method menu switches to Skin Tone due to Photos' facial-recognition ability. To fine-tune the adjustment, use the eyedropper (circled) to click an area of skin. Take care not to click a shiny spot or the white balance will be off.

As you can see from this before (left) and after (right) example, Photos was able to nix the pesky yellow cast.

- **Manual white balance.** If you'd prefer to take white balance into your own hands, then instead of clicking the Auto button, choose Temperature/Tint from the method menu. (Make sure the White Balance adjustment is expanded so you can see its Temperature and Tint sub-sliders.) Next, use the White Balance eyedropper to click a neutral gray in your image, and then use the sub-sliders to finesse the color balance to your liking:

TIP It's usually easier to start with the Tint slider and *then* adjust the Temperature slider, which is why they're listed in reverse order here.

 — **Tint.** Like the tint control on your computer monitor or color TV, this slider adjusts the picture's overall color along the red-green spectrum. Drag this slider to the left for a greenish tint (the slider itself turns green), or right

for red (the slider turns magenta, as shown in Figure 5-21). As you drag, watch the histogram to see the colored graphs shift. This slider is particularly helpful for making skin tones look natural and for compensating for bad lighting conditions.

— **Temperature.** This slider adjusts the picture's overall color along the blue-orange spectrum. Drag this slider right to *warm* the image, making the tones more orange, as if the sun came out (the slider turns yellow—see Figure 5-21). Dragging left, on the other hand, *cools* the image, making the tones more blue so the picture looks icy and cold (the slider turns blue).

TIP The Temperature and Tint sub-sliders are incredibly useful, and you may be able to handle the bulk of your correction chores using nothing but the Light adjustment's Exposure sub-slider and, say, the Temperature slider. However, some shots—especially those lit with fluorescent lighting—may *never* look right. The next time you're shooting a fluorescent-lit scene, head off color problems by using your camera's flash. Make sure it's the dominant light source in the scene so it fills in the gaps in the fluorescent-light spectrum, making color-correcting a little easier. Another solution is to change your camera's white-balance setting to fluorescent light (you'll need to dig out your owner's manual to learn how).

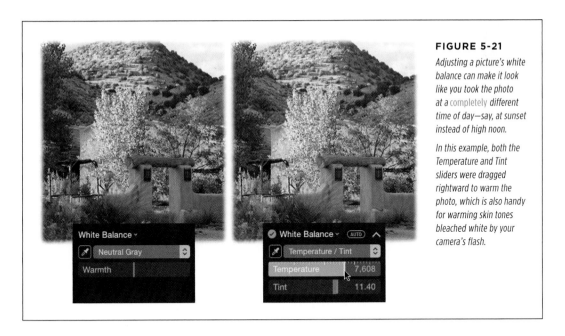

FIGURE 5-21

Adjusting a picture's white balance can make it look like you took the photo at a completely different time of day—say, at sunset instead of high noon.

In this example, both the Temperature and Tint sliders were dragged rightward to warm the photo, which is also handy for warming skin tones bleached white by your camera's flash.

◼ LEVELS

Congratulations! You've arrived at Photos' *most* advanced adjustment. When you choose Levels from the Adjustment panel's Add menu, Photos opens yet another histogram, but this one boasts a whopping *eight* draggable sliders that give you precise control over the brightness levels (hence the adjustment's name) of the tones in your image. You can adjust the brightness levels in just the darkest shadows,

just the midtones, just the lightest highlights, in the tones between shadows and midtones, and in the tones that fall between midtones and highlights. You control all of that in the Levels RGB histogram—the one that shows the red, green, and blue, graphs superimposed on each other—or in each of those channels individually. You also get access to the *Luminance* channel, which is described in a sec.

As you drag the Levels sliders around (which you'll learn how to do later in this section), the histogram you learned about on page 127 changes to reflect the adjustments you're making with Levels. For example, if you need to widen your histogram to more evenly spread out the tones in your image, you can tweak the Levels sliders as explained in this section and watch the other histogram widen as you do so.

> **NOTE** If you've already fiddled with the Light adjustment's sub-sliders (page 129), you won't need to use Levels. Typically, it's best to use the Light *or* Levels adjustment, but not both. While a Levels adjustment works on any file format, you'll likely get better results on raw images because they contain more data. For that reason, it may work best to use Light adjustments on JPEGs and Levels adjustments on raw files. That said, if you *like* using one adjustment more than the other, then go for it! The important thing is to *understand* both methods, as one may work better on some photos than the other.

The Levels adjustment doesn't have any sub-sliders, but it does have a menu that lets you access other histograms. To see it, point your cursor at the Levels adjustment, and then click the icon circled in Figure 5-22.

Producing (Near) Perfect Skin Tones

Producing accurate skin tones is tricky business. Even Photos' fancy Skin Tone white-balance adjustment method (page 139) may not get them right. If you take a lot of portraits, accurate skin tones are *muy importante*...especially if you print the pictures.

One way to ensure good-looking skin is to plan ahead by carrying a photographer's *neutral gray card* and including it in the picture. Just search Amazon.com for "white balance card" and you'll find a slew of options under $10.

Why go to such trouble? Because it's tough to spot a neutral gray in pictures, much less click it with the White Balance eyedropper. By including a neutral-gray colored card in the picture, you've always got a neutral gray big enough to click.

Be sure to position the card somewhere in the picture that's easy to crop out, and make sure the card gets the same amount of lighting as your subject. Another, perhaps easier method is to fire off one shot *with* the card in the frame—say, with your subject holding it—and then take another *without* the card in the frame (this will make sense in a sec).

Later, in Photos, add the White Balance adjustment and choose Neutral Gray from the method menu. Then grab the White Balance eyedropper and click the gray card. Doing so should produce near-perfect skin tones. Finally, use the Crop tool (page 114) to remove the gray card or, if you took two shots, copy and paste your corrections from the photo *with* the gray card onto the photo without it (page 146 has the scoop).

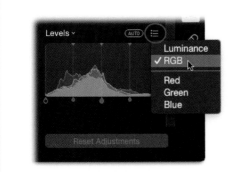

FIGURE 5-22

Photos gives you several different histograms to view and adjust.
When you click the Levels adjustment's Auto button (visible here), the
only histogram that's affected is the one you're currently viewing.

Your histogram choices are:

- **Luminance.** Pick this option to display a histogram that's based on how *human eyes* perceive color, which differs from how a camera, monitor, or other digital device perceives color. Because our eyes are more sensitive to green light than red or blue light, this histogram looks different than the others discussed in this section (it most closely resembles the Green histogram). The Luminance histogram displays the *same* data as the RGB histogram (described next), but in a different way: it shows cumulative brightness values for each pixel as opposed to separate RGB values. If you're attuned to subtle details, you may gain a deeper understanding of the data in your image.

 Heck, it's possible that luminance data is how Photos can turn a color photo into a black and white: By understanding how our eyes perceive color, it's able to translate data in the individual color channels into a visually pleasing grayscale picture onscreen. The only real use for this histogram is to tweak the contrast of a black-and-white image you've made using the aptly named Black & White adjustment (page 133).

- **RGB.** Straight from the factory, this is the histogram you see when you add a Levels adjustment, wherein Photos superimposes the red, green, and blue channels' data atop each other. When you have this histogram displayed and make a Levels adjustment, your changes affect all three color channels (red, green, and blue) at the same time. This is the histogram you'll use the most, and it's actually the same one you encountered earlier in this chapter (page 127), though *this* one has sliders that you can use to affect the image's tonal range.

- **Red, Green, Blue.** These three options give you access to the individual histograms for each color channel. This is handy for controlling brightness levels in a *particular* color channel without affecting the others, which is handy if, say, your image has a stubborn red cast, or if the blues don't look bright enough. In

addition to fixing problems in a specific channel, you can also use these histograms create artistic effects like the ones you can get with the filters discussed on page 120.

> **TIP** If you want to use the Red, Green, and Blue histograms to create some fun effects but you also want to keep the full-color version of the photo hanging around, duplicate the photo first. As you learned on page 66, the duplicate doesn't take up any additional hard drive space. To do it, choose Image→Duplicate 1 Photo or simply press ⌘-D.

As described earlier in this chapter (page 127), if the data in your histogram covers a good chunk of the territory from left to right, then your image has a good distribution of dark and light tones. However, if the data is bunched in the middle or to one side, or if there's a gap between the edges of the histogram and where the data begins, spreading the data out a bit can dramatically improve your picture.

There are two ways to spread out the data: You can have Photos *automatically* adjust the levels in your histogram of choice by clicking the Auto button that appears when you point your cursor at the word "Levels," or you can do it *manually* by dragging the Levels sliders labeled in Figure 5-23 (again, in your histogram[s] of choice). Adjusting these sliders yourself will give you the best results, though you can always *start* with Auto adjustment and then tinker with them.

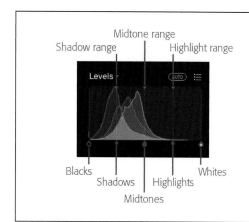

FIGURE 5-23

These are the eight Levels sliders you can use to fix your images. Look closely and you see the blacks, grays, and whites sliders are filled with their respective colors. Handy!

To really understand Levels, it's helpful to imagine a numeric grid beneath the histogram that ranges from 0% to 100%, which is the brightness range you learned about earlier in this chapter (page 127). The Blacks slider on the left side of the histogram represents the darkest shadows in your picture and starts out at 0% for pure black. The Whites slider on the right side, which represents the lightest highlights, starts out at 100%—pure white. To give your image the greatest possible tonal range and contrast, move these sliders so they point to wherever the data starts to slope upward (at the foot of the histogram mountains, so to speak). In other words, if there's a gap between the Blacks slider and the left end of the histogram data, drag that

slider to the right. And if there's a gap between the Whites slider and the right end of the histogram data, drag that slider to the left.

When you move the sliders, Photos adjusts the image's tonal values accordingly. For example, if you drag the Whites slider left to (an imaginary setting of) 85%, Photos changes all the pixels that were originally 85% or higher to 100% (pure white). (Translation: They get brighter.) Similarly, if you move the Blacks slider right to (an imaginary setting of) 5%, Photos darkens all the pixels with a brightness level of 5% or lower to 0% (pure black). Photos also redistributes the brightness levels between 5% and 85%, boosting the image's overall contrast by increasing its tonal range. If you watch the histogram at the *top* of the Adjustments panel (the one you learned about on page 127), you'll see it widen as you change the sliders in this way. Figure 5-24 shows what a difference this can make.

> **TIP** Instead of dragging the Blacks and Whites sliders, just *click* the outer edge of the histogram data to move the slider to that location. It's a wee bit faster and gives you better control over where the sliders land.

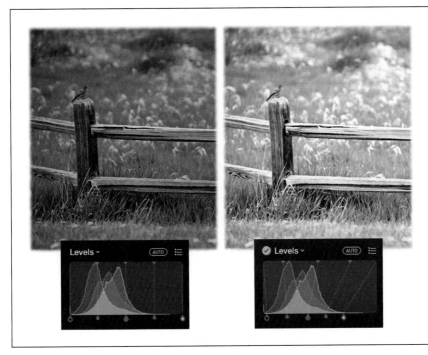

FIGURE 5-24

As you can see, a Levels adjustment can do wonders for a picture's overall lighting and contrast.

Notice the big gap on the right side of the original histogram (left); that indicates that the picture has no real highlights. By dragging the Whites slider inward, the whole image gets lighter (technically speaking, darker tones are remapped to lighter ones).

> **NOTE** If your histogram *doesn't* have gaps at the left or right ends, avoid moving the Black and White sliders inward—doing so destroys any details lurking in the darkest shadows or lightest highlights. Instead, use the Shadows, Midtones, and Highlights sliders described below.

Next, turn your attention to the Shadows and Highlights sliders—they control the tones that fall *between* black and 50% gray, and *between* 50% gray and white (respectively). They only appear when you point your cursor at the Levels histogram, and they give you *immense* control over the entire range of midtones, which is where your picture's fine details live. For example, if your picture's shadows look dark, lighten them by dragging the Shadows slider leftward. Or if your highlights look too light, darken them by dragging the Highlights slider rightward. Dragging these sliders doesn't affect the image's black or white point, which lets you retain details in the darkest shadows and lightest highlights.

Now focus on the Midtones slider in the middle, which controls your photo's values smack dab in the middle between 0% and 100% (or rather, 50% gray). Drag it left to lighten midtones or right to darken them. Doing so decreases or increases contrast (respectively) *without* changing the brightness levels of dark shadows and light highlights.

If you're happy with your photo at this point, awesome. If it needs more tinkering, follow the vertical lines attached to the Shadows, Midtones, and Highlights sliders up to the top of the histogram and you'll notice three microscopic triangles (they're labeled back in Figure 5-23). These sliders let you control *which* range of tones is affected when you move the sliders they're attached to. For example, the Shadows and Highlights sliders normally affect tones that are *exactly* halfway between the Blacks and Midtones, or Midtones and Whites. By nudging the tiny range sliders, you can specify exactly which tonal range you change when you mess with the Shadows and Highlights sliders. Similarly, the Midtones slider normally affects tones that are exactly halfway between the black and white points, but you can change that by nudging its ranges slider left or right, say, to affect the lightest midtone shadows or the darkest midtone highlights (respectively). However, doing so also nudges the other range sliders because the Midtone range slider has to stay between them.

If all this Levels mumbo-jumbo makes you want to head for the hills, you're not alone—it's seriously pro-level stuff. Take a deep breath and remember that it's *impossible* to ruin a picture in Photos—if everything goes to heck in a handbasket when you're dragging sliders to and fro, simply click "Revert to Original" and start again. Also, give yourself time to get the hang of using these controls; just because there *are* eight sliders to scoot around doesn't mean you should use *all* of them on every picture. Generally speaking, use the Blacks and Whites sliders *only* if there are gaps on either side of your histogram. Use the Shadows and Highlights sliders to darken or lighten those ranges, and then adjust the overall contrast with the Grays slider. Lastly, fine-tune the overall brightness of specific ranges using the Shadow, Midtone, and Highlight brightness sliders.

Whew! You can relax—the hardest editing lesson is now over.

Copying Adjustments

As you can see, whipping pictures into shape can involve a *lot* of time and slider scooting. If you've got a bunch of pictures that require the *same* fixes—they were all shot at the same time with the same lighting conditions, say—it'd be tedious to

repeat your efforts on every...single...photo. Fortunately, you don't have to do that. You can simply *copy* your adjustment settings from one photo and *paste* them onto another. This can be a gigantic timesaver if you have a slew of images taken under the same lighting conditions.

Apple put a lot of thought into the Copy Adjustments command. Because you only want to copy and paste *general* changes—those that affect lighting and color—that's all the command does. In other words, the only stuff that gets copied are the changes you make with the Enhance and Filter tools and the Adjustments panel. Changes you make with the Rotate, Crop, Retouch, and Red-Eye tools aren't included. (Those last two tools are covered in the next two sections.)

To copy a change from one picture to another, you have to be in Edit mode. There, simply open a photo you've edited (image A) and choose Image→Copy Adjustments or press ⌘-Option-C. Then, open the other picture (image B)—say, using the thumbnails browser (page 108)—and then choose Image→Paste Adjustment or press ⌘-Option-V. When you do, Photos applies the color and lighting corrections you made to image A onto image B.

> **TIP** You can also Control-click a photo in Edit mode and choose Copy Adjustments or Paste Adjustments from the menu that appears.

Unfortunately, you can only paste changes onto one photo at a time; you can't select 100 thumbnails and paste changes onto all of them in one fell swoop. But if you've got a *bunch* of pictures to paste edits onto, you can speed up the process by opening the thumbnail browser and using the arrow keys on your keyboard to navigate through the pictures. Then use the abovementioned keyboard shortcut to paste your changes onto each one!

Retouching Images

There's nothing wrong with a little vanity, and sometimes an otherwise perfect portrait is marred by small yet annoying stuff like a zit, makeup smudge, or stray hair. Other kinds of imperfections can sneak into digital pictures, too. Historians who scan old prints or negatives may digitize scratches, and scanners themselves are notorious for introducing dust specks. Or maybe your camera's sensor is a little dirty so you end up with the same spot on every picture. As you likely know, fixing these common problems is called *retouching*.

> **TIP** One of the most common retouching tasks is whitening teeth. Unfortunately, you can't do that in Photos, nor can you add digital makeup, brighten eyes, perform a tummy tuck, inject digital collagen into lips, or slim your subject. Those high-end retouching jobs are reserved for more advanced programs like Adobe Photoshop or Photoshop Elements.

Happily, you can easily fix such problems with Photos' Retouch tool. It lets you paint away scratches, spots, hairs, or other small flaws with a few quick strokes, as Figure 5-25 illustrates.

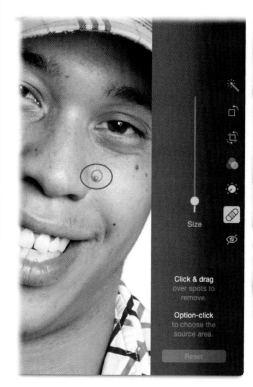

FIGURE 5-25

When using the Retouch brush, resize your cursor (circled) so it's slightly bigger than the item you want to remove, like this mole. When the item fits easily inside your cursor, a single click is all it takes to remove it.

The Retouch tool works its magic by copying pixels from one area of your photo to another and then blending them (blurring, really) into the pixels you click or drag over. To use the Retouch tool, head to the main screen of Edit mode (page 106), and then either click the Retouch tool or press the R key on your keyboard. When you do that, your cursor turns into a black circle rimmed with white (so you can always see the circle atop dark *or* light colors in your image). As explained in Figure 5-25, use the Size slider to make your cursor roughly match the size of the item you're fixing. From there, do one of the following:

- **Copy pixels from just outside the cursor's edge.** If you've got plenty of good pixels around the thing you want to get rid of—say, a cloudless sky around a power line or flawless skin around a blemish—then simply paint over it, either by clicking or dragging. When you drag, you see a white overlay that marks your brushstrokes (the overlay is visible at the bottom left of Figure 5-26). When you release your mouse button, Photos blends the copied pixels into the surrounding ones.

- **Copy pixels from elsewhere in the picture.** If you don't have good pixels around the item you want to remove, you can copy pixels from somewhere else in the image instead. This maneuver is called *setting a sample point*, and it keeps you from introducing repeating elements when you're retouching. To perform this task, Option-click the area you want to copy the pixels from (your cursor turns into a plus sign like the one circled in Figure 5-26, bottom left). Next, release the Option key, and then click or drag over the area that needs fixing. As you work, the plus sign marks the area Photos is copying pixels from and you see a white overlay marking your brushstrokes. If necessary, you can Option-click again to set a new sample to remove the item.

> **TIP** You can adjust the size of the Retouch tool's cursor using your keyboard: Press the left bracket key ([) repeatedly to make it smaller, or the right bracket key (]) to make it bigger.

FIGURE 5-26

Top: The water droplets surrounding this snowflake make it difficult to remove. If Photos copied nearby pixels, those water droplets would be repeated.

Bottom: The fix is to set a sample point elsewhere by Option-clicking, as shown here (left). Depending on the size of the area you're fixing, you may need to set a sample point more than once. As you drag across the thing you want to remove, Photos marks your brushstrokes with a white overlay (visible here). The right-hand image here shows the portrait sans the "cheeky" snowflake.

TIP When you set a sample point, try choosing a spot that's as close to the problem area as possible so the texture and color match better. For example, you wouldn't want to repair skin on your model's nose with skin from her knee.

Don't overdo retouching: If you apply *too* much of it, the area you're working on will look noticeably blurry and unnatural, as if someone smeared Vaseline on it. Fortunately, you can use the Reset button below the Size slider to undo individual brushstrokes (you can also choose Edit→Undo or press ⌘-Z). And if you end up with pixel pudding, you can always click "Revert to Original" to obliterate all the edits you've made.

Fixing Red Eye

One of the most annoying things about taking photos with a flash is the creepy red eyes it can give people. This happens when the bright light of the flash reflects back from your subjects' eyes and illuminates the blood-red retinal tissue there. That's why red-eye problems are worse when you shoot pictures in low light: Your subjects' pupils are dilated, which lets even *more* light from your flash to reach their retinas.

While today's digital cameras are good at preventing this problem with pre-flash flashes, you can always fix it in with Photos' Red-eye tool. In Edit mode, click the Red-eye icon or press E on your keyboard to activate this tool. Figure 5-27 tells you how to use it.

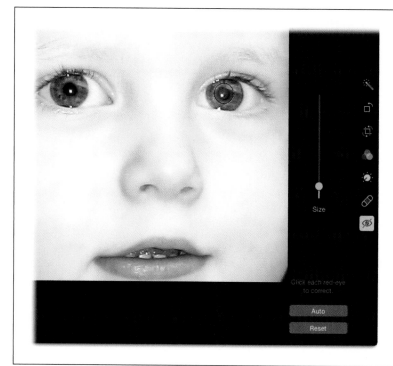

FIGURE 5-27

If you click the Auto button shown here, Photos analyzes your picture and fixes red-eye for you (handy when there are several pairs of eyes in your image). To take matters into your own hands, just click each pupil with the round cursor. Use the Size slider to make the cursor slightly bigger than the problem pupil.

Alas, Photos' Red-eye tool can't fix the equivalent problem in animal eyes because their version of red-eye results in white, green, or golden pupils instead. Bummer!

■ Editing Raw Files

Photos is perfectly happy to work with files shot in *raw* format—the unprocessed file format you can choose on most cameras over $300 or so. To learn how, pull out your camera's owner's manual. (You can't shoot in raw on your iOS device...at least not yet.)

Raw format gets its name because the data is just that: raw and unprocessed. (The term "raw" isn't an acronym, so it doesn't need to be capitalized even though Apple *erroneously* does just that.) Unlike JPEGs, raw images aren't subject to any in-camera processing such as color boosting, noise reduction, sharpening, and the like. If you compare a JPEG and raw file of the same image, the JPEG always looks better because of this in-camera fluffing—but that doesn't mean that, with a little editing work, you can't get the raw image looking just as good or better. Raw files contain more data than JPEGs, so they consume a *lot* of space on your memory card and hard drive, but they give you astonishing amounts of control when editing.

TIP Don't know which photos are raw files? You could pop open the Info panel to find out (page 74) or, in Edit mode, take a peek at the top of the Photos window. If you like, you can gather up *all* your raw files by creating a smart album (page 69): Choose File→New Smart Album and set the menus to "Photo," "is," "RAW." When you click OK, Photos corrals all the raw files in your library into your new album. Slick!

At its heart, Photos is designed to work with JPEGs. So when it grabs a raw file from your camera, it creates a JPEG version of it, but the raw file still exists on your hard drive, deep within the labyrinth known as the Photos Library package (page 39). However, when you open the picture in Photos, you see a JPEG *interpretation* of that raw file. (This conversion to JPEG is one reason Photos takes longer to import raw files than files in other formats.)

This trick of using JPEG look-alikes as stand-ins for your raw files has two important benefits. First, it lets you work with your pictures at normal Photos speed, without the long minutes of calculations you'd endure if you were working with the original raw files. Second, remember that images in your Photos library are accessible from within iMovie, Pages, and so on—programs that don't understand raw files.

So what happens when you *edit* one of these raw-file stunt doubles? Photos applies your changes to the JPEG version of the photo. If you want to go back and start over with the original raw file, choose Image→Reprocess RAW.

Speaking of shooting in raw format, some cameras let you shoot in *both* raw and JPEG formats, meaning that each time you snap the shutter, two files are captured: one in raw format and another in JPEG. (As you may imagine, doing this fills your camera's memory card in no time flat!) When you import those images into Photos,

it considers the JPEG files the originals, and therefore reverts to them when you use the "Revert to Original" command. If you prefer to revert to the raw file instead for a particular image, open the image in Edit mode, and then choose Image→"Use RAW as Original." (Unfortunately, there's no preference in Photos that you can use to say, "I *always* want you to use the raw image as the original.")

Beyond Photos

Thanks to the incredible power tucked inside the Adjustments panel, you may find that Photos lets you do everything you could ever hope to do with your pictures. But then again, if you really take a shine to image editing, you may want to expand your skillset beyond what Photos can do.

For example, if you want to edit certain *parts* of an image—say, to lighten or darken certain areas, smooth skin, whiten teeth, or create a partial-color effect—you need a program such as Adobe Photoshop Lightroom ($150 for a standalone version or $10 per month for a subscription that includes Photoshop). It's a database, just like Photos, so you can use it to import and manage images, plus it includes similar controls to those in Photos' Adjustments panel, though a whole lot more. You can also use it to create pro-level photo books, slideshows, and web galleries.

If, on the other hand, you want to do stuff like combine images for compositing (think swapping people's heads, Hollywood special effects, and graphic design projects), collaging (think scrapbooking), and work with text, you need the more advanced editing power of a program that supports *selections*, *layers*, and *masking*. Adobe Photoshop is by far the most popular tool for these kinds of tasks, but it's also one of the most complicated pieces of software known to man (happily, *Photoshop CC: The Missing Manual* can ride to your rescue). It's also available only by subscription. Fortunately, you can save yourself some money by buying Photoshop *Elements* instead. It's an easier-to-use, trimmed-down version of Photoshop with all the basic image-editing stuff and just enough of the high-end features. It costs less than $100 and is available without a subscription; you can get a free, 30-day trial from *www.adobe.com*. Another good option is Pixelmator ($30); you can buy it or download a free trial version from *www.pixelmator.com*.

> **NOTE** Your humble author has written several books and recorded numerous video courses about Photoshop, Photoshop Elements, and Photoshop Lightroom. You can find them all on her website, *PhotoLesa.com*. Also, watch for her weekly column on *Macworld.com*, where you'll find tips, tricks, and tutorials on creative things you can do on your Mac.

As mentioned earlier, Lightroom is a database, so you can easily use it to import and manage your images. However, the other programs listed in this section are not. Photoshop comes with a companion program called Adobe Bridge that can help you keep track of your stuff, but it's no database (and there are rumors of it being phased out). Photoshop Elements, on the other hand, has a database component

called the Organizer, but it's notoriously difficult to use. And Pixelmator doesn't include a database at all. So if you want to edit images in those other programs, you may want to keep using Photos to import and manage your collection. As noted at the beginning of this chapter, Photos doesn't let you easily use other programs to edit images. Instead, you have to export a picture (page 231), and then open it in the other program. Then, to make the edited version appear in Photos, you have to reimport it (page 27).

Slideshows and Movies

When it comes to showing off your pictures and videos, nothing beats a great slideshow. Imagine watching your digital memories take over your entire screen, set in motion through smooth animations and transitions, complete with background music. It's one of the simplest and most impressive Photos stunts you can pull off.

Such personalized and polished cinematic experiences are easy to create because Photos does all the heavy lifting. All you have to do is pick the images you want to include, and then fiddle with a few settings. The program includes several animated themes that get your images moving, and automatically pairs each one with a specially selected, high-quality soundtrack (though you can use your own music if you prefer).

You can trigger collection-, moment-, or album-based slideshows *instantly*, which is handy when you've got a neighbor or delivery guy trapped in your house for a few minutes. In fact, the program is riddled with play buttons for just this purpose; you see one when you point your cursor at a collection or moment in Photos view, when you view the contents of an album, and so on.

Or, if you prefer, you can take your time and prepare a slideshow project to play at your parents' anniversary party, your next photography club meeting, or whatever. These *saved* slideshows are highly customizable. In addition to choosing a theme and music, you can determine how long each slide stays onscreen; choose the style, speed, and direction of transitions for each slide; and add custom text. When you're finished, you can export the slideshow as a movie file for sharing with others or for playing on another device.

Photos also lets you edit the videos you capture with your camera and iOS devices. You can't do a *lot* to them, but you can trim footage off the beginning and end, as well as export video frames as still images. And if you shoot slow-motion video on an iOS device, you can specify when the footage slows down and speeds up (a slick trick).

In this chapter, you'll learn how to craft instant and saved slideshows in Photos, as well as how to edit videos (tips for editing video in QuickTime Player are included, too). You'll also discover how to play a slideshow on an Apple TV, export slideshows and videos you've edited, share those files with others, and transfer them onto your iOS devices.

Slideshow Basics

Your slideshow journey starts by telling Photos what pictures and videos you want to include. You can base your slideshow on a moment or collection you're viewing, a whole album (including Faces, Last Import, Favorites, and so on), multiple albums, or specific thumbnails. Simply choose the photos/videos you want to include by selecting an album, a collection, or individual photos using the techniques described on page 57. After you've done that, you can trigger a slideshow in two different ways:

- **Instant.** Think of instant slideshows as quick and temporary—you can't customize them very much, add text, or save and export them. To start one on a Mac, click one of the triangular play buttons you see throughout Photos, or Control-click any album and choose Play Slideshow. Either way, the Themes pane appears and lets you pick an animation style for the slideshow (you'll learn about themes in a minute). Photos displays a small preview of your slideshow at the top of the pane and starts playing music. (To change the music, click the Music tab at the top of the pane, or just silence the music by muting your Mac's audio.) If you click Play Slideshow at the bottom of the pane, your pictures take over your screen.

> **NOTE** You can create instant slideshows in Photos for iOS, too, though you don't get a choice of themes (but you can pick a transition style). And just like on a Mac, you get to pick a song to use as the show's soundtrack. Skip ahead to page 161 for the full scoop.

- **Saved.** This kind of slideshow produces a saved project that you can play and export. Slideshow projects are highly customizable, just like Photos' other projects (the books, cards, and calendars described in Chapter 9). You can add text to any slide, control slide order and timing, fiddle with transition styles, fit the slideshow to the music you've picked, and so on. Unfortunately, you can only create saved slideshows in Photos for Mac, not in Photos for iOS.

In this chapter, you'll learn everything there is to know about both kinds of slideshows, as well as how to export saved slideshows so you can share them with others.

NOTE The slideshows you make in Photos play on one screen at a time. So if you've got more than one monitor plugged into your Mac or if your laptop is plugged into an external monitor, the other monitor goes black so it doesn't distract from the show. To create a slideshow that plays on *both* screens, you need to use your Mac's screensaver preferences to tunnel into your Photos library. See page 229 for the scoop on this impressive trick.

Picking a Theme

Photos for Mac sports several slideshow presentation styles called *themes*, which add personality to your slideshow through graphical embellishments and animations. Friends and family will declare you a computer wizard and swear you spent hours crafting the visual feast that is your slideshow when in fact all you did was click a button to pick a theme (let this be your little secret). (You don't get to pick themes when playing a slideshow in Photos for iOS.)

You get the same set of themes with instant slideshows as you do with the saved variety. Your choices are Ken Burns, Origami, Reflections, Sliding Panels, Vintage Prints, Classic, and Magazine. Rather than reading descriptions of each theme, it's far more fun to preview them yourself (Figure 6-1 explains how). The box on page 158 has more about the Ken Burns theme.

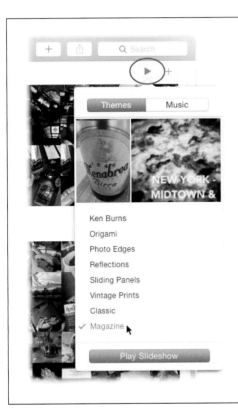

FIGURE 6-1

When you kick off an instant slideshow (as shown here in Collections view), at the top of the Themes pane, Photos previews what each theme will look like applied to the first few pictures you selected. Click through the various options to find your favorite. Saved slideshows, on the other hand, include a handy Preview button you can use to test-drive a theme. You'll learn more about that on page 163.

Photos doesn't have as many slideshow themes as iPhoto. Apple removed Snapshots, Scrapbook, and the super-cheesy Photo and Holiday Mobile themes, along with Shatter and Places. If you import a slideshow project from iPhoto that uses one of those themes, Photos automatically substitutes the Classic theme instead.

Choosing a Soundtrack

Apple understands the importance of background music, so each slideshow theme is paired with a specific *theme song* licensed for your slideshow-viewing pleasure. However, you're not stuck with tunes by the likes of Randy Newman, Miles Davis, and Vince Guaraldi. Using the Music pane shown in Figure 6-2, you can access your iTunes library and pick the songs *you* want to use as a soundtrack.

Using your own music lets you control the mood of your show. For example, if you vacationed in Hawaii and came home with a bunch of slack-key guitar music, suck those CDs into iTunes and then use a few songs as background music. If you partake in winter holiday festivities, you can create a smart album that contains all the pictures you took in December, and then pair it with your favorite holiday tunes. The creative possibilities are endless.

Alas, the Music pane only lets you see the *artists* and *songs* in your iTunes library; you can't see any playlists you've made or music you've handcrafted in GarageBand (Apple's music-recording app). There are other surprising limitations, too. As of this writing, you can't select whole albums to use as a soundtrack, and the Music pane for an instant slideshows lets you pick just one song per show. The song repeats until the slideshow ends. The Music pane for a slideshow project, on the other hand, lets you pick as many songs as you want (page 165 has details).

FREQUENTLY ASKED QUESTION

Who's Ken Burns?

What's up with Apple naming a theme after some dude? Can I get an effect named after me?

No, not unless you're a famous filmmaker. If you've watched many documentary films, you may have noticed that they often feature static photographs. However, sticking a non-moving picture into the middle of a movie or TV show is extremely boring to viewers. So to give the illusion of motion, filmmakers began panning their cameras around still photos, zooming in and out of the area of interest. The person most famous for this technique is Ken Burns; you may have seen his PBS documentaries such as *The Civil War*, *Jazz*, or *The National Parks*. With

Burns' permission, Apple adopted this technique and named a slideshow theme after him.

When you choose the Ken Burns theme, your pictures slide gracefully onto the screen, and Photos slowly zooms in and out of areas it deems important. Due to the program's facial-recognition abilities, the people in your pictures (mostly) stay within view at all times, though other objects may not fare as well and can be left hanging just offscreen and out of view. If that happens, pick another theme. Unfortunately, Photos doesn't let you control where the Ken Burns theme's panning and zooming begins and ends.

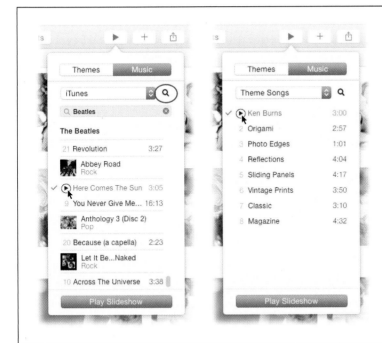

FIGURE 6-2

Left: The Music pane lets you scroll through the artists in your iTunes library. Click the magnifying-glass icon circled here to open the search field so you can enter an artist or song's name. Click a song to select it, or preview it by pointing your cursor at it and then clicking the play button that appears (click the same button to stop the preview).

Right: Choose Theme Songs from the panel's drop-down menu to mix and match slideshow themes with their Apple-assigned theme songs (say, to play the Ken Burns theme song with the Vintage Print slideshow theme).

NOTE Due to copyright laws, you can't use DRM-protected music in a slideshow (DRM is short for "digital rights management"). DRM-protected songs appear gray in the Music pane. If you're the determined sort and you double-click a DRM-protected song, Photos displays a message shaming you into making a different selection. This restriction keeps you from violating copyright laws by, say, exporting a slideshow movie that includes your favorite Beatles song and posting it on YouTube.

This could also be the reason Photos won't let you choose whole albums or playlists for background music: Maybe Apple doesn't want to disappoint you when DRM-protected music refuses to play.

Oddly, there's no way to turn *off* slideshow background music. If you don't want any tunes to play, you have to mute your Mac's audio. Bummer!

Creating Instant Slideshows

There's precious little setup required before creating an instant slideshow on a Mac: All you have to do is tell the program what pictures and videos to include. (The next section explains how to create these slideshows on an iPad.) While you can't customize an instant slideshow beyond switching themes and music—you can't even loop it so it plays continuously—creating one is the quickest way to show off your photos when a viewing opportunity arises.

You can start an instant slideshow in a variety of ways, depending on what you're viewing in the Photos window:

- **In Photos view,** point your cursor at a moment or collection, and then click the play button that appears above the thumbnails on the right. When you do, Photos automatically selects all the thumbnails in that moment or collection. (While you can click the play button in Photos' toolbar, doing so doesn't make the program select the thumbnails for you.)

- **In Albums view,** Control-click an album and choose Play Slideshow from the shortcut menu shown in Figure 6-3, top. To play an instant slideshow of *multiple* albums, select them by ⌘-clicking each one, and then Control-click one of the selected albums and choose Play Slideshow. The albums play in the order in which they appear in Albums view.

To play a slideshow of the currently open album's contents, make sure you don't have any thumbnails selected by clicking an empty area between two thumbnails, and then click the + button in Photos' toolbar and choose Slideshow. Photos automatically includes all the images inside the current album in your show. (If you did have a thumbnail selected, only that image gets included in the show.) To play a slideshow of just a few pictures in the album, select their thumbnails first (page 57), and then play the show.

To control the order of pictures *inside* each album, you have to rearrange them before you start the slideshow. Just double-click the album to open it, and then drag the pictures to reorder them. Doing so lets you handcraft a storytelling experience instead of displaying pictures in random order.

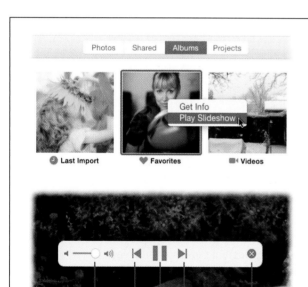

FIGURE 6-3

Top: You can trigger an instant slideshow from nearly anywhere in the program. In Albums view, just Control-click any album—even those created by Photos—and choose Play Slideshow.

Bottom: If you wiggle your mouse (or touch your trackpad) while a slideshow is playing, you reveal the handy controls shown here. Within a few seconds after you let go, the slideshow controls disappear.

NOTE As of this writing, you can't trigger an instant slideshow while in Year view, but you can dip into Albums view and play a slideshow based on the All Photos album. While there's no *official* limit to the number of pictures a slideshow can contain, it's possible that you may have too many pictures for your Mac's memory to handle, causing Photos or your Mac to crash.

- **When viewing the contents of an album,** click the play button in Photos' toolbar (it's visible in Figure 6-2).

- **In the sidebar (page 18),** Control-click an album and choose Play Slideshow from the shortcut menu.

TIP To pause a slideshow that's playing, press the space bar on your keyboard, and then press it again to restart the show. To move through the slides manually, use the left and right arrow keys on your keyboard to go backward or forward (respectively). To end a slideshow, press the Esc key or wiggle your mouse to summon the slideshow controls, and then click the X labeled in Figure 6-3, bottom.

And that, dear friends, is all there is to an instant slideshow. You don't have any other customization options, at least not in Photos for Mac: You can't loop the show, change slide timing or transitions, or save or export it. To do any of that, you need to create a saved slideshow project as explained starting on page 163. (As you'll learn in the next section, the Settings app gives you a few more instant slideshow options in Photos for iOS.)

Instant Slideshows in Photos for iOS

You can play an instant slideshow in Photos for iOS, too, though you don't get to pick a theme (you get to pick a transition style instead). The process varies ever-so-slightly on iPads versus iPhones and iPod Touches, as this section explains.

NOTE While Photos for iOS doesn't give you any way to customize slideshows beyond transition style and (one) song choice, you can employ other apps to spice up your iOS slideshows. Check the App Store for third-party slideshow options such as Flipjam and Slideshow Builder Lite. Just enter *slideshow* in the Search field to see what apps are currently available.

Either way, to trigger an instant slideshow on your iOS device, you have to be viewing the contents of an *album* in Photos. So tap Albums, and then tap an album to open it. If you're on an iPad, tap the word "Slideshow" at the program's upper right and you see the Slideshow Options pane shown in Figure 6-4. On an iPhone or iPod Touch, you don't see a Slideshow option. Instead, tap the first thumbnail in the album to open it (or whatever image you want to play first), and then tap the Share icon at the lower left. In the row of icons that appears at the bottom of your screen, swipe left to scroll horizontally, and then tap the Slideshow icon (it looks like a big play button) to reveal the Slideshow Options pane. To control slide duration, looping, and shuffling on an iOS device, you have to use the Settings app. Once you open it, scroll down until you see Photos & Camera. Give it a tap and then scroll down to the Slideshow section where you'll find three easy to use controls (who knew?).

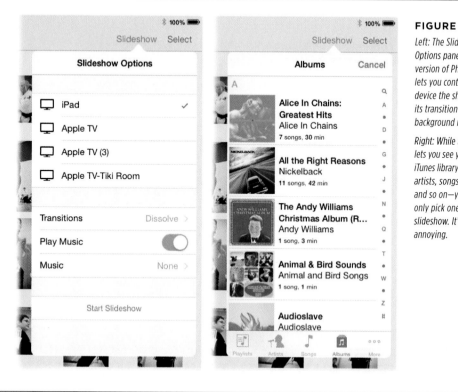

FIGURE 6-4

Left: The Slideshow Options pane in the iPad version of Photos for iOS lets you control what device the show plays on, its transition style, and its background music.

Right: While the Music pane lets you see your entire iTunes library—playlists, artists, songs, albums, and so on—you can still only pick one song per slideshow. It's extremely annoying.

The first section of the Slideshow Options pane lets you pick what device to play the slideshow on (it's automatically set to iPad). If you're on a wireless network that includes an Apple TV, it's included in the list, too. This lets you pull off a slick stunt: You can play the slideshow on the TV connected to the Apple TV (obviously, the Apple TV and the TV itself have to be turned on for this to work). Give it a try the next time your neighbor pops over with vacation photos on their iPad; you'll blow people's minds when you effortlessly project a slideshow of their photos onto your big-screen TV.

> **TIP** As the box on page 175 describes, you can use AirPlay on your iOS device to peruse your Photos library on an Apple TV-connected screen. In other words, you don't have to create an instant slideshow to view your pictures on a TV screen.

The pane's next option lets you control the type of transition Photos uses between pictures. Just tap the word "Transitions" to reveal a list of your options: Cube, Dissolve, Origami, Ripple, Wipe Across, and Wipe Down. Tap the transition style you

want and Photos returns you to the Slideshow Options pane. To stick with the same transition, just tap Back at the pane's upper left.

Unlike Photos for Mac, Photos for iOS doesn't automatically assign background music to your slideshow. If you want a soundtrack, tap the Play Music switch (it turns green), and then tap the word "Music" that appears beneath it (see Figure 6-4, left) to access your iTunes music library (Figure 6-4, right). Use the buttons at the bottom of the resulting pane to find the song you want to play, and then tap the song to select it. Finally, tap Start Slideshow to play the show.

▪ Saved Slideshows

This is where the real slideshow fun begins. By creating a *slideshow project*, Photos saves your slideshow as a clickable icon in Projects view so you can play it again later with the same settings or continue editing it. Saved slideshows are far more customizable than their instant siblings. For example, you can rearrange the slide order, pick more than one song for background music (yay!), control song order, and set the duration of the show to match the music, among many other options.

You can also export saved slideshow projects to share them with others, post online, or sync onto your iOS device. As you'll discover, saved slideshows are as suitable for creating portfolios of your photography or other artwork as they are for showing off vacation pics.

NOTE Seasoned iPhoto slideshow creators will enjoy Photos' simplified controls for customizing slideshows. However, one casualty of that simplification is that, as of this writing, there's no way to pull captions from the image titles or descriptions you've added in the Info panel like you can in iPhoto. The fix is to add a text field to your slides instead. Page 169 explains how.

Creating a Saved Slideshow

Here's how to create a surprisingly sophisticated slideshow:

1. **Select some pictures and/or videos, and then choose File→Create Slideshow, or click the + button and then choose Slideshow.**

 You can create a slideshow from an album, multiple albums, or individual thumbnails. You can also start a slideshow project from a moment or collection you're perusing in Photos view. As Figure 6-5 explains, this route doesn't require you to make a selection first.

TIP For the smoothest slideshow-editing experience, before you create your slideshow project, gather your pictures and videos into an album and drag them into the order you want them to appear. While you *can* adjust slide order once you've created your project, it's easier to do it in an album where you can make the thumbnails big enough to see.

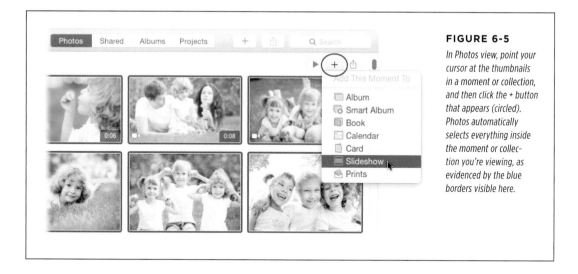

FIGURE 6-5

In Photos view, point your cursor at the thumbnails in a moment or collection, and then click the + button that appears (circled). Photos automatically selects everything inside the moment or collection you're viewing, as evidenced by the blue borders visible here.

NOTE Technically, you can create a saved slideshow using the + button in Photos' toolbar, instead of the one that appears when you point to a moment or collection, but Photos won't select the thumbnails for you if you do. So reserve the toolbar's + button for creating projects while viewing the contents of an album.

2. **In the resulting pane, enter a name for your show, and then click OK.**

 Photos drops you into the slideshow editor shown in Figure 6-6. You see your pictures and video as numbered thumbnails at the bottom of the window, and a preview of the first slide takes center stage with the slideshow (or album) name superimposed on it. Icons for themes, music, and settings are on the right. (Behind the scenes, Photos creates a thumbnail for your slideshow in Projects view. You can click the tiny play button in this thumbnail's lower right to play the slideshow *without* opening the project itself.)

NOTE To change the font, size, or color of the slideshow's title, highlight it, and then press ⌘-T to summon OS X's Fonts panel.

3. **Drag the thumbnails into the order you want the slides to play.**

 To change the playback order of your content, drag the thumbnails horizontally. You can reorder thumbnails en masse, too: Just ⌘- or Shift-click to select more than one, and then drag them into place. When you do, the other thumbnails scoot out of the way to make room for the ones you're moving.

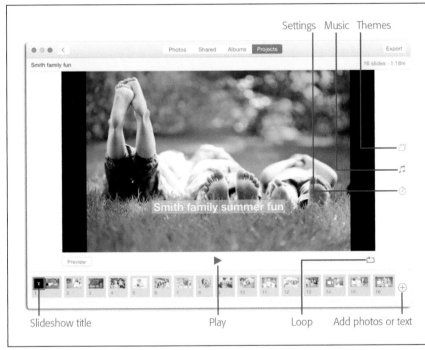

Settings Music Themes

FIGURE 6-6

When you first create a slideshow project, the title slide is active (note the blue border around it at lower left) and Photo displays the slideshow's duration at its upper right (here, that's 1 minute, 18 seconds). To edit the slideshow's name, simply click within the text atop your picture, as shown here.

Slideshow title Play Loop Add photos or text

4. **Click the Theme Picker icon (it's labeled in Figure 6-6), and then pick an animation style (page 157).**

 The slideshow preview shifts leftward and a list of Photos' slideshow themes appears on the right. Just click the name of the theme you want to use. Remember, you can switch themes anytime you want.

5. **Click the Music icon (the eighth notes), and then pick some songs for your soundtrack.**

 Unlike instant slideshows, saved slideshows let you pick *multiple* songs to use as background music. To access your iTunes library, click the down-pointing arrow next to the words "Music Library." You can then scroll through your library or click the tiny magnifying glass next to the drop-down menu to bring up a search field—just start typing the name of the artist or song you want and Photos tries to find it for you. To preview the song, point your cursor at it, and then click the play icon that appears to its left. To select a song for your show, give it a click (the song's name turns blue). When you do that, Photos adds it to the Selected Music section, where you can rearrange the songs into the order you want. Figure 6-7 has details.

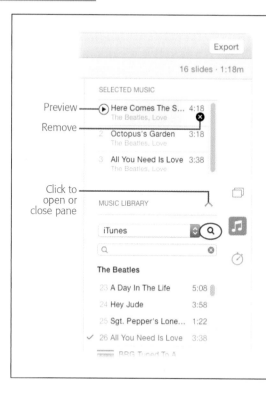

FIGURE 6-7

To remove a song you've added, point your cursor at it, and then click the tiny X labeled here. To change the order of the songs you've selected, drag them up or down in the Selected Music list. You see a thin blue horizontal line as you drag.

6. **Click the Duration Settings icon (the stopwatch), and then adjust the duration of the slideshow, tweak its transitions, and tell Photos whether you want to scale your photos to fit the slideshow's aspect ratio.**

 The Duration Settings icon reveals all manner of options for customizing your slideshow. Some settings affect the whole slideshow while others can affect individual slides, depending on the number of thumbnails selected at the bottom of the window. Here's what all those settings do:

 • **Duration.** Choose "Fit to Music" to adjust the duration of your slideshow to match the length of the music you picked in step 5. Straight from the factory, this option is set to Custom so the length of your slideshow is determined by the duration of the individual slides (discussed next).

 • **Play Selected For.** This option lets you specify how long each picture stays onscreen. To turn it on, you must have at least one thumbnail selected at the bottom of the window, as Figure 6-8 shows (and it can't be a video). If you want all the slides to remain onscreen for the same length of time, select them all by pressing ⌘-A. (If there are videos in your slideshow and

you use this keyboard shortcut, Photos still selects them, but ignores the duration setting you enter.)

Resist the urge to keep photos onscreen for longer than 5 seconds, or your viewers may feel like hostages. After all, you can always pause the slideshow to admire a certain picture for longer if you want to.

NOTE The Play Selected For setting doesn't apply to videos. If you include a video in a slideshow, Photos plays the whole thing before moving on to the next item in the slideshow.

- **Transition, Speed, Direction.** Use these options to specify a transition style, its speed, and which direction you want the transition to move (say, up or down, left or right). The number of slides these settings affect depends on how many thumbnails you have selected at the bottom of the window. The tiny preview beneath these settings lets you see what your transition will look like.

NOTE With great power comes great responsibility. Just because you *can* set a different transition style for every slide doesn't mean you should. Generally speaking, it's best to stick with one to three transition styles for the duration of your slideshow. Otherwise, the transition animations will become the focal point of the show instead of your pictures.

- **Scale photos to fit screen.** This option lets you determine whether, when you play your slideshow, Photos enlarges the pictures in it to fill the screen. This checkbox is automatically turned on, so Photos fits 100% of each image onscreen; that's why you see black bars on either side of them.

 If, on the other hand, you want the photo to fill the screen (in other words, no black bars), turn this option off. Doing so crops the image, so be sure to preview your slides to determine whether this setting works for your slideshow (unless Cousin Andy is positioned at the left or right edge of your picture, it probably will). If you find that people are getting cut in half, you can *reposition* each photo within the slideshow frame. Simply select the thumbnail you want to adjust, and then drag the photo in the main preview area to reposition it so the important bits are in view (see Figure 6-8). It's worth taking the time to do this for every slide in your show.

As you can imagine, these settings let you dig in and customize your slideshow in incredible ways. For example, you can make prizewinning photos remain onscreen longer than others, and you might mix up your transitions a little to add visual interest. Doing so is especially helpful if you're creating a portfolio piece to showcase your photography or other artwork (say, to post online).

7. **Preview your slideshow.**

Click the Preview button below the main preview area to see your slideshow. If you've got a thumbnail selected at the bottom of the window, that's where the preview starts. Click Preview again to stop the playback.

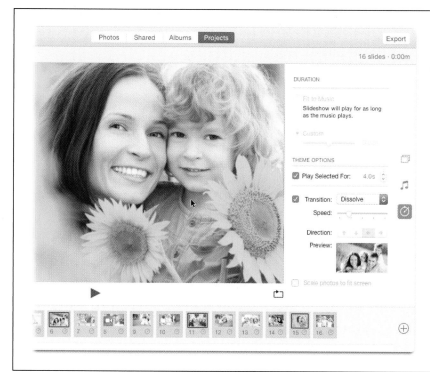

FIGURE 6-8

To make your best photos remain onscreen longer than the rest, select them at the bottom of the window, and then adjust the Play Selected For setting (three thumbnails are selected here).

Once you turn off the "Scale photos to fit screen" checkbox, Photos enlarges your images to fill the screen. By dragging the photos in the main preview area, you can reposition them within the frame.

8. Set your looping option and roll the show!

From the factory, your slideshow is set to loop (repeat) continuously. To make it play just once and end, click the Loop icon labeled back in Figure 6-6 so it turns black (as shown in Figure 6-8).

To play your slideshow from start to finish—or to see a larger preview—click the triangular play button below the preview area, and the slideshow takes over your Mac's screen. (The play button starts your slideshow from the beginning even if you have a slide selected at the bottom of the window.) See the Tip on page 161 for info about pausing, controlling, and stopping a slideshow while it's playing.

When you're finished, there's no need to save your project; Photos does that for you automatically. To exit the slideshow editor, simply click one of the view tabs at the top of the Photos window. The next time you dip into Projects view and double-click the slideshow to open it, you'll find all your customization work fully intact. (If you only have one project, it opens automatically.)

Deleting and Duplicating Slides

To delete content from your slideshow, simply open it in the slideshow editor (go to Projects view and double-click the slideshow's thumbnail), select the offending thumbnail(s) at the bottom of the window, and then press the Delete key on your keyboard. Photos won't ask if you're sure—it simply removes the selected items. If you change your mind, you can press ⌘-Z to undo the deletion, so long as it was the last thing you did.

If you decide to delete the *entire* slideshow, just pop into Projects view (or click the Back button if you're in the slideshow editor), select the slideshow's thumbnail, and then press the Delete key. Photos asks if you're certain—click Cancel to keep the slideshow or Delete to send it packin'. Alternatively, you can Control-click the slideshow's thumbnail in Projects view and choose Delete Slideshow from the shortcut menu. The same shortcut menu also lets you duplicate a slideshow, which can be handy if you want to experiment with different slideshow settings without messing up what you've already done.

Adding Text and Photos

Photos lets you put custom text on any slide you want. As you may imagine, this presents more captioning opportunities than you can shake a stick at. And if you somehow forgot to include that shot of you cavorting with Paul McCartney, you can easily add it to your slideshow project.

Both maneuvers involve the Add button at the slideshow editor's lower right (it looks like a circled + sign and is labeled back in Figure 6-6). However, before you click this button, take a moment to select the thumbnail of the slide you want to add text to or, if you're adding pictures, click the thumbnail you want to *precede* the new content. Then, click the Add button and do one of the following:

- **To add text to a slide, choose Add Text.** Photos adds a text icon (labeled in Figure 6-9) to the thumbnail and the words "Default Text" appear atop the image. Highlight the placeholder text by clicking it and then pressing ⌘-A or by triple-clicking it, and then enter the text you want. You can't change the position of the text, but you can its font, size, and color by pressing ⌘-T to summon OS X's Fonts panel. Figure 6-9 has more info.

 To delete text you've added to a slide, click the Title icon, and then press the Delete key on your keyboard.

- **To add pictures (and/or videos), choose Add Photos.** Photos transports you into Moments view so you can scroll to find and select items to add, as shown in Figure 6-10. When you're finished, click the Add button at the program's upper right. Photos returns you to your slideshow project and adds the content *after* the selected thumbnail.

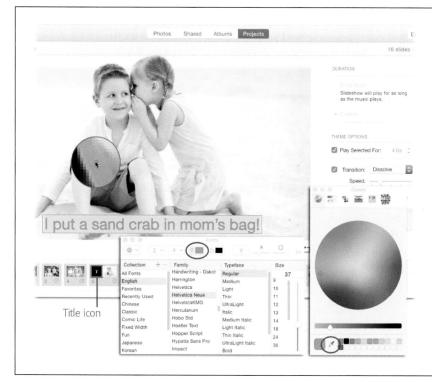

FIGURE 6-9

Once you open the OS X Fonts panel, you can change the text's formatting. Click the color swatch (circled, left) to open the Colors panel shown at right. To copy a color from your image, click the eyedropper icon (circled, right), and then click a color in your image (say, this boy's turquoise shorts). Doing so adds a classy touch to your captions and makes them feel like they're part of the slideshow and not tacked on at the last second.

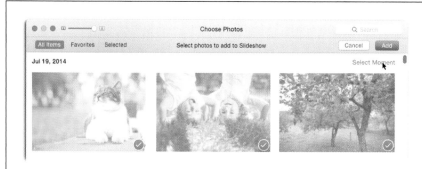

FIGURE 6-10

When adding content to a slideshow, point your cursor at a moment, and the words "Select Moment" appear at upper right. Click it to select all the images in that moment. The Favorites button at upper left lets you view and select items in the Favorites album. The Selected button shows the pictures you've picked to add to your slideshow, as well as the images that are already in it.

Exporting a Slideshow

After spending all that time carefully crafting your saved slideshow, you'll likely want to share it with others. Fortunately, Photos can easily export it in a popular format (.M4V, to be exact) in the size of your choice that folks can play on most any device. You can also send the slideshow over to iTunes so you can sync it onto your iOS devices.

To get the export party started, open the project in the slideshow editor, and then click Export in Photos' toolbar; the Export pane shown in Figure 6-11 appears. Enter a filename for your soon-to-be-exported slideshow, and then use the Where menu to tell Photos where to store it on your hard drive (initially, it automatically chooses your Movies folder, which is as good a choice as any). Next, choose an option from the Format menu. Here are your choices:

> **TIP** You don't *have* to have the slideshow editor open to export a slideshow project. Alternatively, go to Projects view, select the slideshow's thumbnail it, and then choose File→Export→Export Slideshow.

- **Standard Definition (480p).** This option gives you a resolution of 640 × 480 pixels, which is great for transferring onto an iPod Touch (third generation), iPhone 3GS, iPad 1, and Apple TV (first generation). This option produces the smallest file size, so it's a good choice if you plan to share the slideshow with someone who doesn't have high-speed Internet access.

- **High Definition (720p).** Choose this option to produce a resolution of 1280 × 720, which makes for a larger file size but it looks fantastic onscreen. This option is great for iPod Touch (fourth generation), iPhone 4, iPad, Apple TV (second generation), and for posting home movies on Facebook or YouTube (Google's free video-sharing site), or for sharing movies using a file-transfer service like iCloud Drive or Dropbox (see page 173).

- **High Definition (1080p).** This option produces a resolution of 1920 × 1080 pixels, which is perfect for viewing on the latest and greatest iOS devices, Apple TVs, and TV screens. The file size will be humongous, but the movie will look awesome. (You can post a movie of this size on YouTube, though it'll take forever to upload. However, if you're out to win a photo competition, the extra time might be worth it for the quality you gain.)

The "Automatically Send to iTunes" checkbox at the bottom of the pane sends the exported movie to the Home Videos section of iTunes, which lets you sync the movie onto your iOS devices (you only see the Home Videos section after exporting a movie in this way). Likewise, the resulting video can be found in the Home Videos section of the Videos app on your iOS device.

When you get the settings just right, click Save. Photos compiles and compresses your slideshow into a movie file that anyone can play. You see a status bar along with a Cancel button that lets you bail out of the export process if you realize you want to edit the slideshow some more.

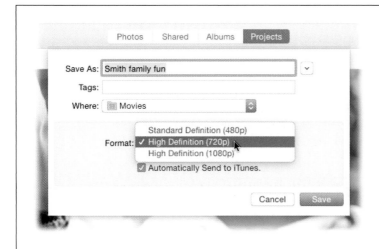

FIGURE 6-11

If you plan to upload the exported movie to a website, be sure to take the spaces out of the filename (the text in the Save As field). However, this isn't necessary if you're going to upload it to Dropbox.com in order to share with someone else—Dropbox automatically swaps in a % character for each space it encounters.

Sharing Exported Movies Online

With all the fancy animation and transition styles tucked into your slideshows, the file size of exported slideshows is *huge*—especially if you include videos in them. The question that naturally arises is how to share these honkin' big files with other people. The answer depends on the file's size and how you want to send it. Here's a roundup of your choices:

- **AirDrop.** To transfer a movie file between Macs on the same network, open an AirDrop window on the sending and receiving Macs, and then drag the file onto the recipient's icon. There's no official file-size limit with this method, but your results may vary if the file is really big—say, over 20 gigabytes. (Page 227 has more on using AirDrop.)

- **Apple Mail.** If you're signed into your iCloud account *and* you use Apple's Mail app, you can email the movie—or any large file—using OS X's Mail Drop feature. Just attach the exported movie to an email like you normally would, and then click Send. In the background, Apple uploads the file to iCloud, and then downloads it onto the recipient's machine when they retrieve their email. Your recipient will have no idea that iCloud acted as an intermediary for the file transfer; they simply see the movie as an email attachment. Mail Drop works for files up to five gigabytes in size. (Happily, Mail Drop file transfers don't count against your total iCloud storage allotment.)

- **iCloud Drive.** This is the name for the online storage space you get with an iCloud account. When you upload files to iCloud Drive, you can download them onto another computer (Mac or a PC running Windows 7 or later) or iOS device. Files can be up to 15 gigabytes in size, but you can't exceed your overall iCloud

storage limit (you get five gigabytes with a free account and substantially more with a paid account, depending on the plan you pick). There are two ways to upload files to iCloud Drive:

— **In the Finder,** choose Go→iCloud Drive or press ⌘-Shift-I to open an iCloud Drive window. You can also open a Finder window and click iCloud Drive in the Favorites section at the upper left of the sidebar. Next, drag the file(s) into the iCloud Drive window to upload them.

— **In the Photos Export pane (or any Save pane that you encounter when saving a file in OS X),** choose iCloud Drive as the location to save your file. This works in any app, including Photos. This lets you export items straight to your iCloud Drive—say, a saved slideshow (page 163) or video you're exporting (page 180).

Downloading iCloud Drive goodies onto your Mac is as easy: Just open an iCloud Drive window in the Finder, and then drag the file(s) onto your Mac's desktop. Annoyingly, as of this writing, downloading files from iCloud Drive onto an iOS device requires another app such as the free Documents app by Readdle Inc., or the $1.99 iCloud Opener. Once you download the app, use its Open command to access your stuff. This process is tragically clunky, but it works great and alleviates the need to use iTunes File Sharing to sync big files like exported videos onto your iOS devices.

- **Dropbox.** This free file-sharing service lets you upload big files to its servers and send a download link to others via email. When the lucky recipient is ready to download the file, they click the link in the email they received and the file transfer begins. This is a brilliant, fuss-free, multiplatform way to share files with people who don't use iCloud. To sign up for a free account with two gigabytes of storage space, point your web browser to *http://dropbox.com*. Once you've created your account, Dropbox creates a folder named Public. Double-click it to open it, and then drag your exported movie into it. When it's finished uploading, Control-click the filename and then, from the shortcut menu, choose Share→Mail. Alternatively, you can choose "Copy public link" from the same menu, and then paste it into the body of an email. Either way, once the recipient downloads your movie, you can delete it from the Public folder.

- **Facebook.** If you're a Facebook fan—and billions are—you can post your exported slideshows there for friends and family to enjoy. As Chapter 8 explains (page 208), Photos can upload the videos you capture with your camera or iOS device onto your Facebook timeline, but to upload an exported movie slideshow, you have to visit Facebook.com via a web browser like Safari. As with all things you post on Facebook, you can make your movie public or private. Movies must be less than 40 minutes long and have a resolution of no more than 1280 pixels wide.

- **YouTube.** This free video-sharing site owned by Google is great for posting videos online. You can easily make your files public or private and, once you've uploaded a file, you can share a link to it via email, or send the movie

to Facebook, Twitter, Google+, Pinterest, and so on. A handy Embed option produces a chunk of HTML code that you can use to embed the video onto your own website. Movies must be less than 15 minutes long and have a file size of less than 32 gigabytes.

Another way to upload an exported slideshow movie to social-sharing sites such as Facebook, YouTube, and Flickr is to use QuickTime Player, Apple's free movie-playing app that's installed on every Mac. The box on page 182 tells you how.

Burning Movies onto CDs or DVDs

Hard as it is to believe, not everyone on the planet has an Internet connection, nor is every human equipped with an iOS device or Apple TV (the horror!). So what if you want to send your exported slideshow movie to, say, far-flung relatives in the piney woods of East Texas or rural Italy? The answer is to burn the movie onto a CD or DVD that you send to them via snail mail. When they get it, they can pop the disc into their computer or DVD player and enjoy your handiwork at their leisure.

When you burn an exported movie—or several, space permitting—onto a CD or DVD, you create a data disc, which is like sharing files on an USB-based flash drive. The movie(s) don't start playing automatically when you insert the disc; you have to tell the computer or DVD player which file to play. On a Mac, simply double-click a movie file and QuickTime Player springs into action and plays the file. (On Windows-based PCs, the file may open in Windows Media Player instead, or folks can download QuickTime from *https://www.apple.com/quicktime/download*). On a DVD player, use the arrow keys on the DVD's remote to navigate to the file you want to play, and then click the remote's play button to get it started.

While Photos itself doesn't give you a way to burn slideshow movies onto a CD or DVD, OS X does. The process is described in full step-by-step glory in Chapter 10.

■ Working with Videos

These days, everyone is recording video. Whether you're using a smartphone, a point-and-shoot camera, or a fancy DSLR (digital single lens reflex) camera, high-quality digital video is easy to capture. Photos happily imports and manages videos alongside your pictures and, as you learned earlier in this chapter, you can include videos in your slideshows.

You can't do a whole lot with videos in Photos for Mac, and even less in Photos for iOS. In Photos for Mac, you can view videos at a variety of speeds, trim footage off either end, change the point at which slow-motion videos slow down and speed up, and export a still image from the video as a picture—and that's it. After all, Photos is a *photo* editor, not a video editor like iMovie. The Note on page 178 has more on iMovie, and the box on page 182 explains what you can do with videos in QuickTime Player. In Photos for iOS, you can only view clips at normal speed, but you can trim footage off either end and adjust a slow-motion clip.

TIP Photos helpfully places a teeny-tiny video icon at the lower left of video thumbnails, and the duration at the lower right, so you can spot them while perusing your photo collection. But there's an easier way to find them: Go into Albums view and double-click the Videos folder. All the videos you import automatically go into this built-in smart album. Sweet!

POWER USERS' CLINIC

Viewing Slideshows on an Apple TV

Few Mac maneuvers are as impressive as displaying pictures and videos on your TV. Once you shell out $69 or so for an Apple TV (*www.apple.com/appletv*), the process is simple: Plug your TV into the Apple TV, and then use iTunes or iCloud to control what it displays. The device crafts an instant slideshow from your content using its *screensaver* feature. As of this writing, the Apple TV includes 18 screensaver themes to choose from, and two of them—Classic and Ken Burns—have 14 variations. How's that for variety?

To get an Apple TV-based slideshow rolling, choose Settings on your Apple TV, and then select Screen Saver. You see a list of settings that let you determine when the screensaver starts, whether the screensaver kicks in while you're playing music from your iTunes library, which pictures to display, and what theme to use. Select Photos, and then choose one of the following image sources:

- **iCloud.** This method requires an Internet connection and prompts you to log into your iCloud account (if you haven't already). On the next screen, choose which photos you want to display: My Photo Stream, Activity (the latest updates you've made to shared albums), or any other album you've shared to iCloud using the techniques described on page 211. By using this method, you can project your *own* photos onto someone else's Apple TV, which is incredibly cool.

- **Computers.** With this method, your Mac and Apple TV need to be on the same wireless network (you don't need an Internet connection) and both devices need to have Home Sharing turned on, which lets you share your iTunes library with other computers, including your Apple TV. (Oddly enough, iTunes manages which images are sent to your Apple TV.) To turn on Home Sharing on your Mac(s)—yep, each Mac in your household can play this game—launch iTunes and choose File→Home Sharing→Turn On Home Sharing. When prompted, enter your Apple ID and password, and then click Turn On Home Sharing (if you're turning this feature on for multiple Macs, enter the *same* Apple ID on each one). Next, choose File→Home Sharing→"Choose Photos to Share with Apple TV." A new iTunes window opens to let you pick which program to share content from: iPhoto or Photos. Choose Photos, and then turn on "All photos and albums" to share everything in your library or pick "Selected albums" to reveal a list of all your albums (including Faces albums) so you can select just the ones you want to share. To share exported saved slideshows (page 163) and videos, turn on "Include videos." When you're finished, click Apply. Now go to your living room, or wherever your Apple TV lives, and choose Settings→Computers→Turn On Home Sharing. Enter your Apple ID and on the resulting screen, click Computers. Simply click the computer that has the pictures you want to display, and whatever albums you've shared from that Mac appear in the list—just pick the one you want and your pictures parade across the screen.

While this setup takes some effort, you only have to do it once, and the results are worth it!

Playing Videos

To play a video in Photos, double-click the video's thumbnail or select it and then press the spacebar. Next, point your cursor at the video preview to reveal the control bar shown in Figure 6-12. Click the play button to watch the footage at normal speed. (The play button turns into a pause button, which you can click to stop the playback.)

> **NOTE** Unlike in iPhoto, pressing the spacebar in Photos merely opens and closes the video file; it doesn't start and stop playback.

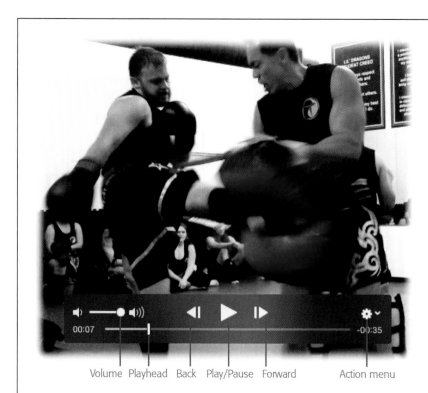

Volume Playhead Back Play/Pause Forward Action menu

FIGURE 6-12

Use the control bar shown here to adjust the video's volume and playhead position, which controls the part of the video you're viewing. The Back and Forward buttons let you step through the footage frame by frame. The control bar disappears when your cursor is still for a few seconds, but you can wiggle your mouse (or touch your trackpad) to bring it back. To reposition the control bar, simply drag it to a new spot.

To play the video at a higher speed, click the gear icon and choose Show Scanning Buttons, as Figure 6-13 shows. Now when you click the Back or Forward buttons, your video increases playback speed to 2x. Keep tapping either button to increase playback speed up to a whopping 60x in either direction. You can also *scrub* through your video by dragging the playhead left or right.

In Photos for iOS, tap the video to open it, and then either tap the big play button that appears on top of it or the blue play button that appears at the bottom of your screen. To pause the video's playback, tap the playing video, and then, in the toolbar that appears at the bottom of your screen, tap the blue pause button. (To start the video playing again, tap the blue play button.)

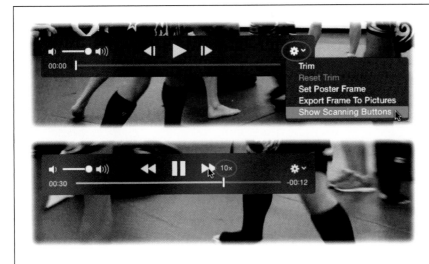

FIGURE 6-13

Top: Click the gear icon (circled) to open this menu. Choose Show Scanning Buttons to play your video at varying speeds.

Bottom: Notice how the Back and Forward buttons change to double triangles to let you know that scanning is turned on. Click either button to increase playback speed; the more you click, the faster it goes. The tiny indicator circled here shows you the current scanning speed.

Trimming Videos

As mentioned earlier, Photos offers precious little in the way of video-editing options. But it does let you trim footage off the beginning or end of your video in order to eliminate boring bits.

> **TIP** Trimming your videos is a wise thing to do, especially the beginning, as that part is typically riddled with camera fumbling, shot framing, and waiting for the action to start. In fact, the *Wadsworth Constant* theorizes that the first 30% of any video is irrelevant, no matter the content (Google that phrase the next time you get a chance). The folks at YouTube apparently agree—if you add *@wadsworth=1* to the end of any YouTube URL, the site automatically skips the first 30% of the video.

To trim a video in Photos for Mac, open it and then point your cursor at it to reveal the control bar. Click the gear icon and choose Trim from the menu shown in Figure 6-13. When you do, the control bar changes to display the individual still images your video contains (if you previously moved the control bar, it also repositions itself near the bottom of the screen). Photos surrounds the stills with a yellow border and places a yellow handle at either end (see Figure 6-14, top). To isolate the part of the video you want to keep, drag the yellow handles inward to where you want the video to begin and end (see Figure 6-14, bottom).

As you can see, trimming footage from your video is a piece of cake. Your edits aren't permanent, either; to bring back the trimmed footage at any time, just click the gear icon and choose Reset Trim.

NOTE Photos can't hold a candle to the editing prowess of iMovie, Apple's video-editing app for Mac and iOS. You can use iMovie to combine still images, video, and text to create a truly one-of-a-kind digital memento complete with Hollywood-style special effects, opening titles, and credits. To learn more about it, check out *iMovie: The Missing Manual*.

Heck, in Photos for iOS, you can send a video straight to iMovie if it's installed on that iOS device. To do so, open the video, tap the Share icon at the lower left, and then tap the More button. In the resulting list of apps, tap iMovie. Neat, huh?

To trim a video in Photos for iOS, tap the video's thumbnail to open it and a control bar appears above it. If you tap and hold the control bar's far left or right edge, the control bar sprouts a yellow border. While you're holding down your finger, drag right or left to trim the beginning or end of your clip (respectively). Once you drag one of the trim sliders, you can lift your finger, and then tap and drag the other trim slider if need be. When you're finished, tap Trim at the upper right and then, on the sheet that appears, tap "Save as New Clip." If you change your mind about trimming the clip, tap Cancel.

Adjusting Slow-Motion Video

When you capture a slow-motion video on your iOS device, you may be annoyed with the apparent lack of control over when the motion slows and speeds up again. The footage *seems* to start out fast, then it slows in the middle and speeds up again at the end; but that's not really what's happening. In the background, your iOS device captures the entire video at a high frame rate, which is what creates the illusion of slow motion. The iOS device then merely speeds up the beginning and end of the video.

Fortunately, you can use Photos for Mac or iOS to control when the action slows to a crawl and gets going again. Or, if you like, you can make the *entire* video play in slow motion.

As you learned in Chapter 3, Photos gathers your slow-motion videos into the Slo-Mo album so they're easy to find. When you open a slow-motion video, you see an extra row of controls in the control bar. Figure 6-15 explains how to use them.

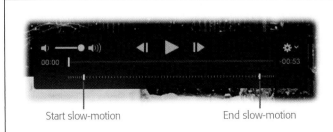

Start slow-motion End slow-motion

FIGURE 6-15

Using the controls labeled here, you can specify exactly when your slow-motion video slows down and speeds up again. By positioning the handles at far left and right, respectively, you can slow the whole video!

TIP On an iPhone 6 or later, you can adjust the frame rate at which your slow-motion video is captured before you start shooting. Grab your device and launch the Camera app, and then swipe rightward until SLO-MO is selected. Take a peek at the lower right of your screen, which displays the current frame rate. Tap it to toggle between the two speeds: 240 FPS (frames per second) and 120 FPS. The frame rate that's listed is the one that the Camera app will use the next time you tap record. However, a higher frame rate produces a slower-looking video, so you'll most likely want to keep your frame rate at 240.

The process for adjusting slow-motion videos works exactly the same way in Photos for iOS: Just drag the sliders that appear beneath the control bar to adjust when the videos slows and speeds up. And unlike trimming a clip in Photos for Mac, you don't have to save your edits as a new clip. In fact, you can open the video and adjust the slow-motion timing as often as you want.

Fun with Frames

In the video control bar (Figure 6-12), click the gear icon and you'll find a couple of menu options that let you access the individual frames in your video. Here's what the two frame-related options do:

- **Set Poster Frame.** Much like setting the key photo in an album (page 63) assigns it as the thumbnail for that album, this command lets you pick a video frame to use as a video's thumbnail. To set a new poster frame, open a video and position the playhead so you're looking at the frame you want to use (the playhead is labeled back in Figure 6-12). Then simply click the gear icon and choose Set Poster Frame.

• **Export Frame To Pictures.** Choose this command to export the frame you're currently viewing as a picture file. This is handy when you want to share, print, or use a certain frame from your video in another project (say, a slideshow, book, card, or calendar). You don't get any kind of status bar or confirmation message when you choose this command; the exported file merely lands in the moment that contains the video.

> **TIP** The easiest way to locate exported video frames (pictures, really) is to have Photos open the moment they're in *for* you. To do that, Control-click the video's thumbnail and choose "Show in Moment." The frames appear next to the video you exported them from.

Sharing and Exporting Video

When you're finished editing your video, you can easily share it with others via iCloud Photo Sharing (page 211); send it to someone else in an email or text message; transfer it to another Mac using AirDrop; or post it on Vimeo, Facebook, or Flickr. Chapter 8 explains how to do all that. (Spoiler alert: Control-click the video thumbnail and choose Share from the shortcut menu to reveal your options. Easy-peasy!)

Exporting your movie, on the other hand, prepares it for life outside Photos. It takes a bit more effort than sharing, but exporting lets you to do things like open it in another program, post it on a website, and share it using a method *other* than the ones listed above (say, on a USB Flash drive). But if you only plan to use a video inside Photos—say, in a saved slideshow (page 163)—then you don't have to export it.

> **NOTE** As you learned in Chapter 2 (page 19), iCloud Photo Library syncs all the pictures and videos in your Photos library onto all your devices (except for saved slideshows that you've exported). However, if you're avoiding iCloud—say, you don't have an iCloud account—it's harder to get edited videos onto your iOS devices. The only way to do it is to sync the video onto your device using iTunes.
>
> Here's how: Plug your iOS device into your Mac (this step isn't necessary if you've turned on wireless syncing), and then fire up iTunes on your Mac and select your device at the program's upper left. From the list of Settings that appears (also on the left), choose Photos. At the top of the resulting screen, turn on "Sync Photos from" and pick Photos from the menu to its right. From there, you can choose to sync your entire library, only certain albums that you select, or everything you've tagged as a Favorite (page 82). The trick is to turn on the Include Videos checkbox so that, when you click the Sync button, any videos lurking in the items you've picked to sync come along for the ride.

Here's how to export videos:

1. **Select the thumbnail(s) of the video(s) you want to export, and then choose File→Export→Export [number] Video.**

 For example, if you selected just one video, the command is File→Export→Export 1 Video; if you selected two videos, the command is File→Export→Export 2 Video; and so on. The pane shown in Figure 6-16 appears. To export your video in its unedited glory, choose File→Export→Export Unmodified Original instead.

2. **Set the exported file's quality.**

The Movie Quality menu contains the same options you learned about back on page 171, plus the option to save the exported file at 4k resolution, which is (as of this writing, anyway) the highest resolution possible for a video in Photos. If you'll show the video on a 60-inch plasma screen, pick this option.

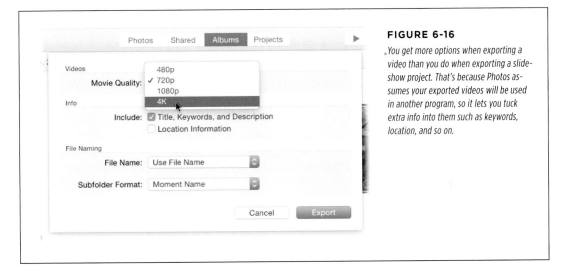

FIGURE 6-16

You get more options when exporting a video than you do when exporting a slideshow project. That's because Photos assumes your exported videos will be used in another program, so it lets you tuck extra info into them such as keywords, location, and so on.

3. **Choose which metadata to include.**

The Info section lets you include metadata such as the video's title (page 54), any keywords you've assigned (page 91), and a description (page 74). Photos automatically includes this info unless you turn off this checkbox, which helps make your files easier to find later on, plus other apps can use this info. The Location Information checkbox lets you tell Photos whether or not to include your video's location tags in the metadata—if your video was taken with a device that captured such info, that is (your iOS device does). The box on page 90 has a workaround for adding location info to files that don't include it.

4. **Choose a filename and subfolder scheme.**

From the factory, Photos sets the File Name menu to Use File Name, which means it simply uses the video's filename for the exported file. But you've got other options: Title (page 54), Sequential (you enter text that appears before a sequential number, to produce filenames such as *blackbelt01*, *blackbelt02*, and so on), and—if your video is part of an album—Album Name With Number.

The Subfolder Format menu is automatically set to None, which means Photos exports the file(s) without subfolders. If you happen to be exporting videos from *different* moments (page 43), choosing Moment Name from this menu instructs Photos to export each video into a subfolder named after the moment it lives in.

5. **Click Export, and then tell Photos where to save the file.**

When you've got all the settings just right, click Export. The standard OS X Save pane appears so you can tell Photos where to save the file. Choose a location, click Export, and Photos sets about compressing and saving your video file.

POWER USERS' CLINIC

QuickTime Player Tricks

QuickTime Player, which lives in your Applications folder, comes preinstalled on all Macs, but most folks ignore it because they think that all it can do is *play* video. This couldn't be further from the truth. Here are a few useful things you can do in QuickTime Player that you *can't* do in Photos:

- **Record video and audio clips.** Using the built-in camera on your Mac or a USB webcam you've plugged in, you can record your own video. You can also record audio using your Mac's built-in microphone, an external mic, or a musical instrument connected with a USB cable. Or maybe you want you want to record what's happening on your screen—say, for a video tutorial. QuickTime Player can do that, too.

 To do all that, choose File→New Movie Recording, New Audio Recording, or New Screen Recording. The first two options require you to pick an input source and quality, and then click the red Record button; the last option merely summons a pane with the Record button. When you're finished recording, click the same button again. You'll find the new video waiting in your Movies folder (inside your Home folder).

- **Rotate or flip a clip.** If your video needs to be flipped or rotated, reach into the Edit menu for the Rotate Left, Rotate Right, Flip Horizontal, and Flip Vertical commands. (Many a Mac user will go insane trying to find the same commands in Photos.)

- **Split and combine clips.** To *split* a video clip into two (or more) pieces, open a file and choose View→Show Clips (or press ⌘-E), and then drag the QuickTime Player playhead—it looks just like the one in Photos—to the spot where you want the video to split. If you choose

Edit→Split Clip (or press ⌘-Y), you see both clips highlighted in yellow. At this point, you can insert another clip (as described next) or rearrange the clips by dragging them left or right. If you split the clip into *three* chunks, you can select the middle one (a yellow outline appears around it) and zap it by pressing the Delete key on your keyboard.

To *combine* clips, open one clip, and then choose Edit→"Add Clip to End." In the Open dialog box, double-click the clip you want to tack on. You can also drag video clips' icons from your desktop into QuickTime Player, which adds them to the end of the existing video. (Repeat this process to combine several clips.) If you want the second video to appear somewhere in the *middle* of the first one, split the clip, and then click the clip that appears just before the spot where the new video will go. Choose Edit→Insert Clip After Selection, and then in the resulting dialog box, double-click the video file you want to bring in. (You can also drag a video file from the Finder directly into the gap between two video clips.)

To export videos edited in QuickTime Player, choose File→Export and you get the same resolution options explained on page 171. Pick iTunes if you want to sync the video onto your iOS devices and Apple TV. Or choose File→Share and pick from Facebook, Flickr, YouTube, Messages, and so on, and Quick Time optimizes your video for that particular use. When you're finished, choose File→Close and in the resulting dialog box, name the edited version and click Save.

To see the edited video in Photos, or the clip you used QuickTime Player to record, simply import it into Photos by choosing File→Import (page 27). Nifty, eh?

Printing Your Photos

L et's face it—digital pictures have a lot of advantages over printed images. They're super easy to store, share, and show off to others. Heck, once you turn on iCloud Photo Library (page 19), your entire photo collection travels around with you on your iOS device(s). Nevertheless, there will come a time when you want to print some pictures. Maybe you want to frame a favorite face to place atop your desk, order a slew of prints to chronicle your latest sporting achievement, or experience the unique joy of seeing your own artwork adorn a wall. (Prints make great gifts, too!)

The process for printing your own pictures from Photos for Mac is exceedingly simple, and you don't even have to wrestle with your printer—you can order gorgeous prints in a variety of popular sizes from Apple instead. Photos lets you customize your print order in a variety of ways to ensure your pictures are perfectly cropped, zoomed, and positioned to fit the print size you pick. (If you did any printing in iPhoto, you'll find more customization options in Photos.) This is the easiest way to go, especially if you want to print at sizes beyond what your home printer can handle, such as panoramas and posters.

In this chapter, you'll learn everything you need to know to about producing high-quality prints on your own inkjet printer and ordering them from Apple. This chapter also explains what resolution is, and teaches you how to calculate it yourself so you know exactly what kind of print quality to expect. Let the printing party begin!

NOTE As of this writing, you can only order prints using Photos for Mac; you can't place print orders on an iOS device. If the printer you have at home supports AirPrint—Apple software that lets you print from your iOS device without having to install drivers for a particular printer—you can print pictures using Photos for iOS, though you can't print more than one per page (in other words, there are no layout options). To do that, select the thumbnails you want to print (page 57), and then tap the Share icon. Next, tap the Print icon in the bottom row, and then on the Printer Options screen, tap to select your printer, use the + and − buttons to specify how many prints you want, and finally tap Print.

Printing at Home

As long as your computer can connect to a printer—arguably the most challenging part of printing—you can easily print your own pictures. You can pick from a variety of common sizes or enter a custom size (though you're limited by the size paper your printer can handle, of course). You can print one photo per page or put a few onto a single sheet to save paper (the number of photos you can print on a single page is determined by the paper and photo sizes you pick).

While Photos makes printing a simple and uncomplicated affair, you need a good printer to produce good results—that "all in one" printer/copier/scanner/fax machine won't produce gallery-quality prints.

There are many printer companies to choose from, but you can't go wrong if you stick with Epson, Canon, or even HP. For the best results, buy a printer that's made *specifically* for printing pictures, like the Epson Stylus Photo or Canon Pixma series. Printers in those two lines use between 5 and 11 different ink colors, depending on the model, so they produce a wider range of colors than printers that use the standard four inks. Of course, this extra quality comes at a cost: The more ink colors your printer uses, the higher its price tag and the more it costs to replenish your ink stash when it runs—or dries—out. (The sale of ink cartridges—and paper—is how printer manufacturers make the bulk of their profits.)

NOTE High-quality printers aren't cheap. While you can certainly find an inkjet printer that'll spit out decent prints for around $100, you'll need to spend $350–$1,000 to produce really good ones.

Once you've procured the right printer, there are other factors to consider before reaching for the Print command. For example, your picture needs to have enough pixels to produce a high-quality print at the size you want, and it needs to be the right aspect ratio. You'll learn how to do all of that in the pages that follow.

Resolution Matters

Resolution is one of the most commonly misunderstood concepts in digital imaging. Understanding it involves realizing that your digital pictures are made up of thousands of tiny, square blocks of color called *pixels*, as Figure 7-1 illustrates.

FIGURE 7-1

A pixel is the smallest element of a digital picture. By zooming way into this photo (to 3200 percent, to be exact), you can see the individual pixels that make up a tiny section of this sunflower.

Unfortunately, Photos only lets you zoom in to 200 percent, so it's tough to see the individual pixels that make up your own pictures. At any rate, at least you know they're in there!

Contrary to popular belief, pixels have no predetermined size, which is where resolution enters the, uh, picture. *Resolution* is the measurement that determines how many pixels get packed into a linear inch in your images, which controls how big or small the pixels are. With that in mind, you may find it helpful to think of resolution as pixel size. On your computer screen, resolution is measured in terms of pixels per inch in the U.S. (*ppi*, as folks typically call it); in most other countries, it's measured in pixels per centimeter (*ppc*). Scanners and printers, on the other hand, refer to resolution as dots per inch (*dpi*).

So the higher the resolution of an image, the smaller its pixels become. Small pixels make for smooth, high-quality prints and big pixels make for ugly, blocky prints that look like a stack of Lego bricks. Generally speaking, you need a resolution of at least 240 ppi to produce a nice print on most inkjet printers. However, if you forked out the big bucks for an inkjet printer that can spray ink at higher resolutions—say, 720 ppi or 1440 ppi—then you'll get better results by printing at those resolutions instead.

To keep things simple, Photos doesn't show you the resolution setting of your image, so you can't even see it, much less change it. However, you can calculate the resolution yourself using the image's pixel dimensions and the size of the print you want to make. Doing so lets you know exactly what level of quality to expect from printing at a certain size. And if the resolution you calculate isn't high enough to print at, say, 8 × 10, then you can make an informed decision to print at a smaller size. If you value your time and money—or rather, ink and paper—consider this quick calculation step one in your printing process.

NOTE It's especially important to calculate resolution for prints you intend to make from images captured on lower-quality devices, such as smartphones and older point-and-shoot cameras. You may find that they don't have enough resolution to create good prints, and it's better to discover that *before* wasting precious photo paper.

The first step in calculating resolution is to find your image's pixel dimensions by peeking inside the Info panel. To do that, select a picture, and then press ⌘-I to open the Info panel. When the floating Info panel appears onscreen, locate the camera info in the second section and jot down the image's pixel dimensions, which are listed beneath it. Next, figure out what size print you want to make, open your Mac's Calculator app, and then divide the longest edge of the *print* (measured in inches) by the longest edge of your *image* (measured in pixels).

For example, the image shown in Figure 7-2 measures 3840 × 5760 pixels. If you want to make an 8 × 10 print, take the longest edge in pixels and divide it by the longest edge in inches of the target print size: 5760 pixels divided by 10 inches = 576 ppi. You're in luck: That's more than enough resolution to produce an exceptional print.

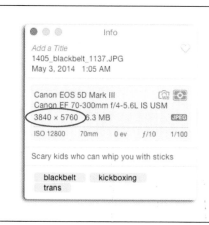

FIGURE 7-2

In order to pick the best size for a print, calculate your picture's resolution. To do that, you need to peek inside the Info panel to learn your picture's pixel dimensions.

Technically speaking, you don't have to calculate resolution each time you print. If you always shoot with the same couple of cameras using the same quality settings, for example, you only have to calculate resolution a few times to learn what print sizes you can expect to make from that device.

However, if you want to take that same image and make a poster out of it (poster size is 30 × 20 inches), you'd have a resolution of 192 ppi (5760 ÷ 30), which isn't high enough for a good print. The picture might not look horrible, but it won't be as clear, sharp, and detailed as it could be. Since poster-size prints aren't cheap—they're currently $18 from Apple, plus tax and shipping—you'll likely decide that printing at such a large size isn't worth it. By printing at a smaller size, you'll save money and be more satisfied with the end result. It's a win-win situation!

> **TIP** As you learned on page 114, when you crop an image, you delete pixels. If you don't have enough resolution to print at the size you want and you previously cropped the image, try uncropping it or cropping it less severely. By doing so, you just might gain back enough pixels to produce the resolution you need at the print size you want.

When Aspect Ratios Collide

Another printing concern is that of *aspect ratio*, which is the relationship between the image's width and its height. For example, a widescreen television has an aspect ratio of 16:9 (which is why the picture is wider than it is tall), a 35mm film camera has an aspect ratio of 3:2, and most digital cameras have an aspect ratio of 4:3. Unfortunately, a 4:3 aspect ratio produces pictures that don't quite fit onto some standard photo paper sizes such as 5 × 7 and 8 × 10. For example, if the paper you're printing on has the same aspect ratio as the image you're printing—say, you're printing a 3:2 aspect ratio image on a 6 × 4 piece of paper—then all is well. But thanks to Murphy's Law, the image you want to print likely won't fit the paper you want to print it on.

In that case, one of two things will happen: Photos will either shrink the image proportionately to fit the paper, resulting in white bands on either edge of the print, or Photos will fill the paper by chopping off some of your image. The outcome is determined by which option you pick in Photos' Print pane: Fit or Fill. You'll learn more about those two options later in this chapter, but they're helpful in understanding the problem of mismatched aspect ratios.

The example shown here illustrates what happens if you print an image with a 4:3 aspect ratio on a 5 × 7 piece of paper: You get white edges on either side of the picture (left) or Photos crops your image (right). If there's nothing important along the edges of your picture, this autocropping business isn't a big deal, but if half your subject's head disappears, as in this example, you need to crop the image yourself. Flip back to page 116 to learn how.

If, on the other hand, you order prints from Apple, you can adjust the autocropping when you place your order so you don't lose anything important. Page 198 has the lowdown.

Printing from Photos

Here's the wonderfully simple process for printing pictures on your own printer:

> **TIP** Before you feed that $1-per-page photo paper into your printer, use your printer's software to print a test page. (Press Shift-⌘-A to open your Applications folder and hunt for a file or folder that carries the name of the printer's manufacturer, such as Epson Software or Epson Printer Utility. Then follow the onscreen instructions.) A test page consists of a series of colored lines, typically one line for each ink color. A break in one or more lines indicates a problem with the ink or print heads. Doing a test print gives you the opportunity to clean the heads or replace an ink cartridge *before* you waste expensive photo paper.

1. **Select the picture(s) you want to print.**

 Use the techniques described on page 57 to select thumbnails of the images you want to print. It doesn't matter what view you're in; the Print command is accessible from anywhere within the program (even Edit mode). Feel free to pick as many pictures as you want. Photos is happy to print them in succession or even gang a few onto a single page (paper and image print size permitting, of course).

2. **When you're ready, choose File→Print or press ⌘-P and the refreshingly simple Print pane shown in Figure 7-3 appears.**

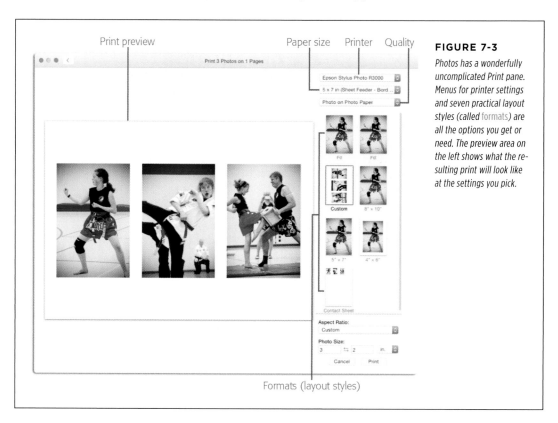

FIGURE 7-3

Photos has a wonderfully uncomplicated Print pane. Menus for printer settings and seven practical layout styles (called formats*) are all the options you get or need. The preview area on the left shows what the resulting print will look like at the settings you pick.*

3. **Choose your printer, paper size, and quality.**

Use the three menus perched at the pane's upper right to tell Photos what printer you want to use (if you have more than one), paper size, and quality.

There's no rocket science involved in choosing a printer or paper size—just pick the printer you want to use and the size paper you want to print on. However, if your printer supports edge-to-edge printing, be sure to pick a paper size that includes the word "borderless." Otherwise, the printer will leave an annoying strip of white around the edges of the print.

The Quality menu's contents depend on the capabilities of your printer. For example, if you have a laser printer, the menu may include the option of printing in black and white at various levels of quality (such as draft). For most inkjet printers, you get the following options:

- **Photo on Matte Paper, Photo on Matte Paper–Fine.** These options set the printer up for printing on high-quality paper. Commonly referred to as presentation paper or fine art paper, it's a little heavier than inkjet paper, but it's not thick or glossy. The Fine option prompts the printer to take more time carefully spraying the ink; it takes longer to print but you end up with a higher-quality result. These two options aren't suitable for printing photographs, but they're perfect for printing your own greeting cards (page 266).

- **Photo on Photo Paper, Photo on Photo Paper–Fine.** Choose one of these options if you're wisely using the stiff, more expensive paper designed for photographic printing. Photo paper can be glossy or matte (non-glossy), and this stuff resembles the kind of paper used when your prints are developed at Costco or your local camera shop. Here again, the Fine option takes longer to print, but produces a better result.

NOTE Most folks are attracted by the shine of glossy paper, but that's not really the best choice for printing photos. While glossy papers produce rich colors, their reflective properties make them a poor choice for passing around or framing. To put your best print foot forward, use high-quality matte photo paper instead. By doing so, you won't have to worry about reflections, plus good matte papers make your blacks look darker, which boosts contrast.

When choosing a paper brand, it's usually easiest to stick with paper made by your printer manufacturer, though there are higher quality papers out there. If you've got money to burn, you can get excellent pro-level paper from Hahnemuhle.com, RedRiverPaper.com, MoabPaper.com, and Ilford.com.

On all but the simplest of printers, Photos' Quality menu is fairly useless because it gives you no real control over specific paper type—for example, you can't specify Ultra Premium Luster Paper or Exhibition Fiber Paper—or the output resolution of the printer itself. To produce the best possible print, you need to access your *printer's* settings, which you can only do by clicking Print (you'll do that in step 6).

4. Choose a format (layout style).

This is where you tell Photos how to handle your picture if it isn't the same as-pect ratio as the paper size you picked, and what size the printed picture should be on the paper itself. On the right side of the Print pane, if you click a format thumbnail, you see what the print will look like in the preview area at left. At the top of the Print pane, Photos dutifully reports how many images will print on how many pieces of paper. Here are your options:

- **Fit.** Pick this format to fit your photo onto the paper size you picked in step 3. Photos doesn't enlarge your image with this option, so if the aspect ratio of your picture doesn't match the aspect ratio of the paper size, you get a white edge on either side of the print. There's more on this topic in the box on page 187.

- **Fill.** This format instructs Photos to enlarge your image so it fills the page. And as the box on page 187 explains, important bits of your image may be chopped off if you haven't cropped the picture to match the paper's aspect ratio. (For more cropping tips for print, see the box on page 119.)

- **Custom.** If you selected more than one picture in step 1, this option shows you the size necessary to squeeze more than one picture onto a page (Figure 7-3 shows this choice in action). You can also use this format to print at a size that's not among the format presets. When you choose Custom, the Aspect Ratio menu appears, along with two fields where you can enter the width and height of the print you want. (These fields are visible in Figure 7-3.) Unfortunately, you can't save custom settings as a format preset.

- **8″×10″, 5″×7″, 4″×6″.** Use these formats to print in traditional sizes. De-pending on the paper size you picked in step 3, you may be able to fit more than one picture onto a page (that is, if you selected more than one image in step 1). Remember, these options don't set paper size; they set the print size of the *image*.

- **Contact Sheet.** This option puts multiple thumbnails onto a page in grid-style fashion, as Figure 7-4 shows. You set the number of columns (up to 12) and the margin width, which controls the space between the thumbnail and the paper's edge.

 You can also choose to add captions—info that's printed beneath each thumbnail. If you click Captions, the pane shown in Figure 7-4 appears. Your caption choices include image title, description, date, keywords, and filename, as well as a host of camera settings such as shutter speed and focal length (handy for, say, teaching or comparing shots taken at different settings to improve your photographic skills).

TIP For the best results when printing Contact Sheets, don't choose a borderless paper option from the paper size menu. If you do, the thumbnails will look like they're about to fall off the edges of the page!

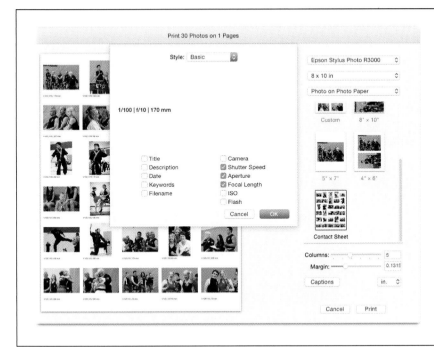

FIGURE 7-4

The Contact Sheet format is handy for printing several pictures side by side on the same page to compare the quality of different images or for showing to others so they can pick which shots to print.

The Captions pane shown here lets you choose from three text formatting styles. Basic left *aligns and bolds the info beneath each thumbnail,* Labeled left *aligns with no bolding, and* Condensed *uses gray text (instead of black) and centers the info in a slightly smaller font than the other styles.*

5. Adjust the zoom level.

If you didn't crop your image before printing, you can fill the frame with your subject by using the Print pane's zoom slider. Just click an image in the preview area to summon the zoom slider shown in Figure 7-5. Drag the slider rightward to zoom into your image. Once you do that, you can drag your image to reposition it within the frame (your cursor turns into a hand).

6. When the preview looks just right, click Print.

Clicking Print displays the OS X print pane shown in Figure 7-6, where you can control your *printer's* settings (which are different than Photos' print settings), such as how many copies to print and which pages to print. Most importantly, this pane lets you tell your printer exactly what paper you're using and what resolution to print at. To reveal these mission-critical settings, choose Printer Settings (or something similar) from the menu circled in in Figure 7-6, and then adjust the options that appear. When you're finished, click Print (or press Return) and your printer whirs to life.

FIGURE 7-5

The Print pane's zoom slider lets you easily fill the frame with your subjects, as illustrated here. The original images are on the left and the zoomed-in versions are on the right. As you can see, the unimportant background elements are no longer visible. Doing this doesn't crop your images; it merely changes the zoom level for printing.

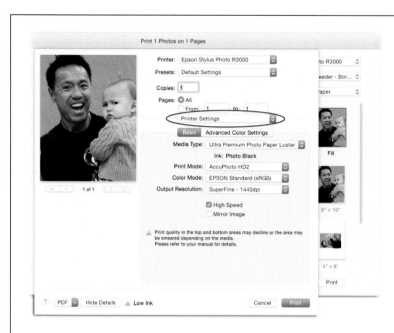

FIGURE 7-6

If you don't have an Epson printer, your OS X print pane may look different than this one. Be sure to dig around for a menu like the one circled here that gives you access to specific paper types as well as output resolution. The more info you give your printer, the better the resulting print will be.

TIP If you get your print settings just right and then decide that you're not quite ready to fire up your printer after all (maybe you realized you're out of ink), the only way to save your settings for printing later is to click the PDF button in the lower left of the OS X print pane shown in Figure 7-6. Choose "Save as PDF" from the menu, and then click Save. When you're ready to print the document, open it in Preview and print away.

Ordering Prints Online

As you learned in the previous section, printing on your own printer is a simple affair... at least theoretically. To be honest, there are a host of problems you can encounter when you print pictures yourself. For example, if the planets aren't properly aligned, your Mac may refuse to connect to your printer, your ink cartridges may be dried out or need replacing, or your paper might not load properly. Or maybe you just want to print at a size that's bigger than your printer can handle.

If sparring with your printer sounds like the opposite of fun, just get someone else to print them. The easiest solution is to leave the printing to Apple (technically, Kodak does the printing on Apple's behalf). Having high-quality, fuss-free prints delivered to your home is just a few clicks away (provided you have an Internet connection, of course). Pricing for prints is extremely affordable and ranges from 12 cents for a 4 × 6 to $18 for a 20 × 30 poster. Even with sales tax and a shipping fee, you'll likely save time and money over printing them yourself.

You can also export your pictures (see page 231) for printing elsewhere and upload them to your local camera shop, Costco, or other online printing services. This method will likely be cheaper than ordering prints from Apple, though it does take time to export the pics, upload them to the printing service's website, pick your print sizes, and so on. If you want to go that route, some excellent online printing resources include Mpix.com, NationsPhotoLab.com, PinholePress.com, Shutterfly. com, and Snapfish.com. Many of these websites offer to print your pictures on a variety of other products, too, like coffee mugs, shopping bags, and puzzles, which make great gifts!

TIP To learn more about creating gifts made from your own pictures, check out your author's video *Holiday Photo Gifts*. You can find it at *www.photolesa.com/videos*.

Buying Prints from Apple

The easiest and most foolproof way to order prints online is to buy them from Apple. The process is incredibly simple: Just select the pictures you want to print—or a whole album, if you want to print every image in it—and then choose File→Order Prints, or click the Create icon circled in Figure 7-7 and then choose Prints.

TIP You can also create a print project from a Moment or Collection while you're in Photos view. Just point your cursor at the thumbnails, and then click the Create icon that appears to the right of the date, above the thumbnails (it looks like a big + sign). Choose Prints from the menu and you're off and running!

FIGURE 7-7

To order prints of everything inside an album (like the one circled in the Sidebar here), be sure there are no thumbnails selected, or else only those pictures get added to your print project. When no *thumbnails are selected, Photos adds the full contents of the album to the project.*

To ensure the right images are selected, peek at the top of the Create menu, which lists how many pictures Photos will include in your project (in this example, it's 30).

Either way, Photos creates a *print project* that you can customize to your liking (it's treated like an album, really). You can change print sizes, order additional print sizes of a certain image, adjust any autocropping that occurs due to mismatched aspect ratios, add a filter effect (like the ones you get in Edit mode; see page 120), change the zoom level, set the number of copies you want of each print, and even enter Edit mode if you need to (whew!). You can also save the print project to work on later—say, after you finish watching *Game of Thrones*.

The Choose Format & Size screen that appears after you create a print project lets you pick a print size by clicking Select to the right of the size you want to order. Options in the Auto-Sized column produce *irregularly* sized prints—instead of resizing your picture to fit standard paper sizes, Apple resizes the paper to fit your picture. Oddly, Photos seems to assume you'll order just one size print for all the pictures in your project. If that's not the case, don't panic. Just pick one size for now, and then change sizes for individual prints on the resulting screen, as explained next.

NOTE If you haven't cropped your pictures to the aspect ratio you'll print—and you don't pick a size in the Auto-Sized column—you get a message saying that Photos cropped some pictures to fit the paper size you picked. If that happens, click OK—and then remember to examine the print previews to ensure your subject's heads are intact and, if necessary, adjust the crop as explained later in this chapter. (You can also click Cancel and then go crop the pictures yourself in Edit mode, but that's a lot of unnecessary work since you can adjust cropping right in your print project.)

■ CHANGING AND ADDING PRINT SIZES

After you click the Select button next to a print size, Photos displays the Review Your Prints screen. To change the size of a print, or to add another size of the *same* print, simply click its preview, and then click the "Add photos or change print size" button circled in Figure 7-8. In the resulting menu, either choose a size from the Change Size submenu to change the current size to something else, or pick a size from the Add Another Size menu to add *another* print of the same image, but in a different size.

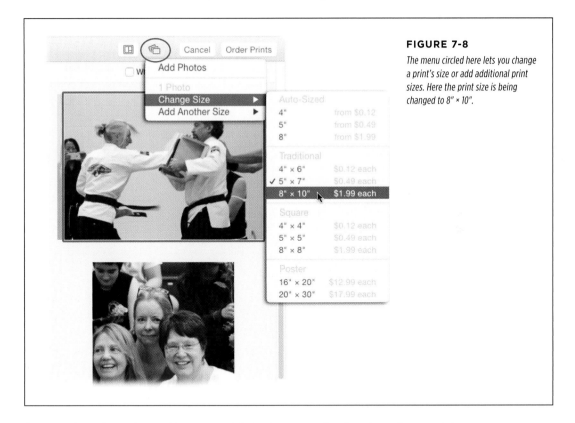

FIGURE 7-8

The menu circled here lets you change a print's size or add additional print sizes. Here the print size is being changed to 8″ × 10″.

Once you've selected more than one print size in your order, the view of your print project changes to reflect that. As Figure 7-9 shows, Photos displays a list of all the sizes and quantities you've selected on the left and previews of the images that'll print at those sizes on the right.

FIGURE 7-9

Click a size in the list on the left to see previews of images you've selected to print at that size. This view can be a little confusing because it looks like your previews have suddenly disappeared, but they're actually just organized by size.

■ ADDING AND DELETING IMAGES FROM YOUR ORDER

If you forgot to include a certain picture in your print project, you don't have to start over. You can easily add it to the order you're currently working on by choosing Add Photos from the "Add photos or change print size" menu (it's circled back in Figure 7-8). When you choose this command, you see the Choose Photos screen shown in Figure 7-10. Just navigate to where the picture lives in your Photos library and click its thumbnail to add it. (You can select more than one photo if you want to add several.) Next, pick a size from the menu at the top of the window (labeled in Figure 7-10), and then click Add. Photos adds the picture to the end of your print project and returns you to the Review Your Prints screen.

The Dreaded Low-Resolution Alert

As you go about the (admittedly tedious) business of massaging your print order, be on the lookout for any low-resolution alert icons—yellow triangles with an exclamation point—that appear at the lower left of an image preview.

These alerts are Photos' way of saying, "Hey there! I know you really want a 20 × 30 poster of your bird riding your cat, but there just aren't enough pixels to have high enough resolution for a good print that size. If you choose to ignore my warning and order it anyway, I'm afraid you'll be disappointed by the crappy quality of the print." You may see the same icon appear when you're crafting other print projects in Photos like books, cards, and calendars (see Chapter 9).

If you spot one of these alert icons, it's best to heed Photos' advice and pick a smaller print size using the "Add photos or change print size" menu on page 195. Just keep reducing the size until the alert icon disappears. As a rule, you *never* want to order a print that's been tagged with a low-resolution alert; however, Photos won't prevent you from doing so.

FIGURE 7-10

The All Items and Favorites buttons labeled here let you navigate through your library. To add a photo, click its thumbnail and a checkmark appears at its lower right. If you decide not to add the picture, click the thumbnail again to remove the checkmark. After you select a picture, pick a size from the menu labeled here.

To see all the photos you're about to add to your order, including those that are already in your project, click Selected at the screen's upper left.

Conversely, if you decide *not* to order a print of a particular picture that's included in your print project, just select the preview, and then choose Image→"Remove Photo from Album" or press the Delete key on your keyboard. In the resulting pane, click Remove to send the picture packin' or click Cancel to keep it in your order. (You can also use this technique to select and remove *several* photos.) To remove all the prints of a certain size from your order, click the size in the list on the left, press Delete, and then click Remove. If one of those photos is in your order at a different size, it remains in the print project.

TIP If at any point you want to bail on the print ordering process—or you just want to take a break to wash your hair or bathe the cat—click Cancel in Photos' upper right corner. When you do, Photos gives you the option of saving the order for later or sending it into oblivion. Click Save Order, and Photos saves the order as a project named with the current date and time. When you're ready to resume futzing with the order, simply double-click the project to reopen it. To trash the order completely, click Cancel Order instead.

■ **CROPPING, EDITING, AND ORDERING MULTIPLE COPIES**

Once you've gotten the print sizes just right, you can adjust the images' cropping, zoom level, or positioning within the frame; apply a filter (page 120); or even pop into Edit mode (page 106). You can also tell Photos how many copies of each print you'd like to buy. You do all this on the Review Your Prints screen.

To adjust the autocropping Photos performed to make your pictures fit the aspect ratio of the print size you picked, click the image preview to reveal a blue crop box. Note whether the edges of your picture appear outside the box. If there are important bits of your image loitering outside the crop box, click the photo (your cursor turns into a hand) and then drag to reposition it within the box, as Figure 7-11 demonstrates.

FIGURE 7-11

Photos is pretty smart, but its auto-cropping feature can be hit or miss. For example, Photos wants to chop off the top of this boy's head to make the picture fit the aspect ratio of the print size (left). Fortunately, you can save him by dragging the picture downward (right).

When the cropping's all set, consider zooming further into your picture so the subject fills the frame. To do that, open the Photo Options panel by clicking the button circled in Figure 7-12. With an image selected, drag the Zoom & Crop slider rightward to zoom in, and then drag the image itself to adjust its positioning within the frame.

The rest of the goodies in the Photo Options panel are self-explanatory: To apply a filter, just click one of the print previews in the Filters section of the panel. To adjust the lighting and color of your print, click Edit Photo to open it in Edit mode. When you're finished editing the shot, click Done at upper right and Photos returns you to your print project.

The Copies field at the bottom of the panel lets you control how many copies of that size print you want to buy. If you want to duplicate your entire order, don't fuss with this field. Instead, use the Quantity field in the Checkout pane described in the next section.

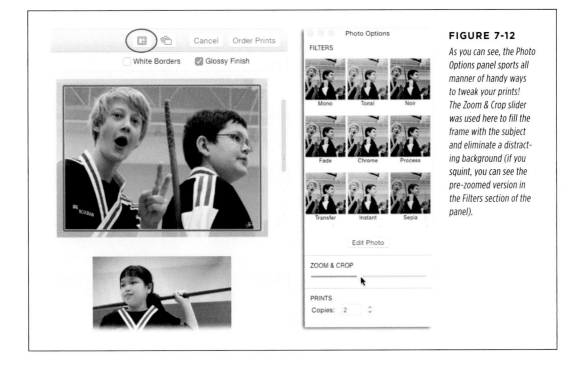

FIGURE 7-12

As you can see, the Photo Options panel sports all manner of handy ways to tweak your prints! The Zoom & Crop slider was used here to fill the frame with the subject and eliminate a distracting background (if you squint, you can see the pre-zoomed version in the Filters section of the panel).

NOTE The Photo Options panel stays open until you close it by clicking the red dot at its upper left. However, if you use the Edit Photos button to dip into Edit mode, the panel automatically closes. To reopen it, just click its button in Photos' toolbar.

■ FINALIZING YOUR ORDER

Hang in there—you're almost done! The next-to-last step in completing your order is to choose a finish for your prints. If you want your goodies printed on glossy photo paper, turn on the Glossy Finish checkbox at the top right of the Review Your Prints screen. If you (wisely) prefer non-glossy matte paper instead, make sure this checkbox is turned off (the note on page 189 explains why glossy isn't the best option). If you're feeling retro and want a thin white border around each image—like a vintage Polaroid—turn on the White Borders checkbox (this option isn't available for Auto-Sized prints).

NOTE If you plan on framing your prints, leave the White Borders option turned off because you may see the white area inside the frame. If, on the other hand, you plan on decorating your refrigerator or other magnetic surface with the prints, the White Border option gives prints a cool yet classy edge (great fun if you plan on passing prints among friends).

When everything is just right, click Order Prints at the upper right of the screen. An empty-ish Checkout pane appears that shows the date, time, and number of prints—you don't see a list of thumbnails with sizes next to them nor an order total. Nevertheless, soldier on by clicking Add Shipping Address, and Photos tunnels into your Contacts app. Pick a name from the resulting list or enter a name in the search field at the top of the pane, and then click to select a contact. To add a new address, click New at the Ship To pane's upper right, fill in the resulting fields, and then click OK. Click Done and the address appears in the Checkout pane with a checkbox to its left and a Quantity setting to its right. The pane also displays the total cost of your order. To send more than one set of your entire order to an address, click the + sign on its right to increase the order quantity. To add another lucky recipient to your order, click Add Shipping Address.

If you deem a recipient unworthy of receiving the gift of prints, simply turn off the checkbox to the left of his name. To edit an address once it's in the Checkout pane, click the down-pointing icon to its right and choose Edit from the menu that appears. Other addresses associated with that contact appear in the menu, too.

Next, check the order total at the bottom of the Checkout pane. If everything looks good, take a deep breath and click Place Order (if not, click Cancel to exit the Checkout pane and return to your print project). Enter your Apple ID when prompted, click Sign In, and Apple dutifully sends your order to Kodak for processing. If this is your first print order, you may be asked to enter the security code for the credit card you have on file with Apple. Finally, Photos confirms of your order and lets you know when to expect it in the mail.

TIP If your impatience gets the best of you, you can check the status of your order by choosing Photos→Print Product Store Account. Photos transports you to Apple's website so you can see what's going on. On the page that appears, you get a handy list of links that let you check your order status, track a shipment, cancel your order, print an invoice, return items, change shipping or billing info, view your order history, and so on.

All in all, the convenience of ordering prints from Apple is awesome, even if it does take a little time to finesse your order. You can do it all from the comfort of your home (and pajamas), and you don't have to worry about quality, paper jams, or mailing prints to far-flung friends or family yourself. What's not to love?

Sharing and Exporting

L et's face it: Prints are expensive and the postal service is slow. To get your pictures and videos in front of others faster (or instantly), you've got to use other methods. Fortunately, Photos includes several ways to share your goodies online. For example, you can easily send them via email or text message, and post them on social media sites such as Twitter, Facebook, and Flickr.

However, one of the coolest tricks in the sharing realm is to create shared albums and then invite people to subscribe to them (don't worry, it's free). Doing so lets you share pictures and videos with certain people in a private fashion; only the people you invite to the album can see them. The opportunities for sharing your photographic life in this way, and for you to share in the photographic lives of others, are vast. For example, in the vacation scenario, your adoring subscribers can instantly see, and comment upon, the picture of the macadamia-nut–encrusted coconut-pineapple pancakes you had for breakfast this morning in Maui. For important life events—graduations, weddings, births, black-belt tests—you can set up a shared album so family and friends can see pictures of the event as you add them. And if you grant them permission, they can upload their own images to the shared album. Shared albums aren't just for Photos-using folks, either: If the person you want to share pictures with doesn't have a Mac, Photos is happy to generate a public web gallery so that person can enjoy and download pictures (so she can print an image or two, say).

This chapter also includes the step-by-step process for setting up family sharing, which creates a special Family album that anyone in your household can contribute pictures to. Of course, you can also export your images from Photos in order to use them in a different app, hand them off to someone else, or whatever. Photos is happy to export files in a variety of formats and sizes, with all your edits applied (you can

also export files in their original, unedited state). Photos handles the heavy lifting such as resizing the files and changing their file formats—all you have to do is enter a little descriptive text and choose a few settings.

As you're about to learn, sharing and exporting can be a lot of fun. This chapter teaches you everything you need to know to get your digital goodies out of Photos and in front of other people.

Sharing via Email

If you're like most people, one of the most common things you'll do in Photos is email pictures and videos to other folks. The process is painless, quick, and simple. There are no fancy graphical templates to choose from or captions to customize—you simply select thumbnails and Photos attaches them to a new email message in the email app of your choice. The process is as straightforward as it gets.

> **NOTE** iPhoto veterans who mourn the death of graphical email themes can take comfort in the fact that you no longer have to rely on your image-organizing app to maintain a record of who got which pictures. Since Photos hands the whole process off to your email app, you can keep track of what pictures you sent to whom there, just like every other email you send.

Unless you tell them otherwise, your Mac and iOS devices use Apple's Mail program for all email-related tasks (the box on page 203 describes how to change this), so that's the app Photos uses to email your digital goodies. All you really have to do is select some thumbnails, add a recipient, type a pithy message, and click Send. Here are the steps on a Mac:

1. **In Photos, select some pictures and/or videos.**

 Use the techniques described on page 57 to select the thumbnails of the pictures and/or videos you want to send.

 If you use Mail for email, you don't have to worry much about sending too many files. If you try to send an email with an attachment that's too large for your recipient to receive, Mail knows not to include the attachment. Instead, it uses the OS X Mail Drop feature to save the attachment on Apple's servers. Your recipient merely receives a download link that he can click to download the files.

 The maximum file size for Mail Drop is five gigabytes per email, but the files only stay on Apple's servers for 30 days, so keep your fingers crossed that your recipient checks her email at least once a month. Fortunately, Mail Drop attachments don't count against your iCloud storage allowance (page 12), though Apple does impose a one-terabyte Mail Drop limit in any 30-day period.

2. **Click the Share icon in Photos' toolbar and choose Mail.**

The share icon (circled in Figure 8-1) lets you send your files to many places, including your preferred email app. When you choose Mail, your preferred email app launches and a new message appears with your files attached. (See the box on page 203 to learn how to change your preferred email app.)

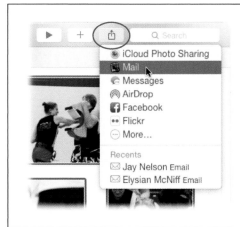

FIGURE 8-1

When you choose Mail, your Mac creates a new email message in the Mail app or in the email program of your choice. The selected thumbnails are either attached to it or—if you're using Mail and the attachment is really big—the files are uploaded to Apple's servers (see step 1 for details).

3. **Choose your recipient(s).**

Pick a recipient or several the same way you do for any other email message: Click the To: field and start typing the person's name. If the recipient is in the Contacts app, you only have to type part of his name—OS X tries to guess and fill it in automatically for you as you type. (If you haven't emailed this person before, you need to enter his full address.) Alternatively, you can click the + button on right of the To: field and pick a recipient from the Contacts app.

To send the email to more than one person, type a comma (,) after the first email address, and then enter another address (or pick one from the Contacts app using the + button). Each person will receive a copy of your message and all the attachments it contains.

UP TO SPEED

Switching Email Apps

While Apple would like you to use Mail as your email program, you certainly don't have to. Some folks prefer to use Microsoft Outlook, Mail Pilot, or whatever. Changing your preferred email app has tripped up many a Mac user because the controls are located in Mail's preferences, just like the settings for specifying which web browser you prefer is tucked into Safari's preferences (but you knew that).

To change your preferred email app, launch Mail (it lives in your Applications folder), and then choose Mail→Preferences→General. From the "Default email reader" menu, choose the program you want to use for email. From that point on, Photos uses your preferred email program whenever you share content by choosing the program's Mail command.

4. **Enter a subject and add a message.**

Give your recipient(s) a clue about what's inside your message by entering something meaningful in the subject line. You can customize the email further by entering a message in the body of the email, such as, "Here's me breaking a board during my third-degree black belt test in Taekwondo. Wish those bullies from elementary school could see me now!"

5. **Choose an image size.**

In Apple's Mail app, use the Image Size menu at the upper right of the email body to pick a size (see Figure 8-2). Here are your options and why you might choose each one:

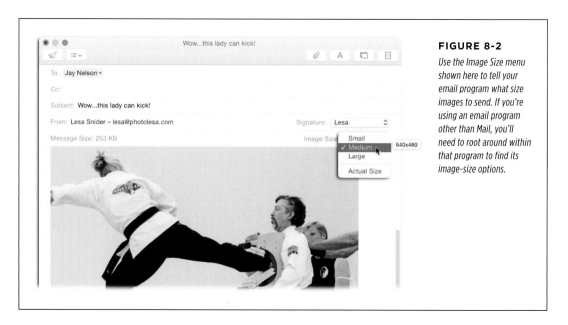

FIGURE 8-2

Use the Image Size menu shown here to tell your email program what size images to send. If you're using an email program other than Mail, you'll need to root around within that program to find its image-size options.

> **NOTE** If you're using Apple's Mail app and you're sending a huge image, Apple's Mail Drop feature may step in to handle the big file. For example, you may see a message that says, "Would you like to send these attachments using Mail Drop?" By clicking Use Mail Drop, the image cools its heels on Apple's servers and is only downloaded when the recipient checks her email. This handy feature is described in depth on page 172 and 202.

- **Actual Size** transmits the image at its original dimensions. If the recipient plans to print the image, pick this option. However, both you and the recipient need to have a fast Internet connections and large inboxes for this to work. Many email services limit attachments to 20 megabytes, so keep an eye on the Message Size value to the left of the Image Size menu—you may need to send multiple messages with fewer images attached. (As you learned in step 1, if you use the Mail app to send emails, OS X's Mail Drop

feature kicks in to handle large attachments.) Because of these size issues, you should use this option sparingly.

- **Small** produces an image that's 320 × 240 pixels and weighs in at roughly 100 KB in file size. Use this option only if your recipient lives in a rural area and has a painfully slow dial-up Internet connection.

- **Medium** yields a file that's 640 × 480, which is plenty of detail to fill a good chunk of your recipient's screen, plus it doesn't take long to download. For example, this option trims a two-megabyte image down to less than 150 KB. Choose this setting if you're sending a lot of pictures with a program *other* than the Mail app, but don't use it if the recipient will print the file—at best, they'd be able to produce a 2 × 3-inch print.

- **Large** downsizes your photos to 1280 × 960 pixels, which fills the average person's screen and is good enough to produce a 4 × 6-inch print. That said, if you're sending a bunch of pictures, this size can push your recipient's mailbox beyond its limit, meaning he may miss out on important emails until he empties his inbox, and be angry with you as a result.

To practice good email etiquette, always try to send the smallest size you think your recipient wants; in most cases, that's Medium. After all, she can always ask for a larger one if she wants it. (As page 185 explains, bigger images can have a higher resolution so they print far better than smaller ones.)

6. **Click Send.**

 In Mail, the Send button is perched at the upper left of the message window and has a paper airplane icon on it (it's visible in Figure 8-2). When you click it, your attachments go sailing through the ether.

As you can see, using Photos to send email is a straightforward process. But if you manage your email using a web browser, you'll need to *export* your goodies from Photos in order to attach them to a web-based email message. It's not as convenient as using Photos to send emails, but it gets the job done. Page 231 explains how to export images.

Emailing Photos from an iOS Device

The process for emailing pictures and videos using your iOS device is nearly the same as on a Mac. The hardest part to remember is to start the email from the *Photos* app, instead of the Mail app (the latter doesn't let you attach images).

To email pictures from your iOS device, use the techniques on page 59 to select some thumbnails in Photos, and then tap the share icon at the lower left. On the screen that appears, tap the Mail icon. After a moment, a new email message pops open. Just tap the To field and enter an address, tap Subject and enter something clever to get your recipient's attention, and then tap the body of the message—above the attached image thumbnails—and enter your message.

When you're finished, tap Send, and then pick an image-size option from the resulting screen. (You get the same size options as you do when emailing images in Photos for Mac [page 204].) Once you tap a size, Photos for iOS prepares the images for their journey and sends your email. You don't get a confirmation message with this method, so you just have to trust that the email actually went where you told it to.

Sharing via Text Message

Another easy way to share pictures and videos with others is to send them via text message. When you do, Photos employs the Messages app that's preinstalled on your Mac and iOS device(s). The recipient receives the communiqué on his cell phone or iOS device, and in the Messages app on his Mac.

In Photos for Mac, the first step is to select some thumbnails of the items you want to send (page 57); you can send up to 10 full-size pictures or one video in a single text message. Next, click the share icon in Photos' toolbar and choose Messages. A new text message appears in the middle of the Photos window, as Figure 8-3 shows.

FIGURE 8-3

Sending a message from within Photos is a wonderfully fast way to share a picture with someone, hence the term instant messaging.

NOTE The first time you choose Messages from the Share menu, Photos prompts you to sign in. Just click Sign In and you're transported to the preferences pane of the Messages app where you can enter your Apple ID or the user name and password of your AIM, Jabber, Google Talk, or Yahoo account.

Enter the recipient's name or cell phone number, or click the + to tunnel into the Contacts app and pick a recipient from there instead. Then click within the body of the message and enter a comment. When you're finished, click Send. If you listen closely, you hear a satisfying *whoosh* sound as the message rockets into the ether (if you don't have your Mac's sound muted, that is).

You can also send text messages from your Mac using the Messages app itself. If you already have a message thread going with your intended recipient, just drag a few thumbnails from the Photos window onto her name, and then press the Return key on your keyboard to send the pictures on their merry way.

In Photos for iOS, select a few thumbnails (see page 59), and then tap the share icon (the square with the up arrow). In the sheet that appears, tap the green-and-white Message icon. Enter a person's name or cell number, and then tap Send.

If you're on the *receiving* end of a text message, you can save the pictures it contains to your Photos library in a couple of ways:

- On a Mac, in the Messages app, double-click the photo to open it, and then click the Share menu that appears at the window's upper right and choose "Add to Photos." Alternatively, Control-click the photo in Messages and, from the shortcut menu, choose "Add to Photos Library."

- On an iOS device, in the Messages app, tap the photo, and then tap the share icon and choose Save Image.

Sharing Online

It's great fun to post pictures and videos on social media websites such as Twitter, Facebook, and Flickr. People can immediately start interacting with you by adding comments, clicking the coveted Like button, and so on. Heck, your buddies can even download your pictures to their own Photos libraries. This section teaches you how to do all that and more.

NOTE As of this writing, Photos lets you post both pictures *and* videos to your Facebook page, but you can only post *pictures* onto Twitter and Flickr. You have to visit those two sites directly (using a web browser like Safari) to post videos.

Twitter

As you probably know, Twitter is the free microblogging site that lets you announce to the world—in brief, 140-character messages—exactly what you're doing or thinking. You can liven up your posts by using Photos to include a picture. For example, instead of declaring that you enjoyed a delicious bowl of oatmeal this morning, you can show the world exactly what it looked like. Ain't technology grand?

Start the Twitter party by visiting *www.twitter.com* and creating an account. Next, in Photos for Mac, select a picture to share, click the share icon in Photos' toolbar (it's circled back in Figure 8-1), and then choose Twitter; the sheet shown in Figure 8-4 appears. (If this is the first time you've used Twitter on your Mac, Photos prompts you to set up your account. Click Add Account and you're transported to the Internet Accounts pane of your Mac's System Preferences. Enter your account user name and password, click Next, and then click Sign In. If everything goes well, switch back to

Photos and choose Twitter from the share icon again.) Enter something clever and, if you like, click Add Location at lower left to add your computer's current location to the message. Click Send and Photos cheerfully lets you know your picture was successfully published.

FIGURE 8-4

The gray number circled here lets you know how many characters you have left in your Twitter message. The image link consumes 21 characters, so you really only have 119 for your prose.

On an iOS device, the process is almost exactly the same except that you click the share icon (the square with an up arrow) to get started.

Facebook

Love it or loathe it, Facebook is an integral part of over a billion people's daily lives. It's the easiest way to share pictures and videos among a large group of people because it's user-friendly and it doesn't matter what flavor of computer or smartphone you use to interact with it. To get a free account, mosey on over to *www.facebook. com* where you can create a profile page and, if you wish, add résumé-like details, lists of your favorite books, movies, quotes, and so on. You can then link your profile to the profiles of other people by sending them a *friend request*. Once the request is accepted, you can see each other's profile pages and socialize with them in the virtual realm. You also get notifications of what they're up to.

Once you get your Facebook page going, you can use Photos to upload individual pictures and videos to your Facebook Timeline, add them to an existing Facebook album, or create a new one. You get full control over who sees your goodies. And by *tagging* friends in your pictures, those pictures appear on your friends' Facebook Timelines, too.

Posting pictures and videos to Facebook is unbelievably easy. Begin by selecting thumbnails (page 57) of the content you want to share. Next, in Photos for Mac, click the share icon in Photos' toolbar and choose Facebook. (If this is the first time you've done this, or if you haven't yet added your Facebook account to your Mac, Photos prompts you to log into your Facebook account; click Add Account, and Photos opens the Internet Accounts pane of your Mac's System Preferences. Enter your user name and password, click Next, and then click Sign In. Switch back to

Photos, click the share icon again, and choose Facebook.) A message pane appears in the middle of the Photos window (see Figure 8-5), where you can set options for the post and enter a description. Click Post, and Photos uploads it to Facebook.

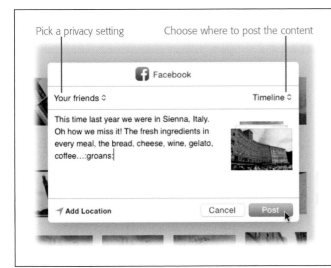

Pick a privacy setting Choose where to post the content

FIGURE 8-5

The menus labeled here let you specify who can see your post and where it appears. The menu at the upper left lets you choose Public, Your friends, or any group of friends you've created in Facebook. The menu at the upper right lets you control where Facebook will display your post: on your Timeline or in an existing Facebook album. You can also add your current location to the picture(s) by clicking Add Location at this pane's lower left.

NOTE Seasoned Mac users who interacted with Facebook via iPhoto may find Photos' simplistic Facebook integration disappointing—or relieving. Gone are the complicated, two-way pipelines between your Mac's photo library and Facebook. There's also no way to connect more than one Facebook account to your Photos library, nor can you use Photos to change your Facebook profile picture. As usual, when Apple replaces a creaking old program (iPhoto) with a sleek new one (Photos), it giveth and taketh away features.

Posting to Facebook using Photos for iOS is quite similar, though you need to log into your Facebook account using the Facebook app (it's free from the App Store). Facebook also needs to be added to your iOS device's list of sharing destinations, as Figure 8-6 explains. Once you've done that, select the picture(s) you want to post, and then tap the share icon and choose Facebook.

After your post is complete, you can sit back and watch the comments and likes happen in real time. It's actually quite fun and satisfying, especially when sharing stuff with far-flung friends and family members who you don't get to see often (or at all).

Flickr

Rounding out the list of Photos' social-media sharing destinations is Flickr, an extremely popular site dedicated to photography. You can get a free account by signing up at their website, *www.Flickr.com*, though you can also log in with your Facebook or Google account (if you have one).

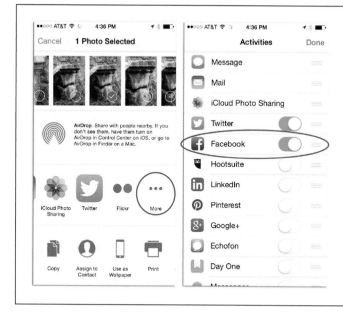

FIGURE 8-6

Left: After selecting some thumbnails (page 59) and clicking the share icon, scroll horizontally through the row of share destinations shown here, and then tap More.

Right: On the screen that appears (shown here), tap the switch next to Facebook to turn it on (it turns green). If you tap Done at the screen's upper right, a Facebook icon appears in the row of sharing destinations. Give it a tap and use the resulting form to set the post's privacy and location, enter a description, and so on.

Amazingly, Flickr lets you upload up to a *terabyte* of photos and videos at full resolution (page 185). For example, if you shoot with a 6.5-megapixel camera, that's 537,731 photos (sounds like a backup solution, doesn't it?). Pictures are limited to 200 megabytes each; videos can't weigh more than 1 gigabyte, and their pixel width can't exceed 1080 pixels in high definition.

When you join Flickr, you're in for quite a ride—it's not just a place to post your pictures on the Web for your friends and family to see, although it's great for that. It's also a place where photography fans give feedback, link to one another's Flickr pages, and so on. Many Flickr fans add tags to their images so folks can easily find them—say, "NASA," "macro," "portrait," or location-based tags such as "Maui" or "Rome." You can also order hardcover, printed *books* of your Flickr posts, complete with matching dust jackets.

NOTE Posting a picture to Flickr doesn't mean the whole world can see it. By using the site's privacy settings, you can keep personal shots out of public view. The site also lets you create lists of friends and family so that only the people on those lists can see specific pictures. For more info, visit *https://help.yahoo.com/kb/flickr*.

Posting pictures to Flickr works just like it does for Twitter and Facebook. First, visit *www.Flickr.com* and create an account. Second, in Photos for Mac, select some thumbnails, click the share icon, and then choose Flickr. If this is the first time you're interacting with Flickr on your Mac, Photos prompts you to add the account. Click Add Account and the Internet Accounts pane of your Mac's System Preferences

appears. Enter your user name and password, click Next, and then click Sign In. Next, switch back to Photos, choose Flickr from the share menu *again*, and you see the pane shown in Figure 8-7.

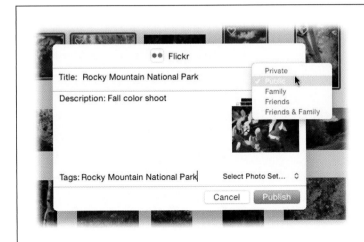

FIGURE 8-7

Here you can add a title, description, and tags to the stuff you upload to Flickr. Use the menu at the upper right to set privacy options, and the one at the lower right to specify which Flickr set (think "album") you want to tuck the images into.

When you're finished filling out the message form, click Publish. Depending on the size and number of items you're uploading, this process can take awhile.

The process for posting content to Flickr using Photos for iOS is nearly the same. Use the techniques described on page 59 to select some content, and then tap the share icon. Scroll through the horizontal row of sharing destinations until you see Flickr, and then tap its icon. Fill out the resulting message and tap Publish. That's all there is to it!

Using iCloud Photo Sharing

As you learned in Chapter 2, iCloud has several components. For example, iCloud Photo Library (page 11) can back up your whole Photos world and sync all your pictures and videos across all your devices. My Photo Stream (page 23), on the other hand, is for those who *don't* use iCloud Photo Library and wish to sync their most recent 1,000 files between devices.

iCloud Photo Sharing is a wonderfully private way to share digital memories with certain people. It works on Macs, PCs, and iOS devices, and the sharing can work in both directions. You start the sharing spree by creating an album and inviting people to subscribe to it via email (Photos handles that part). If your subscribers have an iCloud account, they can like what you post and add comments. They can download your content and, if you grant them permission, add their own to the shared album. If they're rolling sans iCloud, you can have Photos generate a public website that they can use to see your stuff.

NOTE PC users can join the iCloud Photo Sharing party by installing iCloud for Windows. For info on how to download it and set it up, visit *https://support.apple.com/en-us/HT201391*.

When you create or subscribe to a shared album, it appears on all of your devices. This makes iCloud Photo Sharing a serviceable alternative to using—and paying for—iCloud Photo Library (page 11) to get certain imagery onto your iOS devices. Since iCloud Photo Sharing doesn't count against your allotted iCloud storage space (page 12), it's basically free. That said, it doesn't back up the original, high-quality versions of all your stuff to Apple's servers like iCloud Photo Library does.

Turning on iCloud Photo Sharing

In order to use iCloud Photo Sharing, you first have to turn it on. Here's how:

- **In Photos for Mac** choose Photos→Preferences, and then in the iCloud pane (Figure 8-8), turn on iCloud Photo Sharing.

- **On an iOS device,** tap Settings on your home screen (or whatever screen it lives on), and then scroll down until you see Photos & Camera. Give it a tap, and on the next screen, tap the switch next to iCloud Photo Sharing (it turns green).

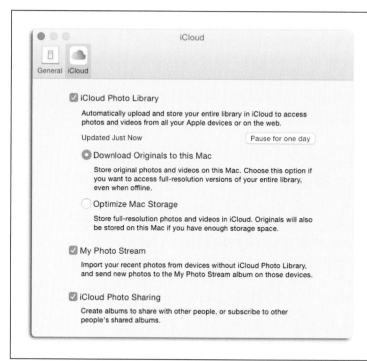

FIGURE 8-8

The iCloud pane of Photos' preferences holds the key to turning on various iCloud services.

If you someday decide to turn off iCloud Photo Sharing on one of your devices, the contents of any shared albums will still be visible and editable on any other devices that still have iCloud Photo Sharing turned on.

Creating a Shared Album

Creating a shared album in Photos for Mac is mercifully simple. Photos for iOS lets you create albums, too, so you can quickly share content with others no matter where you are (talk about instant gratification!).

In Photos for Mac, simply select an album or use the techniques described on page 57 to select a few thumbnails. Next, click the share icon in Photos' toolbar and choose iCloud Photo Sharing, or Control-click a selected thumbnail and choose Share→iCloud Photo Sharing. You can also choose File→Share→iCloud Photo Sharing to get started.

In the "Add to Shared Album" sheet that appears (Figure 8-9, left), click New Shared Album, and the sheet shown in Figure 8-9 (right) appears, which lets you name the album and invite someone to subscribe to it by entering his name, email address, or cell phone number into the To field. In the Comment field, enter a description of the pictures you're sharing.

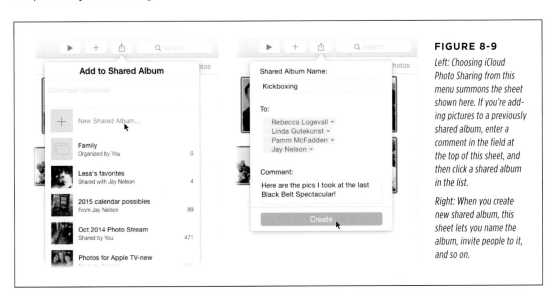

FIGURE 8-9

Left: Choosing iCloud Photo Sharing from this menu summons the sheet shown here. If you're adding pictures to a previously shared album, enter a comment in the field at the top of this sheet, and then click a shared album in the list.

Right: When you create new shared album, this sheet lets you name the album, invite people to it, and so on.

When you're finished filling out the all the fields, click Create. The lucky people you include in the To field promptly receive an email invitation to subscribe to your freshly shared album. Once they click the Subscribe button in the email, the shared album appears in Photos' Shared view on all their devices. The Photos icon in the Dock on the recipient's Mac shows a tiny red circle containing the number of invitations that await them. (When invitations are awaiting your attention, you see the same red circle on the Photos icon in your Mac's Dock and on your iOS devices.)

To create a shared album in Photos for iOS, use the techniques described on page 59 to select some thumbnails—unfortunately, there's no way to select a whole album—and then tap the share icon. On the resulting screen, tap the colorful iCloud Photo Sharing icon. In a moment, you see a message screen with a stack of tiny thumbnails

representing the images you're about to share (see Figure 8-10, left). If you like, you can tap the Comment field to enter some descriptive text (don't worry; you'll get another chance to enter a comment before the album is shared). Next, tap Shared Album at the bottom of the message; you see a list of the albums you've shared and the ones you subscribe to (see Figure 8-10, right). Tap New Shared Album at the top of the list, and enter a name for the album on the next screen. Tap Next, and then tap the To field on the next screen to enter an email address. Tap the + icon at the right of the field to tunnel into your Contacts app and search for the lucky recipient, or scroll to find her name in the list. Keep tapping the + icon to return to your Contacts list until you're finished adding email addresses. Once you're done, tap Next and you see the first message screen, where you can enter a comment if you didn't do so before. Finally, tap Post to send your album invitations!

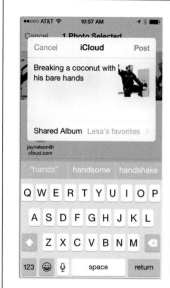
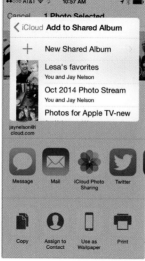

FIGURE 8-10

Left: On an iOS device, use the sheet shown here to enter a comment about your new album (if you wish). When you're done, tap Shared Album.

Right: This sheet contains all your shared albums. Tap New Shared Album, and then fill out the resulting message fields as described in this section.

TIP You can also create a new, *empty* shared album in Photos for iOS in Shared view. Tap Shared at the bottom of your screen and, if necessary, use the Back button at the upper left to close the shared album you're viewing so you see thumbnails of all your shared albums. Then tap the + button at the upper left and fill out the resulting message screens as described above. When you're finished, tap Create and you see a new, empty album in Shared view. To populate it with pictures, open the album by tapping its thumbnail, and then tap the + icon that appears. Photos for iOS transports you to Photos view, where you can tap to select the pictures and videos you want to include. When you're finished, tap Done.

Once you share or subscribe to a shared album (or several), Photos collects updates to shared albums in the *Activities* album (page 46) in Shared view, which you can see in both Photos for Mac and Photos for iOS. When you open this album, you see big, beautiful thumbnails of the most recent additions to each album, grouped

according to album name. Just scroll through the list to see all recent activity, including comments (page 222). Beneath the thumbnails of albums that you've shared, you'll spot a clickable link that takes you into the contents of that particular album ("See all 89 photos," say). This is a great way to breeze through all the goodies in your shared albums and see what everyone is up to.

Adding Content to a Shared Album

Once you've created a shared album, you can add more goodies to it in Photos for Mac in the following ways:

- **Drag and drop onto the sidebar.** First, make sure the sidebar is turned on by choosing View→Show Sidebar. Next, select the pictures and videos you want to add, and then drag them onto the shared album's name in the sidebar's Shared section. (If you see the Shared heading but no albums, expand the section by pointing your cursor at it and then clicking Show.)

- **Choose from a list of shared albums.** Select some pictures and videos to add, and then click the share icon in Photos' toolbar and click iCloud Photo Sharing or choose File→Share→iCloud Photo Sharing. Either way, you see the "Add to Shared Album" sheet (Figure 8-9, left), which lists all your shared albums. Add a pithy comment to the field at the top of the sheet, and then click the album you want to add the content to.

- **Open the shared album and click "Add photos and videos" at its upper right.** When you do, your view changes to let you pick thumbnails to add. Use the buttons at the upper left to navigate between All Photos and Favorites. When you find something to add, click its thumbnail and a blue circle with a white checkmark appears on the thumbnail's lower right (click the thumbnail again to deselect it). Click Selected at the upper left to see all the thumbnails that are already included in the shared album, along with those you've chosen to add.

- **Open the Activity album in Shared view and click the "Add Photos or Videos" link that appears above the images at left.** You get the controls described in the previous bullet point to add stuff.

To add content to a shared album in Photos for iOS, use the techniques described on page 59 to select some photos and/or videos, and then tap the share icon. Next, tap the iCloud Photo Sharing icon; a message screen appears and you can add a comment. Tap Shared Albums at the bottom of the screen, and in the resulting list of albums, tap the album you want to tuck the content into. A blue checkmark appears to the right of its name. Tap Post, and Photos adds your goodies to the album you picked. Alternatively, you can open the shared album first, and then tap the + button that appears at the end of the album. When you do, you're whisked into Photos view, where you can tap to select thumbnails of the stuff you want to include. When you're finished, tap Done. You can also add stuff while viewing the Activities album on your iOS device, as described in the last bullet point above.

Deleting and Unsubscribing from a Shared Album

If, for whatever reason, you no longer wish to share the contents of your Kickboxing album (say, you don't want to give Grandma a heart attack), or if you don't want to subscribe to an album someone else shared with you, you can delete the album. If you're the owner of the album, deleting it doesn't remove its contents from your Photos library. But if you merely subscribe to the album, the content disappears when you delete it (that is, unless you downloaded its content as described on page 222).

NOTE If you merely wish to stop sharing the album with a certain person, don't throw out the shared album with the bathwater. Instead, remove the person (or several) from your subscriber list as explained on page 219.

Deleting a shared album is simple, and you can do it in a few different ways in Photos for Mac:

- **In Photos view or in the sidebar,** Control-click the shared album's thumbnail and choose Delete Shared Album from the shortcut menu that appears.

- **In the preview area or sidebar,** select the album's thumbnail, click the subscriber icon in Photos' toolbar (it's circled in Figure 8-11), and then click Delete Shared Album. It's the big red button at the bottom of the sheet—you can't miss it.

- **In Shared view,** click the < button in Photos' toolbar until you see thumbnails of all the shared albums you've made or subscribed to. Next, in the preview area (not the sidebar), select the one you want to obliterate, and then press ⌘-Delete. In the confirmation box that appears, click Delete. (If you merely subscribe to the shared album you're deleting, the confirmation message gives you an Unsubscribe button instead.)

Dust off your hands and imagine a tiny *poof* sound as the shared album instantly disappears from all your subscribers' devices. Of course, any content your subscribers downloaded from the shared album (page 222) still exists on their devices.

In Photos for iOS, tap Shared at the bottom of your screen and, if necessary, use the Back button at upper left to close the shared album you're viewing so you see thumbnails of all your shared albums. Tap Edit at upper right, and then tap the red circle with a dash that appears to the album's left. Tap the big red Unsubscribe button that appears at right, and then tap Unsubscribe in the confirmation message that appears. The album disappears from Shared view in Photos for iOS and in Photos for Mac.

Letting Subscribers Add to a Shared Album

A bonus (and semi-hidden) feature of shared albums is that you can let any subscriber add his own pictures and videos to the album. Doing so creates incredibly convenient, two-way sharing between you and your subscribers.

To set it up in Photos for Mac, double-click a shared album to open it or, if you have the sidebar turned on (page 18), just click the album's name in the Sharing section to select it. Next, click the subscriber icon in Photos' toolbar (it's circled in Figure 8-11). In the sharing sheet that appears, turn on Subscribers Can Post.

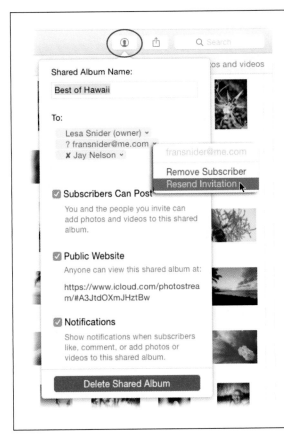

FIGURE 8-11

Click the subscriber icon (circled) to reveal a sheet that lets you perform all manner of subscriber-related chores. An X next to a name means that person unsubscribed from the album (the nerve!), though a question mark to the left of a name means that person hasn't responded. In that case, you can resend an invitation (as shown here), remove subscribers, grant them permission to post material, turn the album into a public website, disable subscriber notifications, and delete a shared album.

NOTE In order to edit an item added by someone else, you have to import it into your Photos library first. Page 222 tells you how.

In Photos for iOS, tap Shared at the bottom of your screen and, if necessary, tap the Back button at the upper left to close the shared album you're viewing so you see the thumbnails of all your shared albums. Next, tap the thumbnail of the album that you want to grant uploading permission to; you see the album's thumbnails, as shown in Figure 8-12, left. Next, tap People at the bottom right and the screen shown in Figure 8-12, right, appears. Tap the Subscribers Can Post switch to turn it on (it turns green). Now your subscribers can add their own stuff to the album.

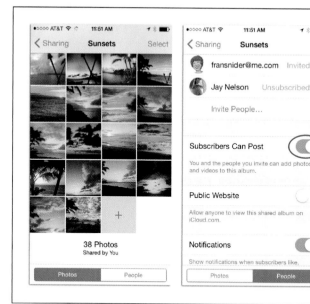

FIGURE 8-12

Left: When you open a shared album in Photos for iOS, use the buttons at the bottom to switch between viewing thumbnails (Photos) and the people you invited to the album (People).

Right: This screen lets you grant subscribers permission to post their own stuff using the switch circled here. You can also see who you invited to the album and their invitation status, invite more people, generate a public website (page 220), manage the album's notifications (page 219), and delete the album (scroll down further to see the Delete button).

From this point on, the shared album synchronizes everyone with access to it: Any items you, or a subscriber, add to the shared album is sent to every device of every person who subscribes to it. Likewise, any items you, or a subscriber, remove from the shared album disappear on all subscribed devices. It's a heck of a lot of fun and the perfect way to share pictures with folks who aren't on Facebook or who aren't particularly tech-savvy.

TIP Don't underestimate the power of creating an *empty* shared album that you add items to later. This is handy when you want to, say, set up a shared album for a friend or relative to put stuff into. To do that in Photos for Mac, choose View→Shared, and Photos shows you thumbnails of all the albums in Shared view. Next, click the + button in Photos' toolbar and you see the sheet shown in Figure 8-9 (right). Give the subscriber(s) permission to add content to the album as described in this section, and you're good to go! The tip on page 214 explains how to do this in Photos for iOS.

Managing Subscribers

So you forgot to add Aunt Edna to a shared album and now she's upset. No big deal—you can easily invite her after creating the album. On the flip side, perhaps you want to remove an existing subscriber from a shared album (handy for breakups and other squabbles). These kinds of subscriber-management chores are easy to handle in both Photos for Mac and Photos for iOS.

First, select the shared album by either clicking it in the sidebar's Shared section or by clicking the album's thumbnail in Shared view. Next, click the subscriber icon in Photo's toolbar (it's circled in Figure 8-11). In the sheet that appears, you can do all kinds of practical stuff such as edit the album's name, invite new subscribers, remove existing ones, resend invitations, and so on:

- **To add a subscriber,** click inside the To field and enter her name. Like most Apple apps, Photos tries to automatically fill in the rest of the name based on the first few letters you type. If the person is stored in the Contacts app, her name appears in a list; just click it to select it. If your intended recipient isn't in your Contacts app, enter her email address or cell phone number to add her to this list (this maneuver doesn't add them to the Contacts app).

- **To remove a subscriber,** click the tiny down-pointing triangle to the right of his name and choose Remover Subscriber from the menu visible back in Figure 8-11.

- **To resend an invitation,** click the tiny down-pointing triangle to the right of her name and choose Resend Invitation.

- **To stop receiving notifications about subscriber activity,** turn off Notifications at the bottom of the sheet. Doing so means you won't hear about each time a subscriber likes, comments, or adds his own content to the shared album.

In Photos for iOS, you can do all of the above using the People screen shown back in Figure 8-12 (right). To get there, tap a shared album to open it, and then tap the People button at the bottom of your screen. There you can:

- **Add a subscriber** by tapping Invite People and entering an email address on the resulting screen. To tunnel into your Contacts app to fetch the email address, tap the + button; you see a list of all the people in your device's Contacts app. Use the search field to find the person you want to invite to the album, or simply scroll through the list. When you find the name you want, tap it. If there's more than one email address associated with that person, her contact sheet opens. Tap the email address you want to use, and it's added to your invite list. To invite more people, tap the + icon again. When you're finished adding email addresses, tap the Add button at upper right to go back to the People screen.

- **Resend an invitation or remove a subscriber** by tapping the person's name at the top of the sheet, and then scrolling down to the bottom of the resulting sheet and tapping Resend Invitation or Remove Subscriber.

- **Turn off notifications for subscriber activity** by tapping the Notifications switch near the bottom of the People sheet.

The ability to manage your shared albums in this way on your iOS device is pretty amazing. Simply put, you don't have to be home and in front of your Mac to do this stuff. You can easily manage shared albums while globetrotting, waiting at the car wash, or getting a tattoo. Just remember to put down your iOS device every once in awhile so you can interact with other humans in person!

Publishing a Shared Album on the Web

If the people you want to share your digital mementos with don't have an iCloud account, don't worry; Photos for Mac and iOS is more than happy to whip up a quick public web page that anyone can view in a web browser. Figure 8-13 shows an example of a public site.

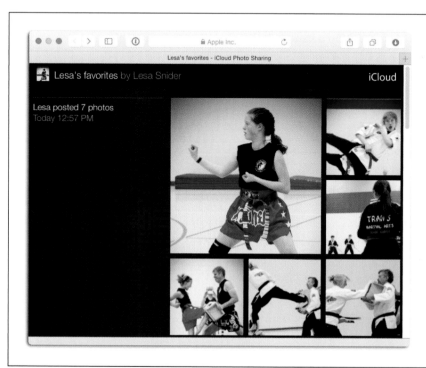

FIGURE 8-13

Here's what a public website looks like. The result is nice enough, sure, but it's a no-frills web page that you can't customize in any way (beyond which pictures and videos it contains).

To create a website from a shared album in Photos for Mac, open the album or select it in the sidebar's Shared section. Click the Subscriber icon in Photos' toolbar (circled in Figure 8-11) and turn on Public Website. A custom web address for the album appears (it begins with *https://www.icloud.com*). Click it and Safari (or your preferred web browser) springs into action and displays the page. If you use Safari, you can easily share the address with others by choosing File→Share→Email This Page in Safari (or choose one of the other sharing options in the same menu). You can copy the address by highlighting it and choosing Edit→Copy, and then you can paste the address into, say, a group email message.

To do this in Photos for iOS, tap to open the shared album, and then tap the People button at the bottom of your screen. In the sheet that appears (visible back in Figure 8-12, right), tap to turn on the Public Website switch (it turns green). Next, tap the Share Link that appears and use the icons on the resulting screen to choose how you want to share the link. You can send it via AirDrop (page 227), Messages (page 206), Mail (page 202), Twitter (page 207), or Facebook (page 208)—swipe left to scroll horizontally to see more icons or tap More icon to view additional apps. You can also

tap the Copy button to copy the link to your device's clipboard so you can paste it in another app on that device (such as Safari, so you can see what the site looks like).

Either way, visitors to your public web gallery can click a photo to enlarge it, and then click the left and right arrows that appear to move through the content (the arrow keys on your keyboard work, too). Even more options appear at the top of the enlarged picture's page, as Figure 8-14 explains.

FIGURE 8-14

After enlarging a picture on a public website, point your cursor near the top of the page and you see the row of buttons shown here. From left to right, they let you return to the gallery page to see all the pictures it contains, trigger a slideshow, download an image, or enter Full Screen view (great for viewing slideshows!).

People who view your public website can easily download stuff you shared. All they have to do is click to enlarge an image, point their cursor near the top of the page, and then click Download. When they do, the full-resolution picture or video is deposited in their computer's Downloads folder. This is great news for far-flung friends or relatives who want to print an image, but maybe bad news for you in terms of would-be picture thieves who can easily grab your content and use it as their own. That said, the probability of such a thing happening is somewhat slim, because the site is a bit hard for the masses to find.

TIP If you're viewing a web gallery using your iOS device, you can download any images it contains to that device. To do so, tap an image to open it, and then tap and hold the image to reveal a sheet that lets you save or copy the image. If you tap Save Image, the picture lands at the bottom of the All Photos album in the Photos app on that device.

Another downside (besides your full-resolution images being available to anyone who happens upon the site) is that your subscribers can't comment or like any of the pictures the site contains. However, if any comments were made *before* you created the public website, then those comments remain visible.

Fortunately, public websites are as easy to take down as they are to create. All you have to do is open the shared album, click the subscriber icon circled in Figure 8-11, and then turn off Public Website. Deleting the shared album using the techniques described on page 216 works, too. In Photos for iOS, open the People sheet as described earlier (page 218), and then simply turn off the Public Website switch (it goes from green to gray).

Downloading Shared Content

Once you give others permission to add their own content to a shared album, you may want to include some of their images in a book, card, or calendar project (see Chapter 9). Or perhaps you want to zap a blemish or add a slick filter to an item shared by someone else. Either way, you have to import the item into your own Photos library first.

To do that, Control-click a thumbnail and choose Import from the shortcut menu. Photos dutifully adds the item to your Last Import album, where you can treat it like any other picture or video in your library: Edit it, add it to another album, include it in a project, and so on. Alternatively, you can double-click a shared image, click Edit (or press Return) to enter Edit mode, and then click Import in the message pane that appears. Next, make your changes to the image, and then click Done. If you want to add the edited version of a downloaded image to the shared album from whence it came, you need to add it to the shared album *again*.

The previous section explains how to download content from a public website created in Photos.

Adding and Viewing Comments

By now you're getting the idea that using shared albums is a bit like having your own personal Facebook experience *inside* Photos, which is just the ticket for folks who are put off by the social-media behemoth. For example, subscribers can like or add comments to your goodies, which kicks the value and fun factor up several notches.

To like and comment on an item in a shared album in Photos for Mac, open the album, double-click a picture or video (or press the spacebar), and then click the + icon that appears in the picture's lower-left corner (it looks like a thought bubble). When you do, a comment sheet appears. Figure 8-15 has more.

When someone likes or comments on a picture, *all* the album's subscribers are alerted via their Macs' Notification Center. Whenever you enlarge a picture, you see a tiny number at its lower left that lets everyone know how many comments await your reading pleasure. To view comments your subscribers have made, simply click the + icon at the picture's lower-left corner.

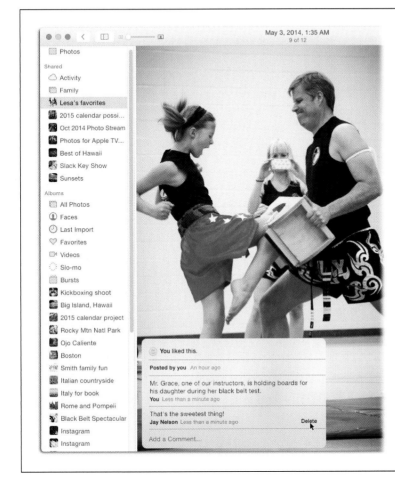

FIGURE 8-15

Click the smiley-face icon to like a picture or video, or click in the comment field and type whatever you like. Click Send, and Photos adds your comment to the list shown here. To delete a comment, point your cursor at it, and then click the Delete button that appears.

To like an image or add and view comments in Photos for iOS, tap to open the shared album, and then tap the picture itself to open it. Beneath the picture, you see the controls shown in Figure 8-15, which let you like the image, view comments, and add your own. To delete a comment, tap and hold your finger down on it, and then tap the Delete button that appears just above the comment.

TIP If your photo streams get a lot of action—comments, likes, or new content—the notifications may drive you insane. Page 219 offers one way to silence them, but you can also shut them up by Option-clicking the Notification Center icon at the right end of your Mac's menu bar. Doing so dims the icon (it turns gray) and stifles all notifications for the rest of the day or until you Option-click the icon again. On an iOS device, you can turn off notifications by tapping Settings→Notifications. On the screen that appears, tap Photos, and then turn off Allow Notifications (the switch goes from green to gray). Whew!

Family Sharing

If more than one Mac- or iOS device–using person lives under your roof—or if you share your Mac with one or more people—iCloud Family Sharing is the best thing since sliced bread. As you learned on page 14, using Photos in a family situation is a complicated matter: You quickly end up with multiple Photos libraries and nobody remembers which pictures live where.

Apple's solution is called *Family Sharing*, which lets you create a special group that you invite family members to join. The end result is an album named Family in Shared view that everyone in the group can access (it can't be shared with anyone *outside* the group). Family members can easily add or remove their own pictures and videos, which are viewable and downloadable by everyone else in the group. This special album is also accessible on the Web; just visit *www.iCloud.com* and sign into your iCloud account to see all the goodies it contains (handy for those rare occasions when you're not parked in front of your Mac or clutching an iOS device).

If you think about it, this solution is brilliant. By using Family Sharing, each family member maintains his or her own Photos library and gets to choose what's shared with everyone else. This gives each member of the group some level of privacy while you, Family Commander-In-Chief, have access to shared items and can include them in projects such as saved slideshows (Chapter 6), or books, calendars, and cards (Chapter 9).

UP TO SPEED

Sharing Limits

One really nice thing about shared albums is that the content you put into them doesn't count against your iCloud storage allowance—Apple basically lets you use iCloud Photo Sharing for free (isn't that nice?). However, there are limits to Apple's generosity:

- You can't share more than 100 albums.

- You can only send 200 invitations per day to a shared album, and the maximum number of subscribers per shared album is 100. So if you send 200 invitations, you're effectively betting that *half* of them decline.

- In a shared album, the maximum number of pictures and videos from all contributors can't exceed 1,000 per hour or 10,000 per day. (That's a lot of pictures!) If you exceed either limit, then no one can add more items until the next hour or day (whichever limit you blew past).

- A shared album can contain a maximum of 5,000 items (that's the combined number of pictures and videos from all contributors).

- You can subscribe to a maximum of 100 shared albums.

- A picture or video in a shared album can have a maximum of 200 comments. And comments aren't limited to text entries: When a subscriber clicks the like icon, Photos counts that as a comment, too.

- Comments can't be longer than 200 characters.

- Shared videos can't be over 5 minutes long, and the only shareable video file formats are MP4 and QuickTime files that are encoded as H.264 and MPEG-4.

- Shared panoramic images can be up to 5400 pixels wide.

- Shared images must be in JPEG, TIFF, PNG, or raw format.

All in all, these limitations are quite reasonable for a free service as convenient as iCloud Photo Sharing.

NOTE The Family Sharing album is just one of several services that you can share among the members in a Family Group. Others services include a shared Apple Calendar; shared purchases from Apple's App store, iBooks store, and iTunes store; and the ability to track the locations of Macs and iOS devices. (For the full story on Family Sharing, grab a copy of *OS X: The Missing Manual*.)

Setting up Family Sharing is a multistep affair. For example, if you share your Mac with anyone else, each person who uses it needs his own Mac user account. As page 15 explains, this grants each person his own Photos library (see *https://support.apple.com/kb/PH18891* if you need help creating user accounts). Next, everyone involved needs their own Apple ID, you need to create a Family Group, and then you need to invite the family members to join the group. Grab a beverage, and then follow these steps to accomplish all that:

1. **Give everyone an Apple ID.**

 If any of your family members lack an Apple ID, visit *https://appleid.apple.com* to create one (or five). Bear in mind that an Apple ID is automatically created when someone purchases an item from Apple.com or you turn on iCloud services on a device running iOS 5 or later, so check for existing accounts.

2. **Create a Family Group.**

 On a Mac, choose →System Preferences→iCloud. In the pane that appears, click Set Up Family, and then follow the onscreen instructions. Because Family Sharing extends beyond sharing pictures and videos and into the realm of iTunes purchases and so on, you're prompted to enter a credit card.

 To set up Family Sharing on an iOS device, tap Settings→iCloud. On the screen that appears, tap Set Up Family Sharing, and then tap Get Started. Confirm that you want to be the family organizer and that you're signed in with your personal Apple ID, and then follow the onscreen instructions. Of course, you'll need a credit card.

3. **Invite people to join the Family Group.**

 Now that you have a Family Group, you can invite family members to join it:

 • **On a Mac,** choose Apple→System Preferences→iCloud. Click Manage Family, click Add Family Member or click + at the lower left, and then follow the onscreen instructions. You'll need each family member's email address, as Figure 8-16 shows, and you'll need the security code for the credit card you entered in step 2 (that's the three-digit code on the back of the card). When you're finished entering the address, click Continue (you have to invite each person one at a time), and then enter your credit card's security code when prompted. If you entered an email address that's associated with an Apple ID, you can enter the person's Apple ID password (if you know it) on the next sheet, which lets you skip the whole invitation bit (handy if you've got kids or a parent who's not particularly tech-savvy). Otherwise, turn on "Send [person's name] an invitation" instead so he gets an email invite.

- **On an iOS device,** go to Settings→iCloud→Family→Add Family Member. Enter the person's name or email address and follow the onscreen instructions. (It's the same as the process described in the previous bullet point.)

Either way, your invitation winds up in the recipient's email inbox. Once she clicks the big blue View Invitation button in the body of the email, the Family Sharing preferences pane springs open, listing all the slick things she can now do—share purchased music, movies, apps, and books; share pictures and videos; and share events on a family calendar. Next, your recipient can click Accept. If she happens to be part of another family group, a message appears stating that she has to leave that group before joining another one. Your recipient can click OK, and then use the preference pane that appears to extricate herself from the other group.

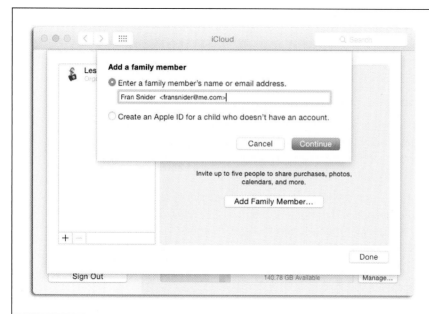

FIGURE 8-16

You can invite up to five family members to join your group using the iCloud preference pane shown here. This same pane also lets you create an Apple ID if you don't have one already.

> **NOTE** You can be a member of only *one* family group, and can only switch family groups once per year.

To check whether your invitation has been accepted, go to Apple→System Preferences, click iCloud, and select Manage Family. Select a person's name to see the status of his invitation. If you need to resend it, select Resend Invitation. (To check your invitations on an iOS device, tap Settings and, in the iCloud pane, tap Family. If necessary, you can resend an invitation from there.)

4. **Set up a shared family album.**

Just kidding! This really isn't a step at all because Photos *automatically* creates a new album named Family in Shared view. Apple also adds a Family category

to the Calendar and Reminders apps. Nifty, eh? (If you don't spot the Family album in Shared view, you're probably viewing the contents of another shared album. In that case, just click the Back button on the left side of Photos' toolbar to close the album so you see all your albums' thumbnails instead.)

5. **Add photos or videos to the shared family album.**

 Now the sharing fun starts. Anyone in your family group can now add pictures and videos in a variety of ways. For example, if the sidebar (page 18) is visible, you can drag thumbnails directly into the Family album. Alternatively, you can select some thumbnails, click the share icon in Photos' toolbar, choose iCloud Photo Sharing, and then click the Family album in the resulting list. Or, if you're viewing the contents of the Family album, click "Add photos and videos" at the upper right, and then pick the thumbnails of the goodies you want to add. Either way, the new content immediately appears in the Family album on the other group members' devices.

6. **Import pictures or videos from the Family album to your Photos library.**

 Remember, shared items don't live on your hard drive. So if a family member wants to edit a photo or or include a picture or video in a project, you need to download it from the Family album into your personal Photos library. You can do it in the following ways:

 - Drag the thumbnail(s) onto the Photos item at the top of the sidebar.

 - Drag the thumbnail(s) onto any album in the sidebar.

 - Control-click the item and choose Import from the shortcut menu that appears.

Now you can sit back and enjoy the fruits of your family-sharing labors. This really is the only sane approach for managing multiple Photos-using people in your immediate family. Remember though, this isn't the way to share content with just anyone: As you recall, you entered a credit card that's now shared by *all* the family members in your group. Consider yourself warned.

Sharing via AirDrop

When you need to transfer files between two iOS devices, Macs, or between a Mac and an iOS device, consider using AirDrop. It's fast, simple, and efficient. There's no setup or password involved, no software to install, and you don't even need an Internet connection.

AirDrop has been around for years. You can use it to transfer files to another AirDrop-enabled device up to 30 feet away. Since it uses Bluetooth (a data-sharing technology), you can fling files to and fro in places that you normally can't—airplanes, cruise ships, and on camping trips, to name a few.

Happily, AirDrop is easily accessible inside both Photos for Mac and Photos for iOS. Here's how to use it:

- To transfer files between iOS devices, you need an iPhone 5 (or newer), an iPad (fourth generation or newer), an iPad mini, or an iPod touch (fifth generation or newer). In iOS 8, launch the Control Center by swiping upward from the bottom edge of the display (in iOS 7, use the Settings app instead). Tap the AirDrop icon that sits to the left of the AirPlay icon. In the resulting menu, pick who you want to share files with: Contacts Only or Everyone. (If you pick Contacts Only, then only those folks who are in your Contacts app can send you files.) Once you make a choice, your device automatically turns on both Bluetooth and WiFi (while a WiFi network isn't required, WiFi still has to be turned on).

- To transfer files between an iOS device and a Mac (or vice versa), your Mac has to be made in 2012 (or later) and it must be running OS X 10.10 (Yosemite) or later. Use System Preferences to turn on both Bluetooth and WiFi (the latter is found in Network preferences). Next, open a AirDrop window in the Finder by choosing Go→AirDrop or by pressing Shift-⌘-R.

- To transfer files between two Macs, they both need OS X 10.10 (Yosemite) or later and both need to have an open AirDrop window.

Using AirDrop in Photos is incredibly easy: Simply select the items you want to share (pages 57–58), and then click the share icon in Photos' toolbar or the one that appears at the upper right of a moment in Photos view. From the resulting menu, choose AirDrop and you get a window (or screen in iOS) containing icons of any nearby AirDrop users. Click the icon of the person you want to send the file(s) to and that's it! (If you're sending files from Photos for Mac and you don't see the person's AirDrop icon, try opening an AirDrop window yourself, as described earlier, which oftentimes awakens the AirDrop engine.)

If your recipient is on an iOS device, she sees a message asking her to accept the shared file. If she's on a Mac instead, a message appears in her AirDrop window giving her the option to save or decline the file(s). When she accepts the goodies on an iOS device, they land in her Photos library. If she's on a Mac, your digital gift lands in her Downloads folder. At this point, she can drag the files onto the Photos icon in her Mac's Dock to add them to their Photos library (Chapter 2 has more importing options).

■ Desktops, Lock Screens, and Wallpaper

Every so often, a photo means so much to you that you'd like to see it every time you look at your Mac or iOS device. On your Mac, you can make the image your desktop picture, and on your iOS device, you can make it the lock-screen image or wallpaper (you can assign a different picture for each one). Using an image in this way lets you enjoy your prized photo 24/7.

Don't underestimate the power of customizing your Mac or iOS device this way. It'll give you a surge of enjoyment when you look at your device's screen from that point on.

Setting a Photo as Your Desktop (Mac)

In Photos for Mac, select the thumbnail of the image you want to use as your desktop picture, click the share icon, and then choose Set Desktop Picture. Ta-da! Next topic.

TIP If you don't see the Set Desktop Picture command in your share menu, you likely selected an *album's* thumbnail instead of an image's thumbnail. The fix is to open an album, click an image, and then try again.

Well, there's a *tiny* bit more to it, but not much. If your photo isn't the same aspect ratio (page 116) as your monitor, OS X fits it to the width of your monitor, centers it, and chops off the top and bottom. For that reason, you may want to crop your chosen masterpiece (see page 114) to the shape of your monitor—or relatively close to it.

Also, be sure to pick a photo that has enough pixels to fill your screen, or else you'll see jagged blocks instead of a smooth picture. To learn your monitor's pixel dimensions, choose →System Preferences→Displays. In the pane that appears, turn on the Scaled radio button; in the list that appears, the topmost item is your monitor's resolution. Back in Photos, you can see a picture's dimensions using the Info panel (page 74). For the best results, make sure the desktop picture you pick has at least as many pixels as your monitor.

Setting a Photo as Your Wallpaper (iOS)

In Photos for iOS, select the picture you want to use as your lock screen or home screen. (The lock screen is the one you see when you first wake up your device; the home screen is what appears behind all your app icons while you're using your device.)

Next, tap the share icon and, in the pane that appears, tap "Use as Wallpaper" (you may have to scroll sideways to see this option). Drag to position the photo, and use the pinch gesture (page xxii) to set its scale. Choose whether you want Perspective Zoom—the effect that moves your photo slightly as you tilt your device—on or off (if you get seasick easily, leave it off). Finally, tap Set, and then choose whether to use this photo on your lock screen, home screen, or both.

■ Photos: The Best Screensaver in the West

OS X's screensaver feature is beautiful to behold. When your Mac is turned on but you don't use it for a few minutes, your screen can take on a life of its own and display world-class photo collections at full size (say, from *National Geographic*) in a variety of animated themes. Better still, you can tell the screensaver to use *your* pictures instead of the preinstalled stuff. In fact, you can pick any set of pictures from your Photos library.

NOTE If you've got more than one monitor hooked up, you see *different* photos on each monitor as the screensaver plays, which makes for a really nice effect.

To customize your Mac's screensaver, choose →System Preferences→Desktop & Screen Saver. At the top of the resulting pane, click the Screen Saver tab. There, choose from one of the 14 *photo-based* screensaver themes in the list on the left (the ones at the bottom of the list aren't photo-based). When you do, the Source menu shown in Figure 8-17 appears beneath the theme's preview.

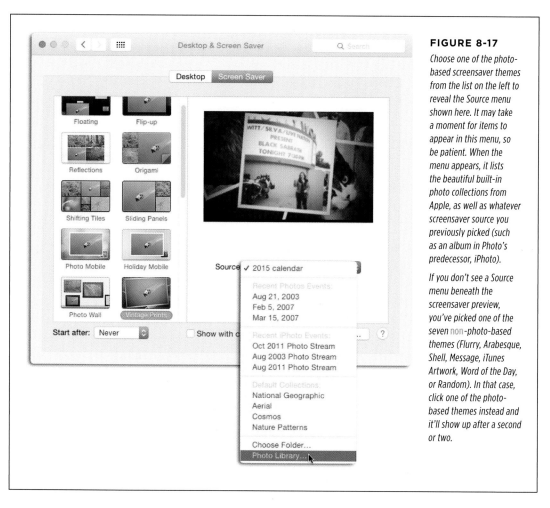

FIGURE 8-17

Choose one of the photo-based screensaver themes from the list on the left to reveal the Source menu shown here. It may take a moment for items to appear in this menu, so be patient. When the menu appears, it lists the beautiful built-in photo collections from Apple, as well as whatever screensaver source you previously picked (such as an album in Photo's predecessor, iPhoto).

If you don't see a Source menu beneath the screensaver preview, you've picked one of the seven non-photo-based themes (Flurry, Arabesque, Shell, Message, iTunes Artwork, Word of the Day, or Random). In that case, click one of the photo-based themes instead and it'll show up after a second or two.

From the Source menu, choose Photo Library, and you see the pane shown in Figure 8-18, which includes all of Photos' different views as well as your iPhoto and Aperture libraries (if you have any). Click any view and the pictures it contains appear as tiny thumbnails on the right. To peek inside a view, click its flippy triangle to expand it so you can see any albums it contains. When you find the view or album you want to use, select it and then click Choose. Back in the Desktop & Screen Saver pane, you see a mini version of your personalized screensaver playing on the right. To shuffle the order of pictures, turn on "Shuffle slide order" beneath the Source menu. To

display a clock atop your pictures, turn on "Show with clock." To control when your screensaver kicks in, choose an option from the "Start after" menu at the lower left.

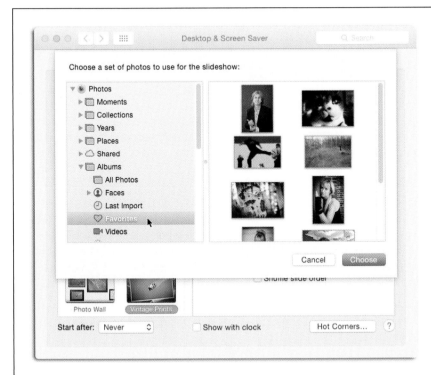

FIGURE 8-18

As you can see, your entire Photos world is up for grabs to use as a screensaver. If you click any item in the list, you see its contents as thumbnails on the right. When you find the pictures you want to use, click Choose.

You can also summon your Mac's screensaver using Hot Corners, which let you point your cursor at a specified corner of your screen to turn it on. To set it up, in the Desktop & Screen Saver preference pane, click Hot Corners, choose Start Screen Saver from one of the four resulting menus, and then click OK. To exit the screensaver, press any key on your keyboard or click your mouse button.

■ Exporting from Photos

As you learned in Chapter 1, Photos doesn't apply your edits to your pictures and videos until you export them. So if you want to use some pictures (or videos) you've edited in Photos somewhere else—say, in another program—or burn them onto a CD or DVD (page 174 and 281), you need to export them. You can also use Photos' export command to reduce a file's pixel dimensions in order to post it online or change its file format.

Exporting by Dragging

Exporting content from Photos is incredibly easy. If you don't want to change the picture's dimensions or file format, just drag its thumbnail onto your desktop, onto a folder icon on your desktop, or into an open Finder window (as you drag, you see a slightly see-through version of the thumbnail next to your cursor). The resulting file is named the same thing it was in Photos, though you can always rename it by clicking its name and entering something else.

You can also drag a picture into a message in the Mail app, or into a document in Pages, Keynote, any of the Microsoft Office apps, and so on. However, for professional publishing in non-Apple apps—all eyes are on you, Adobe—it's best to export your pictures using the Export command (explained next) and *then* import them into your documents.

The Mighty Export Command

To change the dimensions and file format of your pictures, you need to use the Export command. Use the techniques described on page 57 to select some thumbnails, or press ⌘-A to select the contents of a whole album, and then choose File→Export→Export [number] Photos or press Shift-⌘-E. (If you have got thumbnails of videos *and* pictures selected, the command changes to read "Export [number] Items" instead.) The next thing you see is the Export sheet shown in Figure 8-19.

> **TIP** If you want to email just a few photos, don't bother with the Export dialog box—click Photos' share icon instead. Page 202 has the scoop.

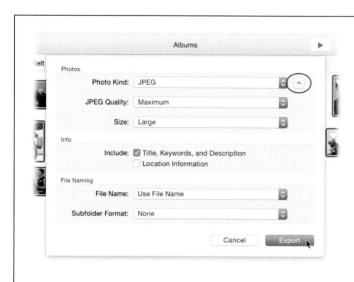

FIGURE 8-19

The first export sheet you see doesn't give you very many options; you have to expand it by clicking the icon circled here to see everything. When you do, you see these options, which let you specify file format, quality, and the pixel dimensions of the exported files. You can choose to include any titles, keywords, and descriptions you've added in Photos (as well as any location info the picture includes) as metadata. And the last section lets you specify a naming scheme for the resulting files and whether you want them tucked into subfolders.

Here are your export options:

NOTE Photos won't let you export images in a shared album (page 211), regardless of whether you shared the album yourself or merely subscribe to it. So if the Export command is dimmed, that's probably why. The fix is to locate the images in Photos or Albums view, and then try again.

- **Photo Kind.** Use this menu to specify the file format of the picture(s) you're about to export. Here are your choices (if you don't see the size options, be sure to expand the pane by clicking the icon circled in Figure 8-18. After all, no pane, no gain!):

 — **JPEG.** This abbreviation stands for Joint Photographic Experts Group (the group of geeks who came up with this format). JPEG is the most popular format for photos because it uses an enormous range of colors, though it uses a *lossy* compression method to produce relatively small file sizes, so you may lose some fine details.

NOTE If you choose JPEG, you can use the JPEG Quality pop-up menu to specify a quality level (High, Medium, and so on). Just remember that the file size gets bigger as the quality increases.

 — **TIFF.** This format (whose name is short for Tagged Image File Format) also uses a wide range of colors but doesn't compress images, so they maintain every bit of quality in the original. However, they consume a lot more disk space than JPEGs. TIFF is a good choice if quality is more important than file size. When you choose this option, a checkbox labeled "16 bit" appears beneath the menu. Sixteen-bit images contain a gazillion colors (65,536 to be exact) in each color channel (red, green, and blue) and are produced by high-end digital single-lens reflex (DSLR) cameras shooting in raw format and by really good scanners.

 — **PNG.** This format (short for Portable Network Graphics) uses a wide range of colors and compresses images to produce smaller file sizes. PNG files are smaller than TIFF images but larger than JPEGs, but don't exhibit any of the compression-related quality issues of JPEGs.

- **Size.** This menu lets you specify a size for the exported file. Your choices include Small (320 × 240 pixels, perfect for emailing to people who have dial-up connections), Medium (640 × 480, great for email and posting online), Large (1280 × 960, superb for slideshows), and Full Size (the picture's original size, which is fit for printing). If the size you need isn't in the list, choose Custom and you get a menu named Max that lets you specify the *maximum* (hence the menu's name) pixel dimensions for each photo's width, height, or—if you choose Dimension from this menu—the longest side. If you're wondering why Photos doesn't give you two separate fields for width and height instead, it's because the pictures you export may have different proportions, and these controls let you determine the *maximum* dimensions for the exported image's width, height, or longest side.

- **Titles and keywords.** Photos keeps track of two names for each picture or video you import: the original filename your camera assigned to it and the title you give it in Photos (if any; see page 54). If you turn on the Export sheet's "Title, Keywords, and Description" checkbox (which works for JPEG and TIFF formats only), then each exported file carries the name you gave it in Photos, as well as any keywords (page 91) and, if you added one, a description (page 74). That means you can locate the file on your Mac using a Spotlight search, and if you import the file into a program that understands keywords (say, another Photos library, Adobe Photoshop Lightroom, or Photoshop Elements), the keywords and description you gave it travel along with it.

- **Location information.** Turn on this setting to include any location info (page 55) your file includes.

- **File Name**. Use this menu to specify how you want Photos to name the exported files. Your options are:

 — **Use Title** results in files that are named using the titles you added in Photos (page 54).

 — **Use File Name** results in files named with the original names given to them by your camera, like IMG_1312.JPG and so on.

 — **Sequential** summons a text field named Sequential Prefix, where you can enter a custom name such as *Roller Derby*, and you end up with files named *Roller Derby 1*, *Roller Derby 2*, and so on.

 — **Album Name With Number** instructs Photos to name your exported photos according to the name of the album they're in and their sequence *inside* the album. For example, if a soon-to-be-exported file is the third picture in the Roller Derby album, Photos names the exported file *Roller Derby–03. jpg*. Since you control the sort order in an album (page 67), you can use this option to control the numbering of exported files.

 — **Subfolder Format.** This option clusters the exported files into folders based on moments (each subfolder is named after the moment). Choose None to export the photos without creating any subfolders.

> **TIP** If you have an iCloud account, you can export your pictures to iCloud Drive and then access them from any Mac, iOS device, or Windows PC set up to use iCloud Drive. For more about iCloud Drive, search for iCloud Drive in Mac Help or pick up a copy of *OS X: The Missing Manual*.

■ EXPORTING UNMODIFIED ORIGINALS

You don't have to export the *edited* versions of your pictures and videos. If you pre-fer, you can export the original versions instead. By choosing File→Export→Export Unmodified Original, you instruct Photos to export the selected files in whatever state, format, and size they were in when you first imported them.

TIP If your camera captured the picture in raw format (page 34), this command lets you export the original raw file so you can, say, work with it in a more sophisticated editor such as Adobe Photoshop Lightroom or Adobe Camera Raw (the latter comes with both Photoshop and Photoshop Elements).

You get the same control over filenames and subfolders using the Export Unmodified Original command as you do using the Export command (page 232). If you added copyright or keyword info to the files in Photos, turn on "Export IPTC as XMP" to export the IPTC (International Press Telecommunications Council) metadata as a *sidecar* file in XMP (Extensible Metadata Platform) format. You can read and edit this file in many apps, including Adobe Photoshop Lightroom, Adobe Bridge, and ACDSee.

■ EXPORTING VIDEOS

All the information about exporting photos (file naming, how to include keywords, and so forth) also applies to exporting videos. The only unique decision you need to make when exporting a video is Movie Quality, which is explained in detail on page 181.

Creating Custom Books, Calendars, and Cards

Welcome to one of the most rewarding chapters in this book. There's nothing like the satisfaction of handcrafting a printed project you can hold in your hands, and Photos lets you do just that. The books, calendars, and cards you can create in Photos are among the most beautiful printed products available. While you can order the same kinds of photo-based products from various companies, the ease in which you can build and customize them in Photos is unmatched. Same for the print and paper quality you get from Apple, even though they're not technically the ones who do the printing (the identity of their printer is a closely guarded secret). Even the packaging they arrive in is awesome—they're stylishly swathed in white, Apple-logoed envelopes. Photos' built-in book, calendar, and card themes aren't cheesy, either; they're professionally designed and drop-dead gorgeous.

Books come in a variety of sizes and greeting cards can be folded, flat, or letterpress (where the ink is physically pressed into the paper). Many of the card themes are designed with a family newsletter in mind, which makes that yearly ritual feel more enjoyable and less like a chore. You can order as many cards you want, whether that's one or one hundred. For calendars, you pick how many pages you want and which month they start with, as well as which country-specific holidays to include. You can also include items from OS X's Calendar app such as birthdays and vacations. The calendars themselves are huge, bigger than you can get anywhere else, and they're printed on super-thick paper stock so they hold up to frequent flipping (handy because everyone who sees yours will want to flip through it).

You can customize many aspects of these projects. For example, you choose how many pictures go on each page, set the zoom level of each image, precisely position each picture within its frame, and add captions.

These printed goodies make impressive gifts. Imagine attending a friend's wedding and presenting them with a book of pictures you took, or giving your mom a stack of personalized thank-you cards she can send out. If you have trouble coming up with yearly gift ideas, a calendar is the perfect solution. But beware: Once you give someone a Photos calendar, they'll badger you for one every year.

> **NOTE** This chapter focuses solely upon Photos for *Mac*. You can't create books, cards, or calendars in Photos for iOS.

In this chapter you'll learn how to create all of these projects, starting with a custom photo book. Happily, the process is nearly the same no matter what you're creating.

■ Creating a Book Project

The books you create in Photos are highly customizable and a lot of fun to make. Once you pick some pictures and the format you want, Photos lays out the book and you set off on a customization adventure: carefully crafting each page, choosing how many photos to include, adjusting the zoom level, writing captions, and so on. When you're finished, you're rewarded with a beautifully printed book (on acid-free paper at 300 dots per inch) that's hand-delivered to your door. It may well be the most satisfying thing you ever do in Photos.

Any book projects you create stay in Projects view, which lets you easily reorder a book later on or duplicate the project so you can tweak it for another purpose without having to start over. The books you make in Photos work well as portfolios, too, allowing you to professionally showcase your photography or other art. In this section, you'll learn how to make a book worthy of showing off at any opportunity, for pleasure or for business.

> **TIP** Once you create some projects, you can use the Info panel (page 74) to view all kinds of neat info about them. In Projects view, click a project's thumbnail, and then open the Info panel by choosing Window→Info (or press ⌘-I). The Info panel opens to reveal who's in that project (or rather, which Faces tags the project contains), how many pictures the project includes, the date range in which the pictures were taken, the combined file size of all those images, and a map showing location info for any pictures that include it. Cool!

Step 1: Selecting Images

The first step in creating a book is selecting the pictures you want to include, which is probably the most challenging part of the whole project. For the best results, pick only your best and brightest shots. This keeps the book engaging and helps keep the cost down.

TIP If you prefer, you can create an empty book that you add pictures to later. This technique is helpful when you want to concentrate on the page design rather than the images; Photos displays empty gray boxes where your pictures will eventually live. Page 244 explains how to add pictures to your project *after* creating it.

Most of Photos' built-in book themes let you place up to seven pictures per page, though some let you squeeze in up to 16. Keep in mind that the more pictures you put on a page, the smaller and less impactful they become—after all, how much of an impact can postage stamp-size art have? For the best results, alternate the number of pictures on each page and mix in some pages that contain one large image—or an image that's spread across *two* pages—to make the design more visually pleasing.

To get started, try gathering 50–75 pictures and organizing them into an album (page 60). That way you can drag the thumbnails into the order you want them to appear in the book instead of leaving it to Photos. You can always rearrange them in the book itself, but corralling them into an album first lets you easily assess them by, say, triggering an instant slideshow (page 159) of the album's contents.

If you want to base your project on multiple existing albums, activate the albums, press ⌘-N to create a new album that includes all of their contents, and then simply delete the pictures you don't want to include in the book. (Remember, as page 65 explains, deleting pictures from an album doesn't delete them from your library.) Arrange the album so your best two shots are at the beginning and end, as Photos automatically uses those for the front and back covers, respectively. (If you forget, you can easily swap cover shots later.)

TIP If you're (wisely) creating a new album for your project, it's helpful to name it appropriately: say, "Italy for book." That way you know at a glance what's in the album and why you made it.

If you don't want to go the album route, just use the methods described on page 57 to select some pictures to start your project with. Either way, you can always add more pictures to your book project after creating it.

Step 2: Choosing a Format and Theme

Once you've selected an album or some individual shots, you're ready to create the book project. To do that, choose File→Create Book or click the + button in the toolbar and choose Book, as shown in Figure 9-1.

The next screen lets you pick a book format and size, and displays pricing info. You get a couple of square and horizontal size options for hardcover and softcover books. The hardcover option isn't plain; your pictures are printed right on the cover itself (front and back). Hardcover books also come with a matching dust jacket and a semitransparent protective sleeve. Softcover books, on the other hand, sport a thick, glossy cover but don't include a dust jacket or sleeve. As you might suspect, softcover books are cheaper than hardcovers: An 8 × 6 softcover book is just $10 for 20 pages, which makes it an extremely affordable personalized gift.

FIGURE 9-1

When you start a project from the + menu (circled), Photos reports how many pictures it'll include at the top of the menu (here, that's 75).

If you're viewing the contents of an album when you create the project, be careful that no individual thumbnails are selected, or else Photos will add only those pictures to your project.

Books have to be at *least* 20 pages long, but they can be longer than that. Peek beneath each book's price to see the cost for each additional page; it ranges from $0.49 to $1.49 per page, depending on the book's format.

To pick a format, click one of the Select buttons beneath the pricing info, and you then see the screen in Figure 9-2, which is where you pick a theme.

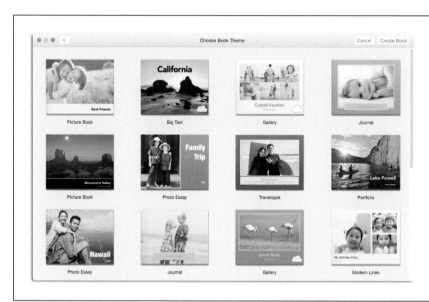

FIGURE 9-2

Here are some of Photos' book themes. Each one displays your pictures slightly differently and uses a particular color scheme. When this screen appears, Photos goes online to see if Apple has added new themes. If it finds any, it adds them here and puts a cloud icon on the thumbnail's lower right to indicate that it will download the theme if you pick it.

To choose a theme, either double-click one of the thumbnails or click a thumbnail, and then click Create Book in Photos' toolbar. Either way, Photos creates the book project and plops your shots onto just enough pages to hold the number of pictures

you picked in step 1. You see the layout screen shown in Figure 9-3, which shows thumbnails of all the pages in your book. This view doesn't have an official name, but it's helpful to think of it as All Pages view.

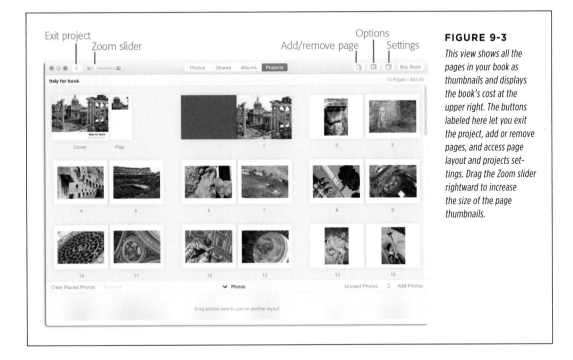

FIGURE 9-3

This view shows all the pages in your book as thumbnails and displays the book's cost at the upper right. The buttons labeled here let you exit the project, add or remove pages, and access page layout and projects settings. Drag the Zoom slider rightward to increase the size of the page thumbnails.

> **NOTE** Don't worry if you don't like the theme you picked—none of the decisions you've made so far are set in stone. You can switch book formats and themes any time. The next section has the scoop.

Behind the scenes, Photos creates a saved project for your book that's visible in Projects view and, if you turned it on, the sidebar (page 18). Because the project is saved, you can exit it and return to it when you've got time. You can rename the project by clicking its existing name and typing something else, tuck it into a folder (page 73) for organizational purposes, and duplicate or delete it by Control-clicking its thumbnail and picking an option from the shortcut menu that appears.

> **NOTE** The projects you create in Photos aren't tied to the albums from which they sprang (if you started a project from an album, that is). So feel free to rearrange and edit your albums however you want—doing so won't affect your projects.

■ CHANGING THE THEME AND FORMAT

Once you get the first glimpse of your book, you may decide to swap themes or pick a different format. Changing either one can zap any customizations you've made to individual pages, so it's best to nail down these options now. To change

your book's theme or format, click the Settings button labeled in Figure 9-3. In the menu that appears (Figure 9-4), click Change Theme to pick a different theme or Change Format & Size to select a different format. Either button takes you back to the screens you saw when you first started the project.

FIGURE 9-4

This menu also lets you specify the number of pages in your project (say, to keep the project below a certain cost), turn page numbering on or off, and remove the light-gray Apple logo that appears at the bottom of the last left-facing page in your book.

NOTE If you decide to experiment with a different theme or format *after* you customize some pages, all your design work will be lost. To preserve your work, duplicate your project, and then change the theme of the *duplicate* instead of your original. To do that, in Projects view or the sidebar, Control-click the project's icon and choose Duplicate. This maneuver saves you a ton of time should you decide you like the original theme after all.

Now you're ready to begin the fun yet time-consuming process of customizing the individual pages in your book. Grab a beverage, get comfortable, and read on!

Step 3: Customizing the Pages

Once you settle on a theme and format, you can dig into customizing each page in your book. You can reorder the pages within the book, swap photos between pages, change a page's layout, enter captions, specify a picture's zoom level, apply a filter to a picture, and so on. Much of your initial customization will likely involve dragging pages and pictures around to get the placement you want. Then you can dig into fine-tuning each picture and adding captions.

Happily, Photos lets you do most of this stuff in All Pages view (Figure 9-3), which includes thumbnails of all the pages in the book. This view gives you an overview of your whole project. It's great for placing pictures onto pages, moving them between pages, picking page layouts and border colors, and generally creating the overall look and feel of the book.

If you double-click a page thumbnail in All Pages view, you enter Single Page view, where you see the thumbnail of just one two-page spread. This view is handy for adjusting how each picture appears on the page, and it's the only place you can edit text (titles and captions). To switch back to All Pages view, click the < at the top left of the window.

This section teaches you how to use both views to customize your book project.

■ REMOVING AND REPLACING PICTURES

If you started your project by selecting a bunch of images, Photos places them onto your book pages in chronological order. If you started with an album, they appear in your custom sort instead. Either way, you're not stuck with this arrangement. If you prefer to manually place pictures on each page, then at the bottom left of All Pages or Single page view, click Clear Placed Photos. When you do, Photos asks if you're sure. If you click Continue, Photos replaces your images with generic gray placeholders, as Figure 9-5 shows. The pictures in your project now appear in the area at the bottom of the window (called the *Photos drawer*). You can drag them from there onto pages.

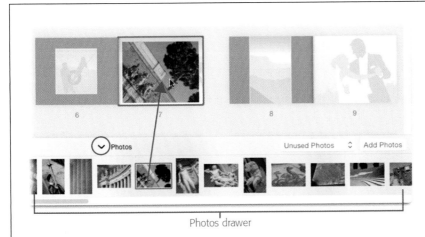

Photos drawer

FIGURE 9-5

Initially, the menu at the lower right of All Pages view is set to Unused Photos (as shown here), which means you see all the unused images in your project in the Photos drawer (you can change this menu to Placed Photos instead). To place a picture onto a page, drag it from the drawer and drop it as shown here. To collapse the drawer, click the down-pointing arrow (circled). To expand it, click the same button again.

TIP When you're arranging pictures in your book, pay attention to where your subject's eyes are pointing. If possible, position your subjects so they're looking toward the middle of the book instead of off the page.

Also, you can amp up the visual interest by placing contrasting shots on the left and right side of each two-page spread. For example, if you put a portrait-type photo on the left-facing page, put a group shot on the right. Or if you put a shot of scenery on the left, use a shot with people in it on the right.

(Photos is happy to refill your newly emptied pages, too. Just select one or more thumbnails in the Photos drawer, and then click the Auto-Fill button. Photos automatically places those shots onto pages for you.)

If, on the other hand, you want to remove just a *few* pictures from the pages in your book, simply click a picture and hold down your mouse button until the picture pops out of its frame. Then drag it to the Photos drawer at the bottom of the window, and Photos swaps in a gray placeholder. To replace one picture with another, drag the picture from the Photos drawer onto the picture you want to replace it with.

To swap two images, simply drag a picture from one page onto another, as Figure 9-6 explains.

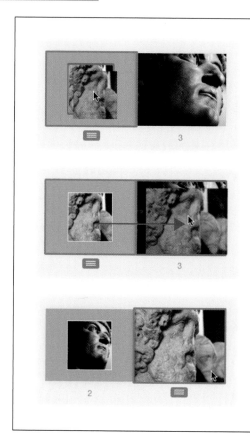

FIGURE 9-6

Top: To swap pictures between pages, click and hold down your mouse button until the picture you clicked pops out of its frame.

Middle: Drag the selected picture onto a picture on another page.

Bottom: Release your mouse button and Photos swaps the two images.

When you start swapping pictures between pages, you may need to adjust the picture's zoom level and positioning inside the frame. Skip to page 251 to learn how.

To remove a picture from your project, select it in the Photos drawer and press the Delete key on your keyboard. You don't get any kind of confirmation; the image simply disappears from the project (but remains in your Photos library).

ADDING PICTURES

If you neglected to include a prizewinning shot of you and Benedict Cumberbatch in your project, don't panic—you don't have to start over. You can add more pictures to your book project anytime by clicking Add Photos at the Photos window's lower right.

NOTE Photos works hard to keep you from duplicating pictures in your project. That's why, unless you adjust the menu described in Figure 9-5, only pictures that you haven't yet placed onto a page appear in the Photos drawer at the bottom of the window. The program automatically places the first picture in your project on both the cover and on the first page of your book, which makes sense. However, if you want to repeat other pictures in your project, you have to add them to the project again. Generally speaking, repeating the same image in multiple places in your book is a waste of space.

When you click that button, Photos plops you into the Choose Photos Screen (it's really Moments view), the same view you see when adding pictures to a slideshow project (page 169). Just scroll to find the pictures you want to add, and then select them by clicking their thumbnails. A blue circle with a gray checkmark appears at lower right of each thumbnail you click (pictures that are already in your book project are dimmed and have a gray circle with a checkmark at lower right of their thumbnails). If you point your cursor at a moment, the words "Select Moment" appear at its upper right—click them to select all the images in that moment.

The Favorites button at the upper left of Choose Photos Screen lets you view and select items in your Favorites album. The Selected button lets you view the pictures you've picked to add to your book, as well as all the images that are already in it. When you're finished adding pictures, click Continue at the screen's upper right and Photos returns you to your book project. The new images are displayed chronologically in the Photos drawer at the bottom of the window (which means you'll need to scroll around a bit to find 'em!). To use the new picture(s) on a page, just select them in the Photos drawer, and then drag them onto a page as shown in Figure 9-5.

■ REORDERING PAGES

At some point, you'll likely want to adjust the order of the pages in your book project. After all, it's only when Photos lays out your book that you get an idea of what it'll look like once it's printed.

To change the order of pages in the book, you need to be in All Pages view (page 242 tells you how to get there from Single Page view). Click a page to select it or ⌘-click to select more than one. A blue border appears around the page(s) and a blue Page button appears beneath it (there's one circled in Figure 9-7). To move the page(s) elsewhere, click the Page button, and then drag it until your cursor is pointing to where you want to move the selected page(s). Figure 9-7 has details.

> **TIP** If you want to move just *one* page, you don't have to select it first. Just point your cursor at it, click the gray Page button that appears underneath it, and then drag it wherever you want.

■ ADDING AND REMOVING PAGES

You can easily add or remove pages from your book project, as Figure 9-8 explains. Just be aware that your book has to be at least 20 pages long and have an *even* number of pages. You get a message saying that Photos will add a blank page if you delete a page that results in an odd number of pages. Removing a page doesn't remove any of the pictures your project contains, but it does delete any captions you've added (page 254).

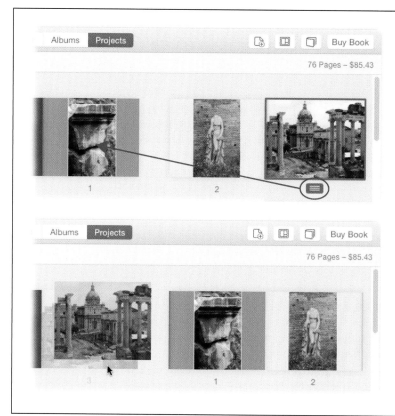

FIGURE 9-7

Top: To move pages around in your book project, drag the Page button (circled) onto another page (not between pages, but atop another one).

Bottom: The page you're moving appears beneath your cursor and subsequent pages scoot rightward to make room for the one you're relocating. Release your mouse button to make it so.

FIGURE 9-8

To add a page to your project, select the page that precedes the one you want to add, and then choose Add Page from this menu. A new page appears to the selected page's right. To remove a page from your project, select it, and then choose Remove Page from the same menu.

You can also add or remove a page by Control-clicking its thumbnail and choosing Add Page or Remove Page from the shortcut menu that appears.

The maximum number of double-sided pages a book can contain is 100. If you need more pages than that to cover your adventures in the piney woods of East Texas, you'll need to make a second book.

TIP If you delete one page from a 100-page book, Photos merely adds a blank page to keep the page count at an even number. So to reduce the number of pages to 98, ⌘-click to select *two* pages, and then press the Delete key on your keyboard to get rid of them both.

▓ CHANGING A PAGE'S LAYOUT

When Photos lays out your book, it sprinkles in a variety of different page layouts. For example, some pages include one picture, while others contain two or three, and some pages have captions while others don't. If you're happy with Photos' layout choices, great! You can skip to the next section and learn how to tweak the book's photos. If not, you can easily change the book's page layouts.

To do that, select the page you want to change, and then click the button circled in Figure 9-9 to open the Layout Options panel. Use the panel's scroll bar to view all the different layout options; your choices depend on the kind of page you selected and the theme you picked when you started the project (page 239).

TIP The Layout Options panel floats on your screen independently of the Photos window. That means you can keep it open all the time if you want.

It's important to understand that not all layouts are available for every kind of page, and not all layouts are available in every theme. Heck, some themes, such as Showcase, only let you have one photo on a page, so you don't see layout options for more pictures than that as you scroll through the panel.

Front and back covers and flaps have the fewest layout options. For covers, you can generally choose between one and three photos with or without a title, and for flaps you can typically pick one small picture with or without text, or a completely blank page. Fortunately, you get a smorgasbord of layout design options for the *other* pages in your book:

- **1 Photo, 2 Photos, and so on.** Layouts in these categories let you specify the number of pictures on the page. You get a wide array of choices for photo placement within each category. For example, some themes offer up to 17 different layouts for one photo per page, six layouts for two photos per page, and so on. Some layouts fill the whole page with your picture, some have room for text, some include borders—you get the idea.

FIGURE 9-9

To open the Layout Options panel, click the button circled here. As you scroll in the panel, you see thumbnails of different layouts organized by the number of pictures per page. Scroll far enough down and you'll find layouts that include maps and two-page spreads. If the layout you pick has blank space around the picture or an empty spot for captions, you can pick a background color by clicking one of the color chips shown here.

- **Text.** This option doesn't include any picture slots; it simply creates a blank page with placeholder text that you can edit. For example, you can make page one of your book a text page that tells your audience the story behind the book. Or, if you'll use the book as a portfolio, a text page could detail your artwork. Text pages can also serve as section dividers, telling the story of the images that follow.

- **Map.** The designs in this category add a map to your book page, which is a fun way to illustrate where you took your pictures (the top of Machu Picchu, anyone?). Once you add a map to a page, Photos checks to see if there are any locations associated with your pictures and, if it finds any, they automatically appear on the map. Happily, you can edit the map and remove, rename, or add your own locations, as well as customize the map's zoom level and appearance.

To open a map for editing, double-click the page it's on to enter Single Page view. Next, double-click the map itself to select it and open the Map Options panel shown in Figure 9-10. (If the Options panel is already open, just single-click the map instead.)

FIGURE 9-10

Behold, the volcano Vesuvius! It looks scary even on this map. The Map Options panel lets you adjust the zoom level and find a specific location. You can add place markers (one was added here) and edit their labels to be as descriptive as you want. You can press Return on your keyboard to add a new line of text to a marker's label, but the text covers up the marker's pretty red dot.

Here are your options:

— **Change map style.** The drop-down menu at the top of the panel lets you change map styles. Your choices are Standard (street-level view with text labels), Satellite (topographic view with no text labels), and Hybrid (topographic view with text labels—Figure 9-10 shows an example).

— **Add a place marker.** If your pictures don't contain location info, you can add your own place markers to the map. First, adjust the map so you can see the location you want to add. You can use the Map Zoom slider at the bottom of the panel to change the map's zoom level (drag it left to zoom out) and drag the map itself to reposition it. When you find the spot you're after, drag the Map Zoom slider rightward to zoom in, and then drag to reposition the map so you're viewing the area you want.

Next, add the place marker by Control-clicking the appropriate spot on the map, and then choosing Drop Pin from the shortcut menu that appears. (You can also click the Map Options panel's + button to add a place marker to the area you're currently viewing on the map.) To move the marker, point your cursor at the red dot, and then click and hold down your mouse button. When the dot gets bigger, drag to move the marker wherever you want.

— **Edit place marker.** You can change a place marker's label to say anything you want. Just double-click a label in the Map Options panel's Places list or on the map itself, and then type the new text. If you're tempted to enter more than one line of text, don't (Figure 9-10 explains why). Instead, pick a layout option that includes a map and has room for your prose elsewhere on the page.

— **Remove a place marker.** On the map, click a place marker to select it, and then press the Delete key on your keyboard. Alternatively, select a marker in the Map Options panel's Places list, and then click the – sign.

— **Show/hide Marker Labels.** If you don't want to see place-marker labels, turn off this checkbox and you see only the place-marker dots.

When you're finished editing the map, you can return to All Pages view by clicking the < button at the upper left of the Photos' window.

• **Spread.** Layouts in this category spread a single picture across two full pages. These layouts have a big impact and give the viewer a visual treat because they're so different from the rest. Try to use at least two or three spread layouts in a 20-page book; if your book is longer than that, consider using a spread layout every five pages or so.

• **Blank.** While this option doesn't really sound like a layout at all, blank pages are quite useful for separating sections of your book. When you choose this layout, Photos creates a blank page that doesn't include any photo frames—but that doesn't mean it has to be stark white. You can fill it with color using the color bar at the bottom of the Layout Options panel or add a background image (page 253 tells you how).

Whew—that's a lot of layout options! You'll need to experiment to find the ones you like best. Generally speaking, it's best to sprinkle different layouts throughout your book for the sake of variety, but there's no law against using the same layout on every page. In fact, sticking to a one-photo layout with a wide, colored border can give your book a classy, fine-art feel.

■ MANIPULATING PICTURES

Once your layouts are (somewhat) finalized and you've (pretty much) arranged the pictures onto pages the way you want, you can fine-tune the *appearance* of each photo on each page. For example, you can adjust a picture's zoom level and its position within the frame, apply a filter to the picture, or open it in Edit mode.

To do any of that stuff, double-click a page to open it in Single Page view. Next, double-click the picture you want to adjust or click the picture once to select it, and then click the Options button beneath it. (If you select a page instead of the picture on the page—easy to do if the page contains a full-size photo—the Layout Options appear instead. Click the image and the panel changes to Photo Options.) Here's what you can do in the Photo Options panel:

- **Enlarge and reposition a picture** within its frame by dragging the Zoom & Crop slider in the Options panel rightward. Once the picture is the size you want, click and drag the picture to reposition it within its frame, as shown in Figure 9-11 (right). This is a great way to minimize distracting backgrounds and fill the frame with your subject. If you haven't already cropped your images (page 116), you need to do this for *every* picture on *every* page of your book—the polished results you'll get are well worth the effort!

NOTE Be careful not to drag the Zoom & Crop slider all the way right. If you do, you may enlarge the picture so much that it won't print well. Be on the lookout for any yellow warning triangles with exclamation points. These symbols appear at the lower left of images in Single Page view to let you know that the pictures don't have enough pixels to print at a high enough resolution at the zoom level you picked. (It's a good idea to trot through every page in your project in Single Page view to check for these triangles.) The fix is to drag the Zoom & Crop slider to the left until the symbol disappears, or pick a different picture.

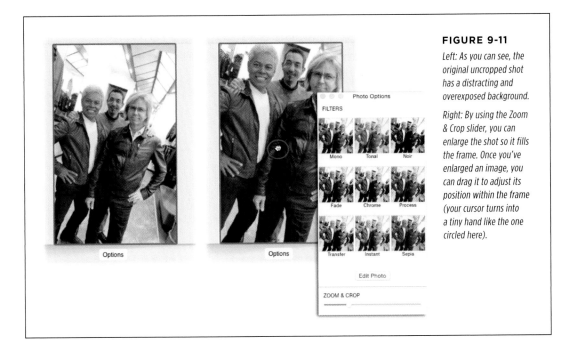

FIGURE 9-11

Left: As you can see, the original uncropped shot has a distracting and overexposed background.

Right: By using the Zoom & Crop slider, you can enlarge the shot so it fills the frame. Once you've enlarged an image, you can drag it to adjust its position within the frame (your cursor turns into a tiny hand like the one circled here).

TIP You can move between pages in Single Page view by clicking the left- and right-facing arrows that appear at the left and right edges of each two-page spread. Move your cursor near the edge of a spread to make the arrow appear.

- **Add a filter** by clicking one of the nine thumbnails in the Filters section of the Photo Options panel (visible in Figure 9-11, right). When you do, a blue strip with the word "ON" appears on the thumbnail you clicked. These Filters are the same ones you get in Edit mode (see Chapter 5). Fortunately, applying a filter in a project doesn't affect the original image; Photos only applies the filter to the instance of the picture in the project. Neat, huh? To remove a filter, simply click the filter's thumbnail again.

- **Edit a picture** by clicking Edit Photo in the Photo Options panel. Your book project temporarily disappears and Photos transports you into Edit mode (Chapter 5), where you can adjust the image's lighting and color, zap blemishes, or straighten it. When you're finished, click Done at the window's upper right and your book project reappears with your changes reflected. Unlike the filters you apply in the Photo Options panel, any changes you make in Edit mode *do* affect the original photo wherever it appears in the program (in albums, in other projects, and so on).

- If a layout has overlapping picture frames (as in the Travelogue and Journal themes), you can **change how the pictures are stacked** by Control-clicking a photo and, from the shortcut menu, choosing "Move to Front" or "Send to Back."

- **Flip a photo** by Control-clicking it and choosing Flip Photo from the shortcut menu, as shown in Figure 9-12.

FIGURE 9-12

To keep this Swiss Vatican guard looking inward toward the middle of the book (rather than off the page), use the shortcut menu shown here to flip the photo. Once you've flipped a picture, a checkmark appears next to the command's name in the same menu.

- **Fit a photo to its frame** by Control-clicking it and choosing "Fit Photo to Frame" from the shortcut menu. When you do, Photos adjusts the zoom level of the shot so that every single pixel in it fits into the frame. This typically results in white bars above and below or on either side of your shot. Why? Because the aspect ratio of the image rarely matches the aspect ratio of the frame. (For more than you ever wanted to know about aspect ratio, see the box on page 187.) If you want to use the Zoom & Crop slider again, you have to turn this command off by Control-clicking the image and choosing "Fill Frame with Photo."

- **Remove a photo** from a frame by dragging it to the Photos drawer at the bottom of the window, by Control-clicking and choosing Remove Photo, or by selecting the photo and then pressing the Delete key on your keyboard.

■ PAGE BACKGROUNDS

If the layout you picked has some empty space—meaning the photo doesn't extend to the page's edges on all four sides—you can specify a background color that's visible in those empty areas. To do that, select the page in All Pages or Single Page view, and then open the Layout Options panel. In All Pages view, you do that by clicking the Options button in Photos' toolbar (it's circled back in Figure 9-9). In Single Page view, click the Options button beneath the page.

Either way, you see a color bar at the bottom of the Layout Options panel. Just click a color swatch to apply it as the background color. If you lean toward your screen and squint, you can see that the last swatch in the color bar is actually a gray picture placeholder (if the theme has a ton of background-color options, this swatch may be the last one in the first row of swatches). Click it to convert the page's background to a picture frame that you can fill with another image. Then, when you select the background image, the panel changes to Photo Options and includes an Opacity slider, as Figure 9-13 shows.

You might not want to add a background image to every page, but on some it can make a big impact. Good candidates for background images include scenic shots such as sunsets, trees, and beaches, as well as closeup shots of textures (in other words, people pictures generally don't work well as backgrounds).

> **NOTE** As of this writing, there's a bug in the program that prevents you from seeing a background image you've placed onto a page in Single Page view, though it's perfectly visible in All Pages view. Ah...such are the joys of using version 1.0 software.

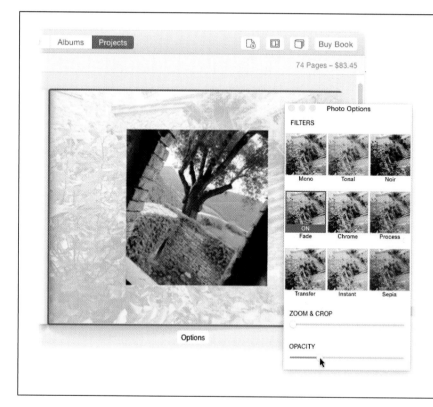

FIGURE 9-13
Adding a background image to some pages can really make them pop. To keep the background image from overpowering the other images on the page, reduce its Opacity using the Photo Options panel: Drag the slider leftward to make the shot more see-through. In this example, the Fade filter was also applied to the background image to tone it down further.

Step 4: Edit and Format Text

Once you're finished playing with layouts and pictures, you can move on to adjusting the text in your project. There's no sense in messing with text until you finish placing your pictures and adjusting layouts, so save this step until the end.

Text opportunities abound in your book. For example, every book has a title that's printed on the cover and, if you picked a hardcover format, its matching dust jacket. If you started your project with an album, Photos automatically uses the album's name as the title, so you'll probably need to change it. If you picked any layouts that have room for captions, you'll want to edit those, too. Perhaps you added a text-page layout that you want to use to describe the motivation for your book or to serve as a bio, or maybe you want to add your contact info to the cover flap.

> **TIP** You can turn page numbers on (or off) by clicking the Settings button (labeled in Figure 9-3 on page 241), though you can also do it by Control-clicking anywhere on a page and choosing Show Page Numbers to turn them on or off. Unfortunately, you can't select them in order to change their font or style. Oh well!

If there's text on a page, you can easily edit it in Single Page view. After all, that's the only place you can make the page thumbnails big enough to *see* the placeholder text they contain. Once you double-click a page to enter Single Page view, drag the zoom slider at the window's upper left rightward to enlarge the page so you can see the text. Then use the scroll bar above the Photos drawer to position the text so you can see it (if the scrollbar is tough to grab with your cursor, try using a gesture on your Apple Magic Mouse or trackpad instead). Next, click a text box and start typing (Photos automatically highlights the placeholder text). When you do, the formatting controls shown in Figure 9-14 appear (if they don't, just click the Options button in Photos' toolbar to summon the panel).

NOTE If your text doesn't fit within a text box, Photos alerts you of impending doom by displaying a red triangle with an exclamation point inside. If you see that warning symbol, either whittle down your text or reformat it so it fits.

When you're finished, just click outside the text box to see the end result. You're not forced into crafting your prose in Photos either. You can just as easily open your favorite text editor, enter your text there, and then use the Edit menu's Cut, Copy, and Paste commands to transfer it from your text editor into Photos' text boxes.

POWER USERS' CLINIC

Creating Pro-Level Books

While Photos may seem like a tool for dabblers and hobbyists, opportunities abound for professional-level uses, *especially* when creating book projects. Here are a few ideas for taking your book project to the next level:

- **Custom backgrounds**. The ability to use a photo as a background gives you all manner of creative options. Try shooting your own textures with this use in mind. For example, if you like nature photography, you could take a close-up shot of rocks, grass, or tree bark and use that as a background. If you're creating a book of your kid's favorite sport, take a picture of a soccer ball, ballet shoes, or dirt bike and use that as a background on some pages.

 If you're a fine artist and paint on a specific medium (canvas, velvet, watercolor paper, or whatever), you could take a closeup shot of that texture for use in a book that showcases your work.

- **Branded intro or outro page.** Let's say you use Photos for organizing and processing personal imagery, and you use another image-editing program for more serious work.

You can save JPEGs of your masterpieces in the other program, and then import them into Photos and create a book of them. You could even create a branded *logo* page in the other program, and then import it into Photos for use as the first or last page of your book. Once you know the size book you'll make, just create a document in the other program that's the same size. But remember that Photos doesn't understand transparency (see-through areas), so you need to think about what color background you want your logo to appear on and include that in the document, too.

- **Testimonial pages**. If you're creating a portfolio book, you can add testimonials from your best clients by sprinkling in a few layouts that include text blocks.

And that's not all! You can use the process described above to design a custom *background image* that includes your logo. To keep the logo from being distracting, put it at the bottom of the page in a small size, or position it so it hangs off a page's edge, making only a portion of it visible. Back in Photos, use the Photo Option panel's opacity slider to keep it subtle.

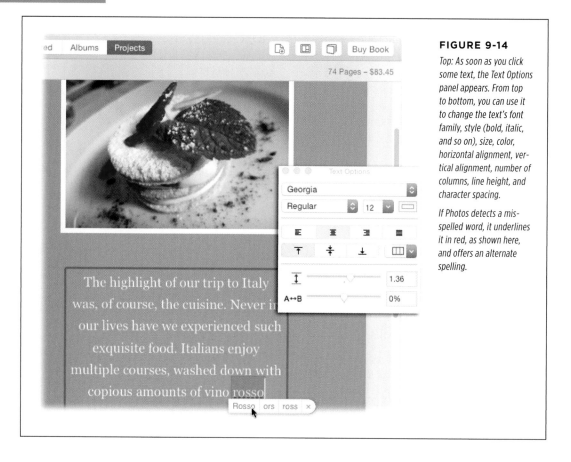

FIGURE 9-14

Top: As soon as you click some text, the Text Options panel appears. From top to bottom, you can use it to change the text's font family, style (bold, italic, and so on), size, color, horizontal alignment, vertical alignment, number of columns, line height, and character spacing.

If Photos detects a misspelled word, it underlines it in red, as shown here, and offers an alternate spelling.

▨ SPELL CHECKING

Few mistakes are as embarrassing (or avoidable) as a misspelled word. Most software comes with a built-in spell checker, and Photos is no exception, so there's little excuse for typos (*wordos*—real words in the wrong place—are another story). And let's face it: It's difficult to spot your own mistakes, either because you've been staring at them for too long or because you're in a rush. That's why it's best to employ a spell checker before ordering your book.

Happily, Photos comes set to check spelling automatically. As illustrated in Figure 9-14, if Photos finds a suspect word, it puts a red dotted line beneath it. Control-click the underlined word and, if the shortcut menu contains the correct spelling, choose it. If the word is correctly spelled, choose Ignore Spelling, and Photos stops underlining the word. Choose Learn Spelling to add the word to OS X's dictionary so it won't be flagged in the future. If you find the red underlines distracting, choose Edit→Spelling and Grammar→Check Spelling While Typing to turn off this setting.

Photos also automatically fixes common spelling mistakes. If you type "exercize," for example, the program changes it to "exercise" and puts a blue dotted line under the word to let you know that it did so. If Photos' correction is wrong, you can Control-click the word and choose "Change back to '[original word].'" And if this behavior drives you batty, choose Edit→Spelling and Grammar→Correct Spelling Automatically to turn off the checkmark next to this setting and stop Photos from meddling with your prose.

Here are a few other spelling- and grammar-related options:

- **Check grammar with spelling.** To have Photos automatically hunt for spelling *and* grammar mistakes as you type, choose Edit→Spelling and Grammar→Check Grammar With Spelling.

- **Check just *some* text.** If you've turned off Photos' automatic spelling and grammar checking, that doesn't mean you have to live with typos. To have Photos examine a specific block of text, click it, and then choose Edit→Spelling and Grammar→"Show Spelling and Grammar." (Alternatively, you can highlight a section of text before choosing that command.) You can also Control-click a text box and choose the same command from the shortcut menu, or simply press ⌘-: (that's a colon). Whichever method you use, OS X's "Spelling and Grammar" dialog box appears and alerts you to potential problems.

 To check the spelling but *not* the grammar of a selected text box or highlighted text, choose Edit→Spelling and Grammar→Check Document Now (or press ⌘-; [that's a semicolon]).

Step 5: Preview Your Project

Photo books aren't cheap, and you've just spent a lot of time carefully crafting the contents of every page. After all that hard work, one final round of proofing is in order, just to make sure everything is squared away. Photos gives you a couple of different ways to do this.

The best way to proof a document of any kind is to print it. While that may not sound very earth-friendly, seeing your project on paper can illuminate errors you'd never spot on a computer screen. Plus, the print serves as a fantastic preview of what the real thing will look like. To print your book, open it in Projects view and then choose File→Print. In the OS X Print dialog box that opens, pick a printer, and then click Print (obviously, the printer needs to be turned on for this to work!).

NOTE Unlike its predecessor, iPhoto, Photos can't play a book project as a slideshow.

Another option is to turn the project into a PDF file, which is short for Portable Document Format. PDFs can be opened on any kind of computer (Mac, Windows, Linux, or whatever). The great thing about PDFs is that they preserve all the images, fonts, and backgrounds so they look exactly like they do on your screen. That means you can send a PDF of your project off to someone else for proofing or approval, or just

so they have a digital copy of the book (maybe you created a genealogy book for your family, and 20 of your closest cousins want a copy). Plus, PDFs are searchable. So if you captioned your pictures, your cousins can search for whomever they want to find in the book. You can also sync the PDF file onto your iOS devices using iTunes' file-sharing abilities so you can show the book off on your iPad.

Here's how to create a PDF file of your book and then get it onto your iOS device:

1. **With your book project open, choose File→Print.**

 You see the standard OS X Print dialog box.

2. **At the dialog box's lower left, click PDF and choose "Save as PDF."**

 The Save sheet appears.

3. **Enter a name for the PDF in the Save As field, pick where you want to save it, and then click Save.**

 A status bar appears as OS X processes each page and creates the PDF file. To bail out of the PDF-making process, click Cancel.

 If all you wanted to do was create a PDF of your book, you're done! But if you want to get the PDF onto your iOS device(s), keep reading.

TIP The OS X Print dialog box isn't the only place you can create PDFs. If you Control-click any page in your project, either in All Pages or Single Page view, you can choose "Save Book as PDF" from the shortcut menu that appears. When you choose that command, you see the same Save sheet described in step 3 above. To *see* the PDF before saving it, choose Preview Book from the shortcut menu instead. Doing so also creates a PDF, but it opens in the OS X Preview app so you can determine whether it's worth saving to your hard drive. To save the file, choose File→Save.

4. **Fire up iBooks on your Mac and drag the PDF file into its window.**

 The iBooks app comes preinstalled on every Mac, and it's just the ticket for viewing PDFs on your iOS device. To launch it, double-click its icon in your Mac's Applications folder. Next, in the Finder, press ⌘-N to open a new Finder window. There, find the PDF you just created (unless you changed the save location of the file, it likely landed in your Pictures folder), and then drag the PDF file into the iBooks window (a green circle with a + sign appears next to your cursor as you drag). After a moment, the book's icon appears in the iBooks window.

5. **Launch iTunes, connect your iOS device to your Mac, and then click your device's icon.**

 Once you attach your device, its icon appears toward the upper left of the iTunes window. (If you use wireless syncing, you don't even need to attach your iOS device to your Mac to see its icon.) Give this icon a click to select your iOS device. When you click your device's icon, a list of settings appears on the left, as shown in Figure 9-15.

6. **On the left side of the iTunes window, click Books. Next, turn on Sync Books, and then pick which files to sync.**

 You can sync all your books or just ones that you pick. Make sure you see your PDF in the Books area in the middle of the screen. If you pick "All books," the PDF will automatically sync onto your device. If you pick "Selected books," turn on the checkmark next to the PDF's name, like the one circled in Figure 9-15.

7. **Click Apply to sync the PDF onto your iOS device.**

 Within a few seconds, the PDF will be on your device. To see it, launch the iBooks app on your iOS device and tap your PDF to open it.

Now your beautiful book project will travel around with you wherever you go.

Step 6: Buy the Book

Once you finish proofing your book and it's ready for printing, in Photos' toolbar, click Buy Book. Photos does a quick check of your book to find any problems.

If the program finds any placeholder text (say, a caption that you didn't edit), a message appears. Click Continue to ignore the message, or click Review to return to your project for more editing. Photos helpfully shows you where the problem is. Fix it, and then click Buy Book again.

Photos repeats the checking process each time you try to buy the book. Another kind of message you may encounter during this process is one involving text that's

too long to fit the box it's in. You get the same Review and Continue options for this message, too. Once you fix the text, click Buy Book yet again.

A third kind of message you may encounter involves placeholder pictures; if Photos finds any, you see a message saying your book is incomplete. Click OK and Photos returns you to the page that needs fixing. Once you fix all the problems, click Buy Book *again*.

If Photos doesn't find any more issues, a Checkout sheet appears. If this is the first time you've ordered a print product using Photos, you may be prompted to enter your Apple ID and password. Next, select a shipping address from the list by clicking the checkbox to the left of the name—you see all the addresses you've previously shipped stuff to—or click Add Shipping Address to add a new one. You can also ship books to more than one address. Once you pick a shipping address (or several), Apple calculates the order total. Use the Quantity field on the right to tell Photos how many books you want to send to each address: Click the + to increase the quantity or the – to decrease it.

When you're finished, pull the trigger by clicking Place Order. Now all you have to do is bide your time until the book arrives in the mail. You'll be mightily impressed when you hold the finished product in your hands! Now, pat yourself on the back for a project well done.

NOTE You can order books if you live in Europe, the Asia Pacific, Japan, or North America, but Apple offers shipping only to addresses in your own region. To change your country of origin for print products, choose Photos→Preferences, click General, and then pick a country from the Print Products Store menu.

Photo Calendars

Calendars are perhaps the most practical project you create in Photos—they're absolutely stunning, and they make memorable gifts. At 10.4 × 13 inches, they're bigger than the custom calendars you can order anywhere else, and they're printed on nice, thick stock. Each calendar is wire-bound with a big picture area above the date grid. Just like the book projects you create in Photos, you can customize your calendar with different page layouts and captions. You can add national holidays, pull events from your Calendar app, and put pictures on individual the date squares (fun for birthdays!).

Fortunately, the process of creating a calendar is nearly identical to that of creating a photo book, so there's no need to rehash *all* those details here. The good news is that most calendars are 12 pages (instead of 20) so they don't take as long to make as books. However, you can make your calendar longer than 12 months if you like—up to 24 months—and you don't have to start with January. As of this writing, a 12-month calendar costs $20 and each additional month costs $1.50.

This section teaches you how to create and customize a calendar project, and refers you to the previous section for basic stuff such as placing pictures onto pages,

changing layouts and backgrounds, editing text, and so on. As with book projects, you'll use All Pages view to do high-level design stuff like moving pages and pictures around. When you're ready to fiddle with specific pictures and add text, double-click a page to enter Single Page view.

Step 1: Pick the Pictures

As with any Photos project, the first step is to pick the pictures you want to include. Unless you want to feature just one picture per page, it's best to start your calendar project with 20–35 pictures. While some layouts let you squeeze oodles of pictures onto a page, calendars tend to look best when they feature just one to three photos per page; just use your own judgment.

It's easiest to start your project from an album created specifically for the calendar project. That way, you can put the pictures in the order you want them to appear in the calendar, which saves you a bit of clicking and dragging later on. But if you prefer, you can begin your project by selecting a moment, individual thumbnails, or multiple albums. Chapter 3 teaches you how to select pictures and create albums.

Step 2: Choose the Length, Start Date, and Theme

Once you've selected your pictures, click the + button in Photos' toolbar and choose Calendar. The screen shown in Figure 9-16 appears, which lets you set the length and starting date of the calendar.

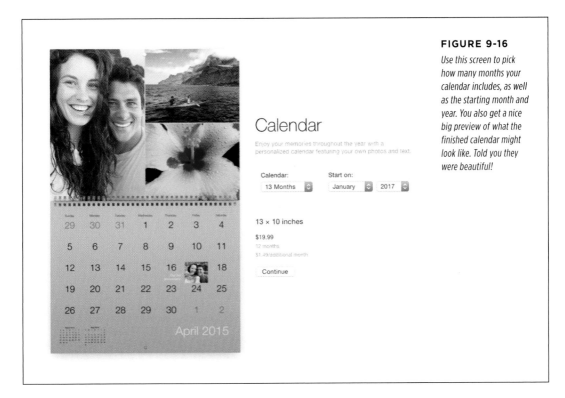

FIGURE 9-16

Use this screen to pick how many months your calendar includes, as well as the starting month and year. You also get a nice big preview of what the finished calendar might look like. Told you they were beautiful!

Once you choose your settings, click Continue and the Choose Calendar Theme appears and shows you all of Photos' calendar themes. Just like the book themes, each design has different layouts and color schemes. Photos checks online to see if Apple's added any new themes. If it finds any, it adds their thumbnails, which display a tiny cloud icon at their lower right to indicate that they must be downloaded; that happens automatically if you choose one of those themes.

It's tough to get any real sense of what the calendar will look like based on this screen's thumbnails, so just pick one that looks good. You can always change it after Photos assembles the calendar (that way, you can see what each theme looks like using your pictures). The Big Date theme is especially nice because it uses really big numbers, which means you can see them without being nose-to-nose with the page itself.

To pick a theme, single-click its thumbnail and then click Create Calendar, or simply double-click its thumbnail. Either way, Photos assembles your calendar and presents it in All Pages view (Figure 9-17).

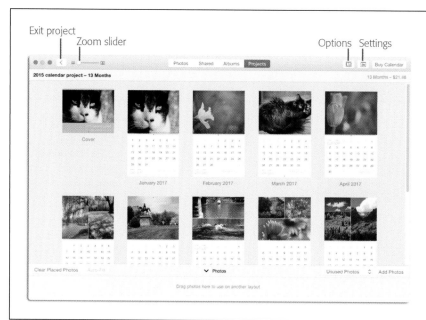

FIGURE 9-17

All Pages view gives you a satisfying sense of what your calendar will look like. You can move pages and pictures around in this view and use the Options panel to change layouts. The Settings panel lets you alter the calendar's length and start date, add national holidays, change themes, and more.

Photos also saves your project so that it's visible in Projects view and, if you turned it on, the sidebar (page 18). You can rename the project, file it in a folder, or delete it, just like you can with any other project. You can exit the project and return to Projects view by clicking the left-facing arrow at the screen's upper left (labeled in Figure 9-17), and then simply double-click your calendar project later on to reopen it and continue working on it. In other words, you don't have to build the whole thing in one sitting.

■ CHANGING SETTINGS

The decisions you've made thus far aren't set in stone. Ever flexible, Photos lets you change a great deal about your calendar using the Settings panel. To open it, click Settings in Photos' toolbar (it's labeled in Figure 9-17). This panel—shown in Figure 9-18—is where you can change your calendar's length and start date. You also get these handy options:

- **Show national holidays.** Choose a country from this menu to add events that your country's government deems important. For example, United States holidays include Valentine's Day, Mother's Day, Thanksgiving, and so on; the Italian holidays include Epiphany, Liberation Day, St. Peter and Paul's Day, and so on. When you pick a country, the relevant date numbers turn red and the holidays' titles appears in red text below them.

- **Show birthdays from Contacts.** This option adds any birthday entries you've made in OS X's Contacts app (here again, the dates' numbers turns red and red text appears beneath them). If you haven't added birthdays to your Contacts app, you can always add a person's picture to their birthday date square, or simply add custom text to the date square. The benefit of adding birthdays to the Contacts app is that you don't have to remember to add notations to your calendar every single year.

- **Show calendars.** If you use OS X's Calendar app, you can pull those events into your calendar project. This is really handy if you schedule vacations in advance. There's nothing like flipping a calendar page and realizing that you've got a two-week stay in Maui headed your way!

- **Include Apple Logo.** Calendars you create in Photos include a small, light gray Apple logo on the back. If you don't want to advertise for Apple, turn this option off. (Mac owners tend to be proud folk, so most leave it on for sheer bragging rights: "Look what I made with my Mac!")

- **Change theme.** If you want to test-drive other calendar themes, give this button a click and the theme screen reappears. Just pick the one you want to use and Photos makes it so.

Step 3: Customize the Pages

You customize a calendar just like you do a book (page 242). For example, to move a page, click or point your cursor at it. When a rectangular icon appears below it (like the one circled in Figure 9-7 on page 246), click the icon and hold down your mouse button. Drag the page *on top of* the one that's in the desired location (in other words, don't drag it *between* two pages). When the page in the target location dims, release your mouse button. Photos moves the selected page to its new home and shifts the rest of the pages rightward.

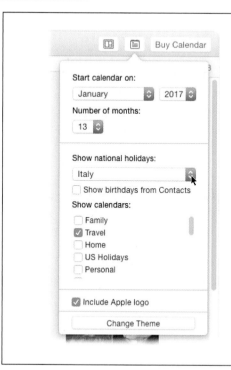

FIGURE 9-18

The Settings panel is available in both All Pages and Single Page view, and lets you change key settings for your calendar project. Be sure to settle on a theme before you start customizing each page, or else all your hard design work will go right out the window.

To move pictures around, click an image and hold your mouse button down until the picture pops out of the frame, and then drag it to another frame (see Figure 9-6 on page 244). To remove a picture, drag it to the Photos drawer at the bottom of the window. You can also clear the pictures Photos automatically placed and add images yourself (page 243), add more pictures to your project (page 244), as well as change layouts (page 247) and background colors (page 253).

TIP For the best results, pair pictures with appropriate months. For example, prize-winning shots from your leaf-peeping tour of New England work well for autumn months, shots at the community pool are great for summer months, and so on. Also, be sure to repeat the cover shot on one of your calendar pages, or else you'll never see it.

To fiddle with individual pictures and to mess with text, you need to double-click a page to enter Single Page view. That's where you can change a picture's zoom level and positioning with a frame, apply a filter, or open it in Edit mode. To do any of that stuff, double-click a picture in Single Page view and the Photo Options panel shown back on page 251 appears.

To edit your calendar's title or any captions, just click the placeholder text and type away. The Text Options panel shown back on page 256 automatically opens, which you can use to change the font family, size, style, color, and alignment. To add custom text to a date square, click the square and a text box appears (the Text Options panel also pops open). Just enter the text you want, and then format it to your liking. Date squares are really small, so it's best to keep your prose brief.

For even more creativity, you can add a picture to a date square, as shown in Figure 9-19. Just drag a picture from the Photos drawer onto a date square; the square's number disappears and the picture takes over the whole square. This is a great way to mark an important date involving someone special, such as a birthday, anniversary, or graduation.

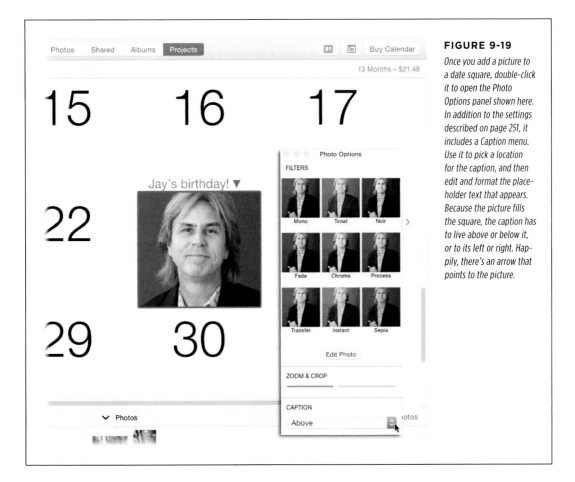

FIGURE 9-19

Once you add a picture to a date square, double-click it to open the Photo Options panel shown here. In addition to the settings described on page 251, it includes a Caption menu. Use it to pick a location for the caption, and then edit and format the place-holder text that appears. Because the picture fills the square, the caption has to live above or below it, or to its left or right. Happily, there's an arrow that points to the picture.

TIP The text you edit or add in Single Page view is really small. Save your eyesight and use the zoom slider in Photos' toolbar to zoom in so you can see what you're doing.

To remove a picture you've dropped onto a date square, click it, and then press the Delete key on your keyboard, or simply drag the picture into the Photos drawer at the bottom of the window. Removing the picture also removes the caption you added.

When you're finished editing the pictures and text in a particular month, you can move to the next month by clicking one of the left or right-facing arrows that appear on either side of the calendar page in Single Page view (you can also use the arrow keys on your keyboard).

Step 4: Final Inspection

You can proof your calendar just like you can a book project, and it's equally important to do, even though it may not include as much text as a book. So take the time to print it or turn it into a PDF as described on page 257. And for goodness' sake, remember to spell check your calendar using the techniques described on page 256. Typos on a calendar are *worse* than typos in a book because you have to stare at the pages they're on for a whole month!

Step 5: Buy the Calendar

When you're finished inspecting your gorgeous new calendar, fire up Apple's printing presses by clicking Buy Calendar at the upper right of the Photos window. When you do, the program takes a spin through your calendar looking for problems such as placeholder text, placeholder pictures, and text that's too long to fit in its box. If Photos encounters any of these issues, it alerts you and lets you fix it. As page 259 describes, just keep clicking Buy Calendar until you run out of error messages.

Photos then packages the calendar and uploads it. If this is the first print product you've ordered from Apple, you'll be prompted to enter your Apple ID. The next screen lets you pick a shipping address, add additional addresses, and set the order quantity for each address. The total cost for your order appears at lower right. Click Place Order and try not to count the hours until your handcrafted calendar arrives in the mail (the packaging is nearly as impressive as the calendar itself). When it's finally delivered, you'll squeal with joy as you pore over every page as if it's the first time you've seen it.

> **WARNING** When you give custom calendars to loved ones, there's no going back: They'll expect them *yearly*, and may pout publicly if they don't get one.

◼ Custom Cards

You can also create gorgeous greeting cards and postcards. Since they're just one or two pages, they take very little time to design. Photos also includes several templates for yearly newsletters, which take longer to craft.

The cards you make in Photos are as high quality as the books and calendars, plus they're perfect for any occasion: holidays, birthdays, congratulations, thank yous, and more. Cards can be folded or flat and, if you've got the money, you can even order *letterpress* cards, where each letter and image is physically pressed into textured paper. There's no minimum order for cards: You can order one or 100. There are no quantity discounts either, but they do come with matching envelopes.

■ CREATING A CARD

Card projects work exactly like book and calendar projects: start by corralling photos (say, 5–20) into an album, and then click the + button in Photos' toolbar. Choose Card and you see the Choose Card Format screen in Figure 9-20, where you can pick a format.

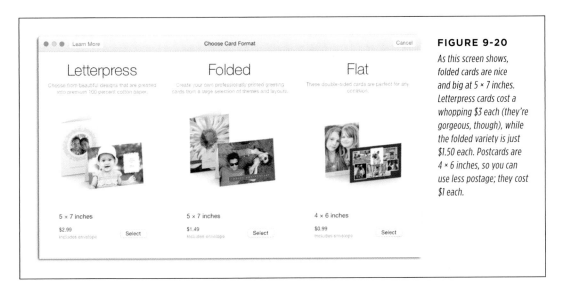

FIGURE 9-20

As this screen shows, folded cards are nice and big at 5 × 7 inches. Letterpress cards cost a whopping $3 each (they're gorgeous, though), while the folded variety is just $1.50 each. Postcards are 4 × 6 inches, so you can use less postage; they cost $1 each.

Click any Select button to pick a card format, and the next screen displays a variety of themes (see Figure 9-21). Photos also checks to see if there are any new themes online, and if so, displays their thumbnails with a cloud icon in their lower right. To choose a theme, click its thumbnail and then click Create Card, or simply double-click the thumbnail.

> **NOTE** Because there's no need to rearrange pages in a card project, you work only in Single Page view. In other words, there's no All Pages view.

Once you pick a theme, Photos plops your pictures into the frames the theme includes and gives you a nice big preview of the card's front. Now you can set about customizing it.

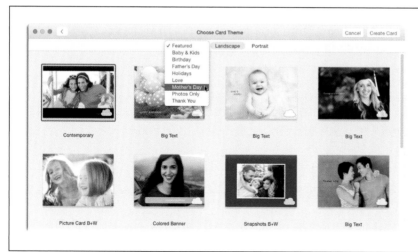

FIGURE 9-21

The Choose Card Theme screen lets you view designs by category; just pick the kind of card you want from the menu shown here. You can also use the buttons to the right of this menu to see only landscape (horizontal) or portrait (vertical) orientated cards.

■ CUSTOMIZING YOUR CARD

Once you choose a theme, the buttons above the preview area let you switch between viewing (and customizing) the front, inside, and back of the card. To change theme or card format, use the Settings menu shown in Figure 9-22. As with all of Photos' print projects, each theme includes different page layout options and background colors, all of which you can change via the Layout Options panel (page 248).

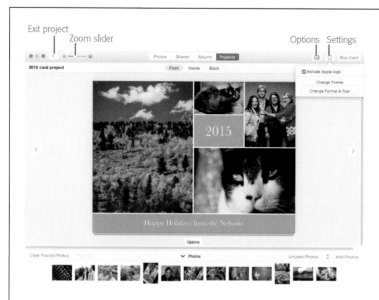

FIGURE 9-22

Before you start fiddling with the card, you need to nail down the theme and format. To change either one, use the Settings menu shown here. This is also where you can elect not to include an Apple logo on the back of your card.

If you click a photo while the Layout Options panel is open, it changes to the Photo Options panel, which includes options for the picture instead of the page itself. For example, you can use it to alter a picture's zoom level and positioning with the frame (page 251), or to add a filter or enter Edit mode (page 106). If you click a text box while the panel is open, it changes to show you text-formatting controls (page 256).

> **TIP** To switch the controls in the Options panel, say, from photo options to layout options or from text options to layout options, just click the Options button beneath the card preview.

If you prefer to place pictures into frames yourself, you can clear the automatically placed photos by clicking Clear Placed Photos at the screen's lower left. When you do, all the pictures you started the project with are moved to the Photos drawer at the bottom of the window. Just drag a thumbnail from this area into a frame to place it manually. You can also swap pictures between frames by clicking and holding down your mouse button until the picture pops out of the frame, and then dragging it onto another image. To remove a picture, drag it to the Photos drawer. The Add Photos button at lower right lets you add more pictures to your project.

To edit any text the card contains, just click a text box to activate it, and then type away. If you double-click to highlight any of the text, the Text Options panel automatically opens (page 256). If you picked one of the Year In Review themes, you've got a *lot* of text to edit—the inside of the card includes a huge text box flanked by a column of small photos on either side. Since there's so much text to enter for this particular kind of theme, you may want to type your prose in a word processor, copy it, and then paste it into your card.

> **TIP** Photos helpfully adds a red warning triangle to any text boxes you haven't edited so they're easy to spot.

■ FINALIZING THE CARD

After you customize the card to the best of your abilities, take the time to proof and spell check it. As page 257 describes, you can print the card or save it as a PDF. Page 256 details your spell checking options.

■ BUYING THE CARD

When you're finished, click Buy Card at the upper right of the Photos window. If this is the first time you've ordered a print product using Photos, you'll need to enter your Apple ID. On the next screen, pick an address or click Add Shipping Address to enter a new one. You can choose multiple addresses and specify a card quantity for each one. The total cost of your order appears at lower right once Photos knows at least one shipping Zip code. Click Place Order and try to exercise patience as you wait for your cards to arrive.

As you'll discover, the cards you make in Photos are incredibly impressive and—unless you opted for letterpress—affordable. Once you start sending them to friends and family, your status level will soar. After all, you're now one of the few humans left who cares enough to design your own cards and put them in the *physical mail*.

Managing Your Library

Photos' library concept is very tidy: Your entire Photos existence is bundled into a single file. It's also quite versatile because you can maintain a single library or several. (You first met your Mac's Photos library file back in Chapter 2; see page 38 for an overview of what it contains.)

Photos makes it easy to create new libraries and switch among them on your Mac, but there are consequences. For example, it may sound like a great idea to create a new library for your kid's sporting events, your niece's wedding, or your space walk outside the International Space Station (hey, astronauts might read this book). But is that a good idea? This chapter points out the many reasons why it's not.

If, for whatever reason, you find yourself in Multiple Library Land, you can always merge them to simplify your Photos experience. Unfortunately, doing so is no easy task. Since Photos can't merge its own libraries, you have to employ other methods that cost money. This chapter walks you through all your options.

Another important aspect of managing your library files is backing them up. Recent surveys report that the things people are most afraid of losing in a catastrophe—besides other people and pets, of course—are their digital photos and videos. Even if you're using iCloud Photo Library (page 11) and you feel smug knowing that you maintain an offsite backup of your library on Apple's iCloud servers, it's safer to err on the side of caution and back up your files elsewhere, too. This chapter teaches you how to do that in a variety of ways, such as the strategy detailed in the box on page 285.

Burning files to a CD or DVD is also useful, even though it may feel old school to some. As page 174 explains, this is an easy way to send photos and exported slideshow movies to far-flung friends and family. This maneuver also lets you view pictures,

videos, and exported slideshows on your TV, which is handy if you don't have an Apple TV (the box on page 175 has more on using an Apple TV).

TIP You can't access your Photos library on an iOS device, so this chapter deals solely with Photos for Mac.

Using Multiple Libraries

If you're an organized person, you may think that you can easily keep track of more than one Photos library. In reality, trying to do so is a nightmare. In a very short period of time, you'll have no idea which content lives in which library.

The one situation where multiple libraries make sense is when you've got multiple people using the same Mac. (As page 15 explains, setting up different user accounts on a shared Mac creates separate Photos libraries for each user.) On the other hand, maintaining more than one library per Mac user account makes no sense. Let us count the reasons why doing so is a *very* bad idea:

- **You can't search across multiple libraries.** One of Photos' superpowers is that it lets you find stuff in a million different ways—but only in one library.

- **Projects can only include pictures from the currently active library.** That's a deal-killer right there. Because of this limitation, the custom calendar you plan to give folks during the holidays won't include anything from another library unless you switch to that library, find the photos you want, export them, switch back to the first library, import the photos—which duplicates them on your hard drive, devouring precious disk space—and *then* include them in your calendar project. Ditto for cards, books, and slideshows. It's exhausting just thinking about it.

- **Merging libraries is painful.** You may assume you can easily merge multiple libraries later on if you need to, but as page 275 explains, the process is messy, time-consuming, and expensive.

- **iCloud can only share and sync content from one library at a time.** You'll learn more about iCloud later in this chapter, but in a nutshell, you can use it to share some of your content or you can pay a fee and sync all of your content across all of your devices. Either way, iCloud only works with one library at a time—specifically, your main Photos library, which Photos call the *System Photo Library* (page 13).

- **You have more libraries to back up.** As you'll learn later in this chapter, backing up your files is extremely important. The more libraries you have, the more files you have to worry about backing up. iCloud Photo Library (page 11) makes this less of an issue but it's still best to have multiple backups of your digital mementos.

The takeaway here is that if you value your sanity and you're honest about your abilities (and shortcomings), it's best to keep all your digital memories in one library per user account on your Mac. (To learn more about managing Photos for families, flip back to page 14.) After all, Photos is designed to handle massive libraries, so there's really no benefit to splitting up your picture and video collection.

Assuming you're convinced that one library is the best policy, you can skip straight to page 277 to learn how to back it up. But if you're the stubborn type, keep reading to learn about managing multiple libraries.

Creating a New Library

So, you've considered all the reasons in the previous section for not using multiple libraries, and yet you *still* feel compelled to create a new Photos library. Fine. It's easy to do—if you know the secret handshake.

To create a new, empty Photos library, press ⌘-Q to quit the program, and then press and hold the Option key while launching it (just click the icon in your Dock). The dialog box shown in Figure 10-1 appears. Click Create New, enter a *unique* name for your fresh new library—say, Photos Library Space Walks—and then pick a location to store it.

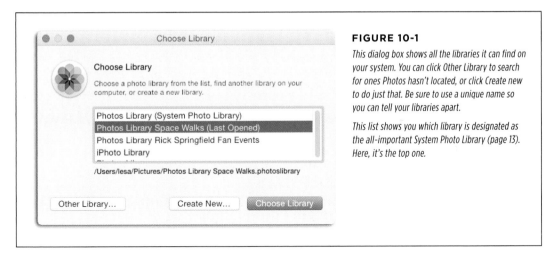

FIGURE 10-1

This dialog box shows all the libraries it can find on your system. You can click Other Library to search for ones Photos hasn't located, or click Create new to do just that. Be sure to use a unique name so you can tell your libraries apart.

This list shows you which library is designated as the all-important System Photo Library (page 13). Here, it's the top one.

Although Photos remembers where you saved your new library (so you can easily switch to it later), Apple recommends that you store *all* your Photos libraries in your Pictures folder—you'll find your Photos life simpler if you do. Nonetheless, if your Photos library is so big that it gobbles up all your internal hard drive space, it's perfectly legal to store it on an external drive instead. Just be sure to include that drive in your backup regimen, and bring it with you when you travel if you plan to do any Photos work during your trip.

TIP If you want to have separate libraries for your kids or other loved ones who use your Mac, give them their own user accounts. That way, when they launch Photos for the first time, the program creates a new library for them and uses it whenever they're logged into their accounts. To create a new user, go to the →System Preferences→Users & Groups and click the + sign under the list of users. See page 224 for the full scoop on using Photos in a family situation.

Switching Between Libraries

If you've completely ignored this book's sage advice about using only one library per Mac user account and you've stubbornly created multiple libraries, sometimes you'll need to switch between them. There are two ways to do this:

- **Double-click any Photos library file in the Finder.** You can do this whether Photos is running or not. If the program is running, a pane appears offering to switch to another library. Click Switch, and Photos quits and relaunches using the library you double-clicked. If the program isn't running, Photos springs into action and opens the new library.

- **Quit Photos and hold down the Option key on your keyboard while you relaunch it.** You see the Choose Library dialog box shown back in Figure 10-1 that lists all the Photos libraries you've created, as well as any iPhoto or Aperture libraries on your Mac. Click a library to select it, and then click Choose Library.

NOTE Hopefully you named your other libraries in a way that lets you distinguish between them; otherwise, it's a guessing game as to which one you want. Fortunately, single-clicking each library displays where it lives on your hard drive, though if you keep all of them in your Pictures folder, that info won't help you very much.

Keep in mind that switching from your System Photo Library (discussed next) to a different library disables iCloud sharing and syncing as well as iTunes syncing. This means any changes you make to the other library won't be shared or synced to any of your other devices, and any content you add to the Photos library on your other devices won't show up in this one.

Changing the System Photo Library

If you have multiple Photos libraries, only one can be anointed the System Photo Library at any time. (If you only have one library, it's automatically the System Photo Library.) As you learned in Chapter 8, this is the library that gets used by iCloud Photo Library, iCloud Photo Sharing, and iCloud's My Photo Stream. It's also the library that iTunes pulls from to deliver photos and videos to your iOS devices and Apple TV (see the box on page 175).

Just because you *can* open a different library and tell Photos to make it your System Photo Library doesn't mean you should. Consider the following consequences of doing so:

- **iCloud doesn't like it.** When you switch your System Photo Library, Photos turns off iCloud Photo Library syncing. If you re-enable it using Photos' preferences,

the contents of the new System Photo Library are added to your iCloud Photo Library, along with the contents of your previous System Photo Library—and they're all merged into your current library. (In fact, this is how you merge Photo Libraries, as the next section explains.)

Also, whatever albums you shared in the previous System Photo Library using iCloud Photo Sharing stop being shared, and any albums in the new System Photo Library that you previously shared using iCloud Photo Sharing begin sharing again. The iCloud Photo Stream also stops streaming to the previous System Photo Library and begins streaming to the new one.

- **iTunes doesn't like it.** Similarly, iTunes stops sending pictures and videos to your iOS devices and your Apple TV because the Photos library it used is suddenly gone (remember, it uses your System Photo Library to do all this). So if you open iTunes and try to adjust the Photos settings for an attached iOS device (or one on your local network), only the pictures, videos and albums in the new System Photo Library are listed. This can cause all manner of mayhem in your household.

Now that you know what's at stake, here's how to designate your currently open Photos library as your new System Photo Library: Choose Photos→Preferences and you see the pane shown in Figure 10-2. Click the General tab, and then click "Use as System Photo Library." May the Force be with you!

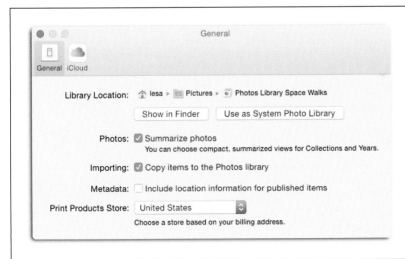

FIGURE 10-2

If the "Use as System Photo Library" button is grayed out, that means the currently open library is the System Photo Library. As you learned in this section, changing System Photo Libraries seriously messes with both iCloud and iTunes. Consider yourself warned!

Merging Libraries

If you've got multiple Photos libraries, you may want to merge them at some point. Perhaps you created multiple libraries by mistake, you inherited a library from another person, or you merely came to the conclusion that you can't juggle more than one. Whatever the reason, you can merge multiple Photos libraries into a single library, but the process is painfully slow, complex, irreversible, and *it costs money*. That's because

Photos can't merge libraries on its own. Instead, you have to employ iCloud Photo Library (page 11) or third-party software to get it done, both of which *aren't* free.

At this point, the frugal among you are tempted to try the following in order to avoid spending money on this venture:

- **Bad idea #1: Export pictures and videos from one library and import them into another.** The problem with this method is that any edits you've made to the exported content become permanent. Plus, you lose any album organization you've done, meaning your stuff ends up in one gigantic, unorganized, lumbering library.

- **Bad idea #2: Burn the contents of one library onto a CD or DVD and then import it into another library.** This method wastes both time and discs, plus you wind up in the same boat as bad idea #1.

Is it fair that Apple forces you to spend money to merge Photos libraries? No, but there's nothing for it. Even Photos' predecessor, iPhoto, couldn't merge its own libraries, so this isn't a news bulletin if you've been a Mac user for any length of time.

The good news is that both of the merging methods explained in this section have benefits, so the money you spend isn't wasted. In fact, you stand to gain quite a bit.

■ MERGING LIBRARIES USING ICLOUD PHOTO LIBRARY

As you learned back in Chapter 1, iCloud Photo Library is an Apple service that syncs all the pictures and videos in your System Photos Library app onto all of your devices, and vice versa. It's incredible, but it's not free (unless you have a tiny library): If your library is over five gigabytes in size (and yours probably is), then you have to pay for this service.

Here's how to use iCloud Photo Library to merge Photos libraries:

1. **Open your System Photo Library in Photos.**

 As you learned on page 11, iCloud Photo Library works with your System Photo Library only, and that's the one you need to open first. If you don't know which library that is, press ⌘-Q to quit Photos, and then launch the program while holding down the Option key on your keyboard, to summon the dialog box shown in Figure 10-1. The library designated as your System Photo Library has a parenthetical beside its name that says so. Click its name in this list, and then click Choose Library.

2. **If you haven't already done so, turn on iCloud Photo Library.**

 Choose Photos→Preferences and, on the iCloud tab, turn on iCloud Photo Library. Photos calculates how much storage space it needs to add your library to your iCloud account and offers to upgrade you to the smallest size possible (see page 12 for pricing). Once you upgrade, Photos starts uploading your library to Apple's servers. Wait until the upload is complete—you can look at the iCloud tab in Photos' Preferences to check progress. Depending on your library's size, this can take minutes, hours—or days.

3. **Open the next Photos library you want to merge, designate it as the new System Photo Library, and then turn on iCloud Photo Library for it.**

 Use the methods described on page 274 to open another Photos library. Next, choose Photos→Preferences and, on the General pane, click "Use as System Photo Library." As you learned earlier in this chapter, doing so disables iCloud Photo Library. To turn it back on, repeat step 2, and then wait until the new library is finished uploading.

4. **Repeat step 3 until all your libraries have been uploaded to iCloud.**

 Tedious, isn't it? Treat yourself to a beverage, snack, or nap—or all three. Hopefully you'll only ever have to do this once. When the last upload is finished, the resulting library contains all the albums, projects, pictures, videos, and metadata from all the libraries you merge—miraculously *without* any duplicates.

The obvious drawback to this process is that you have to wait for all your pictures and videos to upload from all your libraries—and that can take hours or even days per library. If your Internet service provider limits the amount of data you can upload or download each day, you may encounter additional fees or severely limited Internet service for a while. And then there's the cost of iCloud storage.

But the benefits are huge. Now all your files are accessible in the Photos app on all your devices, and you have an offsite backup of all your stuff.

■ MERGING LIBRARIES WITH A THIRD-PARTY APP

An alternate method for merging Photos libraries is to spend $19.95 on PowerPhotos (*www.fatcatsoftware.com*). This program not only streamlines the process of merging Photos libraries, but also shows you which library is set as your System Photo Library (and whether it's syncing to iCloud), lets you search across multiple libraries (which Photos can't do), reveals individual pictures or videos in the Finder, and eliminates duplicate photos.

■ Backing Up Your Files

Your pictures and videos are priceless—and so is all the organizational toiling and project creating you've done in Photos. Unfortunately, your digital files aren't bullet-proof ,and neither is your computer. Because files can get corrupted and hard drives routinely crash, you need to keep a copy of your Photos library in at least one other location. The good news is that your backup options are relatively inexpensive and painless to set up, as the box on page 285 explains. And taking the time to implement a backup plan is far better than losing a lifetime's worth of digital memories.

If you're using iCloud Photo Library (see page 11), you already have *one* excellent backup of your Photos library—it's offsite and available wherever you are, provided there's an Internet connection. But honestly, it would take forever to download all your stuff in order to recover it, and your files disappear if you stop paying Apple's

monthly fee. For those reasons—and your peace of mind—it's smart to stash another backup copy elsewhere.

> **NOTE** Mac professionals who rely on their files to make a living always keep at least one backup where their computer lives and at least one additional backup copy that they stash elsewhere. The second location could be someone else's house, a safe deposit box, or a cloud-based (Internet) service such as CrashPlan. The box on page 285 describes one strategy for creating such a backup system.

In this section, you'll learn the smartest ways to back up your Photos library—or any group of files—to a hard drive or disc.

Backing Up to a Hard Drive

Some people make a copy of their most important files in a second location (folder) on their main hard drive. For example, say you store your Photos library in your Pictures folder (which is what Apple recommends), and a copy in a Backups folder on your desktop. This is handy if the original file gets corrupted—you can just switch to the backup copy and keep trucking. However, if the whole hard drive goes south, which is frighteningly common, both copies disappear. So, think of this kind of thing as a *convenience copy*, not a real backup. If you've got the hard drive space, you can make a convenience copy of your Photos library in the Finder, and then choose File→Duplicate and pick another spot on the same drive. The new file includes the word "copy" at the end of its name.

To create a *true* backup you need to copy the file onto a second hard drive, be it internal or external (one that's plugged into your Mac with a cable). You can do this manually by dragging the Photos Library file from one drive onto another, but then you have to remember to repeat this process every so often. A far better solution is to use a third-party program to perform a backup for you each night. (OS X's Time Machine is also a great solution, but quite different; you'll learn about it on page 280.)

> **NOTE** When this book refers to a "hard drive," that means either a traditional spinning-platter hard drive or a newfangled SSD (solid state drive) that has no moving parts but is much faster (and more expensive) per gigabyte of storage space. Another kind of drive you may hear about is called a *fusion drive* or *hybrid drive*, which combines a hard drive with solid-state memory to minimize cost and maximize capacity and speed. Any of these options works for backups.

■ BACKING UP MANUALLY

To create a manual backup of your Photos library (or any file), you just drag the file from one hard drive to another. Here's how:

1. **Open two Finder windows—one that houses your Photos library and another for the backup destination.**

 Unless you've moved it, your Photos Library file lives in the Pictures folder inside your Mac's User folder. If you moved it but don't remember where you put it, press ⌘-Q to quit Photos, and then relaunch it while holding down the Option

key. In the dialog box that appears, click a library to see its location on your hard drive (Figure 10-1 shows an example). Either way, open a Finder window to wherever your Photos library lives.

NOTE If you changed Photos' preferences so your pictures and videos are *not* copied into Photos' library file (page 28), then you need to remember where you stashed them so you can back them up, too! Otherwise you're merely backing up Photos' organizational structure and not your pictures and videos.

Next, open another Finder window to where you want to store the backup copy. By opening two Finder windows, you can see the original file's location as well as the location where the backup copy will go. That way, you won't get confused when you attempt this nerve-wracking procedure. For example, if you regularly perform this kind of manual backup, there will already be an older copy of your Photos library in the destination. Keeping two Finder windows open helps you avoid accidentally replacing the newer file with the older one (a catastrophic mistake, indeed).

2. **Drag your Photos Library file into the backup destination's Finder window.**

As you drag the file from one window to the other, you see a ghosted icon of the file follow your cursor. When your cursor is inside the destination folder on the second hard drive, release your mouse button, and the Finder displays a dialog box and status bar showing the progress of the copy operation. If your Photos library is big, this can take a while, but feel free to continue working on other tasks during the process. Working in Photos, however, is *not* a good idea, since your Mac is in the act of copying the very files you're working on.

NOTE If you migrated your old iPhoto or Aperture libraries to Photos and you haven't yet deleted those libraries, you don't have to back them up, too. Even though Photos links to the content of those libraries (as the box on page 6 explains), OS X is smart enough to include that original content whenever you copy your Photos library to a different location.

When it's all finished, you have a safe backup of your Photos library. Now all you have to do is remember to repeat the process every so often so your backup remains current, which is a good excuse to add a repeating reminder in OS X's Calendar app.

■ BACKING UP AUTOMATICALLY

Although it requires some setup, an automated backup system provides far more peace of mind than the manual method described in the previous section. Fortunately, backup software is much easier to use than it used to be.

There are myriad apps to help with this. Heck, some external hard drives include software that backs up your Mac to the external drive whenever you plug it in (some let you do it on a schedule, too). Rather than buying a drive just to get the backup software it includes, consider using Carbon Copy Cloner ($40 at *www.bombich.com*) or SuperDuper ($28 at *www.shirt-pocket.com*) to create your own

automated backup to any hard drive your Mac can see—including drives elsewhere on your network (say, a wireless multidrive backup system such as Drobo.com). Both options let you instruct the software to copy one drive to another on specific days and at specific times.

A big benefit of using these two apps is that your external backup drive becomes an exact duplicate of your internal drive—so if your internal drive crashes, you can restart your Mac from the external drive and keep working. (Starting up your Mac from an external drive can be really slow, so you only want to do this in an emergency.)

The first backup you run with either one of these apps takes a while, but subsequent backups zip along much faster. This is due to a trick called *incremental backups,* which means that only files that have been added or changed since the previous backup are included.

■ USING TIME MACHINE

If you like the idea of automated backups and the ability to recover previously saved versions of your files (and who doesn't?), Apple has a slick solution called Time Machine, which is built into OS X. It does what the automated backup programs mentioned in the previous section do, but with minimal setup required. One important thing to consider, though, is that unlike Carbon Copy Cloner or SuperDuper, you can't restart your Mac from your Time Machine backup drive because it doesn't backup your operating system. If your internal hard drive fails, you have to replace it, install OS X on it, and *then* restore your files from the Time Machine backup, which can be an overnight process best started before going to bed.

To use Time Machine, you need a storage device such as a second internal hard drive, an external USB, Thunderbolt, or FireWire hard drive, or an AirPort Time Capsule (*www.apple.com/airport-time-capsule*). The kicker is that the backup drive has to have more storage space than the drive you're backing up. And bigger is better—the more space you have on the Time Machine drive, the farther back in time you can recover previous versions of your files. (A good rule of thumb is to make the backup drive at least twice as big as the drive you want to back up.)

Turning on Time Machine is a piece of cake. The first time you attach an external drive to your Mac or install an additional internal drive, you see a message inviting you to use that drive as Time Machine's backup drive. If you accept the invitation, the Time Machine preferences pane shown in Figure 10-3 appears.

Turn on Time Machine by clicking the enormous On/Off button, and it immediately sets about copying everything on your hard drive to the backup drive. You can stop or pause the process at any time by using that same On/Off button, and if you decide to use a different disk for your Time Machine backups, you can select it here. The checkbox at the bottom lets you add a Time Machine icon to your Mac's menu bar, which is handy for quickly seeing the status of your latest backup and for telling Time Machine to start backing up right away rather than waiting for its next hourly cycle. You can also use this icon to recover a previous version of a file (say, if you made a change to it and then saved the file).

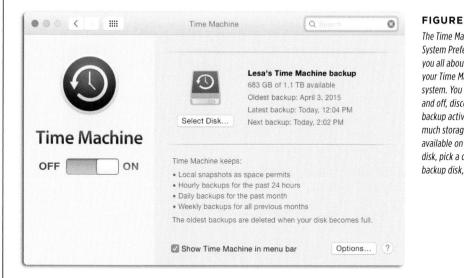

FIGURE 10-3

The Time Machine pane in System Preferences tells you all about the state of your Time Machine backup system. You can turn it on and off, discover its latest backup activities, see how much storage space is available on your backup disk, pick a different backup disk, and so on.

Backing Up to CDs and DVDs

Because CDs and DVDs can only hold so much, you'll likely only want use them for archiving pictures and videos you export from your Photos library, instead of using them to back up your entire Photos library. A blank CD can store about 700 megabytes of data, while a single-layer DVD stores six times that much (4.3 gigabytes), and a dual-layer DVD stores a whopping 8.5 gigabytes. If your Photos Library file is smaller than 4.3 gigabytes, you can back it up onto a single-layer DVD. If it's less than 8.5 gigabytes, you can back it up onto a dual-layer DVD. (It's unlikely that your Photos Library will fit on a CD.) To see the file size of your Photos library, select it in the Finder and choose File→Get Info. In the window that appears, you see how hefty it is.

> **TIP** When you're shopping for blank CDs or DVDs, Verbatim DataLifePlus is a good brand to look for, especially their archival quality DVDs and Blu-ray discs, which allegedly last for 100 years.
>
> It's important to note that your Mac can't burn Blu-ray discs directly, but if you have an external Blu-ray burner, you can use an app named Toast to burn Blu-ray discs. A single-layer Blu-ray disc holds 25 gigabytes, and a dual-layer Blu-ray disc holds 50 gigabytes. Each disc costs about $1.50 or $4.00, respectively, when you buy them in packs of 50, and you can get an external Blu-ray burner (which also burns DVDs and CDs) for less than $100.

The process is the same whether you're burning your *entire* Photos library onto a disc, or only your exported pictures, videos, or slideshow movies. Here's how it works:

1. **Prepare your files.**

 If you want to burn your whole library, locate it in the Finder. Unless you moved it, it lives inside your Pictures folder in your User folder. If you don't remember where your library is, you can find it by opening the Choose Library window, as explained on page 274.

 If you want to burn a collection of pictures and videos, you first have to export them from Photos (page 231). And to burn a slideshow project, you need to export it into a video file (page 171 tells you how).

 TIP You can also Control-click your Photos library file and choose "Burn Photos Library to Disc." When you do, your Mac requests a disc and tells you exactly how much free space you need. Handy!

2. **Insert a blank CD or DVD into your Mac's optical disc drive and tell your Mac what to do with it.**

 When you insert a blank disc, it takes your Mac a few seconds to figure out what kind of disc it is. Eventually, the dialog box shown in Figure 10-4 appears, asking you which app you'd like to handle the disc. In the Action drop-down menu, choose Open Finder, and then click OK. The disc appears on your desktop as an Untitled CD or Untitled DVD with a round disc-shaped icon. The disc also appears in the sidebar of any open Finder window with a tiny burn symbol on it (you can see this symbol in Figure 10-5).

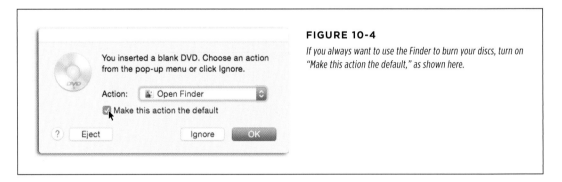

FIGURE 10-4

If you always want to use the Finder to burn your discs, turn on "Make this action the default," as shown here.

3. **Drag your file(s) onto the disc's icon on your Mac's desktop.**

 This disc behaves like any attached drive—just drag the file(s) you want to copy onto its icon. You can also double-click its icon to open a Finder window that shows its contents. You can create folders on the disc, drag files onto its open window as shown in Figure 10-5, rename the files you're about to burn, rename the disc, and so on.

 It's important to understand that as you're crafting the disc's contents, you're not moving files around on your hard drive, nor is your Mac burning any items to the disc quite yet. The files you drag onto the disc's icon or into its Finder

window are *aliases*—pointers to the original items on your hard drive. (Look closely at the files you're going to burn and you see their icons include the tiny, curved arrow that indicates they're an alias; it's visible in Figure 10-5.)

This means if you change the contents of the soon-to-be-burned file *before* clicking Burn, the disc will include the altered contents. For example, if you edit a picture in your Photos library or delete a project from it and then click the Burn button, those changes appear on the burned disc, too.

FIGURE 10-5

When you click the disc's icon in the sidebar, the bottom of the window displays how much free disc space is left (if any). Here there are 4.1 gigabytes left on the DVD. Click the icon circled here to refresh the free-space amount as you add or remove files.

4. **Tell your Mac you're finished editing the disc's contents.**

 When you've dragged all the files you want onto the disc and are happy with how those files are arranged, let your Mac know you're ready to burn it in by doing one of the following:

 - On your desktop, click the disc's icon, and then choose File→Burn [disc name].

 - In the sidebar of a Finder window, click the Burn icon next to the disc's name (it looks like a yellow and black radiation symbol).

 - In the upper-right corner of the disc's Finder window, click Burn.

 - On your desktop, drag the disc's icon toward the Trash icon in the Dock. As soon as you begin to drag, the Trash icon turns into a yellow Burn icon. Drop the disc's icon onto it.

 - On your desktop, Control-click the disc's icon and choose Burn [disc name].

 Whatever method you use, the confirmation dialog box shown in Figure 10-6 appears.

5. **Enter a name for your disc, and then click Burn.**

 When you click Burn, your Mac begins physically recording your chosen files to the CD or DVD. When it's done, double-click the disc's icon to ensure the contents were indeed transferred, and then eject it by pressing ⌘-E.

FIGURE 10-6

Here you can rename your disc or bail on the burning process altogether by clicking Cancel. If you click Eject, your Mac spits out the disc and plops a burn folder onto your Mac's desktop containing the contents you were about to burn, just in case you decide to burn a disc with those contents later on. (If you named the disc, the folder bears the same name; if not, look for a folder named Untitled DVD or Untitled CD.)

NOTE The discs that your Mac burns work on Macs and on Windows (or Linux) PCs, too. But if you plan to use the disc on a PC, it's important to know that Windows doesn't let you use certain characters in filenames, folder names, or disc names; specifically, these: \ / : * ? " < > |. If you include those characters in file, folder, or disc names, you won't be able to open them in Windows.

■ USING A BURN FOLDER

Another way to collect files for burning onto a disc is to create a *burn folder*. This technique lets you collect files at your leisure and then burn them when you're ready. The only drawback to this method is that you won't know how much disc space you've got on the CD or DVD. In other words, you may collect more files than you've got space for. Still, if you're sure that the files you're going to burn will fit onto the CD or DVD you plan to use, give it a shot. This method is handy if you're out of discs; just make a burn folder, and then burn its contents to a disc when you get one.

To create a burn folder, go to the Finder, choose File→New Finder Window, and then click Desktop in the list on the left. Next choose File→New Burn Folder. A new folder named Burn Folder appears on your desktop and in the Finder window you opened. Name the folder anything you like, and then drag the files you want to burn onto its icon or, if you double-click to open the burn folder, right into its Finder window. When you're ready, open the folder and click the Burn button in its upper right. Your Mac then asks for a blank CD or DVD and walks you through the process of burning it.

NOTE When you make a new burn folder, it lands inside whatever folder you're viewing in the frontmost open Finder window, which could be anywhere on your hard drive (say, in the Rotary Club Recipes folder that lives in your personal folder inside your Documents folder—whew!). By taking a moment to open a Finder window set to display the contents of your Mac's desktop before you make the burn folder, you'll make it easier to find because it'll land on your desktop.

A Super-Awesome Backup Strategy

There are as many good backup plans as there are people who dream them up, but if you're looking for a fairly simple plan that combines simplicity with low cost, read no further than this box.

Your noble goal is to have multiple copies of your hard drive backup in different locations. Start by using Time Machine, which is built into OS X. To do that, you need to buy an external hard drive with a greater capacity than the drive you're backing up (say, twice as big). Remember, it's best to buy more space than you need. Fortunately, memory is cheap these days: A three-terabyte external drive currently costs around $100. Plug the drive into your Mac and follow the instructions on page 280 to get Time Machine rolling. (It's worth noting that Thunderbolt or FireWire drives tend to offer faster transfer speeds than USB drives.)

Next, buy *another* external hard drive that's bigger than your main hard drive. You'll use this drive as a clone of your main drive. That way, if your main drive goes south, you have another drive that you can immediately start your Mac from. To create this clone, invest in either Carbon Copy Cloner ($40 at *www.bombich.com*) or SuperDuper ($28 at *www.shirt-pocket.com*). Both programs include help guides that walk you through the process of setting them up on a schedule. Make sure you

schedule the backup to occur daily while you're asleep. If you're truly paranoid, you can invest in *several* external drives that you use for cloning, and then swap them out periodically. Keep one attached to your Mac for a while as its backup drive, and then take it to someone else's house, your office, or a safe deposit box. Next, attach a different external drive to your Mac and let the cloning happen to it instead. (This redundancy trick works with Time Machine, too.) Repeat this as often as is convenient for you.

The final piece in your super-awesome backup strategy is a cloud-based (Internet) backup service. If all you're concerned with is your Photos library, then Apple's iCloud Photo Library is the easiest solution (page 11). Of course, all cloud-based backup services cost money, and iCloud is no exception. If you want to back up your entire hard drive, not just your Photos library, try a service such as *www.CrashPlan.com*. It'll take a long time to upload your first full backup, but subsequent ones take far less time because only the files you've changed get uploaded. (That said, some services, including CrashPlan, offer to mail you a disk that you copy files onto and then mail back to them.)

Now, aren't you glad you bought this book?

Troubleshooting

Photos for Mac is a brand-new program, and while it's based on an app that's been around awhile—Photos for iOS—it has to deal with the far more complicated interaction of OS X apps, automation, upgrading two kinds of libraries (iPhoto and Aperture), and more. Photos for Mac also has to support all the devices you connect to it, such as old iPhones, iPads, digital cameras, hard drives, and the like.

So it's no wonder that Apple focused on getting all the pieces and parts to work, rather than including *every* feature of iPhoto and Aperture. Thankfully, that makes this troubleshooting appendix less about soothing you because nothing is working, and more about how to work around a missing feature that you formerly relied on.

That said, apps and the brainy engineers who make them aren't perfect. Alas, from time to time, bugs sneak into the mix and weird stuff just happens (especially when you're in a hurry). Whether it's Photos for Mac or Photos for iOS that's gone rogue, this appendix teaches you how to handle the most common problems you're likely to encounter.

■ The Big Takeaway

If you've used a new Apple app before, you know that a bug (or three) are fairly common. When this happens, the Apple community at large rises up and makes the bugs known by assaulting the support section on Apple.com with fiery posts or, if it's *really* bad, they take to the phone lines. Apple's engineers then spring into action and fix the problem(s), and a few weeks later the Mac App Store notifies you of a software update. That's just how it goes with new apps. (Of course, there's no

excuse for a company to release bug-riddled software, but that's never really been the case with Apple. Aside from a few glitches here and there, Apple software is solid.)

The big takeaway here is to always use the latest version of Photos. That's it. If the Mac App Store notifies you of an update, for Thor's sake, save yourself some stress and install it. If you're not sure whether you're running the latest version, choose →App Store and, in the Mac App Store window that opens, click the Updates tab. If you see a Photos update, click Update. Doing so may fix whatever the trouble you're experiencing.

Upgrading and Importing

Overall, most people report a smooth upgrade process from iPhoto or Aperture to Photos—aside from grieving over the loss of some features, that is. But if "overall" means "everyone but you," this section has suggestions for dealing with a library that stubbornly refuses to open or upgrade, and tells you why Photos won't let you see some of the stuff you had in those other libraries.

> **NOTE** Most of the troubleshooting advice for importing and upgrading iPhoto and Aperture libraries to work with Photos is covered in Chapter 1. So if your particular problem isn't listed in this section, flip back to that chapter for help.

Should I remove duplicate images from iPhoto or Aperture before I upgrade to Photos?

No. Photos is smart enough not to import multiple copies of a picture or video. Even if you combine Photos libraries using the technique on page 275, duplicates shouldn't appear. But if you insist upon tidying up your iPhoto or Aperture library, check out the $8 Duplicate Annihilator for iPhoto (*www.brattoo.com/propaganda*). They also have an $8 version for Photos, in case you accidentally import duplicates later on.

Photos says it's unable to upgrade my photo library. Why?

If this happens, there may be locked files somewhere inside your iPhoto or Aperture library. If something's somehow gotten locked, Photos can't convert it to the latest format in order to open it.

Rather than trying to find the locked needle in a haystack, you can use a Unix command in your Mac's Terminal app to unlock your files. Yes, this is scary territory, but as long as you're careful and type the commands *exactly* as they're listed below, everything will be just fine (better than fine, actually, because Photos will be able to open your library!).

First, make sure you're logged into your Mac as an administrator (see *https://support.apple.com/kb/PH18891* for help on that). Next, open your Applications→Utilities folder, and then double-click Terminal. The resulting command console may look completely alien, but just take a deep breath and type the following, exactly as it appears here:

```
sudo chflags -R nouchg
```

—and add a space at the end (after "nouchg"). Don't press Return yet!

Switch to the Finder. Open your Pictures folder and drag the offending iPhoto or Aperture library icon *into* the Terminal window to add its directory to the command you just entered. You now see a command that looks something like this:

```
sudo chflags -R nouchg /Users/Spock/Pictures/iPhoto\ Library/
```

Press Return to run the command. When prompted, enter your Mac's password, and then press Return again. Now try using Photos to open your old library again; it should open right up without a hitch.

Photos says I don't have enough storage space on my Mac to import my iPhoto or Aperture library, but I have plenty!

Unfortunately, Spotlight—OS X's search feature—has been known to calculate available storage space incorrectly, leading Photos to refuse to upgrade an iPhoto or Aperture library. Don't panic; the problem is easy to fix.

To perform your own storage-space check, open a Finder window and choose View→Show Status Bar. At the bottom of the Finder window, you see a line of text that tells you how much free space you have on your hard drive. Next, choose →About This Mac and click the Storage tab. If the amount of free space shown there doesn't match what the Finder window indicates, try resetting Spotlight. To do that, choose →System Preferences→Spotlight. In the Spotlight preference pane, click the Privacy tab, and then drag the hard drive icon from your Mac's desktop into its list. (If you don't see a hard drive icon on your desktop, click the + icon at lower left of Spotlight's preference pane and in the resulting pane, select your hard drive and click Choose. In the confirmation message that appears, click OK.) This disables indexing for that drive.

Hopefully, Photos will now agree to import your iPhoto or Aperture library. When Photos is finished doing that, go back to the Spotlight preference pane, click Privacy, and then select your hard drive in the list. Click the – icon at lower left to remove your hard drive from the Privacy list, and Spotlight resumes indexing the drive's content.

If you really *do* lack hard drive space, then you've got a great excuse to go shopping for a bigger hard drive. If you've got the money, spring for a solid-state drive (SSD)—they're a lot faster than their spinning-platter brethren, as the Note on page 278 explains.

After upgrading to Photos, some items have a gray, black, or empty thumbnail preview. What happened?

This particular problem has several possible causes:

- **You didn't empty your iPhoto or Aperture trash, or the Finder's trash, before you upgraded to Photos**. If you converted an iPhoto or Aperture library to Photos, but didn't empty the trash in those apps—or the Finder's trash—*before* doing so, some of the items you thought were deleted may mysteriously reappear in Photos with gray boxes in lieu of thumbnail previews. Think of these resurrected goodies as image zombies—images you thought you had deleted but that sprang back to life in Photos.

 You can double-click any of these gray boxes to be sure they're photos you want to delete, and then delete them by pressing the Delete key on your keyboard. Just be aware that after you view one of these images, Photos generates a thumbnail preview for it and you lose that gray-box reminder of its zombie status.

- **One of your iPhoto projects—a card, book, or calendar—uses a downloadable theme that you haven't yet used in Photos**. A gray project preview indicates that the project uses a theme that Photos hasn't downloaded yet. The fix is to double-click the project's thumbnail to make Photos grab the theme from Apple's servers.

- **Videos display black rectangles instead of preview thumbnails**. If, while perusing your video collection, you see some with black rectangles instead of thumbnails, it means that Photos hasn't yet generated a thumbnail for them. To force Photos into action, select the video, press the spacebar on your keyboard to open the clip, and then press the spacebar *again* to close it. (Or double-click the video to open it, and then close it.) When you close the video, the proper thumbnail should appear.

 If you have a mountain of movies to generate thumbnails for, a quicker way is to open the first one, and then look for black thumbnails in the Split View pane on the left. (If the Split View pane isn't showing, choose View→Show Split View.) Click one of the black thumbnails to display it in the preview window. When its thumbnail changes from black to the first frame in the clip, click another black rectangle in the Split View pane. Rinse and repeat until all the black rectangles are replaced by happy thumbnails.

 You can also coax the program into generating new thumbnails by repairing your Photos library. To do that, quit Photos by pressing ⌘-Q, and then relaunch it while holding down the ⌘ and Option keys. Keep holding down these keys until you see the sheet shown in Figure A-1.

- **Some image thumbnails are gray.** This can be caused by anything, but the fix is to force Photos to generate new thumbnails by repairing your Photos library, as explained in the previous bullet point.

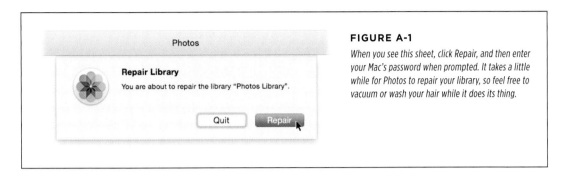

FIGURE A-1

When you see this sheet, click Repair, and then enter your Mac's password when prompted. It takes a little while for Photos to repair your library, so feel free to vacuum or wash your hair while it does its thing.

iPhoto disappeared after I upgraded to Photos and I want to open my old iPhoto library in iPhoto. What can I do?

Don't panic—you can use the Mac App Store to download iPhoto. Choose →App Store, and then click the Purchases tab. Scroll down until you see iPhoto. If there's a button labeled Install, click it. If the button says Open, click it and, if iPhoto launches successfully, it's still available to use. If iPhoto refuses to launch, locate it in your Applications folder, put it in the Finder's trash, and then empty the trash. Next, Quit and relaunch the App Store, click the Purchases tab, and then scroll down to iPhoto. Now the button should say Install. Click it and your Mac downloads the latest OS X Yosemite-compatible version of iPhoto.

Unfortunately, this technique won't work if you never downloaded or upgraded iPhoto using the Mac App Store. If your Mac is older than 2011 and you never upgraded iPhoto using Software Update or the Mac App Store, you may need to find an iPhoto installer on a DVD and install it from there. Once you've done that, the technique described above should work to update it to the current, Yosemite-friendly version. Alternatively, if you have another Mac that uses your same Apple ID, you can drag its copy of iPhoto onto a removable storage device such as a flash drive or external hard drive, and then copy iPhoto from that device into the Applications folder on your Mac. Just be sure to update iPhoto to the latest version *before* copying it to the removable storage device. Or, if you have an Apple store nearby, you can pack up your Mac and beg the wizards at the Genius Bar to install a functioning copy of iPhoto for you.

I upgraded to Photos and I want to open my old iPhoto library in iPhoto, but iPhoto won't launch. What can I do?

You need to delete and reinstall iPhoto as explained in the previous section.

I tried updating iPhoto to the newest version after I upgraded to Photos, but the App Store's Update button doesn't seem to work. What can I do?

Unfortunately, you need to delete and reinstall iPhoto as explained two sections ago.

The file size of the Photos app is a fraction of the size of the iPhoto app. Is Photos that much more efficient than iPhoto, or is it because there are fewer features?

You're right, the file size of the two apps is vastly different: 1,700 million bytes for iPhoto versus 50 million bytes for Photos. This is likely due to a combination of efficiency and fewer features.

The plug-ins I used in iPhoto don't work in Photos, and I can't use my external editor. Am I destined to a life of Photos-imposed limitations?

Your pain is shared by thousands of formerly happy plug-in and external editor users. While Apple hinted that Photos would support plug-ins, it hasn't happened as of this writing. But keep your eyes peeled for a Photos updates that allows plug-ins, as Apple may add that feature soon.

As for external editors, there's a (clunky) workaround: You can export images from Photos, edit them in another program, and then import the edited version back into Photos. While it's not as seamless as iPhoto's ability to simply hand images off to other programs when you click the Edit button, it still works. Here again, keep your fingers crossed that Apple adds this ability in future versions of Photos.

Photos doesn't recognize my camera. What do I do?

Photos generally works with any recent camera model, including iOS devices. If you don't see the Import screen (Chapter 3) even though the camera is connected, try the following steps in order:

- Make sure the camera is turned on and confirm that the USB cable is securely plugged in at both ends.

- Unplug the USB cable from the port it's in and plug it into a different one. If the cable was previously plugged into a USB hub with multiple plugs and that hub has other stuff plugged into it, try plugging it into a USB port on your Mac instead.

- If you're using an old camera that has a special PC mode for connecting to a computer, set the Mode dial to that.

- Unplug the USB cable, turn the camera off, plug the USB cable into a port on your Mac, and then turn the camera back on.

- Turn the camera off and then on again, while it's plugged in.

- If all else fails, remove the memory card from the camera and plug it into a memory-card reader (page 25) or the SD card slot on your Mac (if it has one).

Where there's a will, there's a way.

◼ Organizing Troubles

Photos is good at keeping track of all your images, but occasionally problems crop up. Here are some of the most common ones related to organizing your goodies.

I want to delete a picture but Photos won't let me.

You may be trying to use the Delete key on your keyboard to delete a picture in a smart album, which you can't do. The fix is to Control-click the thumbnail, and then choose "Delete 1 Photo" from the shortcut menu that appears.

I deleted a photo, but it came back!

That's doubtful. You probably *removed* the image from an album or project instead of *deleting* it from your library. As page 65 describes, pictures and videos in albums and projects are merely *aliases* that point to the actual files in your library. Removing a thumbnail from an album or project doesn't affect the original file. If you really want to delete an item from your library while you're viewing its thumbnail in an album or project, Control-click the thumbnail and choose "Delete 1 Photo" from the shortcut menu.

When I delete a photo from my library and then switch to a slideshow that used that image, the photo is still in the Photos drawer at the bottom of the window.

As of this writing, this is a real, live bug. Although the thumbnail is visible in the Photos drawer, it doesn't appear in the slideshow when you play it. But if seeing the image in the Photos drawer bugs you, close the slideshow project and then reopen it; the rogue thumbnail should be gone. If not, then let's hope that Apple fixes this in the next Photos update.

I created a new album but don't see it in Photos' sidebar or in Albums view.

As page 73 explains, Photos lets you stash albums into folders in order to organize them. It's likely that your new album ended up inside a folder. If a folder is selected in the sidebar or in Albums view when you create an album—or a folder, for that matter—then the new album or folder lands inside the selected folder. To get it out of the folder, double-click the folder to open it, and then Control-click the album's icon. Choose "Move Album Out Of [folder name]" and the album appears as an icon in Albums view just like the others.

Faces isn't correctly identifying the people in my pictures.

The Faces feature merely wants your attention. By following the instructions on page 99, you can train Photos and greatly improve its facial-recognition accuracy. By telling Faces when it's right and wrong, it gets better at identifying the people in your photographic life.

One of my photos isn't with the others I took at the same time.

If you upgraded your iPhoto or Aperture library, some items may not appear in their correct chronological order in the All Photos album. As of this writing, the problem appears to be a bug. If you want to ensure you're seeing *all* your pictures and videos taken within a specific timeframe, switch from Albums view to Photos view, and then find the date you're looking for using Moments, Collections, or Years view.

When I'm in an album and choose View→Keep Sorted By Date, I can still reorder the items. What gives?

In an album, you can drag photos into an arbitrary order, or choose View→Keep Sorted By Date to revert to the oldest-to-newest order. Even then, you can drag photos into any order, so the word "Keep" in the name of that command is misleading. Apparently in Apple's world "Keep Sorted" means "Temporarily Sort."

Items that I added location tags to in iPhoto don't have them in Photos. What happened?

While some people experienced the loss of any manually added locations tags, most didn't. Unfortunately, Photos won't let you add location tags, though the box on page 90 has a few workarounds.

■ Sharing and Syncing

Photos offers many methods for sharing and syncing your digital goodies (see Chapter 8), including a few methods that were adopted from iPhoto. Here are a few problems you may run into in Photos' sharing and syncing realm.

Where's the export-to-web-page option in Photos? I used it in iPhoto all the time.

While Photos doesn't have a feature like the one in iPhoto, you can create a web gallery in Photos by setting up a Shared album and then turning on its Public Website option. Page 220 has the scoop.

I turned on iCloud Photo Library three days ago, and it's *still* uploading files to Apple's server. My other Internet activity has slowed to a crawl, and now my Internet service provider is threatening to pull the plug on me because I'm using too much bandwidth. Can I slow down the data transfer so I don't get slammed with extra charges or receive slower service from my ISP?

This is an ugly problem indeed, and one that Apple really needs to fix. When Photos first syncs with iCloud, it tries to do so immediately and as quickly as possible. As you noticed, this can slow your other Internet usage to a crawl. You can turn the process off and on in Photos' iCloud Preferences or pause it for one day (page 20). Ideally, your Mac should sense when you're using it and throttle down the upload speed, but Apple doesn't offer this feature (yet!).

iCloud Photo Library ruined My Photo Stream, and now I can't see it on my Mac.

The most important thing to remember about iCloud Photo Library is that if you turn it on on one device, you need to do so on *all* your devices. Otherwise, you won't see photos from one device on the other. To turn iCloud Photo Library or My Photo Stream on or off on your iOS device, tap Settings, and then scroll down to Photos & Camera and tap it. Page 20 has details.

My Photo Stream isn't syncing!

My Photo Stream only syncs across your devices when you're on a WiFi connection; it doesn't work over a cellular network. You can also encounter syncing problems if the Camera app is open on your iOS device—you have to close it before pictures will upload to iCloud. Or you may just have a low battery: If your iOS device has less than 50% power left and isn't plugged into a power outlet, the syncing comes to a screeching halt.

I've got iCloud Photo Library turned on, but the changes I make in Photos for Mac aren't showing up in Photos for iOS (or vice versa).

Depending on how many changes you make or pictures you take, it may take awhile for all that to be reflected on the other device. If nothing happens for a really long time, make sure your iOS device has WiFi turned on and that it's connected to the same network as your Mac. If that doesn't do the trick, try the following:

- Quit and then relaunch the Photos app on your Mac and iOS device. In iOS, double-click the Home button, and all the apps currently running appear in a swipeable row across the screen. Swipe left or right until you see the Photos app, and then swipe the miniature screen above the app's icon upward toward the top of your device. When it disappears, you've successfully quit the app. Now relaunch Photos.

- Restart both your Mac and the iOS device, and then launch Photos.

- Turn iCloud Photo Library off and back on again (page 19).

A little patience goes a long way when dealing with iCloud Photo Library; though if it still seems stuck, try signing out of and back into your iCloud account on each device.

Multiple users (accounts) in my family shared the same iPhoto library on our shared Mac. But I can't seem to let multiple users share one Photos library. Is there a way to do that?

Alas, no. The ability to share a library is a casualty of Apple's introducing iCloud Photo Library, and it's not a feature that's likely to return. Photos' concept of a library is *one per user*. That way, you can have all your pictures and videos available to you on all your devices—not everyone else's photos. The solution is to set up a Family Group, as explained on page 224, and then use the Shared Family Album. The box on page 14 has more on using Photos in a family situation.

I stored my Photos library on a network drive and now I can't use iCloud Photo Library to sync my photos with my iOS devices.

To use iCloud Photo Library, the drive you're using on your network must be in Mac OS Extended format, also known as HFS+. (Photos' method of keeping track of your stuff requires complex file-management features that aren't in other formats.) There are two solutions to this problem: You can buy a Mac-formatted network drive and then copy your Photos library to it, or you can back up your library to another

storage device and reformat your network drive to Mac OS Extended format. To erase and reformat your drive, make *triple* sure your files are backed up on another drive (just to be safe), and then launch Disk Utility; it's in your Applications→Utilities folder. Choose your drive from the list on the left, and then click the Erase tab on the right. Finally, from the Format menu, choose Mac OS Extended (Journaled), and then click Erase.

Before upgrading to Photos, I created albums in iPhoto and then used iTunes to copy some of them to my iPad. After upgrading to Photos, this is no longer an option in iTunes. Can I continue using my old approach, or do I need to do something different?

You can continue with your old habit if you wish. The thing to remember is that if iCloud Photo Library is turned on on your iOS device(s) and your Mac, iCloud Photo Library takes over all photo-syncing duties so you can see *all* your Photos albums on your iOS device—not just the albums you pick in iTunes. To continue using iTunes to sync only selected albums to your iOS device, turn off iCloud Photo Library on the iOS device. To do that, tap Settings, scroll to Photos & Camera, tap it, and then on the resulting screen, make sure the iCloud Photo Library button is white (off) not green (on). If it's green, tap it to turn it white. You should then be able to synchronize albums using iTunes as you always have. For more on iCloud Photo Library, see page 11 and 19.

I'm using Photos on two Macs, and accessing the same library on both. Why don't I see my projects or Faces on the second Mac?

While you can sign into iCloud on the second Mac using the same Apple ID you use on your primary Mac, Photos limits what's available to you on the second Mac. After you sign in, the following items appear in the Photos app on *all* of your Macs (see *https://support.apple.com/en-us/HT204486* for details):

- All original photos and videos
- All folders and albums
- Smart albums
- Keywords
- Searchable keywords based on Faces tags
- Key photo selections

The following goodies are available only on the Mac on which they were created:

- Books, cards, and calendars
- Slideshows
- Keyword shortcuts
- Unused keywords

- Last Import album (this album contains photos you most recently imported on that specific Mac)

- Faces tags and Faces data

In addition, your pictures and videos need to be stored *inside* the Photos library for them to be accessible through iCloud Photo Library. See page 28 for more on copying items into your Photos library versus *referencing* them externally.

Editing Woes

Fortunately, there's not a whole lot that can go wrong when you're editing images or videos in Photos. After all, you can always revert to the original version. Nevertheless, here are a few problems and their solutions.

I messed up a picture while editing it, and now it's ruined!

Open the offending thumbnail in Edit mode (page 106), and then click "Revert to Original" at the upper right, or choose Image→"Revert to Original." Photos restores your image to its original state, using a backup it keeps squirreled away in its library (page 38).

Photos crashes when I double-click a thumbnail to edit it.

The culprit here is usually a referenced file that you changed the name of in the Finder. For example, if you imported the file as a *referenced* file (page 28) instead of letting Photos copy it into its library, and then you changed the name of the file in your Mac's Finder, Photos won't be able to find the file anymore. Alternatively, the file may have gotten corrupted somehow. Either way, the solution is to delete the file in Photos (page 75), and then reimport it.

If the problem persists—and you've kept your paws off the file's name in the Finder—try opening it in Preview (it's in your Applications folder) and then using its File→Save As command to create a new version of the file that you import into Photos.

Printing Problems

Most printing problems have to do with your printer itself, in which case turning it off and back on solves most troubles. However, there are a few settings in Photos that can frustrate you and waste precious paper and ink.

I can't print more than one picture per page and it's awfully wasteful to use a whole sheet of paper for one little 4 × 6-inch print.

Agreed. Photos is perfectly happy to put multiple pictures onto a single page, so try the following fixes:

- Make sure you picked a paper size that's larger than the prints you want. See page 190 for more on this topic.

• Confirm that you've selected more than one photo before triggering the printing process. Page 57 tells you how to select multiple items in Photos for Mac.

My picture doesn't fit properly on 4 × 6-, 5 × 7-, or 8 × 10-inch paper.

As you learned in the box on page 187, most digital cameras produce photos in a 4:3 width-to-height ratio, which means they don't quite fit standard print sizes. The fix is to crop your images to the appropriate aspect ratio (page 116), or use the zoom slider in the Print pane to change the crop just before you hit print (page 191 tells you how).

General Questions

Last but not least, here's a handful of miscellaneous problems.

If I'm using iCloud Photo Library, do I need to back up my Photos library elsewhere?

Absolutely! Things go wrong, even on Apple's servers. Apple recommends that if you use iCloud Photo Library, you should also use Time Machine to back up your Mac, which includes your Photos library. Be sure to keep your Photos library and Time Machine backups on different disks, too, so that *when* that disk fails—and it will—you won't lose everything. Just keep your Photos library in your Pictures folder and set Time Machine to back up to an external drive, to a disk on your network, or to a Time Capsule.

See the box on page 285 for a simple backup strategy.

All my pictures are gone and I'm freaking out!

or

The library starts to open but it never does and I'm freaking out!

You have just two options when these extreme problems occur: You can *repair* the library or *replace* it with a backup copy. (You might think that you could use iCloud Photo Library to restore a library file, but that would take forever.) Here's how:

• **Repair the library.** The quickest solution is to let Photos repair the library. To do that, press ⌘-Q to quit Photos, and then reopen it while holding down the Option and ⌘ keys. Click Repair in the message box that appears. Photos then analyzes every image and every album, inspecting them for damage and repairing them if it can. Feel free to run some errands or compose a novel, because this process takes a while. Finally, you end up with a fresh new library.

• **Recover from a Time Machine backup.** If you (wisely) turned on Time Machine for backups (see the box on page 285), you can use it to restore your Photos library to the state it was in at a given moment in the past. (Sadly, you can't use Time Machine to restore individual items inside your Photos library.) First, locate your Photos Library file in the Finder; it's normally in your Pictures folder (see page 39). If you don't know where it is, choose File→Find, and type *Photos*

Library in the search field that appears. After a moment, an alphabetical list of items appears that (hopefully) includes your Photos library. Control-click the Photos Library file in the list, and choose "Show in Enclosing Folder" from the shortcut menu. This opens a Finder window set to that location. Next, click the Time Machine icon in your menu bar or Dock and choose Enter Time Machine (you can also double-click its icon in your Applications folder). When you do that, your desktop fades away and you see the currently open Finder window with dozens of matching windows layered behind it that seem to extend into outer space. Each window is a snapshot of how that Finder window looked when a Time Machine backup occurred. Here's how to navigate through your backups to find the time when your Photos library was fat and happy:

— **Drag your cursor through the timeline on the right side of the screen**. It looks likes a vertical ruler that sails through the Finder windows so you can see how they looked in the past.

— **Click one of the small arrows pointing up or down to the right of the Finder window stack**. Each click takes you backward or forward to the next time that folder was backed up by Time Machine.

— **Use the search box at the upper right of any Finder window.** If you get lost or want to find a different file, enter its name here and Time Machine displays results exactly like the Finder does when you use its search box.

Once you find the backup from which you want to restore your Photos Library file, select that Finder window, and then click Restore beneath the Finder window stack. The OS X desktop reappears and asks if you want to replace your current version of the file with the recovered version or keep both versions. Choose Replace and your troubles should be over.

Index